The Anatomy of Fashion

Colin McDowell

The Anatomy of Fashion

WHY WE DRESS THE WAY WE DO

Φ

Phaidon Press Limited
Regent's Wharf
All Saints Street
London N1 9PA

Phaidon Press Inc.
180 Varick Street
New York, NY 10014

www.phaidon.com

First published 2013
© 2013 Phaidon Press Limited

ISBN 978 0 7148 4947 8

A CIP catalogue record for
this book is available from
the British Library.

Designed by Byboth
Cover design by Julia Hasting

Printed in China

CONTENTS

THE ANATOMY OF FASHION

»The Anatomy of Fashion« takes a new approach to chronicling how we dress. By breaking fashion down into its basic elements and showing how they all fit together, it goes beyond the what, when and who of fashion to address a much more difficult – and much more interesting – question: Why? Why do we dress as we do? Why has fashion changed and evolved over centuries? Why does the human body shape, which, when all is said and done, does not vary massively in its essential form, require so much variation in its clothing?

The answers to such questions put clothes in the context of society and social change because clothes are, after all, a social construct. How we dress reflects a wide range of influences, from the technological development of new textiles or dyes to the economic advances that created a stratified society, from the requirements of unrestrained movement on the battlefield to the psychological desire to align oneself with a group of others through dress, from religious proscriptions on particular garments to the fascination of artists with other societies.

Above all, however, clothes reflect the different functions and needs of parts of the body. It goes without saying that the priorities when clothing the head are different from those we face when clothing the legs. The hands require a degree of freedom that the feet do not. The constant wear and tear on the feet, however, means that they need more protection than the hands. The feet are cushioned by layers of hardened skin, but early cultures further protected them by tattooing the skin with designs they believed could magically prevent evil spirits entering the body from the ground. The next stage was to tie soles of tree bark or grasses to the feet, followed by fur; these were the ancestors of the hard-soled sandals later worn by the Assyrians, Greeks and Romans.

Like the feet, other parts of the body have particular requirements from clothing – and reflect their own particular symbolism. Each shows the influence of the broader sweep of forces at work in the creation and development not just of clothing but of all aspects of appearance. Throughout history, people have had far greater freedom of choice in how they present themselves than in many other fields of life. That freedom was once a privilege but is now – in the developed world at least – a right.

Once the basic requirements of clothing – protection, warmth, comfort – were addressed in ancient times, it can be argued that any later change reflects not necessity but fashion. Items of dress have remained static, not least because the human body has remained static. Much change in fashion is a variation on a theme worked out centuries ago, and reflects clothing's role as a weapon to impress, protect, excite or intrigue. Those variations are at the heart of »The Anatomy of Fashion«. Why did a suntan replace a pale, peaches-and-cream face as a sign of a high-class woman? Why did men shave their heads so that they could wear closer-fitting wigs in the seventeenth century – or so that they can wear a beanie hat today?

Covering up has been the norm in most societies for at least 3,000 years. The reasons humans wear clothes are many. One – the basic impulse in cold climates – is for warmth. For our early ancestors, using animal skins to supplement their own insulation allowed them to roam further in search of food from the warm regions they initially inhabited. Another reason is closely related to the first: our clothes protect our relatively vulnerable skin from cuts, bruises, knocks, dirt and also the heat of the sun.

Other impulses to cover our skins are more complex. Although nakedness is our natural state, it is also the state that most reveals our animal natures. This has meant that it has been viewed with deep suspicion by those for whom the physical is the debased side of our natures, compared with the spiritual and intellectual nature that separates

us from the animal world and lifts us closer to the divine. Religions have urged their followers to cover themselves since the Old Testament days, when Eve fed Adam the forbidden fruit in the Garden of Eden and they became ashamed of their nakedness.

Under the urgings of Christianity, Buddhism and Islam, the human form virtually disappeared from public view for centuries (or even from private view: in the early modern world it would not have been unusual for a husband and wife to rarely see one another entirely naked, and even the Prince in the classic Italian novel »Il Gattopardo«, set in nineteenth-century Sicily, tells his mistress that, although he is a father, he has never seen his wife entirely nude). In a dualistic view of the universe, the spiritual is pure and holy; the physical is corrupt and licentious. The sight of nudity encourages base appetites and lust, a universal sin. It is worth noting, however, that the oldest of the surviving major religions, Hinduism, did not place such a high value on being clothed: the Naga Sadhus (saints) still go naked in their thousands, although often their bodies are covered in a layer of mud.

Moral and religious injunctions against nudity have rarely been entirely successful, however. Since Salome's Dance of the Seven Veils in the Bible, strip-tease artists, pornographers and priests have understood that partial nudity is usually far more arousing than complete nudity. The 'well-turned ankle' of the early ninetenth century or the 'glimpse of stocking' of its close took on erotic significance only in the context of clothing that otherwise disguised the body completely. Such is the complexity of the relation between clothes and skin that nudity may at times seem like the most innocent (and honest) of all human states.

Once everyone in a society wears clothes, how one dresses becomes a form of projection and differentiation. Clothes present clues about the wearer. Finer cloth, richer dyes or whiter linen have

always been the preserve of the wealthy. The poor meanwhile were dressed in fabrics that itched or chafed, dull browns, blues and greys, garments and shoes (if any) that fit poorly … or with wearing next to nothing.

Clothes do not simply conceal the body: they alter it. Pads make shoulders wider; bras change the silhouette of the breasts; corsets and belts provide narrower waists; collars make necks longer and more slender; vertical stripes elongate the body; dark clothes appear to slim. These physical trompes l'oeil have an emotional counterpart: if we think we look good, we feel good. This is the reason that clothes become an obsession for so many people – because ultimately we do not dress for other people; we dress only for ourselves and what we perceive as our physical inadequacies and imperfections. We dress in order to clothe whatever perception we have of ourselves and to shape how we wish the world to perceive us. Clothes become part of our personalities, betraying how we wish we were rather than who we actually are.

The signals that we send to others are reflections of our visions of ourselves. Of course, clothes do send out signals. They might reveal our job or where we stand in society; they might indicate our preferences in music, in sports or even in bed; they might reflect a tradition in which we function. But the signals are strongest to ourselves. Apart from clothes that people are forced to wear, we dress to reinforce how we see ourselves, to give us comfort, help us to belong (or not) and to instil a feeling of well-being and confidence when facing the world.

That is one reason why many clothes are so similar. The majority of people are more comfortable if they feel that they are part of a larger whole. Although society has at various times imposed rules on what people may or may not wear, a far more profound influence on dress has been people's inherent conservatism and peer attitudes. Excepting the most robust individualists, few of us want to move

too far away from the herd. The continuity of clothing for conformity and anonymity is often a far greater force in how we dress than the innovation of fashionable clothing, and one of the reasons (the other being lack of money and the right social habitat) why fashion change has been such a relatively slow-moving stream for most of civilization, with whole centuries passing with very slight variations in dress, which might better be called tweaking more than creating: a slightly wider sleeve here, a bigger pattern there.

To some extent, all dress is fancy dress, unless it is purely practical. Once anyone owns more than one set of garments, dressing for the day becomes a series of decisions – conscious or otherwise – about how to present oneself to the world. The clothes become part of whatever character it is wished to create. Thus, in a psychological sense, the adult's wardrobe remains an echo of the child's dressing-up box.

The power of clothes is that they are tools in our constant quest to find a personality with which we are comfortable. They are like the decorative and often concealing masks that liberate revelers from the responsibilities and repressions of daily life. They allow a new spirit to take over. We can be bold where we are normally shy, flirtatious when usually modest, provocative instead of correct. (When it comes to fancy dress parties, it seems to be always the naughty figures that appeal – transgressive Mother Superior, saucy tart, Marie Antoinette, Nell Gwyn are figures with overwhelming personalities that lend power to even the most retiring character.)

Designers love the make-believe element of clothing. Why not? This is where their imagination and creativity finds free rein. They no more want to be trapped in the everyday and humdrum than the rest of us, so they are happy to give us the clothes to help us escape. To that extent, they share the same sense of wonder and acquisitiveness of the seafarers and merchants who in past centuries voyaged around the world, witnessing strange sights and behaviours and bringing home the richest

and most exotic goods from the cultures that they encountered. But they are also storytellers who use clothes to impart their vision of the world – a vision that is filtered through a prism of romance, beauty and escape. Indeed, it could be argued that the fashion shows of the great designers are largely a coat of many colours offering a surrogate alternative to the imagination rather than suggestions for actual fashion wear. During their careers, John Galliano, Vivienne Westwood and Marc Jacobs have increasingly presented a make-believe, unrealizable fashion story which is no longer a serious suggestion of how to dress but a fantasy fairy tale that frequently leaves the viewer bewildered as the gap between the vision and reality looms ever larger. The only saving grace is the fact that little, if any, of the catwalk fantasy actually appears in the stores.

»The Anatomy of Fashion« is a new exploration of how we dress, based on that most obvious – but often overlooked – foundation: the human body. Examining each part of the body and how it has been dressed allows for historical or geographical or cultural juxtapositions that are not instantly obvious from a more traditional approach to fashion, illuminating both contrasts and continuities. This is not intended to be an encyclopedia. Rather than being comprehensive, it is intended to highlight some of the more interesting and revealing facets of dress that are often overlooked. It is not a book written for the dress specialist or costume academic but, rather, a book for the general reader of any age who wishes to learn more about themselves and their fellows by how they dress. Many of the images are not 'fashion': this book is about dress, and dress exists outside the stylized pages of magazines, in advertisements, snapshots, drawings, news images and everyday photographs. Dress is the inescapable and essential element of lives at all levels – and its variety and complexity is endlessly revealing and fascinating.

12

The Body Unclothed

14

THE BODY UNCLOTHED

Two hind limbs modified for upright walking, a pelvis and torso, front limbs modified into arms and highly dextrous hands and the head, seat of the largest brain in the animal kingdom: in evolutionary terms human anatomy reveals instantly its close relationship to the mammalian hominids from whom we are descended. Today our closest animal relatives all have hair. Alone in the animal kingdom, humans wear clothes.

Once humans started wearing clothes, the body was by and large hidden for centuries, but the unclothed body reemerged in the later twentieth century in Western cultures – or rather in some sections of Western cultures. It is by no means universal, but the once shocking exposure of an arm or a leg is now widely accepted, as are bare shoulders. The exposed female midriff has become a staple of urban glamour, as the bare back has in eveningwear. The naked male torso is to be seen everywhere, from sunny parks to building sites. It is difficult to imagine that until only 1936 it was illegal for men to bathe bare-chested in some parts of the United States. The naked female breasts are still a rare sight outside certain highly proscribed areas – mainly designated beaches – but are again more common than previously. For male nudity, it is necessary to seek out naturist or gay locations.

The body's largest organ, the skin grows with us throughout our lives – and inevitably reflects the wear and tear of those lives. It is a record of our ageing and it is an unavoidable record of our long decline from the physical peak of our youth. At various periods, the skin has also been a social signifier: those of higher birth who labour less have softer, clearer skin; those who spend their time indoors have paler skin than the workers who toil in the sun. For centuries, pale skin has been a sign of breeding. It was only in the early twentieth century that the growth of sports and leisure pursuits such

as swimming led to the opposite situation: a suntan became a sign of those with enough money to chase the sun and, once found, to romp in it all day long.

From the earliest times, archaeological evidence suggests, people have had an impulse to decorate the skin, either to disguise its inadequacies or, equally likely, to exploit the chance it provides for self-display. Even those who went naked or largely naked often painted or tattooed the body, or used scars to create patterns on the skin.

This same need to project ourselves – which underlies the human impulse to dress, along with warmth, protection and modesty – is what turns coverings into fashion. The origin of the vulnerability that underlies the impulse is uncertain – it may be the cultural creation of generations of social pressure rather than anything innate – but it certainly exists.

The first clothes were made from the resources closest to hand – bark, plant fibres or animal skins – but as early economies developed and clothing became an important component of trade, so the range of available materials grew broader. There are two main components of any garment in addition to its shape: material and colour or pattern. Together, they have produced an almost infinite variety of effects.

Animals produced fur, hides and wool; plants produced cotton and flax. The need for such materials shaped the history of continents – the European demand for fur encouraged the French exploration of Canada, for example.

Textile production meanwhile drove technological development, from the evolution of the loom to the coming of the cotton mills in the Industrial Revolution. The cloth people wore was as significant as the clothes themselves: satin, silk, cashmere and linen for the wealthy, wool, cotton and, again, in some periods, linen for the rest.

Just as the materials that make our clothes have their own semiotics, so do their colours. It is tempting to believe that the values we associate with colours – danger or sensuousness with red, coolness with blue, grief with black – are somehow inherent in them. There is no evidence that this is true. The colour of mourning in many countries at many times was white, while before Queen Victoria was married in white, most wedding dresses were coloured. In general, however, it is true that the richest colours have been the preserve of the wealthy – if only because of the exorbitant cost of producing dyes such as the famous Tyrian purple worn by the emperors of Rome.

Since humans began to cover their bodies, the demand for cloth and dye and the powerful messages they convey have ensured that the elements of dress have also been to a large extent the elements of our history.

S
K
I
N

+

B
O
D
Y

A
D
O
R
N
M
E
N
T

Skin is where all fashion begins: the naked human form. Nudity is humankind's natural condition. As the Book of Job informs us, we enter the world naked and we leave it in the same condition. The skin, the body's largest organ, regulates body temperature so well that in ancient times it was physiologically necessary for humans to wear clothes only in extreme environments. As far south as Patagonia in South America, native peoples adapted to the climate and were able to live without clothing. Clothing is an adjunct to the skin, but an entirely necessary one. Even from the earliest days, the impulse to dress has been based not only on practicality, but also on ideas of modesty and attractiveness. The skin both protects the individual and projects something about him or her. Such is its importance in defining who we are that in ancient cultures it was seen as something magical. Flaying or wearing the skin of a dead enemy was a sign of power. In the Sistine Chapel, Michelangelo

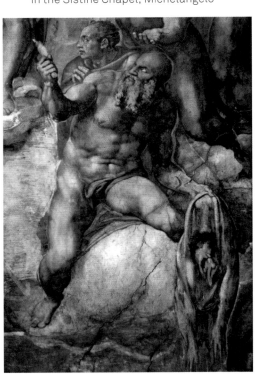

[1] painted the flayed martyr Saint Bartholomew holding up his own skin [1 - St Bartholomew by Michelangelo Buonarotti, 1537-41]. Bartholomew, one of the twelve Apostles, is said to have had his skin peeled off and been crucified upside down as a punishment for converting the king of Armenia to Christianity. The priests of the ancient Aztec god Xipe Totec ('Our Lord the Flayed One') wore gold-dyed skins taken from prisoners in a fertility ritual. Fashion has made clothes from the coverings of virtually every other

creature, but not of humans: the symbolism attached to the skin is too great. In 2007 French artist

[2]

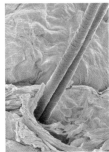

Olivier Goulet produced a bag and garments made from synthetic human skin, but they had little worth apart from shock value, and only served to reinforce the taboo status of skin.

Meaning of the Skin

Skin may have lost its associations with power, but it retains an air of mystery, especially since the advent of close-up photography has revealed the beauty of its microscopic landscape of pores and hairs [2 - Scanning electron micrograph of human skin]. Our skin is a record of the wear and tear of our lives. Its sags and scars are a highly visible sign of our ageing. Our physical peak comes relatively early, so most of us spend decades in physical decline, whose ravages we would rather keep hidden. The cells of the epidermis – the outer layer of the skin – become thinner and drier; the underlying dermis becomes less elastic, causing the skin to wrinkle and sag. But despite – or perhaps because of – this eloquent testimony of the skin, aged skin can be both beautiful and dignified. For twenty years from 1917, Edward Steichen photographed the naked body of his wife Georgia O'Keeffe, tracing the changes in her skin [3 - Georgia O'Keeffe, photo by Philippe Halsman, 1967]. The craggy face of the older W. H. Auden, or the weathering of a Cherokee chief, or the liver spots of Doris Lessing's hands are similarly badges of seniority and a moving testimony to the dignity that comes with age. They are signs that command our respect.

Fashion, of course, places a premium on youth – or at least the appearance of it. A vast business has been built on reducing the signs of age – $88 billion in 2010 in the United States alone. The skin complexion that is most valued tends to be smooth and flawless. Blemishes are hidden, spots are treated, scars are disguised; but that has not always been true. In the sixteenth century, Queen Elizabeth I of England used blue make-up to highlight the veins in her exposed breasts, themselves plastered with white – and poisonous – lead powder. She was echoing Egyptian noblewomen from 3000 BC,

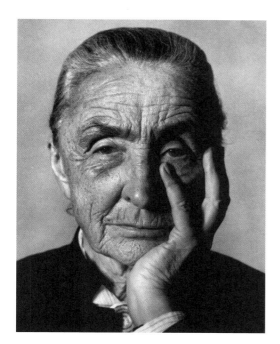

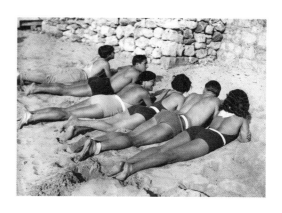

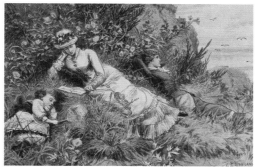

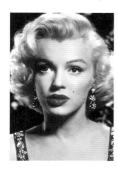

who also believed that varicose veins increased beauty and so highlighted them in their legs and breasts (see Bust, page 78). In the 1660s women at the French court used a range of beauty spots made from black taffeta that they placed strategically to highlight their facial features. A spot placed on the left cheek showed that a woman was engaged; on the right, it showed that she was married. A spot near the mouth indicated a willingness to flirt. Closer to the present day, Marilyn Monroe drew in a beauty spot above her lip [**4 - Marilyn Monroe, c.1954**], while there is an argument that Cindy Crawford's career as a supermodel was enhanced rather than damaged by her prominent mole (see Face, page 64).

Skin is as subject to fashion as clothing. At different times in various societies, certain qualities in the skin have been considered more fashionable: smooth, white porcelain; craggy and distinguished by age; tanned, shaved and athletic; dark and rich. In Western high society from the seventeenth to the late nineteenth century, women have often gone to great lengths to keep their skins fashionably pale. Any glow of colour was at best associated with low-class occupations that took place in kitchen, laundry or field, and at worst suggested physical, including sexual, exertion. Those people who never knew the sweat of toil had neither a physical reason to remove any clothing nor a sense of etiquette that would allow them to do so in any case.

In eighteenth-century Europe, fire screens were invented to protect pale skins from being burned by the heat of the flames, and during the 1840s, women took to drinking vinegar to keep themselves looking pale. Upper-class Victorian ladies rarely went out in the day without covering their skin entirely: gloves and hats, including veils, were de rigueur [**5 - »The Lotus Eaters« by Charles Joseph Staniland, 1882**]. The Victorian husband wished his wife to do absolutely nothing all day – and to look as though she did nothing. In »Gone with the Wind« (1939), set at the time of the American Civil War (1861–65), Scarlett O'Hara appals the servant Mammy by going out without a hat and therefore risking burning her skin like the low-class women (see Head, page 52); as Mammy dresses her charge, she constantly chastises Scarlett for various similar social solecisms.

The suntan only became desirable around the 1920s. As sports exerted more influence over everyday life, and as air travel made it easier to reach sunny destinations, a tanned skin became the sign of being wealthy enough to do nothing productive all day – but this time, in the open air; originally in the mountains, with walking and skiing, and later on the beaches, swimming or playing ball games [**6 - Cannes, France, 1933**]. In turn, the arrival of mass tourism as a concept in the 1970s made the suntan entirely democratic, with no implication of social class. Dark skin became highly desirable. It was only at the end of the twentieth century that the wisdom of getting a suntan was questioned, with the realization of the damage the sun's harmful UV rays can do to the skin, making even dedicated fashionistas reconsider the pursuit. In addition, the rise in popularity of unhealthy looking, waiflike models – so-called heroin chic – seemed to indicate that pale, if not pallid, skin was again revered.

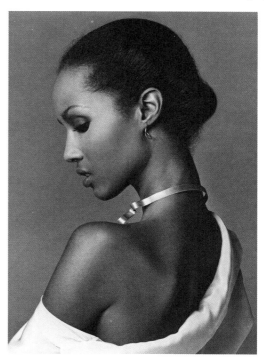

Dark skin tends to be left to black models [**7 - Iman, photograph by Francesco Scavullo**]. Traditionally black skin did not often feature in the fashion world, and even now, despite the occasional high profile of models such as Iman, Naomi Campbell, or Tyson Beckford, it remains true that designers, investors, buyers and journalists are all equally unlikely to have darker skin. Models with non-white skin are increasingly visible – although rarely in the world of couture – as a way to give clothes a hint of exoticism and the glamour that comes with it. The numbers remain relatively low but will rise, if only in acknowledgement of the fact that black people in most societies increasingly enjoy the wealth that enables them to be fashion consumers. Fashion is, ultimately, about nothing but appearance – and money. It is one enterprise in which the colour of the skin is far more important than the individual inside it.

Fashion, like the rest of society, remains fascinated by the skin and by nudity: numerous designers have put semi-naked models on the catwalk to sell clothes, from Yves

[3]

[4]

[5]

[6]

[7]

Saint Laurent in the 1970s to Katharine Hamnett in the early 2000s. Nudity has long been a staple of Western art, but with the development of photography, the presentation of nakedness became more widely available and, therefore, acceptable. While paintings or engravings were the exclusive reserve of the wealthy, by the late nineteenth century most people could afford a small photograph of a nude model if they required one. Such postcards had the thrill of the illicit at a time when many people saw no one completely naked, not even their spouses. In Paris, hundreds of studios opened to provide images of 'artist's models'. In the 1880s, the trade in these postcards employed 20,000 people, many specializing in hand-colouring skin tones on images that largely featured full-figured, middle-aged domestic servants.

Society's fascination with nudity created an elaborate double standard. In the West nudity became acceptable in the young and in those of other races in the 1860s, during the reputedly puritanical Victorian age. Photographers such as T. H. Huxley and John Lamprey evolved an acceptable code to justify publishing images of naked Africans. Huxley used a measuring rod, while Lamprey shot his subjects against a grid of 2-inch squares made from string to give a veneer of scientific authority to what was a thinly disguised exercise in prurience for the many who simply liked to look at nudes [**8 - Views of a Malayan male by John Lamprey, 1868**]. When the editor of »The Photographic News« was prosecuted for obscenity after publishing photographs of naked Zulus in 1879, he argued that the pictures were a valuable anthropological record. Nudity was acceptable, but only when shielded by a veneer of scientific or practical purpose – or wealth, which at that time silenced all criticism.

[8]

Today the unclothed body remains rare in most Western cultures, although the once shocking exposure of an arm or a leg is now

widely – though not universally – accepted. Bare skin has become acceptable as a fashion statement only in the last few decades. The display of women's midriffs between low jeans and crop tops would have scandalized even as recently as the 1960s (see Waist, page 96). The naked female shoulders, acceptable to the upper middle classes since the days of Ingres and earlier but not approved of among the lower classes until modern times, are nevertheless always to be covered in holy buildings in Islamic and Christian countries in an acknowledgement of the belief that female flesh is dangerously incendiary (see Shoulders, page 70). Although it is permissible for women to sunbathe topless on the beach, to lie in an urban park in a similar state would risk prosecution for indecent exposure. Even today, there are those who express disgust at the exposed breast of the woman who feeds her child in public. Such mixed reactions show how uneasy the exposure of the flesh makes society as a whole.

Decorating the Skin

The impulse to project ourselves as well as to cover the flesh was surely one driver for prehistoric peoples to begin to decorate the skin. For them, as well as us, the excitement of covering the body – with mud or ochre, with tattooed designs, or later with furs and skins – came from the act of disguise. Perhaps they felt closer to their gods by arrogating the colours of divine power, such as the yellow of the sun; it protected them from the evil in the universe, which might otherwise enter through the unprotected skin. Above all, perhaps, it made them look other than they were – it enabled them to transform themselves to their own advantage. The same motivation encouraged the adoption of clothing. It could be argued that we wear clothes at least in part because we feel more vulnerable when we do not. Even among tribal peoples for whom going naked or largely naked is the norm, the impulse is to decorate the skin in various ways, by body painting or tattoos or even scarification. It is as if the naked skin itself is somehow wanting – or perhaps as if the opportunity it affords for self-display is impossible to ignore.

The instinct to colour or tattoo the skin is inextricably linked with the human desire to interact with the world around us, and with the invisible, spiritual world beyond. For millennia decorating the skin

was associated with supernatural power. Decoration that echoed the colouring of animals was believed to help hunters become close to the spirits of their prey. Other forms of colouring brought humans into contact with the divine. Neolithic skeletons are buried covered with red ochre, which must have had a ritual meaning; figures that appear in Saharan rock art nearly 10,000 years old may be wearing tattoos; in Polynesia, tattooing was considered a sacred art that had been given to humans by the gods.

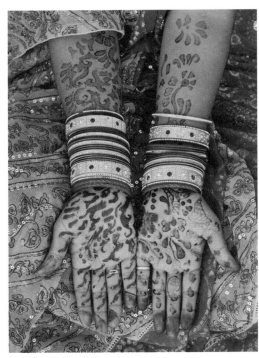

[9]

In more recent times, skin decoration in the form of tattooing has become an overt way to demonstrate membership of a particular group. In early societies it was a sign that placed the wearer in that society, by marking both social class – sometimes, tattooing was the preserve of the wealthy and powerful; at others, of the criminal or the alienated – and an individual's passage through life, with milestones such as puberty and parenthood. Tribal peoples in some parts of Africa, for example, still use this method to chart a young woman's life cycle, adding symbols to mark her first menstruation, the birth of her first child, the end of breastfeeding and so on, so the tattoos act as a visual biography, displaying her position in the cycle of fertility and childbirth. The practice of hand-painting, known in India as mehndi, has a related function [**9 - Mehndi tattoos, Amritsar**]. Henna is used to create a decorative effect analogous to the Western wearing of jewellery, and to mark a woman as special at a particular,

'In the nude, all that is not beautiful is obscene' ROBERT BRESSON, 1975

symbolic moment – most often a wedding – until it fades over a few weeks and she can be seen to return to her more ordinary life. Its intricacy makes it expensive and thus a sign of the value of the woman whose skin is being treated. Henna is said to be able to work magic, warding off the evil eye or propitiating the dead when used to wash graves. Likewise, in mehndi, good-luck charms and the names of the newlyweds are hidden within the swirling patterns.

Tattoos have always been magical. Women in Berber tribes tattoo coloured spots near their eyes, nose, ears and mouth, and on the soles of their feet, to ward off the evil eye from points at which it might enter the body. It is almost as if by inscribing things on the skin, we can guarantee them. In the same way, men have for decades tattooed names inside hearts on their biceps to declare their permanent devotion to 'Mum'. Or, in the case of David Beckham's tattoos of his children's names, they highlight the living proof that he is sufficiently masculine to father offspring, taking tattooing back to its earliest manifestations [10] as proof of physical power.

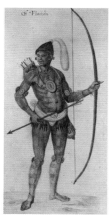

In climates in which clothes are unnecessary or inconvenient, tattoos and other forms of adornment provided an alternative way of decorating the body. In the 1580s the artist John White painted Native Americans wearing 'costumes' of designs made from soot or plant sap, pricked into the skin using the jawbone of a fish or small mammal [10 - Indian man from Florida by John White, 1585]. When the first Europeans landed on the Marquesas Islands only a decade later and encountered all-over body tattooing, they believed that the people were wearing costumes of lace. Among the peoples of Oceania tattooing was common – the word 'tattoo' comes from the Tahitian word 'tatau'. On the Marquesas, noblemen were tattooed all over; women of rank decorated only their faces and limbs. Faux Maori tattoos may seem to be on every shoulder or bicep today, but few fashionistas would dare to emulate the authentic Maori approach, in which facial tattoos were more important than

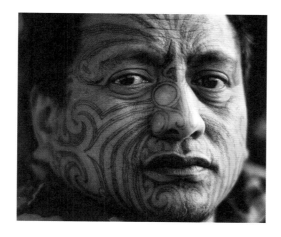

[11] body tattoos. Even the lips were tattooed to make them appear blue (see Face, page 64) [11 - Tame Iti, with traditional moko tattoo].

The facial tattoo bestowed an identity as unique to the individual as a signature or fingerprint. Low-born Maori and slaves were forbidden tattoos, which had to be earned in battle and, by reflecting bravery, improved a man's chances of finding a partner. In modern society, tattooing the face remains largely taboo – mainly because, while body tattoos can be hidden or revealed according to the social situation, facial tattoos allow no such flexibility. The Western attitude towards tattoos remains ambivalent but, although it may seem prudent even for enthusiasts to ensure that a tattoo is capable of concealment, the neck and bald skull are increasingly seen as a canvas for tattoos with a simple underlying message: 'Don't mess with me.'

Another purpose of the tattoo has been as a brand; a permanent mark [12] of class or status. As early as the

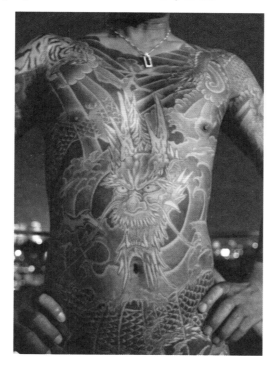

sixth century, the Japanese used tattoos to mark criminals or those of low caste. Today the punishment has been turned on its head: criminals use tattoos to flaunt their criminality. The Yakuza, the Japanese mafia, have a tradition of all-over body tattooing known as nihon irezumi, or 'tattooed Japanese' [12 - Irezumi tattoo with water dragon motif]. These tattoos are badges that prove their rejection of society. The pain involved in the process makes them marks of spiritual strength and physical courage in the same way as the duelling scars displayed proudly by German students in the eighteenth and nineteenth centuries.

Sailors originally brought the art of tattooing home from voyages to the Pacific in the late eighteenth [13] century, and the practice spread through Europe's ports. The intricate, twisting designs of tattoos were reminiscent of those of scrimshaw, the designs sailors scratched onto whalebone or walrus tusks. But if the modern tattoo carries an air of nobility associated with the South Sea islanders, it is also impossible to dissociate from the political message of the branded skin of slaves in the nineteenth-century United States or the tattooed numbers of the inmates of the Nazi concentration camps – once co-opted for a Benetton advertisement whose notoriety was as undeniable as its taste was dubious [13 - Survivor displays concentration camp tattoo].

By the nineteenth century, the tattoo in the West was widely seen as a defilement of the body associated with low living, sleaze and criminality. It was virtually unknown outside the military and the navy and confined entirely to males – hence the fascination with the tattooed lady, who was a staple of fairgrounds and freak shows. But the skin's link with physicality and sex made the tattoo irresistible for the upper classes and social transgressors. Edward, the Prince of Wales, had a Jerusalem cross tattooed on his arm during a visit to the Holy Land in 1862. His sons, the dukes of Clarence and York, followed his example, and were tattooed by a celebrated Japanese master, Hori Chiyo. The royal seal of approval – the Duke of York became King George V in 1910 – began a vogue

for tattooing among the British aristocracy, albeit a vogue concealed from the lower classes, in acknowledgement of its louche and sexual connotations. Unlike tattoos today, these were always covered in public and seen by others only under the most personal and intimate« circumstances.

Scarring the Skin

An even more extreme form of permanent marking than tattooing is scarification, which is traditionally linked mainly with the peoples of sub-Saharan Africa, and to a lesser extent with some Asian peoples. In Western culture there is a general reluctance to make permanent alterations to the skin that are purely decorative. Part of the reluctance to tamper with the body has its roots in religious strictures. Only the unwary – or the outright immoral – would tamper with the body that God has given them. (The most obvious example to the contrary – male circumcision – is, ironically, justified almost entirely on ritual grounds, being entirely unnecessary on the grounds of health or cleanliness.)

Scarring creates texture that invites touch and therefore encourages an obvious sexual intimacy. The most common sites for scarification – usually caused by opening cuts and then rubbing in ashes or charcoal to prevent them healing – are traditionally women's backs and men's chests. The rubbing between the two enhanced the tactile pleasure of rear-entry sex, which was universal among tribal peoples until the late eighteenth and early nineteenth centuries, when Westerners arrived with their own ideas about the morality of mating like animals and instead promoted the missionary position.

The scarring of the body made pain the prerogative of both sexes. In Western Samoan tradition, for example, young men had intricate designs scarred into their buttocks as a sign of their sexual maturity. Young Shilluk women in southern Sudan have a ring of pearl-like scars on their foreheads, created by pulling up the skin with a fish hook and then cutting it off [**14 – South Sudanese woman with tribal scarification**]. At the extreme end of this physical pain continuum is female circumcision, which is now more usually – and more accurately – referred to as female genital mutilation. The female genitals are modified by crude surgery in order

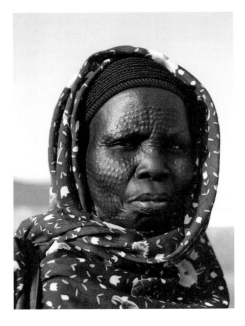

[14]

to create a tighter vagina and therefore increase sexual pleasure for the male. Condemned by international bodies such as the World Health Organization, the practice is still continued among some African and Asia societies.

As with aged skin, scarring marks life's landmarks and achievements, perhaps in battle or in the hunt. To that extent, it is a badge of honour. But it is also the social signifier of a society that has been stable and unchanging for a long time. Modern societies move too quickly to risk making permanent changes to the bodies of individuals, in case they become the object of scorn in ten or twenty years. In the West, intentional scarring is comparatively rare.

[15]

Real scars, on the other hand, are interesting precisely because they are accidental. They are blemishes. They have rarely caught on as a fashion item in the West, however, particularly among women [**15 – appendectomy scar**]. In men, battle wounds have traditionally been a sign of macho credibility, to the extent that there was a short-lived craze among German aristocrats of the nineteenth century to deliberately cut their face to resemble duelling scars. Actor Keanu Reeves has been photographed

baring a chest scar he received from falling off a motorbike. There is more reluctance to show women with scars. The dress anthropologist Ted Polhemus praises scars as signs of authenticity in models whose very perfection makes them seem unreal. In a 1997 photo shoot by Sean Ellis entitled 'Tissue', »Face« magazine displayed models with scars – including the actress Patsy Kensit with an appendectomy scar – although they were otherwise unblemished. Ellis admitted to airbrushing other marks, such as acne scars, in his attempt to make a modified statement whereby selective blemishes enhanced rather than weakened the appearance of otherwise perfect skin.

Everyone has seen images of peoples who change their features by using rings to elongate their necks, such as the Kayan of Myanmar, or to cause their lower lips to protrude in an exaggerated way, such as the Mursi or Suri of Ethiopia or the Botocudo of Brazil (see Neck, page 68) [**16 – Padaung woman with neck coils, Myanmar**]. Such modification seems unnatural to us, but the results are evidently judged attractive by those who practise it, perhaps. Some academics theorize that the sub-Saharan peoples of Africa originally made their women wear lip plates to make them unattractive in the eyes of Arabs who might otherwise take them into slavery. The Arabs displayed affection by kissing, but the Africans used other methods, similar to Maori nose-rubbing rituals. Deformed lips therefore made females far less attractive as slaves or concubines.

[16]

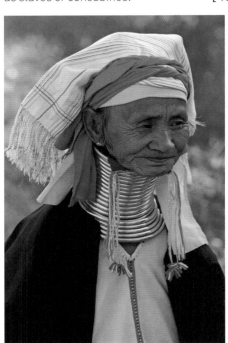

In the West, the closest comparison is the use of conical plugs to increase the size of holes in earlobes, which has become something of a fashion among the young only since about 2010. Body piercing – itself a form of scarification – has a far longer history in the West. The oldest-known mummy, a male body 5,300 years old found in a glacier in Austria, had pierced ears to accommodate earrings. Nose and lip piercing were traditionally more common in African and Asian cultures. Nose studs have been worn in India since about 1500 BC, in part because Ayurvedic medicine suggests that the left nostril is linked to the female reproductive organs. In modern times, virtually all piercing, even of the ears, was rare in the West in the twentieth century before a rise in the practice in the 1970s, encouraged by the punk movement, the gay subculture and Californian innovators. Piercing some parts of the body – including the navel, the nipples and the genitals – has remained a minority pursuit.

Taken to an extreme, the same impulse that is behind scarification and piercing also drives the urge to undergo cosmetic surgery – the desire to make the body more perfect. The procedures include abdominoplasty ('tummy tucks'), breast reduction or enlargement, facelifts, rhinoplasty ('nose jobs'), liposuction or the injection of Botox or collagen into the face **[17 - Rhinoplasty, Iran, 2007]**. Such surgery increased in popularity by 50 per cent between 2000 and 2007, during which time some 11.5 million procedures were performed in the United States alone. There is evidence from a sixth-century BC Indian manuscript to show that rhinoplasty was already a known procedure – although the failure rates of any type of surgery until the nineteenth century made it relatively rare. Reports suggest that in Iran, more than 100 surgeons carry out 35,000 'nose jobs' every year. The operation is so fashionable that there are reports of people who have

not had it wearing bandages as if to suggest that they have. Some patients justify their decision by citing the Koran's claim that God loves physical perfection; sociologist Desmond Morris cites instead the fact that the practice of veiling in Islamic countries focuses attention on the nose, as it is one of the only parts of the face left visible.

From the Naked to the Clothed
Alone in the animal kingdom, humans wear clothes to augment the skin. But clothes also hide our nakedness – that is the message of Adam and Eve, who ate fruit from the tree in the Garden of Eden: 'And the eyes of them both were opened, and they knew that they were naked; and they sewed fig leaves together, and made themselves aprons' **[18 - Adam and Eve from Apocalypse of Beatus Liebana, 10th century]**. Early in human history, nudity ceased to be neutral and became something of which to be ashamed. To some extent the history of fashion is the history of our impulse to cover our bodies for the sake of modesty versus our impulse to display our own attractiveness.

When Robert Burton wrote in »The Anatomy of Melancholy« in 1621 that 'The greatest provocations of our lust come from our apparel', he provided a clue to the real purpose of fashion. Nudity reveals flaws. It limits our options for how we present ourselves, making it almost impossible to alter or disguise our appearance. With nudity, what you see is what you get; in complete contrast, the best fashion promises that there may be so much more to the body within the clothes.

Fashion does not hide the body's nakedness to inhibit sexual attraction, but to highlight it. Far from being a covering for modesty, it invites arousal, through subtle hiding or revealing of body areas or through its display of conformity: a strong signal to a prospective mate in terms of evolution, in which conformity promises a better chance of survival. Fashion allows us to appear not only more desirable but also more powerful, more socially secure or more intelligent than we might be. That is why such illogical garments as see-through clothes have existed since 3,500 years ago, when ancient Egyptian nobles wore diaphanous tunics as symbols of high status. And why the average nightclub will provide far more titillating sights than a nudist colony.

'The finest clothing made is a person's skin, but, of course, society demands something more than this' MARK TWAIN, 1890s

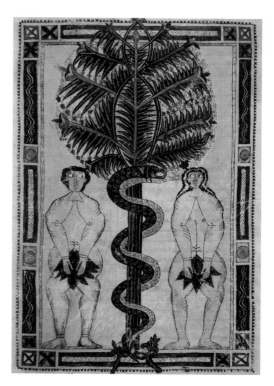

[18]

M
A
T
E
R
I
A
L
S

+

T
E
X
T
U
R
E

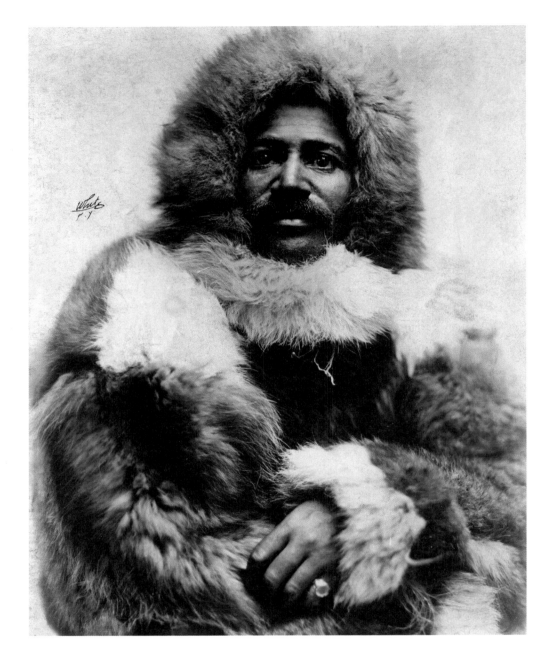

[1] Materials are the stuff of fashion. Obvious, maybe, but something that is liable to be overlooked now that colour, cut, shape – and cost – have become the staples of fashion exchanges. Fabric is taken for granted, yet the designer's vision can only be realized by exploiting the inherent qualities of the material. That is one reason why so many different materials have been used to clothe the human body – and why the textile industry has shaped history. Some materials are skins: fur, which retains the hair or outer hide of an animal, or leather, in which the hide is stripped and tanned for preservation. Others are textiles: cloth that is either woven or knitted from threads of cotton, flax or other fibres. There are pressed fabrics such as felt, and fabrics that use various natural substances such as grass, leaves or birds' feathers. And there are synthetics, usually based on derivatives of petroleum, including nylon, polyester and acrylic. Specialized clothing uses materials made from minerals, such as glass fibre and, for glamour, threads of gold or silver.

Fur and Skins

Fur was the first fabric our early ancestors wore: it was warm, soft and thick. Humans learned from the animals they hunted and consumed. If polar bear or caribou didn't feel the cold, what better way to stay warm than to make a covering from their skin? If the leopard's coat allowed it to get close to its prey, then why shouldn't a hunter wear the same camouflage? Over millennia, different ways of treating furs developed. People learned to separate the hair from the skin, leading to the division between fur on one hand and hides and leather on the other that remains today, leading to the paradox of those who wear leather shoes but would never wear a fur coat. Fur was practical and readily to hand, but it soon began to connote status. The rich and powerful wore the finest,

thickest or most attractively coloured fur. Perhaps inevitably, the sensuous qualities of the material, together with its associations with wealth, combined to give fur its modern image as something fundamentally sexy and indulgent, a symbol of someone with more money than both sense and – in the Western world at least – sensitivity.

For most human beings throughout most of history, the debate about whether to wear or not wear animal fur would have seemed, if not outright absurd, then certainly an indulgence. Fur was – and remains – the warmest of fabrics. It is hard today to imagine, in the period before the modern age of central heating and insulated homes, just how cold people became in normal life. Even at the Versailles of Louis XIV in the eighteenth century, admired throughout Europe as the cynosure of luxurious living, the dining rooms could be so cold during the winter that wine reputedly froze in the glass during meals. Fur was the obvious answer to the question of how to keep warm, in the same way that it remains obvious today to the farmer in Siberia wearing a Russian ushanka – with ear-flaps – made of rabbit or fox pelt, or the Inuit who wears reindeer fur in the Arctic [1 - **Matthew A. Henson, Arctic explorer, c.1909**].

Fur is one of the most enduring of all fashion 'drugs': it is so glamorous, sexy and luxurious that, like the criminal underworld behind the trade in cocaine, the conflict that underpins much of the diamond trade and the exploitation that goes with the manufacture of cheap clothes, most fashionistas choose to ignore the undoubted suffering that makes it available. While no designer will ever again show endangered species such as leopard or ocelot on the catwalk – convincing copies of big cat furs are available for the tiny number of women who actually want them – today's key ethical conundrum concerns the less exotic animals farmed for their pelts: how they are raised and, especially, how they are killed.

More than 80 per cent of the world's fur comes from farmed animals. The remaining share is hunted in the wild from dozens of species: beaver, fox, muskrat, ermine, squirrel, mink, opossum and raccoon. Much of this hunting is carried out by peoples of the far north, using traditional methods. When European and

American explorers struggled to survive in the Arctic in the nineteenth century, often wearing Western clothes, fur-clad Inuit communities sometimes lived without fear of the cold only a few miles away. (In 1860, explorer Charles Francis Hall, marooned when ice crushed his ship on Baffin Island, was startled to be visited in his cabin by an Inuit woman wearing a crinoline, flounces and a huge bonnet; a wardrobe acquired when a sea captain had taken her and her

[2]

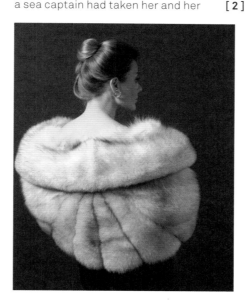

husband on a two-year trip to England. She had come to invite Hall for a cup of tea. When he visited her igloo, he noted that despite her impeccable etiquette, she had abandoned her Western clothes for more practical caribou hides.)

There is, of course, fur … and there is fur. Squirrel and rabbit don't make the same statement – or arouse the same controversy – as mink and sable. The rarest, softest fur is the most highly prized: in the Russian empire in the nineteenth century, nobles turned their backs on the ubiquitous mink in order to wear the less-common sea otter. Fashions have changed: beaver was worn in the early days of American colonization; tiger during the British Raj; lion- and leopard-skin during the colonization of Africa, along with colubus monkey; and chinchilla, which was popularized by Anna Wintour, the editor-in-chief of »American Vogue«, at the end of the 1990s. Designers today tend to steer clear of old-fashioned pelts, preferring to woo fur virgins with fitch (polecat), wolf and coyote [2 - **Silver fur stole coat, 1970s**].

In the Middle Ages, even those who were neither rich nor concerned with status might wear fur from rabbits

or squirrels, or goat or sheepskin, but in Britain only nobles could wear sable, the hair of the marten, thanks to a decree by Henry VIII. Sable has no grain: it is equally smooth and silky in whichever direction it is brushed, leading one seventeenth-century Russian observer to identify it with the ancient Greek legend of the golden fleece. Sable was traded widely as a luxury fur throughout Europe from its source in the forests of western Russia. Even inside Russia, the fur was valued enough to be demanded from client states as a tribute payment and was largely reserved for the aristocracy, in the same way that ermine (the fur of the white stoat) was in the West.

The ankle-length mink coat remains the ultimate status garment (if it's exclusive Barguzin sable, with its silky golds, browns, silvers and blacks, so much the better). Others might aspire to a stole, a muff or even the trim on their parka. Like virtually no other fabric, fur has a permanent aspirational quality, as well as being synonymous – for many – with sex. Fur has long been used as a shorthand for sexual availability, from fin-de-siècle grandes horizontales to actress Sarah Bernhardt, who always received gentlemen friends reclining on a variety of pelts. During the Renaissance, Titian painted women in their furs [3 - **Isabella d'Este, Duchess of Mantua, Titian, 1534**]; Peter Paul Rubens dressed the goddess Venus in fur; the great Islamic painter Riza-i Abbasi drew

[3]

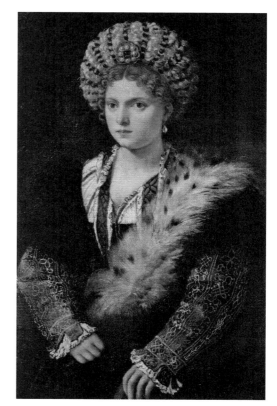

25

an elegant girl posing proudly in a fur hat – when people had their portraits painted, they dressed in their best clothes, just as celebrities do today when they are going to be photographed. Fur's appeal seems to be particularly strong among young black Americans, who by 2006 accounted for a quarter of the US fur market. Fur remains the ultimate symbol of conspicuous consumption: DJ Biz Markie boasts that he has fifteen furs, including three sables and three minks.

Fur has always been seen as somehow magical; the more powerful the animal from which it came, the more magical the pelt. It follows that the pelts of the big game cats are the most powerful of all. To ancient hunters, wearing a skin taken from an animal, as well as being camouflage, was a way in which to take on some of the animal's strength. Alexander the Great was sculpted with a lion's head hat. Among African peoples, the pelts of big cats – sometimes with the head left on to act as a type of crown – became the mark of the chieftain, possibly because of their association with hunting prowess. Julia Margaret Cameron photographed Europeans in Ethiopia (then Abyssinia) in the 1860s, and Captain Tristram Speedy can

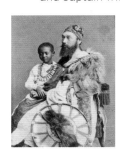

be seen in a photograph from 1868 having adopted native dress and wearing a lion skin [**4 – Captain Tristram Speedy with Prince Alamayou of Abyssinia, 1868**].

[4] **The Lure of Leather**
The history of stripped and tanned animal skins – leather – has taken them from necessity through practicality and display to symbolism. Our ancestors learned how to treat skins to preserve them, scraping off the hair and sewing strips of material together, during the Neolithic period (9500–5500 BC). Skins were treated in different ways to create stiff, thick leather or soft buckskin and suede. Dyeing followed, as did decoration. In the hands of craftsmen from different cultures, from Cordoba in Spain to the Native Americans of the Eastern Woodlands, leather became a means to display power, wealth and skill. Taken from beasts ranging from cows, pigs and sheep to ostriches, pythons and fish, its modern uses

vary from the motorcyclist's glove to the luxurious Hermès luggage and trophy Louis Vuitton bag of the international elite; from the totally practical footwear of policemen and nurses to the Manolos of »Sex and the City«; from the jackets of rebel bikers to a 'soft as silk' Ralph Lauren suede evening skirt; and from the coats of early airmen to the erotic fantasy of the »Avengers« catsuit.

[5]

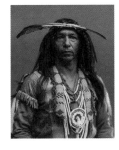

Leather retains an ethnic quality that harks back to its importance in early societies, from the Sami and the Inuit – for whom it remains an essential protection against the cold – to African peoples who wore fine leather aprons for protection from branches and thorns. In North America, the annual buffalo hunt was the basis of the leather economy of the Native Americans, who used hides to make blankets, tepees and moccasins, as well as protective garments. Groups from across a wide region would traditionally meet to form a temporary camp for hunting and trading. Deer and goat skins were common, but the precise leather used depended on where people lived: the Micmac of Nova Scotia tended to use fish and bird skins, for example [**5 – Arrowmaker, Ojibwa brave, c.1903**].

In the West, thick leather was for a long time the most practical protection against arrows or blades, being cheaper and more comfortable than metal armour (see Armoured, page 162). Later, as firearms rendered metal armour largely useless, the leather doublet became standard wear for the infantry, as it allowed more ease of movement for firing matchlocks and flintlocks. Even after it was abandoned by the military, leather remained common in workwear: the smith's apron, because it was not troubled by sparks from the forge; the gardener's gloves, because they protected against thorns; the horseman's chaps, because they prevented friction [**6 – Outrider, Bicentennial wagon train, 1976**]; and the despatch rider's jacket, because it helped avoid road burns in the event of a crash (see Workwear, page 234).

Before it became associated with motorcycles, leather was for

centuries closely associated with horse riding. It protected the legs from rubbing on the animal's sides, and the rider's body from thorns and branches. It was the obvious hard-wearing material to use to make harnesses and saddles, which emerged in Constantinople around the fourth century. By the late eighteenth century, France led the way in producing hides. Some of the most illustrious marques in modern fashion originated from the leather trade: Hermès opened as a saddler and harness maker on rue du Faubourg Saint-Honoré in Paris in 1837; Louis Vuitton was founded in 1834 to make luggage; Alfred Dunhill began providing leather clothes – gloves, jackets and helmets – for motorists in 1897, and within a few years was advertising itself as 'the largest leather clothing manufacturer in the world'.

[6]

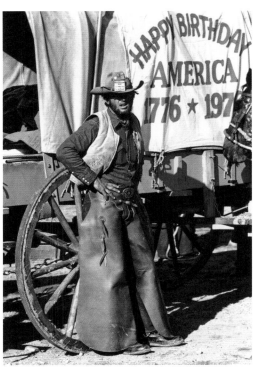

Like denim, leather was one of the materials that tamed the Wild West. If the men who actually worked with the cows didn't wear their hides, then what? Saddles, chaps to protect the legs, and bevel-heeled and increasingly elaborately tooled and decorated boots – with high shafts to protect the lower legs from snakebites – were made from cow skin. They also used deer, snake, lizard or just about anything else that could be hunted, as well as – by the mid-nineteenth century – imported skins such as crocodile, highlighted with tips of silver, garish gemstones or fancy stitching. The boots were both a sign of the cowboy's trade and a symbol of his self-reliance, integrity and resilience;

'Fine furs are born – not made' – »ROMANCE OF FURS«, 1936

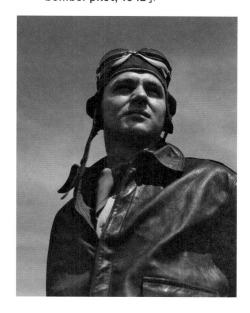

[7] qualities that have come to embody the American spirit (see Feet, page 140). Little wonder, then, that the fancy boot has become an iconic clothing item in some parts of the United States, where it is acceptable in urban environments (even with business suits, and often paired with a Stetson) in a way simply not conceivable elsewhere.

Leather's intimate association with riding extended to other forms of transport thanks to developments during the early twentieth century: the aeroplane, motorcycle and car. It was a request from a motorcycle distributor on Long Island that inspired Irving Schott to design in 1928 the Perfecto, the archetypal leather jacket that was still current at the century's end. One of the first zipped leather jackets, with ingenious pockets and snap fasteners, small chains to allow the zips to be opened even when wearing gloves, and tapered sleeves designed to retain warmth by keeping out the wind while riding, the Perfecto set a pattern for leather jackets that has never yet been superseded. The jacket's association with motorbikes – Marlon Brando did not take his off in the 1953 movie »The Wild One« – led to its identification with delinquents and it being banned from many schools [7 - **Marlon Brando in »The Wild One«, 1953**]. Punks brought the Perfecto back to the forefront of street wear, and in the 1970s and 1980s the biker jacket made its way on to the catwalks in versions by Gianni Versace, Jean Paul Gaultier, Dolce & Gabbana and others who took the garment far beyond its roots (and its original $5.50 price tag) as clothing for protection … to clothing for projection.

The leather flying jacket was equally iconic, even after the US Air Force had replaced leather with cheaper and more serviceable cotton. The first flying jacket was made in 1915 by the German army for none other than Baron von Richthofen, the air ace also known as the Red Baron. The garment was a practical answer to the freezing temperatures in open cockpits. American pilots also adopted leather, but their jackets were transformed by the use of zips, which replaced clunky straps and buckles. The iconic garment was the A2, introduced in 1932: made of brown horsehide, it had a khaki cotton lining, a stand-up collar and elasticated ribbing at the waist and wrists to keep out the wind. It was considered to be, if not actually indestructible, then at least able to withstand rough treatment for many years. During World War II factories turned out some 200,000 jackets, which were reintroduced to wider society when the air crews returned to the United States at the end of the conflict [8 - **USAAF bomber pilot, 1942**].

[8] Few fabrics evoke such powerful associations as leather. Biker gangs, James Dean, Marlon Brando and other youthful rebels; skintight trousers, catsuits and thigh-length boots that reek of sexuality; gay chic and bondage; the sinister ankle-length greatcoats of the SS; the manly boots and saddles of the cowboy; the reliable doctors' bags and elbow patches; the heroism and courage of aviation pioneers, motorcycle despatch riders and bomber crews; the functional aspiration of highly advertised branded luggage. Leather is the symbolic material of the modern age, able to mean all things to all men. Rarely at the height of fashion, it is never entirely out of

fashion. It's not just for clothing, of course. Shoes and boots, gloves, belts, handbags and other accessories tempt us all into a little discreet fetishism.

One of the appeals of leather is that it reads as a palimpsest of the everyday bumps and bruises of life; it becomes its own record. The leather of the doctor's bag, the antique flying jacket, and the construction worker's boots are endearing because their marks betray their history: patent leather is the opposite. Its perfection is pure and much shorter-lived, being subject to creases that degenerate into cracks. The patenting process, invented in the United States by Seth Boyden in 1818, covers the leather with a lacquer or plastic coating to give it a high-gloss shine. These are shoes for twinkling toes like Fred Astaire's which barely seem to touch the ground, let alone trudge through the dirt (see Feet, page 138).

Leather retains its macho associations with power, violence and even bullying intimidation. In modern times the Gestapo and officers of other totalitarian regimes have worn long leather overcoats, giving the material a new threatening edge. When bikers took up wearing leather again in the 1960s, it was not only because it could protect them but also because of these earlier connotations of super-macho power, verging on brutality (see Aggressive, page 152). For a certain sort of man – possibly the kind who feels the need for a visual proof of his masculinity – a huge motorcycle throbbing between his legs is an extension of his virility, just like the black leather garments that go with it and heighten the intense sexuality of the riding experience.

Black leather first appeared on women in the 1930s and continued to do so through the war years on the backs of 'tough babes' such as Marlene Dietrich and Katharine Hepburn. It began to appeal more generally in the 1960s and 1970s, as gender differentiation in clothing began to fade and the age of the fashion follower dropped. The timing persuaded some observers that post-feminist women had adopted the clothing of men as a symbol of power, control and freedom. A slightly more convincing argument is that women were subconsciously seeking an alternative to fur, which was too expensive and too controversial for most. The sense

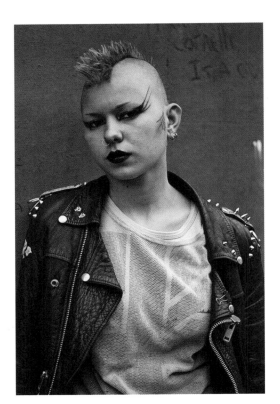

[9]

of power they obtain from wearing black leather is the same as the power they once accessed by wearing ocelot fur. Leather on women is all about sexuality. It is animalistic, and if to some it suggests underlying unrestrained bestial appetites, it suggests to even more a form of subconscious transvestitism – it is no accident that punk and biker girls wear it [9 - King's Road, London, 1983]. Their world is so crudely masculine that they must outwardly demonstrate that they have taken on male attitudes.

Leather is often worn tight, as if to emphasize its role as a second pelt. It is tactile and invites the observer to physically engage with it. Its use as horse reins or for bondage straps and buckles gives it clear associations with control and restraint [10 - Leather clothing by Fleet Ilya, 2012]. The appeal of bondage is clear: the bands, buckles and belts are a form of harness that make the restrained individual a substitute animal from whom the inhibiting veneer of civilization has been stripped away (see Escapism, page 186). The fetishistic qualities of leather are apparent: it is soft and smooth to the touch, it has its own

[10]

distinct smell, and it is above all ritualistic. The more buckles, the more there is to undo – all the better to enable the participants to appreciate the undoing ...

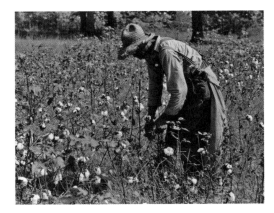

Textiles – Cotton, Wool, Silk

Textiles were not worn for millennia after our ancestors first began to wear clothes made from animal skins. The furs worn by our earliest ancestors were probably augmented by clothing made from bark or grasses. Once humans learned to produce yarn by twisting together fibres that they obtained from plants, textiles developed that were far removed from their roots. A shepherd's fleece coat is still demonstrably related to a sheep, a knitted woollen sweater far less so, and a woollen Armani suit not at all. The desire to adapt raw materials in order to produce better materials has encouraged technological innovation.

Wearing animal skins, or sewing them together with fibres, is far less complicated than the technology required for spinning animal hairs or plant fibres into yarns to weave or knit together. Spinning was originally done by rolling yarn on the thigh, or with the use of a spindle, a straight stick often weighted with a spindle whorl. A degree of mechanization appeared with the invention of the spinning wheel around the twelfth century, soon followed by the development of specialized textile industries in northern Italy, the Low Countries and southern England. These regions grew wealthy and became the focus of political power and cultural achievement in the period leading up to the Renaissance.

The great technological steps forward during the Industrial Revolution were powered in part by the need to produce cheaper clothing to meet the demands of the rapidly growing population of northern Europe. The social upheaval was huge, as the new concentration of manufacturing industries encouraged urbanization. Later, the use of synthetic dyes was pioneered in the textile industry and this was the foundation for the development of the chemical industry (originally in Germany) – a development that eventually extended to the arms industry. In the late twentieth century the consumption demands of the developed world led to the industrialization of developing economies such as India and Brazil, which were well placed to achieve centralization and economies of scale while at the same time remaining relatively free of regulation.

A relatively limited number of sources of yarn have dominated the history of textiles: sheep and goats for wool, cotton plants, flax for linen and silk worms for silk and velvet. Other resources have been locally important at particular times – tree bark among the Native Americans of the Eastern Woodlands, raffia in parts of Africa, straw for the hat industry in late nineteenth-century England and North America – but it was the major sources of cloth that shaped the way the world developed.

For over a century, cotton has been the most important natural fibre. Comparatively cheap to produce, it yields yarn that is highly adaptable, soft, comfortable, breathable and easy to maintain. It was first developed as a crop in the Indus Valley some 7,000 years ago, but it is symbolically linked to the birth of the modern, industrialized world. The spinning jenny and the spinning frame, invented in England in the 1760s by James Hargreaves and Richard Arkwright respectively, began the process of mass production (and encouraged the centralization of work in mills and factories). In the United States, it was Eli Whitney's 1793 invention of the cotton gin, which separated cotton fibres from the cotton seeds, a job previously done by hand, that paved the way for the abolition of slavery by lessening the cotton growers' economic dependence on human labour [11 - Sharecropper Will Cole picks cotton, North Carolina, 1939].

[11]

The British Raj was built on cotton. India was the jewel in the crown of the empire on which the sun never set. India not only supplied the raw material to be worked in English mills cheaply; it also provided a vast captive market for the manufactured goods that resulted. The people who grew the cotton had effectively to pay British workers to buy the garments made from it. Little wonder that in his campaign against British

rule in the middle of the twentieth century, Mahatma Gandhi identified the cotton trade as a symbol of economic exploitation. Gandhi began a campaign to get Indians to wear khadi – homespun cloth – and the spinning wheel became a symbol of the independence movement [**12 - Gandhi using a spinning wheel, 1946**]. (It only reinforces the complexities of textile history that in contemporary India and elsewhere in Asia the manufacture of clothing for Western businesses, often for low wages and in unregulated conditions, has become a symbol not of domestic independence but of renewed economic exploitation.)

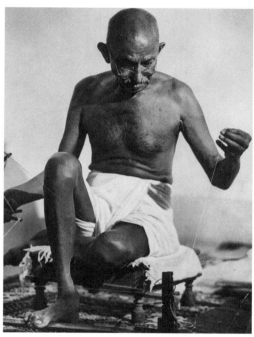

[12]

Today, India remains one of the six major countries (China, the United States, Pakistan, Uzbekistan and Brazil are the others) that produce the vast majority of the global total of about 27 million tons of cotton every year. The connection between cotton and exploitation remains. Uzbekistan has recently been accused of exploiting child labour in its cotton industry, while the demands of the cotton harvest wreak havoc in neighbouring countries, whose workers travel in large numbers to Uzbekistan, leaving their domestic economies to founder, while the processing also takes much of their water.

Cotton has various guises, including denim, cambric (or chambray) and corduroy. Denim evolved from a cheap cloth worn by workers in Nîmes in France in the 1880s and cowboys on dude ranches in the 1930s, through the fabric of rebellious youth it became in the

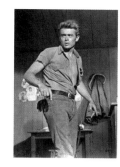

[13]

1960s, to the all-purpose fashion essential it now is for virtually everyone. The transformation began in the 1950s, when style renegades Marlon Brando, James Dean and Jean Seberg wore denim, and in doing so, made it irresistible to accountants, estate agents and secretaries who had never rebelled in their life. It was picked up by designers Jean Paul Gaultier and Vivienne Westwood in the late 1970s, run with by Calvin Klein in the early 1980s, and had became ubiquitous by the end of the 1990s [**13 - James Dean in »Giant«, 1956**].

Cambric, like denim, is usually pale blue and hard-wearing, and is closely associated with manual workers. Cambric – named for Cambrai in France, where it was woven to make farmers' clothes – is a little softer and lighter than denim. It came into its own with the huge industrialization of the late nineteenth and early twentieth century and the standardization of labourers' clothes, often paid for by an employer. Particularly in the United States, the blue cambric shirt became so inextricably linked with manual workers that it gave its name to their whole class: 'blue-collar workers'. The term, and its opposite, white-collar worker, was applied to a whole strata of society ... and the distinction persisted long after the cambric shirt itself lost its popularity [**14 - 'We Can Do It', poster by J. Howard Miller for US War Production Coordinating Committee, 1942**].

Corduroy, meanwhile, owes its characteristic ridged appearance to twisted fibres woven so that they lie parallel, then cut off to leave ribs of pile tufts separated by channels that reveal the base fabric beneath. The width of the cords is measured in wales, or cords per inch, with a range from 1.5 (very thick cords) to 21 (the finest). Its roots lie in a fabric named fustian, originally brought back by the Crusaders from the Middle East (its name comes from al-Fustat, the original name of Cairo, where it was made). Fustian was a hard-wearing cloth; the name covers corduroy and other velvet-like fabrics (moleskin and velveteen), as well as twills such as denim and chino, which are woven in such a way as to create diagonal

ribs on the surface. In the nineteenth century fustian became closely associated with workers – the main centre of production was in the industrialized regions of East Lancashire and West Yorkshire in northern England. The Chartists, agitating for votes for workers in the 1840s, wore fustian jackets as a symbol of their social status.

Seersucker is a cotton textile from South Asia that is woven with an uneven distribution of threads to make the cloth wrinkled and hold it away from the skin, making it cooler to wear in warm climates. In the modern world it is most closely associated with the southern United States. Originally it was cheap material for field hands, but in 1907 the first seersucker suit was made in New Orleans. Seersucker soon became establishment clothing, to the extent that the US Senate still holds Seersucker Thursday, where people wears seersucker suits in a conscious remembrance of the summer wear of the South before air-conditioning.

Wool also had an impact on world history. The velvety woollen broad-cloth produced from hill sheep in England in the Middle Ages was exported throughout Europe; taxes from its sale formed the basis of the wealth of the Tudor Golden Age – the Virgin Queen (Elizabeth I), William Shakespeare and all else that went with it. In Renaissance Italy, around the late fourteenth century, fully a third of the population of Florence was engaged in the production and finishing of woollen cloth, overseen by the powerful Arte della Lana, or Wool Guild. The wool trade supported the emergence of the Medici and

[14]

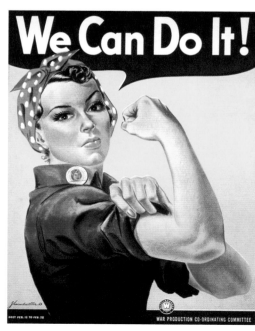

29

other banking houses in Italy and the Low Countries, fuelling Europe's capitalist development and the artistic flowering of the Renaissance. In the north, Flanders was the great centre of wool production, where

[15] workers processed and made up

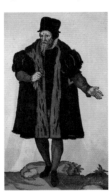

garments from wool imported from England, until the English government discouraged the trade to protect its wool supplies [15 - Senator from Leipzig, Germany, 1577, hand-coloured engraving].

When the British later returned to exporting wool, they found that Flemish industry had declined – mainly due to shifts in political and economic power within Europe – while Italy turned increasingly to silk production. The British guaranteed a market for their wool exports by forbidding their American colonies to trade wool with any other country – one of the grievances that eventually led the frustrated Americans to declare independence in 1776.

While cotton and wool have clothed the masses, silk was for centuries the preserve of the wealthy. For two millennia, the Chinese had the monopoly on silk production. It was a time-consuming process, which guaranteed that the cloth was originally limited to the imperial family, as was fitting for a discovery attributed to Lady Hsi-Ling-Shih, wife of the legendary Yellow Emperor (recent archaeological discoveries

[16]

actually date the production of silk to about 6,000 years ago, long before the reign of the Yellow Emperor). Silkworms – the offspring of moths fed on mulberry plants – are kept in controlled environments until they spin cocoons from a thread of up to 900 metres of silk. The cocoons are then boiled and unrolled, usually by hand. While silk became so popular in China that it was worn at all levels of society, in the West it remained a sought-after luxury: the trade in Chinese silk inspired the development in the second century BC of the so-called Silk Road, in fact a network of trade routes that joined Asia with the West. The ancient Egyptians wore Chinese silk, as did the Greeks and Romans [16 - Emperor Qianlong on horseback by Giuseppe Castiglione, c.1739].

Sericulture moved west from China – first to Korea, then to India – but still did not reach the West until the sixth century AD ... and then only by subterfuge. In about AD 550 two monks arrived at the Byzantine court in Constantinople with stolen silkworm eggs smuggled inside their hollow bamboo walking canes. The eggs hatched to produce worms, and the Byzantine silk industry began. It was not for another seven centuries, however, that silk making reached Europe itself, when weavers from Constantinople fleeing the Second Crusade were transplanted to Italy.

Silk's later history was nothing like as smooth as the fabric itself. Sponsorship from the French monarchy in the fifteenth century meant that France, particularly Lyon, soon took over from Italy as Europe's leading silk centre. Silk weavers were skilled artisans who shared a reputation with shoemakers for being articulate and politically radical, and after the Reformation, many French weavers adopted the new Protestant faith. Threatened with persecution in 1685, these weavers – known as the Huguenots – fled in huge numbers, carrying the secrets of silk production to Germany, Britain and back into Italy. The approximately 50,000 Huguenots who moved to England – mainly to the Spitalfields area of London – were probably the single biggest influx of immigrants in British history. Lyon's weavers rioted frequently throughout the eighteenth and early nineteenth centuries, while London's Huguenots marched against the importation of calico and other textiles to Britain from India. The power of the weavers was

eventually undermined, however, first by the invention of a mechanical loom that could weave patterned silks (the Jaquard loom, invented in France in 1801 and encouraged by Napoleon Bonaparte) and later by the shift of sericulture away from Europe to East Asia, particularly Japan (see Legs, page 134).

A variation on silk, velvet is created by an intricate and expensive process of weaving silk into two pieces of face-to-face material which are then cut apart, leaving the pile exposed. When King Richard II of England died in 1400, he was buried in velvet, which was still a luxurious novelty, having been introduced to northern Italy in around the twelfth century from its origins along the Silk Road in Central Asia. Velvet became a driving force of the Renaissance, bringing wealth and power to Italian city-states such as Lucca, Florence, Genoa and Venice, and later to the Flemish cities of the Low Countries. It has ever since retained a quality of theatricality and display – it was for good reason that Giuseppe Verdi insisted that the singers in his operas wore only velvet outfits [17 - Portrait of Baldassare

[17] Castiglione by Raphael, c.1515].

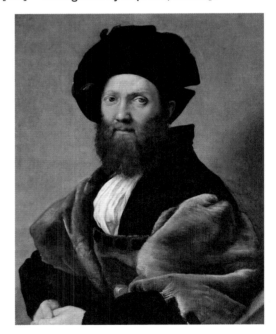

Luxury Textiles
Cotton, wool and silk have dominated much of the history of clothing. But many other fabrics have also been influential, such as the linen used to wrap Egyptian mummies. Light, up to three times stronger than cotton, and valued for its coolness, linen has often been considered a luxury fabric. Produced from fibres of the flax plant, it was used for priests' clothing among the Israelites and Egyptians and was introduced

to Britain and Ireland by Phoenician traders in the centuries before Christ. The Irish linen industry was started in the late seventeenth century by a Huguenot weaver fleeing France, and by the nineteenth century Belfast was the world's major producer. Today the sources of the best linen remain in Western Europe, although they are increasingly being challenged by China and East Asia. A disproportionate share of the demand for this material comes from the fashion market. Whereas for much of the twentieth century linen was used mainly for furnishings and napery, the rise of the designer phenomenon and the growing market for luxury goods in the West in the 1980s and 1990s saw close to three-quarters of the world's linen being used for clothing.

Even more luxurious than linen is cashmere, made from down combed from the long hair of pashmina goats in Kashmir, India. The woollen cloth the down yields is claimed to be unparalleled for softness and warmth. Although shawls – now called pashminas – were woven from the wool as early as the third century BC, the industry came into its own only in the fifteenth century, when the rulers of Kashmir introduced weavers from Turkestan. Cashmere made its fashion arrival via Paris. Soon the French were weaving cashmere and importing their own cashmere goats. In the 1830s, Scots manufacturers imported French techniques and began spinning their own yarn, which formed the basis of a sizable industry. Fineness was paramount: in the nineteenth century, the quality of a cashmere shawl was judged by whether it could pass through a wedding ring [**18 - Madame Rivière by Ingres, 1806**].

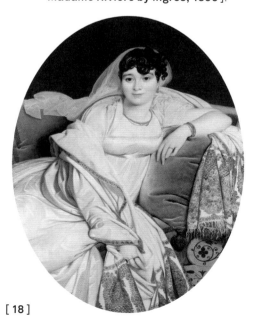

'It is at times like these that you realize the blessings of a good thick skirt' – MARY KINGSLEY, nineteenth-century traveller, on falling into a tiger trap

[19]

Tweed, meanwhile, is a coarser woollen cloth that has nevertheless become linked with the upper classes. Hardy Amies once claimed that tweed could take an English lady anywhere, from the grouse moors to lunch at the Ritz, always looking perfectly dressed. Soft tweed was a staple of every lady's wardrobe. Victorian men, on the other hand, liked their tweeds so thick and heavy that their trousers could stand up against a wall overnight without sliding to the floor. The drop in the age of fashion influence in the 1960s killed fine tweed as a badge of class for women, although in the early twenty-first century designers from Vivienne Westwood to Nike were attracted to the characteristic colours of Harris tweed, which is made only in the Outer Hebrides from wool dyed and spun there. The definition is important enough to be enshrined in law (the Harris Tweed Act, 1993). The cloth is characterized by its flecks of colour, particularly oranges and reds, achieved by combing dyed with natural-coloured hairs in the yarn. In the mid-nineteenth century, local aristocrat Lady Dunmore began to market Harris tweed, founding an industry that, apart from a few mechanical improvements, remains to this day organized much as it originally was [**19 - Tweed suit by Coco Chanel, 1960s**].

Whereas tweed is thriving, felt is a fabric that may have run its course, being now almost exclusively associated with the French or Basque beret and its various manifestations, such as the famous light-blue berets of UN peacekeepers (see Head, page 56). It was, as far as we can tell, the first fabric early humans made to

augment animal skins, sometime before 6500 BC. It was relatively easy to process, because felt does not require spinning; instead, wool is rubbed and pressed so that the fibres mat together. The main fashion use of wool felt has been in the manufacture of hats. Much of the exploration of the northern mountains of North America was driven by Europe's insatiable appetite for beaver felt hats.

Synthetic Materials

The need for change in fashion is a constant. As long ago as the 1930s, Paris couturier Elsa Schiaparelli was using cellophane for her designs. In the 1960s Paco Rabanne and Pierre Cardin continued the experimentation with new materials such as plastic and wire. Modern experiments involving 3D printing and high-tech materials are simply the most recent manifestations of a desire for innovation that has inspired clothing design for millennia.

Synthetic fabrics are, by their very nature, perceived as modern (although not exclusively; cloth of gold, twined from strands of gold or silver, reached its high point in the early Renaissance). It is the technical aspect of synthetic fibres that gives them their fashion cachet. The first true laboratory-created fashion fabric was arguably artificial silk, or viscose, which appeared only in 1894 (cellulose appeared some sixty years earlier, but its fibres were spun from plant materials, so it is usually considered artificial rather than synthetic). In the middle decades of the twentieth century, each successive new material – nylon (1939), acrylic (1950), polyester (1953) – started its own fashion craze ... and soon after settled into a more humdrum place in the fashion inventory. From only 22 per cent of global textile production in 1960, chemical fibres had risen to 58 per cent by the early twenty-first century. Part of the stimulus for this came from the 1960s, when designers such as Paco Rabanne began dabbling with alternative materials in a conscious attempt to break with the past. Rubber, metals, plastic, even fish skin: the technological revolution that put humans on the Moon and digital watches on every wrist was exciting, modern and youthful, so everyone wanted to play.

The rise of artificial fabrics, as opposed to synthetics, began with rubber, which has its origins in tree sap. Rubber has a romantic story.

It has obsessed people, ruined lives and shaped the course of empires since Spanish colonists in the sixteenth and seventeenth centuries noted that natives in the Caribbean took latex from trees and brushed it on their clothes. In Britain in the 1820s the Scot Charles Macintosh and his partner, Englishman Thomas Hancock, dissolved rubber in a solution of coal-tar naphtha. Sandwiched between two layers of fabric, the solution created the first truly waterproof manufactured fabric, and established the link between fashion and the chemist's laboratory – a link that would eventually lead to nylon shirts, plastic boots, rubberized bondage gear and many other developments.

The macintosh (a garment made from the material) was far from perfect. It gave off an unpleasant odour. It decayed. It grew brittle when it was cold. In 1839 Charles Goodyear solved the difficulties by creating a heat treatment process that turned a mixture of rubber, white lead and sulphur into a more user-friendly form of rubber. Goodyear called his product fireproof gum; it was later renamed vulcanized rubber, after Vulcan, ancient Roman smith to the gods [20 - Gene Kelly in »Singing in the Rain«, 1952].

Demand for waterproofed clothing sparked a rubber boom in the later decades of the nineteenth century (demand peaked again when the invention of the bicycle and later the car increased the need for rubber for tyres). In Africa in 1879, the Belgian king Leopold II engaged the services of Henry Stanley – 'Dr Livingstone, I presume' – to create a personal fiefdom in the Congo in which slave

[20]

labourers lost their hands if they failed to meet their rubber harvesting quotas. In the Amazon, the rubber boom created Manaus, a jungle city of French wrought-ironwork with its own opera house but no surfaced roads in or out. Meanwhile the British changed the face of Southeast Asia by bringing rubber seeds from the Amazon to Ceylon and Singapore, via the Royal Botanic Gardens at Kew.

The most famous synthetic material is nylon. Perhaps everyone has heard how nylon earned its name because it was invented simultaneously in New York and London: the fact that it is not actually true has done nothing to slow the spread of this myth. What is true is that warfare, as in so many areas of technology, was the mother of invention. Before World War II allied chemists were searching for a synthetic material that would free them from dependence on silk from Southeast Asia – already under Japanese influence – for military uses such as parachutes. DuPont Industries patented nylon in 1937, after years of development, and showed it off at the 1939 New York World's Fair. Fashion soon overtook practicality as the main purpose of nylon. In 1940 nylon stockings went on sale in the United States, and sold 72,000 pairs in one day – and 64 million pairs in the first year. That was a true retail phenomenon for the times.

One of the next synthetic breakthroughs came in 1959. Where would the superhero be without Lycra? [21 - **Lycra advertisement, Dupont Corporation, 1960s**]. The figure-hugging suits of Batman, Superman, Spiderman or the Power Rangers would surely soon grow loose and baggy without it. In fact, Batman and Superman both pre-dated the 1959 invention patented by the Spanjian brothers, whose name gave the fabric its US name, spandex (in Europe, it is properly known as elastane). But the skintight clothing obtained by weaving elastic spandex fibres into other garments is the closest real life has come to a suit with special powers, as parodied by the character of Edna Mode, the fashion designer for superheroes in the 2004 movie »The Incredibles«. In real life, spandex also enhances athletic prowess: sprinting and

[21]

speed-skating body suits cut wind resistance, swimsuits slide through the water and compression garments squeeze the muscles into performing better. The effect in men is similar to that produced by early suits of armour, where the compression of the stomach emphasizes the breadth of the male chest and the bulge of the biceps (see Armoured, page 162). A shared ideal of the masculine silhouette links Batman to Charles Atlas – the founder of modern body-building – and also to the padded doublets and tight hose of the Elizabethans.

[22]

For their hard-edged fantasies of space-age women in the early 2000s, meanwhile, Dolce & Gabbana, Jean Paul Gaultier, Alexander McQueen and John Galliano adopted PVC, rubber and patent leather in place of traditional materials [22 - **Bustier by Thierry Mugler, Spring/Summer 1997**]. High-tech and futuristic, they created modern re-runs of the 1960s skinny-mini, with simple shapes that allowed the quality of the fabric to shine through. And it did, sometimes with a pearlized glow, occasionally with a high-gloss shimmer and frequently as mesh, wire, rivets, bolts and even large imitation stones. To many women, the materials appeared alien, but fashion pioneers were drawn to the sleek, shiny, colourful materials, because they made the wearer feel instantly modern.

[23] **Variety of Effects**

Fashion aspires to get as close as it can to achieving infinite variety. Given the limited range of materials, the application of different treatments to them opens up the possibilities enormously. Take mesh, for example. Mesh has a long pedigree in the form of spinsters' crochet or lace gloves, whose gaps reveal as much flesh as they cover. (Revelation is inherently titillating.) Mesh is practical too, for its cooling properties: see the male string vest – initially made during World War II from fishing nets – or 'healthy' Aertex, developed in Manchester in the 1880s and marketed in the 1930s as the shirt that 'helps you breathe, even in exertion'. Today mesh is mainstream, and comes in every material imaginable, from tiny-holed high-tech surfaces to thick nets **[23 - Woman smoking in veil]**. It can have the femininity of lace, but it also has a frisson of male–female that is the essence of sexiness. Designers use it as a veil to hide and to soften shapes; blurring outlines and toning down **[24]** colours and patterns.

Like mesh, sheer fabrics reveal while appearing to cover **[24 - Mata Hari performs the Dance of the Seven Veils, 1906]**. Today every fashion magazine is full of images of women's breasts seen through clothes (the high street is a completely different matter, of course). It was

all so different in 1971, when Yves Saint Laurent sent a sheer black blouse down the catwalk (see Bust, page 78). There was an outcry at the idea of a woman's breasts – and especially the nipples – being clearly discernible. (In fact, as recently as 1800 BC, it had been acceptable for upper-class Minoan women to appear in public with bared breasts – though nipple emphasis remained the private reserve of courtesans, who often had them rouged or even gilded as an extra incitement.) By the later twentieth century, though, few people seemed to care any longer about the occasional flash of nipple. Designers instead used sheer fabrics to show off the legs and the bottom, a development that led initially to the invention of 'big knickers' but which later formed a far more successful partnership with the thong.

Closely related to mesh is lace, important historically as one of the means by which the elite distinguished themselves from the hoi polloi. As a status symbol, it had everything going for it. Handmade, it was extremely expensive (especially if it came from Bruges, the lace capital of Europe); pristine white, it required frequent laundering. In the sixteenth and seventeenth centuries lace conveyed a message of wealth and status among men. For courtiers, and later for government officials and merchants, lace – often in the form of ruffs that a contemporary critic moaned could be 'a quarter of **[25]** a yard deep' – was taken for granted

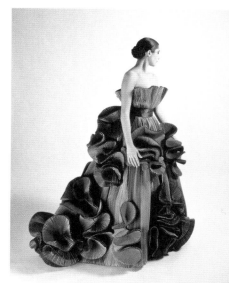

as part of the daily uniform, distinguished by its quality and the quantity of starch used to keep it stiff and crisp **[25 - Francis Stephen of Lorraine painted by Martin van Meytens, 18th century]**.

In the nineteenth century, mass production made lace increasingly available to people who were neither rich nor grand. Lace for men virtually disappeared, while cheap, factory-made lace began to swamp the Victorian female and her home in a welter of lace handkerchiefs and those other symbols of middle-class rectitude: the doily and the serviette. Availability made lace déclassé until the invention of the dolly bird in the 1960s and 1970s. Young, pretty and rather silly, these icons of youthful

beauty appalled feminists and fashion-watchers alike. Covered head-to-toe in lace like a Christmas dinner table, they were utterly frivolous, socially and stylistically.

[26]

Ever since the eighteenth century, men have been excited by the challenge of female lace, with all its fluting, frills, ruffles, pleats and tiers. These things go to make what French dressmakers call flou – any ultra-feminine non-tailored dress. For men, an important part of seduction was often the struggle to quell endless miles of intractable material. The Italian couturier Roberto Capucci once made a gown that, to the uninformed, may have looked rather like a Venetian blind that had endured a few too many pulls in the wrong directions **[26 - Bougainvillea dress by Roberto Capucci, 1989]**. To fashionistas, it put him right up there with Yves Saint Laurent as one of the great architects of fashion. The many, many pleats moved at their own speed, in their own space, to produce a magical effect. Such a dress packs a seductive punch. The tumbling frills are like the petals of a flower: soft enough to be parted by the male hand. The paradox is that the volume gives the wearer just the slightest Queen-of-the-Night scariness.

While delicacy has its place, so does weight and heft. Knits remind us of being wrapped in a shawl or blanket, and their chunkiness flatters by disguise. Classic knitwear such as Aran – based on fishermen's sweaters traditionally knitted on the Aran islands off Ireland, where oils were left in the yarn to make the wool waterproof – has become high fashion since Yves Saint Laurent's cocoon wedding dress in the 1960s,

appealing to designers from Jean Paul Gaultier to Dolce & Gabbana and interpreted in styles that ranged from the highly conservative to the weird and wonderful [**27 - Bestway knitting patterns, 1950s**].

Patchwork makes regular appearances on the catwalk. It has a long tradition that runs from the thriftiness of New England Puritans – the origins of the quilting tradition that remains popular in the United States today – to the homespun wholesomeness of the more modern hippy (see Hippy, page 206). In fashion hands like those of Marc Jacobs or Etro, however, patchwork becomes far more sophisticated, often in multicoloured prints that have nothing to do with little old grannies working under ancient apple trees. Patchwork has prevailed for so long, albeit frequently on the periphery of fashion, because like lace it is remarkably at ease no matter what the fashion mood is.

Light and Shine
Whenever the essential shapes of fashion seem set to remain static for a while, designers look for ways to excite with textures. In the second half of the twentieth century the must-have new texture was metallic.

[27] Metallics were seen as being exclusively for eveningwear before the rise of the young Italian designers in the 1970s – new, eager, untrammelled by tradition and out to overcome the hegemony of Paris. These savvy marketeers realized that the big money in the future could come from an emerging new, brash customer, who was primarily interested in projecting his or her wealth by showing it off in the most obvious way: with shine – day and night; in town or country; whether young or old.

As throughout history, gold was the favoured metallic, with copper, silver and metallic pinks, purples and reds following closely behind. Gold and silver are the most valuable metallic fabrics; they are created using the precious metals they replicate. Ancient Romans wove gold threads into textiles to make cloth of gold; the myth of the golden fleece suggests that the ancient Greeks did the same. In China under the Mongol khans, gold thread and silk were both valuable enough to act as currency. Gold thread – either gilded on to a core of silk or stretched into a very fine, flexible wire – was not only woven into silk cloth but also used in embroidery by kings and clerics.

Fifteenth-century chronicles and scholars linked the awe that gold was regarded with not only to its intrinsic value but also to its spiritual connection with the worship of sunrise and solstice. The high point of golden display came with the royal families of Europe in the sixteenth century. Charles V, the Holy Roman Emperor, met Henry VIII of England wearing a robe 'the right half of cloth of silver, the left half of alternate stripes of gold and silver, all lined with costly sables'. Henry VIII, no slouch in terms of self-promotion, met Francis I of France in a fashion parade so luxurious that the meeting itself became known as the Field of the Cloth of Gold, at a time when even a couple of yards of cloth of gold represented a vast fortune.

The connection between metallics and royalty extends also to military prowess. It is the prerogative of those with proven physical courage to wear heavily brocaded clothing without being suspected of effeminacy: think of the great chevaliers of France. The same is true of the matador's outfit, which the Spanish call the traje de luces, or 'suit of lights', for its elaborate golden embroidery (the banderilleros, who sticks spears between the bull's shoulders before the matador delivers the coup de grâce, traditionally wears silver embroidery) [**28 - Juan Serrano, 'Finito de Cordoba', Barcelona, 2010**]. The modern equivalent is stage clothes worn by performers such as Liberace and Elton John, or Glen Campbell, the 'Rhinestone Cowboy'. They brought such a high degree of camp with their sparkling clothes that they have acquired an unmistakable air of the pantomime. A regular feature of performance clothes is sequins, sewn in [28] overlapping patterns on garments

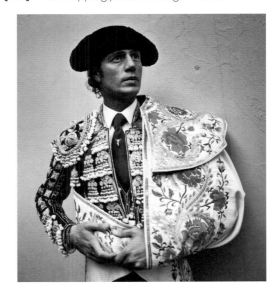

that turn any movement by the wearer into a shimmer of iridescence (see Romantic, page 222). For ballroom dancers or figure skaters, they add a magical gliding quality to the movements of the body. It can take thousands of sequins to decorate a garment; in haute couture they are frequently sewn on by hand, which is one reason for the vast expense. (Diana, Princess of Wales's wedding dress in 1981 had 10,000 mother-of-pearl sequins and pearls sewn on to it.)

Clearly inspired by the spacesuits of astronauts, his shiny outfit of metallic jersey and spangled muslin looks absurd now because, despite its undoubted functionality, it turned its back on

[30] the basic impulse to decorate the body that is at the heart of fashion. Clothes that allow no possibility of embellishment become sterile very quickly. When all is said and done, actually people do not want clothes to be machines to wear **[30 - Coat by André Courrèges, Spring/ Summer 1994]**.

And what of an actual 'suit of lights'? Illuminated clothes are something of a fad, although fiberoptics make it feasible for clubbers to clothe themselves in glowing neon. Electricity and clothing do not necessarily go together well, however, as illustrated by the story of the Marchesa Luisa Casati, the Italian noblewoman who spent a fortune on attempting to earn the reputation of being the most fashionable woman in Europe. Twice, her attempts to wear outfits that included electric light bulbs ended disastrously. In one incident, the costume short-circuited and Casati was actually knocked off her feet by an electric shock that could well have killed her; in another, a fellow party guest described her sparkling tangle of lights and wires as looking like 'a smashed Zeppelin' (see Extreme, page 194).

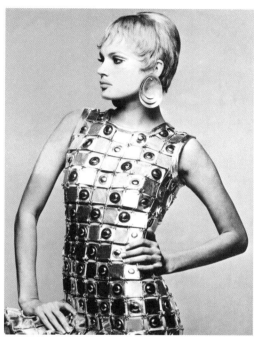

[29] The genesis of modern metallic textiles came in the 1960s, the decade when fashion embraced the spirit of scientific adventure – what British Prime Minister Harold Wilson called 'the white heat of technology'. The race to the Moon was on. All things intergalactic became 'cool', attributed to the young and futuristic. Paco Rabanne embraced the possibilities, incorporating metal discs, chains and hammered metal plates decorated with crystal beads, cellophane patches, pieces of celluloid or metallic embroidery into his clothes **[29 - Dress by Paco Rabanne, 1967]**. Rabanne led the way for other designers, including Thierry Mugler and his gold armour plates (worn with crêpe skirts) and Gianni Versace's experiments with chain mail (see Armoured, page 162).

André Courrèges, like 'space age' Pierre Cardin, believed that clothes could be made purely functional, a fashion version of Le Corbusier's dictum that a house is a machine to live in. The expression of this faith came in 1981, when Courrèges won an international competition for his design for the woman of 2000.

Modern chemical technology may eventually make luminescent clothes available without running such risks. New fabrics are constantly developed, although few become established as staples. So while materials promise to remain as varied as ever, it seems equally certain that those materials that were historically important – cotton, wool, linen – will continue to provide most of the world's clothes.

C
O
L
O
U
R

+

P
A
T
T
E
R
N

Colour in dress is always a statement. It can proclaim the wearer's mood or conceal it. It warns of danger. It advertises loyalties. It differentiates. At times when the sources of rare dyes have been almost as expensive as gold, it has served as a visual signifier of rank or wealth. In the same way, patterns – the ways in which colours are arranged – also give out messages about the people who wear them: how we should judge them and where they should be placed in society.

Communicating with Colours

Colour and pattern are thus both vital in the language of clothes. In terms of colours, red is often considered warm, exciting, dangerous and powerful. Meanwhile blue is cool and glamorous; orange is outgoing and lively; purple is luxurious; green is youthful [**1 - Gown by Pierre Balmain, 1953; photograph by Philippe Pottier**]. Some of the qualities associated with colours have their origins in nature; the yellow and black of bees are warning signals echoed by, say, the traditional uniform of the British traffic warden. Other colour associations are purely cultural: we learn how to read colours depending on where we grow up. Their qualities are not inherent; they can change. Because colours in clothes carry such powerful messages, they have long been used to judge the wearer. In the famous story in the Book of Genesis, the coat of many colours

[1]

given to Joseph is a sign of the favour of his father, Jacob. In the eyes of Joseph's brothers, though, it is a symbol of Joseph's arrogance and superiority. They eventually throw him into a pit before selling him into slavery – from where he rises to become ruler of Egypt. Since biblical times, too much colour has been seen as a sign of ingenuousness or vanity. It represents the sort of conspicuous consumption that good taste condemns as vulgar. But taste has not always been about moderation. Fabulous excess – in jewellery and materials as well as in colour – has also enjoyed popularity, particularly among men of power.

Modern designers enjoy putting together colour combinations so bold that they could only be worn by

the few individuals with absolute confidence in their own status. 'Look at me,' the wearer seems to proclaim, these days without fear of being thrown into a pit. This is the tradition continued by Gianni Versace in the 1980s, when he began

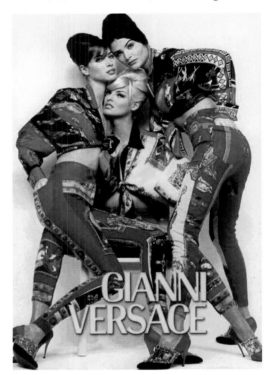

[2] producing brash silk shirts for yuppies [**2 - Versace advertisement, early 1990s**]. The swirling designs and bold colours could be viewed either as the height of vulgarity or as an invigoratingly exuberant style statement, according to one's perspective. (There is a codicil to this story: problems with biblical translation may after all mean that Joseph's famous coat wasn't multicoloured at all – just long and striped.)

Colour in dress also has a purely economic function. One or other of the two main variables in dress – colour or shape – needs to change from time to time to keep consumers interested ... and spending. There are times when the fashionable silhouette, the fixation of most designers, becomes accepted for a relatively long period. In the first decade of the twenty-first century, for example, the silhouette was stuck at short, narrow and simple, with unadorned shirts and sheath dresses and skirts. Designers reacted by getting out the crayons and colouring in. Spring colours or rich summer tones were combined by designers such as Missoni in exuberant zigzags, flowers and abstract swirls. The last time fashion had been so heavily patterned was in the 1970s, another period when

[3] the silhouette remained relatively static. Colours either complement each other, or they contrast. Complementary colours are traditionally associated with modesty and sophistication. The wearing of boldly contrasting colours, meanwhile, is a sign of assertiveness and confidence, which might be seen by some as crass. As Versace's success suggests, though, clashing colours often surface in aesthetically crude periods such as the late nineteenth century, or the latter part of the twentieth century and first decade of the twenty-first, when the most fashionable dress was the preserve of the young and the brash. Putting together colours that are not a natural fit expresses a certain creativity; an imagination that refuses to be limited by convention. By contrast, to dress in subtle or matching tones, or complements, has often been taken to express a sophisticated, nuanced degree of taste as well as a mature acceptance of the rules that govern dress. The generation gap all but disappeared in the 1980s and 1990s, for example, when, for the sake of sophistication, fashionistas of all ages bought into Armani's twenty shades of taupe, grey and beige, or Chanel's navy, black and white [3 - Tatjana Patitz in Chanel cream jacket, 1990s].

The most dramatic rejection of colour in dress came in the early years of the nineteenth century. The whole male sex put away its coloured garb – and, it might be argued, did not get it out again for nearly 200 years. This so-called Great Masculine Renunciation – the phrase was coined by the psychologist John

Carl Flügel in 1930 – ended the far longer period of costume history during which male dress was commonly more colourful than that of the female [4 - Georgian man, 1797]. Sumptuous surfaces, extravagant jewels, slashed outerwear to reveal the rich fabrics within: the male had been the peacock of the species. The reason was simple: display was about power and status as much as sexual appeal. Only the wealthy could afford delicate lace, pale pastels, satin, silk and gold.

Exactly why men turned their backs on the power of colour is a complex subject. One of the most convincing answers begins with the clothes of the Macaronis, young London men-about-town who took fashionable dress to extremes as a way of ridiculing the older generation. Nothing kills a fashion – especially

[4]

for men – as effectively as ridicule. By showing up the vulgarity of male fashion, they drove it underground. Consumption became more discreet; fashion became more circumspect. Out went the bright waistcoats and barley sugar striped trousers of the Georgians; in came sober greys, blacks, browns and dark blues. Ingenious nuances of cut, fit and proportion replaced colour and decoration. From now on, gentlemen would communicate with one another through subtleties of clothing – of tailoring, style ... and slight variations of colour.

Colour in History
Throughout history, dress has taken its colour inspiration from anywhere and everywhere. The sources of colours – dyes – have been important commodities. In early economies they shaped trade networks that stretched across continents. As early as the third millennium BC, citizens of the Indus Valley cities of Harappa and Mohenjo-daro – some of the world's earliest urban societies – wore cotton garments coloured with vegetable dyes, particularly madder (a strong shade of red made from the roots of the herb rubia) and indigo, a blue made from the indigo plant.

The most common colours for textiles have been the tones of the natural world: tans and ochres, beiges and browns. For much of the Middle Ages, ordinary people tended to wear clothes of browns and greens; the expense of dyeing cloth red or blue limited those colours to the wealthy (and particularly to the clergy and royalty, respectively). Neutral colours remain a popular fashion palette. Drab khaki became so ubiquitous in the last decades of the twentieth century that it gave its name to a style of trousers that was, in fact, available in a range of colours.

Alongside neutral tones, though, the natural world can provide stronger colours. Some, such as Tyrian purple, were so rare that their expense restricted them to only the highest levels of society. Where cost alone did not exclude the masses from wearing a colour, exclusion has at times been reinforced by laws that limited the wearing of certain colours to particular social classes. Desire for access to a strong colour such as indigo encouraged the European colonization of the French West Indies and what are now the American states of Georgia and South Carolina. Cochineal, kermes

[5] and lac all produce reds of various shades, from scarlet and crimson to something more like plum [**5 - Portrait of a Man by Jan van Eyck, 1433**]. These dyes were extracted from the bodies of insects that lived only in Central America (cochineal), India (kermes) or Southeast Asia (lac). Sourcing red dye from logwood was one of the primary impulses behind the British exploration of Belize. Within Europe, older plant dyes included madder (not used in a pure form until about 1650), saffron (yellow, from crocus stems), weld (another yellow) and woad (blue). Weld and woad could be mixed together (like paints) to create a form of green.

Apart from the show garments of rulers and prelates – literally richer colours, because they came from more expensive sources – most people's clothing remained neutral. Even Marie Antoinette's dress books, which contained swatches of fabric to remind the doomed French queen of garments in her vast wardrobe, show that most of the colours were so subdued that they were often barely a shade [**6 - Queen Marie-Antoinette and Two of Her Children by Adolf Ulrich Wertmüller, 1785**]. Pale fabrics were considered more tasteful in women's clothes, in particular. They also had glamour: cream, gold, beige and oyster have been the proof of privilege for centuries, not least because of their need for constant cleaning.

[6]

For most people the range of colours remained relatively limited until the middle of the nineteenth century, when the invention of aniline dyes made a far wider range of bold shades affordable. Aniline dyes – synthetic creations mixed up in a laboratory – appeared in 1856, when William Henry Perkin invented this cheap method of colouring fabric and revolutionized the fashion palette. Not only did new colours become available – Perkin's first dye was mauve, which he discovered accidentally while trying to make the anti-malarial drug quinine – but the tones themselves were far brighter than those yielded by natural dyes. Perkin's invention sparked an enthusiastic riot of colour in clothing … sometimes over-enthusiastic. As everyone experimented with the possibilities – the new dyes made coloured cloth far cheaper – the same garment might incorporate a number of colours for different parts, all clashing happily. It appealed essentially to the nouveau riche, as old money tended to reject its violent 'look at me' effect.

[7]

The next major step in clothing colours did not come until the 1960s. Again, new materials and technologies enabled designers to introduce a palette of vibrant pinks, greens and oranges. And so acid colours – named for the brightly coloured illusory effects achieved by taking the drug LSD – entered the fashion vocabulary. These shocking pinks, biting greens and molten oranges were from the outset the enemies of understated elegance, clashing with virtually every shade in the everyday world [**7 - Chiffon dresses by Marc Bohan for Christian Dior, 1966**]. The colours, like the drug taking, were a sign of youthful rebellion and experimentation, and were typical of the decade's tendency towards simplified, sometimes even obvious, fashion statements.

In the 1970s, fashion became a balance of simple, bold shapes allied with equally simple, even simplistic, bold colours. Kenzo, Issey Miyake and Sonia Rykiel – 'grown up' designers – began using blocks of full-strength colour straight from the tube, as it were. Everybody followed, beguiled by the dream of a nursery world of poster paints. More

'His grace was apparelled in a garment of cloth of silver, of damask, ribbed with cloth of gold … it was marvellous to behold'
– EDWARD HALL, describing the Field of the Cloth of Gold, 1521

recently, labels as varied as Marc Jacobs, Burberry and Roberto Cavalli have turned the catwalk into a similar rainbow: no shades, no nuances.

The Symbolism of Colours
It is tempting to assume that the symbolism of colour is somehow inherent to the colours themselves: red for the power of the church and the erotic promise of the scarlet woman; white for virginal purity; purple for royalty; gold for wealth and opulence; blue for coolness and stability; green for fertility and closeness to nature. There are cultural differences, however, as mentioned earlier: while purple is the colour of royalty in the west, where the expense of Tyrian dye from the Lebanon made it a great luxury, in China and elsewhere in East Asia the colour of the emperors was a shade of yellow extracted from precious saffron. Current psychological theory accepts that colours have deep resonances in the brain, but that it is the cultures people live in that attribute specific meanings to individual colours.

The ancient Chinese believed that there were only three strong colours: black and white (not technically colours at all, of course) and red. Red has been a favourite of higher clergy, princes and kings for centuries, and the reason for this is clear. Red speaks of authority. For fashion people, it speaks equally of drama, which is why Diana Vreeland, [8]

the editor-in chief of »American Vogue« during the 1960s, used the colour everywhere in her office and Park Avenue apartment. Modern fashion designers are also aware of the erotic possibilities of red.

Valentino, for example, always included it in his collections, frequently ending with a display of 'Valentino red' evening dresses. Red, especially scarlet or flame, has long been seen as the colour of danger – and is the most sexual of all colours [8 - Galliano collection, Autumn/Winter 2012–13, Paris].

Pink is the prettiest and most feminine colour: it has been a safe bet since the days of Jane Austen in the early nineteenth century, when it represented refinement and gentility. By the middle of the twentieth century it was the universal colour of girls' nurseries and princess dollies [9 - Baby in pink bonnet, 1965]. Around the start of the twenty-first century, a new pink appeared on the catwalk. In the hands of Marc Jacobs and Emanuel Ungaro, it became an altogether more assured, almost sassy colour. But pink for men remains relatively rare, so strong are its gender associations. The French rugby team Stade de France – no shrinking violets – caused controversy in the early 2000s when they adopted a pink jersey for their away matches. Paradoxically, pink is a colour favoured by upper-class and military men in the UK for shirts, in stripes or checks.

The reasons for the gender bias in colour, though attempts are often made at explanation, are largely lost in the mists of time. Blue seems to have first become associated with boys as early as the seventeenth century. Blue was the colour of the sky, and thus was associated

[9]
[10]

with God; it was invoked to protect male children from the Devil. The association of pink with girls, on the other hand, may have reflected a fairy tale from central Europe that described girls being created from pink roses. Whatever the origins, the division is clearly enforced today. But even as late as the start of the twentieth century, pink was seen as a rather masculine colour, because of its relationship with red. Blue, on the other hand, was the colour of the robes of the Virgin Mary, and so associated with constancy and daintiness, or feminine qualities. The shift to what is familiar today seems to have taken place in the 1930s.

Purple dye has a long history of exclusivity because its extraction was so difficult and costly. The colour was worn by Alexander the Great, by the kings of Egypt, by the Seleucid emperors and most famously by the emperors of ancient Rome: only the emperor was allowed to wear purple robes, while senators' togas bore a single stripe of the colour. This imperial or Tyrian purple came from the Phoenician city of Tyre, where it was extracted from the bodies of many thousands of tiny molluscs in a prohibitively expensive process. In the Middle Ages, many centuries after the production of Tyrian purple had ceased in Western Europe – it continued to be made in the Byzantine empire until 1453 – royalty adopted a far bluer shade of the colour, which was dubbed royal purple [10 - King George VI in Coronation robes by Frank O. Salisbury, 1937].

Combining Colours

While colours are more or less universal, it's how they are combined that makes them unique. The combination of colours in an Inca woman's traditional costume, or traje, or in Scottish tartan is an identifying badge of a village or a clan, somewhat like the colours of sports teams. The main methods of creating combinations of colours – patterns – in textiles are weaving, embroidery or printing. In weaving, yarns of different colours are combined to create stripes or checks or other combinations; embroidery uses coloured threads to pick out a pattern which may be highly detailed; printing uses paints or other pigments to stamp a design on to a material, ranging from the traditional printing of Indian cotton to the mass-printed T-shirts that became fashionable in the 1960s, when American inventor Michael Vasilantone patented a

'Blue is the male principle, stern and spiritual. Yellow the female principle, gentle, cheerful and sensual. Red is matter, brutal and heavy and always the colour which must be fought and vanquished by the other two' – FRANZ MARC, 1900s

[11]

machine for printing silk screens, often with photographs or other unique one-off designs. The basic patterns – stripes, checks, dots, plaids, floral prints – go in and out of fashion regularly, but hardly develop at all.

Patterns can vary in their impact. During Edwardian times and World War II, for example, when every woman had at least one spotted blouse, spots were seen as a little conservative, even prim. Designers such as Christian Dior and Cristóbal Balenciaga created lady-like looks by using diaphanous spotted fabrics in classic colour combinations such as grey and white or navy and white [11 - Polka dot smock with black dress by Cristóbal Balenciaga, 1951]. (When kicking out Jeff Chandler, her cross-dressing lover, the 1950s actress and swimmer Esther Williams delivered the immortal parting shot: 'Jeff, you're too big for polka dots.') After the emphasis shifted from skilled tailoring to shape in the 1960s, spots reappeared in a more effusive guise, with small Victorian posies printed on cotton, interspersed with sprigs of roses and tiny pea-sized spots.

Coloured stripes, meanwhile, offer powerful graphic possibilities. Like the architects who created the black-and-white-striped baptistery in Florence, designers understand the strength of a colour combination that produces uncompromisingly directional lines. And stripes can be flattering, as well as dramatic. Of course, there are dangers: on a curvaceous figure, the lines can

[12] distort sensually; on a full one they will distort grotesquely. But if the figure can take it, stripes are hard to beat for creating an impression of elegance, glamour and drama. **[12 - Jean Seberg in a Breton top, 1965]** Checks, too, can add glamour. Christian Dior loved the elegance of fin-de-siècle French female dress (as worn by his mother) and the dress of the Edwardian male English aristocrat. He returned constantly to both archetypes, but he was especially stimulated by Prince of Wales and houndstooth checks in sharp black and white. He used houndstooth at varying scales to give an authoritative look to his trademark suits, formal jackets and city coats for women **[13 - Giant check jacket by Christian Dior, 1964]**. For Dior, black and white was a combination for the city, where it worked with the greys and neutrals of the townscape.

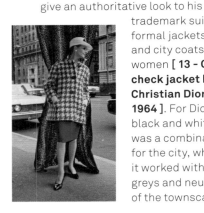

[13] The most famous of recent checks – the Burberry check – appeared during World War I in the trench coat, which was celebrated for decades for its waterproof and windproof qualities. By the mid-1990s, however, Burberry's image was looking tired. The company re-launched itself as a fashion brand, using as its power base the famous check. It was a brilliant move. Kate Moss – Burberry's 'face' – made it hip, and the label became so fashionable that David and Victoria Beckham dressed themselves, their children and their pets in it, and Japanese followers of fashion wore it by the

'Checks were an invention – not of the devil – but of some grasping, economical cloth manufacturer who wanted to use up his odds and ends of wool. He should have been strung up … Never wear checks if you desire to be known as a well-dressed woman' – MABEL BARNES GRUNDY, 1910s

yard. Before long, though, football fans began to wear Burberry, too. On the terraces, a trend that had begun in the early 1990s reached its apotheosis in the mass adoption of Burberry's iconic check. Burberry's response was pragmatic. Christopher Bailey, the creative director, split the brand into Burberry Prorsum (for the style set), Burberry London (for the Queen and her cronies) and Thomas Burberry (for eighteen- to twenty-five-year-olds), allowing yobs and nobs, hipsters and fogeys to all wear the check in different ways – an oblique harking back to Burberry's foundations in the rigid rules of the officer class.

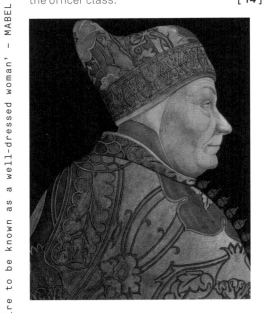

In the days before mass production, patterns were often applied to the surfaces of textiles rather than woven into them. One such technique was embroidery, or sewing designs in yarn. The process takes time, which is why embroidered cloth has always been expensive. In its heyday in the early Middle Ages, Opus Anglicanum, or 'English work', was prized throughout Europe. Embroiderers followed designs drawn by celebrated artists and sometimes used gold thread to create outlines, filled in with silk stitches and embellished with jewels and pearls. This was decoration for the sake of status and it cost so much that it was limited to the grandest wearers **[14 - Doge Francesco Foscari by Lazzaro Bastiani, 1457-60]**. When heavier cloths such as velvets came into fashion, which were more difficult to embroider, the embroidery was usually either limited to hems and edges or was done on finer cloth and then appliquéd on to the velvet.

In 1430 the Broderers' Company was formed in London to protect professional embroiderers from competition, although embroidery remained a popular pastime for young and aristocratic ladies. The introduction of machine embroidery in the late eighteenth century began to undermine the skill and cost of hand embroidery, and its status in high fashion declined steeply – until it was more associated with homemade clothing. But, even today, embroidery's close relative, lace, preserves some of its status. Brussels, Valenciennes in France and many other European locations still lay claim to producing the finest and most delicate lace – now used mainly for domestic decoration.

[14]

Printing designs and colours on fabrics has been accomplished in numerous ways. There have been variations on the theme of tie-dyeing, which is in some ways a simpler equivalent of printing. There has been woodblock printing and stencilling, both extensively used in southern and eastern Asia. Modern prints are usually achieved by screen-printing, the process for which was patented in 1907, though it had by then been used in China for at least a thousand years. A mesh of silk – today synthetic fibers are sometimes used – is used to support a stencil, and ink is squeezed through the mesh to create the pattern. The advent of digital printing, in which a photographic image is transferred directly on to the fabric, has again broadened the range of effects available, giving a new generation of designers another exciting toy to play with.

[15]

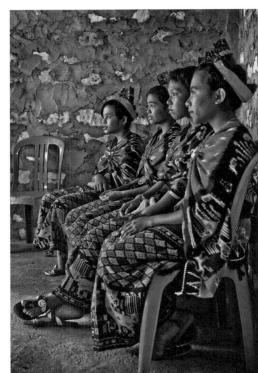

Batik is older than Christianity. In the fourth century BC ancient Egyptians dyed shrouds for their mummies by coating linen in wax and then scratching out designs that would let the dye through to create a pattern in the cloth. Historically, as today, batik has been most closely associated with southern and eastern Asia, and particularly with Indonesia (the word itself is thought to come from the island of Java) [15 - **Sabu harvest festival dancers, Indonesia, 2011**]. Historically, batik was subject to a high degree of formality and symbolism, and the designation of batik by UNESCO in 2009 as a Masterpiece of Oral and Intangible Heritage of Humanity now obliges the Indonesian government to preserve its traditional forms. The original colours used – indigo, brown and white (representing the Hindu deities Brahma, Vishnu and Shiva, respectively) – reflected the limited natural dyes available, and certain designs were restricted to different ranks of the social hierarchy. Today's batik is by contrast far freer and more expressive.

Printed fabrics have often reflected their exotic origins through their use of colour and pattern. By the eighteenth century, for example, trade between India and the West meant that Jane Austen's

[16] heroines probably wore Indian fabrics, usually subtly patterned with small abstract or floral designs. The mix of richness and delicacy has continued to fascinate designers such as Romeo Gigli and Dries van Noten, who subtly play with printed wools, sensual crushed velvets and tiny floral patterns à l'Indienne [16 - **Waistcoat by Romeo Gigli, Autumn/Winter 1994**]. Meanwhile, arabesques – 'in the Arabic style' – filtered into European embroidery during the Renaissance and later became a common pattern on printed cloth. These decorative scrolls and foliage are a celebration of vegetative profusion, but for Europeans part of their appeal was their whiff of the exotic Orient, the lands of the Arabs and Moors. Islam forbade artists from painting figurative scenes, which was to arrogantly assume the powers of Allah, the one true creator, so throughout the Muslim world, artists concentrated on scrollwork (calligraphy was the other great Islamic art form). The idea that a pattern conceived in such modesty should eventually end up wrapped around the female or male form in a blatantly sexual way – one thinks of Versace's colourful silk shirts of the 1980s – is surely one of the many ironies of modern fashion.

The technique of silk screen-printing brought textiles close to the world of art, particularly with manifestations such as the infamous lobster and tears designs created by Salvador

[17] Dalí – and transferred to fabric by Sache – for Elsa Schiaparelli in the 1930s. The ability to print garments cheaply was responsible for the great popularity of floral prints in the early decades of the twentieth century, when artists of the calibre of Raoul Dufy designed them for École Martine, the fabric atelier of the couturier Paul Poiret. By the 1930s, florals had become the fabric of choice for many outdoor events of the season, even though Chanel was not a fan. Pre-World War I delicacy and prettiness gave way to drama, with large, highly-coloured blooms often on dark backgrounds. In the 1960s, florals fought with Emilio Pucci's psychedelic swoops and artist Bridget Riley's swirls – but this was a battle the florals lost. Even in the skilled hands of Ossie Clark, Celia Birtwell's floral prints could never quite shed the image of an Edwardian lady in limp floral silk [17 - **Floral print dress by Celia Birtwell, 1970s**]. But modern designers such as Marc Jacobs have made English-country-garden florals hot again, in a much more demanding, even intellectually challenging mix of bold stripes or solid blocks of colour, or using digital technology.

Black and White

In light terms, black is the absence of colour, while white is the presence of all colours. For artists, the opposite applies: black results when all the pigments are mixed, while white denotes their absence. Fashion loves black and white: together or apart. They are dramatic; they have an architectural quality; they have a purity rarely matched even by solid blocks of 'real' colour. In fashion, black and white are also highly adaptable. They go with dark or tanned skin as well as they do with freckles and rosy cheeks. White is, certainly in terms of widespread popularity, a relatively modern indulgence: the time and care needed to keep white garments clean were not available to most people until at least the twentieth century. White was also the colour of refinement, which is probably why it came to symbolize purity and even virginity at the altar.

The symbolism of black and white is well known. 'Hung be the heavens with black, yield day to night!' wrote William Shakespeare, to bemoan the death of King Henry V at the start of Henry VI. The connection between death and the deepest 'colour' is clear: black stands for eternal night, the darkness of the tomb, the black cap of the judge passing the sentence of death. [18 - **Princess Elizabeth (left), Queen Mary (centre) and Queen Elizabeth at the funeral of King George VI, 1952**] As recently as twenty years ago, widows in some rural communities in southern Europe wore black mourning dress for the rest of their lives. However, black for mourning clothes is not universal. In Burma, mourners wear yellow, the colour of Buddhist monks' robes. In Iraq the colour is brown, in Armenia sky blue, in Ethiopia grey-brown (respectively, symbols of dead leaves, the heavens, and the earth to which the dead return). In China, mourning clothes are white, the colour of purity. The same colour was also worn by the bereaved in ancient Rome and Sparta, and in England, France and Spain until the end of the sixteenth century (in France royal mourning was known as deuil blanc, or 'white mourning'), when Queen Anne of France mourned her husband Charles VIII by plunging herself into black.

[18]

The deuil blanc tradition was co-opted by Norman Hartnell when Queen Elizabeth (later the Queen Mother) made a state visit to France in 1938 while mourning the death of her mother. The Countess of Strathmore died just five days before the visit was due to begin (in fact it was put back three weeks) and Hartnell had to remake his entire wardrobe in mourning colours. Fearing that black was not practical in the height of summer, he suggested white and this met with the queen's approval – and, more importantly, that of the king, his ministers and the British ambassador to France.

[19]

The look was re-created by Cecil Beaton for the showstopping number 'Ascot Gavotte' in the Lerner and Loewe musical »My Fair Lady«, which starred Audrey Hepburn in the 1964 film **[19 - Audrey Hepburn in »My Fair Lady«, 1964]**. Beaton's Ascot reconfirmed the architectural qualities of black-and-white for making a statement. Its black quality drew on the death of Edward VII in 1910, which deprived high society of its fun-loving leader and threatened to rob them of Royal Ascot, the glory of the season, which fell during the period of mourning (see Establishment, page 188). A compromise was found: Ascot took place, but women showed their respect by wearing mourning dress. Just for that year, Black Ascot was born – and, with it, a whole new approach to fashion **[20 - Black Ascot, June 1910]**.

The association of white with wedding dresses is a similarly artificial construct. Before 1840, when Queen Victoria set the fashion for white at her own wedding, brides had worn pretty much any colour they wanted. European weddings

[20]

were low-key affairs. With the exception of the Romans, for whom a yellow veil signified homage to Hymen, god of marriage, most brides were betrothed wearing a garland of fresh flowers dipped in scented water on their heads (see Romantic, page 222). Unless they were very rich, they wore frocks of ordinary fabrics and colours. Mary Queen of Scots caused a stir when she married in 1558 in a gown of white, which was then considered a royal colour for mourning: silver cloth was reserved for royal brides. Then, hundreds of years later, came Queen Victoria's long-and-white diktat **[21 - Queen Victoria on her wedding day, 1840]**. Then, nothing. The wedding dress evolved not a jot for the rest of the nineteenth century and the entire twentieth. Now the traditional dress seems old-fashioned and conformist even to those who believe in marriage. Yves Saint Laurent was the first designer to question white, producing a stunning black wedding dress in 1981. Since then there have been heavy knitted Aran wedding dresses (YSL and Jean Paul Gaultier); all colours, including scarlet (once the colour of the whore); and many other different styles. And yet white is still the favourite colour of the Western bride in a dress with a train, a veil and an extravagant bunch of flowers.

The glamour of white is that it is – above all – clean. It is the same in nature: the tiger is impressive; the white tiger even more so. White fur is even more prized than black. Ermine was the traditional colour of the fur worn by Britain's nobles, while in Russia the imperial court wore finest white sable (see Materials and Texture, page 25). White's cleanness speaks directly of its association with purity. It is considered a colour of virginity and innocence, which explains its association with very young babies (for whom common sense would dictate anything other than this most easily soiled colour). Cleanness – and perhaps purity – is also linked to wealth and luxury. The lifestyle that allows whites to remain unblemished for long is not one of toil and effort. Once white spread down through the classes in the 1960s and 1970s, its nature changed. Strappy white tops and thigh-hugging white mini-dresses with tanned, young skin are far raunchier than the young woman's or house servant's prim white pinafores of the past. When worn 'with attitude', white soon sheds its suggestions of purity.

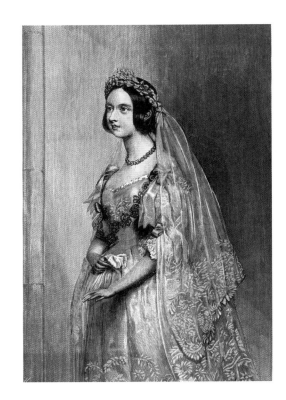

[21]

The perennial appeal of the white shirt is the fact that it is crisp, no-nonsense and seen, erroneously, as essentially non-feminine (see Torso, page 72): think of Marlene Dietrich **[22 - Marlene Dietrich, photograph by Eugene Richee, 1932]**. A white shirt, whether in satin, linen or cotton, empowers a woman and gives her an air of authority, yet without making her look even mildly masculine (as long as it's a shirt and not a blouse, the softer cut of which symbolizes feminine acquiescence). It was feminism that made this transition from the girlish to the masculine inevitable. It is generally accepted that what killed couture in the 1950s was that women stopped relying on dress allowances from their husbands and earned their own money to pay for their clothes themselves instead, and that got them thinking realistically. Women took to the man's suit with such enthusiasm in the late 1980s that for a while it looked as though skirts might become

[22]

one of fashion's endangered species, while the shirt for women in the hands of Calvin Klein, Ralph Lauren, Vivienne Westwood and Katharine Hamnett reached heights of casually sexy confidence undreamed of by the makers of the formal male original. Although black has glamour for fashionable women, it also has gravitas, as a reminder of our mortality. It is the colour of decay

and putrefaction. Despite its powerful impact, however, it rarely overshadows the individual. It creates a neutral but dramatic setting for the face, the mirror of the soul. Black also possesses nuances that enhance surface and texture. Black on black can in some ways be 'colourful', with gradations of subtlety and richness. Black gives fur a lustre and sets off jewellery and precious stones. This is a colour for the connoisseur. Its subtlety precludes all those who do not know about fashion, and wrongly feel it is boring or ageing.

As early as 1528, Italian Baldassare Castiglione suggested that, for courtiers and diplomats, 'a black colour hath a better grace in garments than any other'. His sentiments were echoed in a general restraint that entered male dress in the mid-sixteenth century. Above all in Spain, growing dominant in Europe thanks to the wealth of its American colonies, ostentation was eschewed, gaudy colours became unacceptable and black took over. Charles V had dressed in somber colours; his successor Philip II had such a preference for black that it became fashionable among all upper-class Spaniards. From there, it became the court colour across Europe, and later it would be taken up by the Puritans as a visible symbol of their rejection of worldly vanity. Black had become part of the fashion vocabulary, speaking of morality and rectitude then as it has done in more recent times. It had an equally potent symbolism for the beatniks of the 1950s and 1960s,

when again it marked a conscious rejection of materialism and physical vanity and the embracing of anonymity and egalité [**23 - Italian beatnik, editor of »Mondo Beat«, Milan, 1960s**].

In high fashion black has been a vital part of a woman's wardrobe since Coco Chanel's little black dress in the 1920s: for day (the wool dress), for evening (the lace cocktail number) and for night (the taffeta evening gown). Black is clean and abstract, and has a certain structural quality that appeals to a particular type of designer. It was especially popular among the Japanese designers who made such an impact in the early 1980s, and thus achieved a kind of intellectual probity through its association with the perceived purity of the Japanese aesthetic. Rei Kawakubo noted that she worked with eight different shades of the colour. In the hands of the Japanese, black spoke for equality, intellectuality; for a kind of fashion levelling. It was helped, of course, by the fact that it is also the most flattering of all colours. Black offered the comfort of uniformity: racks of black clothing in stores reflected the streets outside, peopled by fashionable women wearing identical clothes of black. The high point of black followed in the 1990s, when the colour took over the fashion world to such an all-encompassing extent that it swamped colour almost completely for several years and became permanently entrenched as the colour of fashion and sophistication [**24- Rei Kawakubo for Comme des Garcons, Autumn 2010**].

On men, black remains macho. The black overalls of the special forces, the black leather jacket of the biker, the activist's balaclava, the sports kit of the New Zealand All Blacks, even the black of the business suit are all expressions of maleness. The colour's power lies not only in its uniformity, but also in its firm rejection of display and decoration: it stays undiluted; no-nonsense. The wearer of black is far too businesslike to be swayed by mere appearance. Of course, it is a statement of its own, projecting the wearer as a male archetype, drawing on long traditions of black's association with evil and the underworld. That was why Benito Mussolini, the most theatrical of dictators, dressed his fascist thugs in black shirts, in a sinister echo of

'White is not a mere absence of colour; it is a shining and affirmative thing, as fierce as red, as definite as black … God paints in many colours; but He never paints so gorgeously, I had almost said so gaudily, as when He paints in white' – G.K. CHESTERTON, 1909

[**24**]

the famed Redshirts who had helped Garibaldi win Italian unification in the nineteenth century. But modern men wear black for the same reason as women. It is associated with power, sexiness and cool – and it flatters all figures.

Black, like other colours, carries its own coded meanings. The black of the undertaker, the white of the bride, the red of Santa's costume, the green of Robin Hood's Merry Men, the patchwork of the jester: all of these colours draw on associations lodged so deep in our culture and our subconscious, and so complex and rich, that we may be barely aware of them. The same is true of the wide variety of patterns, whose symmetry, palette, contrasts or strong graphic lines are also signals that we learn to read early in our lives, albeit not consciously. Therefore, whenever anyone puts on clothing that is anything more than a neutral, plain monochrome – a palette which itself also gives out messages – we are using dress to make a statement about ourselves that cannot be silenced.

[**23**]

44

The Body Anatomized

THE
BODY
ANATOMIZED

I
N
T
R
O
D
U
C
T
I
O
N

It seems virtually unnecessary to remark that the human body is made up of various – and very different – parts. Yet this truism is often ignored in fashion books that tend to treat the body as a uniform whole. How we clothe the legs reflects different requirements than how we clothe the neck. The fleshy padding of the buttocks – with their associations both with sex and with bodily waste – is clearly very different from the hands and feet, which are among the most human of our characteristics (the human foot contains nearly half of the bones in the human body).

Each part of the body has its own physiological purpose. The head is the location of the brain and the senses; the shoulders and chest are generators of power, in the male; the ribs protect most of the vital organs; the pelvis has evolved to enable us to walk bipedally, but in women has changed even further to allow them to give birth to babies that have gestated for nine months. But the parts of the body are also different in their symbolism. While the head has been almost universally recognized as the seat of our consciousness, the Japanese give the nape of the neck a sexual significance that it does not possess in the West. The bared female shoulder has been seen as an immoral provocation at various times in different places; at others, it has been part of a display of innocent health associated with

sports and exercise. The feet, while occasionally fetishized in the West, are still seen in some tribal societies as offering evil spirits a way to enter the body from the earth, while in many parts of Southeast Asia they are so closely associated with dirt that revealing the soles in public is considered a huge insult.

In terms of dress, some parts of the body tend to be highlighted while others tend to be more hidden or disguised. The ideal body shape is different for men and women, and clothes sometimes underline the differences – the slender upper arms of the female versus the rippling biceps of the male, the broader hips of the child-bearing woman versus the slender hips of the athletic, hunting male. Yet variations in clothing have also to be dictated by practicality: the need to protect the head or keep the neck warm, to allow movement for the arms or legs, to regulate the temperature of the torso. It is these constrictions on dress that make it both a limited canvas for designers – and yet produce such a remarkable range of results.

48

HEAD TO WAIST

The head is the centre of the personality, the location of the brain, the part of the body from which we perceive the world. As such, it has always been revered as the most important part of our anatomy. Ancient peoples considered it possessed magical powers, and cut off the heads of their enemies as a sign of ultimate triumph.

Headwear protected this most valuable and vulnerable part of the body. Warriors wore helmets from earliest times to deflect blows. Specialized headwear evolved to protect the heads of porters, artists, firemen and horsemen (the origins of the bowler). Today the helmets of motorcyclists and cycle couriers use advanced materials to achieve strength without excess weight.

Headwear also alters an individual's appearance – usually in order to impress or to emphasize allure. From the earliest times, the head was the logical location for displays of rank such as crowns and, in mythology, haloes, which also had the virtue of making the wearer seem taller and more physically impressive. An unfeasibly tall or wide hat – an impractical garment – was also a sign of status and wealth. In contemporary society the mitres and berettas of senior clergy, the wigs of judges and the mortarboards of academics continue the association between impracticality – and anachronism – of headgear and social status.

Like the head, the neck is vulnerable. Some people find it an erogenous zone; others shudder at the thought of allowing it even to be touched. Clothing for the neck tends to be either practical – such as variations on the scarf – or decorative, as with necklaces, shirt collars of all shapes and sizes, and ruffs. Such garments serve to frame the face and to make the neck appear either more slender and graceful or more solid and powerful.

Improvement of the body's appearance, particularly the face, has been a feature of civilized life for generations. Make-up is ancient. Evidence from neolithic tombs suggests that prehistoric humans

painted their bodies with ochre powder. That continued throughout millennia, as both men and women used powder to colour their faces as well as other parts of the body. In modern Western culture, make-up is predominantly seen as a female interest, but it was not always that way. 'Putting a good face on it' is at least as much about power as allure. The traditional war paint of Native American warriors finds an echo in the facial camouflage of the contemporary military or even the markings on the cheekbones of American football players.

Like make-up, the history of hair traces changing ideals of beauty. Hair has the power to impress or strike awe into the viewer, and to enhance sex appeal. Its very power as sexual communication makes it morally dangerous. The hair is the single part of the body seen as being most morally ambivalent in many societies. All major religions have had various injunctions against exposed or untidy hair, particularly female hair, that recalls the dishevelment of sexual abandon. But the lure of long hair ensures that it constantly returns to fashion.

The upper body is what gives the figure bulk. The legs make up half of human height, but it is the shoulders, torso, stomach, waist and hips that define how the body is perceived: slender, fat, obese, too thin and so on. For most of history, the upper body has been covered. Initially that might have been to protect the skin from the sun or the cold; later it became a question of morality as religions argued that exposed flesh was a form of temptation. Although it is now commonplace in Western societies to see shirtless builders or women's midriffs exposed, such a spectacle would have shocked – and upset – people as recently as our grandparents' generation, if not even later.

It was not always that way. Exposure of the torso has been the prerogative of the sportsman, the performer … and the harlot. At the Greek Olympic games, the competitors were naked. In ancient Crete, Minoan noblewomen exposed their breasts; in Venice in the seventeenth century, it was

prostitutes; in the late nineteenth century the anthropological interest in 'primitive' cultures, as featured in »National Geographic« magazine, meant that it was naked African women; post-World War II it was the naturists featured in »Health and Efficiency« magazine; today it is sunbathers – but only on the beach rather than in a city park.

Nearly all change in dress has come in response to altered environments or social requirements. In the days before central heating, when to venture outside was to face the elements and to stay inside was also often to be cold and damp, various forms of coat, shawl or blanket were the most important outerwear for the upper body. The rest of the wardrobe was underwear, which was never publicly seen except in the form of ruffs at the collar and cuffs or during brief periods when it was fashionable to slash outer garments in order to expose the quality of the linen beneath. The arrival of the modern shirt, which could be worn beneath a jacket or as a form of outerwear, came in the late nineteenth century. Its variants, such as the T-shirt, lost their status as underwear only in the earlier part of the twentieth century.

The shape of the upper body been subject to constant change and new ideals: the curvaceous Renoir beauty is a far remove from the generation of waifs spawned by Twiggy. The push-up bra gives the breasts a completely different silhouette from the monobosom that protruded in front of the Edwardian matron almost like a shelf, or the flat chests of the Flappers in the 1920s.

One change in the shape of the torso has been constant: in the West, humans have become fatter. We tend to eat more, and more calorific, food than our ancestors. However, the subconscious ideals of masculinity and femininity – both in others and in ourselves – still reflect a more primeval period in which the male silhouette was an inverted »V« of powerful shoulders and narrow waist and the female was more of an hourglass, slender apart from broader breasts and hips.

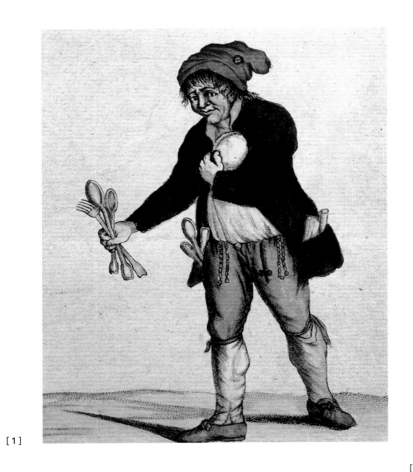

[1]

[2]

52

[3]

[4]

The impulse to cover the head is almost as old as humankind. In many ways the head covering, or the hat, is the least necessary of garments – but also the most powerful. It has a role as a form of protection, from the weather or from blows, but also as a form of projection and display that makes its wearer taller, more visible and more imposing. The basic hat styles were developed many centuries ago. In essence, there were only two styles – brimmed and unbrimmed – and only two basic forms, the soft cap and the shaped hat. An ivory figurine of a woman's head carved in what is now France over 35,000 years ago wears a form of soft cap; thousands of years before the birth of Christ, the Sumerians and ancient Egyptians wore shaped, upright hats. Soft caps have included the beret and soft forms of bonnet and mob cap (worn indoors for modesty, but outdoors only beneath another hat); the fillet, which is a circlet worn around the head; the hood, which covers the head in a pocket; the turban, which wraps around the top of the head; and the wimple, which wraps around the head and face. Shaped hats have included the French hood, which has a rounded shape; the poke bonnet, which projects forward over the face; the helmet; and the various types of hard hats with brims and crowns, from straw boaters to bowlers.

–

Soft caps include turbans, hoods and cowls, berets, bonnets – adopted by noblemen throughout Europe in the thirteenth century – and the so-called Phrygian cap of soft felt. The cap originated in Phrygia in ancient Anatolia under the Persian empire in the sixth century BCE, and spread throughout much of the Near East. In the late eighteenth century, a red felt Phrygian cap was adopted by revolutionaries in France because of a popular belief that it had a connection with early democracies in Greece; the French proclaimed it the 'cap of liberty' (see Allegiance, page 156). Even before this move towards egalitarianism, soft caps had long been associated with informality. When hats with stiffened crowns became popular among professional people in sixteenth-century England, a sumptuary law of 1571 forced apprentices to wear only flat caps as proof of their lowly status in society (see Workwear, page 234).

[2] For much of the last 500 years, hat shapes – for both men and women – have been a variation on the theme of a crown and a brim, both of various sizes. They include the wide-brimmed, plumed hat of the Cavaliers, in which the width of the brim and the extravagance of the plume, or other decoration, became more exaggerated as the fashion developed. Eventually, the brim was so wide that it interfered with easy movement, particularly of the cavalier's sword arm, so it was 'cocked', or raised and pinned to the side of the crown, out of the way. Variants on the cocked hat followed, which ultimately resulted in the three-cornered (tricorne) hats that were ubiquitous for much of the eighteenth century. The slightly later two-cornered hats, or bicornes, became widespread in the 1790s and are most closely associated with Napoleon Bonaparte, whose rapid rise to power occurred at about the same time. The bicorne could be folded flat and carried under the arm, giving it the alternative name of chapeau-bras (from the French for 'hat' and 'arm'). It remained part of ceremonial uniform for naval officers in the United States, England and France until the twentieth century, and is still part of court or diplomatic dress in some countries.

[3] Hats come in many fabrics, but throughout history the main ones used have been straw and fur, specifically beaver. European demand for beaver hats in the late sixteenth and seventeenth centuries, for example, was one of the prime factors that pushed European fur trappers to explore North America, moving further into the interior and attracting settlers in their wake (see Skin and Body Adornment, page 18). Over the centuries that followed, the beaver was hunted nearly to extinction as hat making became mechanized, an inevitable development given its economic importance. The mercury nitrate used for felting animal pelts caused confusion and loss of memory in those who breathed its fumes, leading to the popular image of the 'mad hatter', as captured by Lewis Carroll in »Alice's Adventures in Wonderland« in 1865. The chemical was finally outlawed in the US hat industry only in 1941. (There was an echo of this story in the 1950s, when the demand among children for the coonskin hat worn

HEAD – HISTORY + VARIETY

in the television series »Davy Crockett« led to the United States running out of raccoons' tails.)

STRAW HAT FACTORY, LUTON, UK, 1930

[4] One of the cheapest materials for hats was straw. In medieval societies straw hats were associated with peasants, and it was only in the fifteenth century that more affluent people began wearing them. Some 200 years later they became summer wear for urban Europeans making a self-gesture of sophisticated rusticity. The best straw was said to come from Italy, although the English straw-hat industry around Luton employed some 48,000 people at its height. This number fell as the United States developed an industry inspired by the straw hats created by Betsey Metcalf on Rhode Island in 1798. Straw plaiting was laborious and painful, causing constant split fingers and cut mouths from sucking the straw to soften it. Plaiters were among the poorest of the working classes; at the 'plait schools' set up for their children, education was neglected and children were forced into plaiting straw from the age of three or four. Despite such exploitation, straw hats have often been seen as having a jaunty air – especially the boater, which emerged in the 1880s for the young and dashing. The Panama, so-named because the hats were shipped from Ecuador via the Isthmus of Panama, was an upmarket hat that became the summer headgear for those of a certain authority and age because of its ability to retain a formality of appearance with a soft-hat degree of comfort and shade.

CHRISTOPHER WALKEN IN »HEAVEN'S GATE«, 1980

[5] The Edwardian age brought a degree of informality after a century dominated by the top hat and the bowler. Lounge suits were now more commonly worn with lower-crowned hats such as the homburg, a stiff felt hat with a dent running from the front to the back of the crown, which was a favourite of the Prince of Wales. Also popular were the fedora, again with a dent in the crown, and the soft felt trilby, which took its name from an 1894 play by George du Maurier, in which it was worn by the actor Herbert Beerbohm Tree. An even less formal trilby, with a narrower brim, was the all-purpose classless hat throughout the first half of the twentieth century in Europe and North America. Sometimes known as the snap-brim, it was universal in business until World War II.

[6]

LITHOGRAPH FROM »FASHIONS AND CUSTOMS OF MARIE ANTOINETTE«, c.1885

[6] In the late seventeenth century, women's headwear became independent of men's and became known as 'millinery', because of straw hats' association with Milan (the word originally applied to all kinds of fancy wares). Straw hats and mob caps were standard for the eighteenth century – although they battled for dominance with the wig. From the early nineteenth century, women's hats were available in a profusion of styles, including the caps that were universal in the new United States; poke bonnets, which had a projecting brim; and Edwardian platters heaped with ravishing mounds of fruit, flowers and, until Queen Alexandra expressed her disapproval, the feathers, heads or even complete carcasses of stuffed birds.

WOMEN USING EDIPHONES, USA, c.1905

[7] Although hats have little real fashion significance today, they are still everyday wear in the West, particularly among urban males. In terms of female fashion, however, a garment so intimately linked with status was unlikely to survive the social upheavals of the twentieth century. The trend towards relaxed looks began after World War I, as the increasing numbers of women who worked – often in compulsory headgear – did not want to wear hats in their leisure time. Some adopted headscarves or broad bandeaux that virtually covered the hair, but the development of hairsprays and wigs in the 1950s and 1960s freed women from the need to rely on hats to keep their hair dressed (see Hair, page 58). What really killed off hat wearing, though, was the social liberation that allowed women to wear their hair however they liked.

[8]

JACQUELINE KENNEDY, LONDON, 1961

[8] The most famous hat of modern times is probably the pink pillbox hat Jackie Kennedy was wearing when her husband was assassinated. It was made for her by Halston, based on a design by Givenchy. The design was later echoed by Philip Somerville for Diana, Princess of Wales, as suitably businesslike for her attempt to establish a public role after her divorce. The pillbox does not obscure the face – as to be expected in a hat originating in Hollywood. Its modern manifestation, created by Adrian for Greta Garbo in 1932, was based on earlier hats that decently covered the hair while leaving the brow exposed. These days it is often embellished with a modest scarf and worn by female cabin crew on Middle Eastern airlines.

'Unfortunately for elegance, since the war we have been witnessing the virtual disappearance of the hat' – FRANÇOIS BOUCHER, c.1973

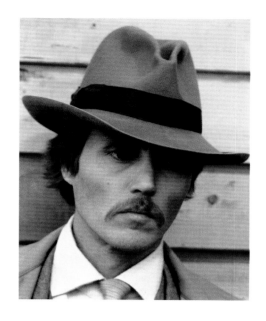

[5]

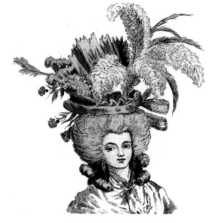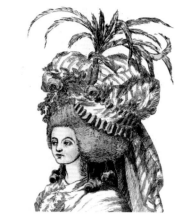

[6]

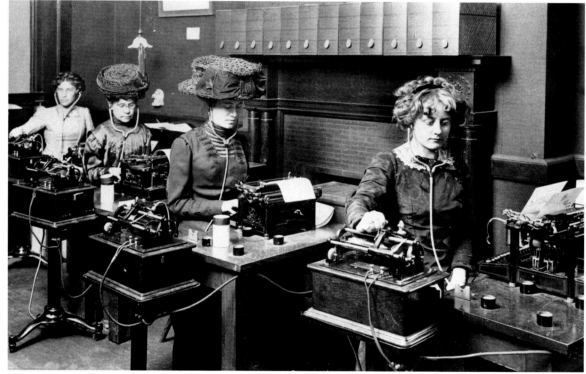

[7]

[8]

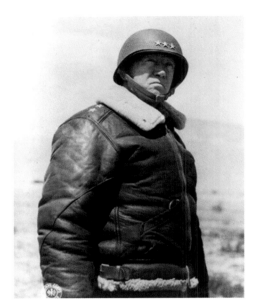

54

The hat's primary practical function is to protect the head. The brim covers the neck from the elements, especially sunshine. The peak of the cap shields the eyes. The crown keeps the head from becoming overheated, while also protecting it from blows. The bowler hat protects a horse rider's skull from low-hanging branches, in much the same way that the construction industry hard hat, the motorcyclist's helmet or the cycle courier's 'lid' exist to cushion blows. Hats offer another form of protection, however: of the wearer's modesty. Throughout history, the display of female hair, especially disarrayed hair, has been a symbol of sexual wantonness, vanity and immorality. Puritan settlers in North America, for example, forbade long hair for either men or women. The wearing of a hat helped to avert such sins, just as the vestigial headdress of the bridal veil today announces a modesty that befits a single woman being presented to her future husband (and the world) as a suitable and seemly partner.

–

[1] Not all protective headgear is hard. The turban was worn in North Africa and West Asia long before the rise of Islam in the seventh century. In desert climates it protected the wearer from sand, wind and heat, as it could be wound around the face and neck as well as the head. Unwound, it could be used as a blanket. The turban later became associated with the elite of Muslim societies such as the Moguls of northern India. In the West, women first wore turbans in the seventeenth century; although never entirely out of fashion since, neither have they been common. The essential shape has varied little, although designers have attempted to ring the changes. As a rule turbans are created anew each day by the wearer, so they are never quite the same.

[2] The helmet exists solely for protection, enclosing the head in a hard case. Leather was the standard material for helmets before the introduction of iron in the later Middle Ages and, during the last century, plastic. For centuries after the age of knights in armour, soldiers eschewed the metal helmet as heavy and uncomfortable, preferring cloth or leather headwear – often flamboyantly decorated with feathers, which in the sixteenth century were awarded to chevaliers as marks of their valour. It was the shrapnel and artillery fire of modern warfare that brought back the non-ceremonial, totally utilitarian metal hat, with the tin helmet worn on the battlefields of Flanders in World War I.

[3] It is impossible to overestimate the importance of the horse in the evolution of fashion. For most of human history, horses were the only means of transport. The riding hat, stiff enough to prevent scratches from branches or concussions from falls but light enough to be worn with little discomfort, introduced many standard styles, including the bowler (known as the derby in the United States). Made by Lock's of St James's in 1850 for William Coke of Norfolk – he wanted a hard hat for his gamekeepers, who kept damaging their soft hats while riding – the bowler became universal among gentlemen farmers. Such are the strange odysseys of hats, however, that by the middle of the twentieth century the bowler was associated entirely with urban workers in the City of London, who enjoyed much higher status than gamekeepers. Their transition from headgear of protection to objects of status projection was an indication of the change in social attitudes towards hats in general. Having become redundant in practical terms, they have become associated with formality and social superiority, as well as conservatism (see Establishment, page 188). They were also, of course, ideal for wearing on crowded trains and omnibuses on the daily commute into London and home again.

[4] It was the custom as late as the 1950s for women in the West to keep their hair covered in public for all but the most informal events. Headwear protected modesty. The ultimate expression of such modesty is the veiled head, which is common in societies thanks to religions which require women to keep their head covered in public. In the West, however, the headscarf could also be seen as a liberating garment, holding the hair in place with no need for elaborate coiffure and allowing the wearer to function in almost any given situation. Even movie stars such as Marilyn Monroe, who excelled at the projection of sex appeal, regularly wore headscarves when off duty.

[5] The non-military helmet in the modern world has largely been shaped by transport and sport. The emergence of car travel and air travel in the late nineteenth and early twentieth centuries prompted new headgear to protect drivers and pilots, not least from the wind. Originally leather, the helmets were later made from fibreglass and plastic for better protection without additional weight. The helmets of pioneer aviators, racing drivers and World War I despatch riders inspired the female fashion of the toque or cloche, the tight-fitting headgear that gave Flappers of the 1920s an androgynous look – paralled today by the beanie. Of course, the idea of a hat that clings closely to the shape of the head is not new, being an echo of the leather bonnets of the Middle Ages. A similar shape is seen in the leather headwear of coalmen, with flaps to protect the neck and shoulders from the sacks of coal, or porters in specialized markets like Billingsgate, whose leather hats enable them to carry stacked boxes of fish on their head.

[6] In the West, the traditional niqab, which veils the face, or the chadri or burqa, which cover the head and the body, are often seen as defining characteristics of Islam. Within Islamic countries, however, there is continuing debate about the religious requirement that women cover their faces. Some scholars argue that the requirement for wearing hijab – modest dress – is set out in the Koran. Others counter that the Koran's specific teachings on veiling are by no means straightforward and that, in any case, the practice seems to have predated the coming of Islam by some centuries. In Iran, the burqa is required for women in public, as it was in Afghanistan under the government of the Taliban. In Syria before the uprising that began in March 2011, on the other hand, it was banned in all educational establishments. While the practice is declining in countries where it was once strong, such as Pakistan, it is reportedly becoming more popular in the West, where young Muslim women adopt it as a gesture of solidarity. Some people see such 'alien' dress as a threat to Western traditions: France has forbidden the wearing of the veil in public, and similar laws are either in effect or under discussion in Italy, Belgium and even Australia.

[7] In ancient Greece and Rome, men only wore hats for travelling. On other occasions, people apart from labourers or slaves were largely able to avoid exposing themselves to extremes of weather by simply staying indoors or under shade. The increased need for personal travel and the use of horses made it more important to have headwear that protected the head from the sun. For that reason, the most important feature of a hat was the broad brim, not only to shade the face but also to carry water away from the body when it rained. In the late nineteenth century, the broad brim was the dominant feature of both the cowboy's Stetson and the sombrero of his Mexican counterpart, the vaquero.

[8] Rubberized hats such as the sou'wester became possible after the introduction of galvanized rubber by Charles Goodyear in the late nineteenth century (see Materials and Texture, page 24). Different forms of waterproof headwear followed, including swimming caps that keep the hair dry during total immersion in the pool. Such garments are not practical for long-term everyday wear, as their non-breatheable material makes the scalp hot and damages the hair. In daily life, there is little point in keeping the hair 'dry' if it is plastered to the head by sweat once exposed.

[9] The hat's connection with modesty remains in religious contexts, such as the wearing of hats at weddings. The papal crown, bishop's mitre, biretta and cardinal's hat have remained unchanged for centuries. Judaism has the skullcap. Rastafarianism has the leather or knitted hat that contains the dreadlocks, which are seen as a symbol of spiritual wisdom; Sikhism, which forbids men from cutting their hair, has the turban. Along with their relatives – the wimple and cowl – hoods have also been associated with piety and rank for centuries. Covering the head has been a mark of respect and a sign that the individual is subordinate to the divine. Contrast the hoods of the Capuchin Friars, the hooded monks of the sixteenth century, or academic gowns with today's youthful hoodie who, in popular myth at least, is believed to be less interested in covering the face to obscure individuality than in avoiding identification for criminal purposes.

'In the Philippines there are lovely screens, to protect you from the glare, in the Malay states there are hats like plates, which the Britishers won't wear, at twelve noon the natives swoon, and no further work is done – but mad dogs and Englishmen go out in the midday sun.' – NOËL COWARD, 'Mad Dogs and Englishmen', 1931

[5]

[6]

[7]

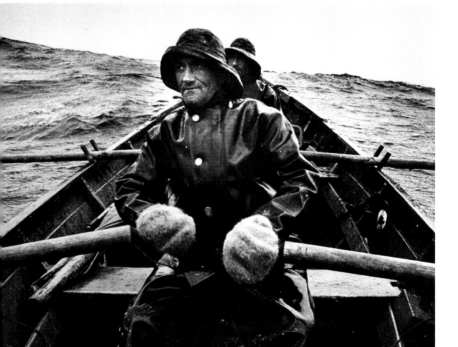

[8]

[9]

55

[2]

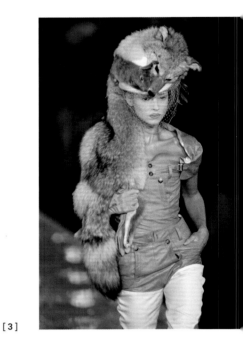

[1]

[3]

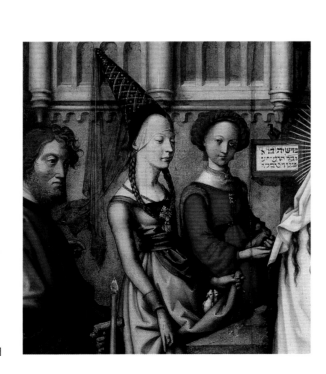

[4]

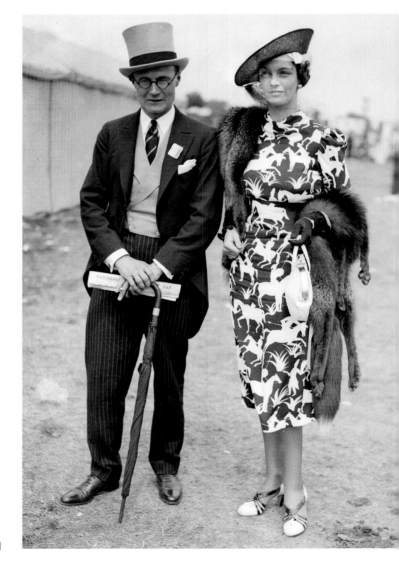

[5]

One of the earliest forms of ceremonial headwear – and the most significant – was the crown, either secular or religious. In the Middle Ages, when hats conveyed social status, only rulers could wear crowns and their variants. The association of headgear with rank is a result of the head being synonymous with the soul, and of physical height being a manifestation of bodily power. Among tribal peoples in Africa, chiefs wore headwear made from the heads and furs of wild animals, as an indication of physical strength or hunting prowess. Among Native Americans, the feathered headdress again enhanced the physical presence of chiefs; feathers were considered a symbol of the divine. The golden eagle was considered a messenger to the spiritual world, while in the Aztec and Mayan empires, the bright green feathers of the quetzal were associated with the god Quetzalcoatl and were traded over long distances.

–

[1] The shape of the crown – initially no more than a circlet placed on the head – follows that of the laurel wreath handed to victors at the ancient Olympic Games, but its purpose has become somewhat different. Not only is it a symbol of temporal power, but also – in the form of the crown of the Virgin Mary or other religious crowns – of spiritual purity. In the past it has also operated as a portable bank vault: the monarch put his most precious jewels on his head in a conspicuous display of wealth. Crowns exist outside fashion; their purpose is not to change. The paper crowns that fall out of Christmas crackers are a pastiche: they mark us all as lords and ladies of misrule for the day. To some extent, the symbolism of the crown is what all hats aspire to, as Vivienne Westwood recognized with her soft crown in a patchwork of colours.

[2] The top hat emerged in its original form in the 1760s as a narrow-brimmed, high-crowned felt hat worn for riding by country gentlemen as a kind of elementary crash helmet. It even possessed an inner drawstring that could be pulled tight to hold the hat on the head. From this status hat – a hat that gave its wearers presence – evolved the tall 'silk' hat, made in Paris from beaver fur polished so highly that it shone like satin

and was known as 'silk beaver'. The style was introduced to London by John Hetherington, a hatter from Charing Cross, who applied a fine silk shag to a felt base to create 'hatter's plush'. Hetherington's hat caused a sensation – it is said that when he first wore it, he sparked a riot among Londoners. But the top hat became universal in the early nineteenth century as the headwear of authority, despite constant complaints about its ludicrous proportions and the discomfort of wearing it.

[3] The big hat has a long pedigree. Its very impracticality proclaims breeding and the privilege of not having to work (see Extreme, page 194). Such exaggeration might come in the form of height: the conical henin of the fifteenth century may have risen a metre or more to elongate the wearer's appearance; a similar role is played by Carmen Miranda's piles of fruit or the bearskin of the Guards. Or exaggeration may come in the form of width, as in the brims that typify Ladies' Day at Royal Ascot. Or it may come in the form of sheer excess, as in the hats featuring dead birds and masses of flowers popular in the Edwardian era – hats that inspired women in Boston to form the Audubon Society to protect the environment by outlawing the use of birds and feathers.

[4] Women's hats have been used for projection since at least the Middle Ages, when the practice of covering the hair with scarves or hoods stopped being universal. Female headgear, like that of men, became more fashionable as part of the gorgeousness of display that characterized the period. The two dominant styles of the fifteenth century, the henin and the butterfly headdress, set the tone in that both were inconvenient and impractical. The henin shackled as much as it glorified, leaving its wearer incapable of even minor physical effort. In the sixteenth century women increasingly wore hoods, but high-brimmed hats were back in fashion in Elizabethan England. Then, during the reign of James I, Anne Turner was condemned to death for conspiracy to murder. As Turner was renowned for her fashion sense – she held a lucrative monopoly in supplying the yellow starch then in vogue for collars and ruffs – the judge ordered her to be hanged in her most stylish outfit: including her ruff and her high-crowned hat.

HEAD – PROJECTION

Women never returned to yellow starch or to high-crowned hats, except as part of riding dress.

[5] Ladies' Day is one of the more unusual events on the British social calendar. For one day each year at Royal Ascot, women feel obliged, or able, to wear huge, outlandish hats. The roots of this display lie in the court of King Edward VII and Queen Alexandra in the early twentieth century, when Ascot became the proving ground for the year's millinery fashions. Crowns grew enormous, as did brims to balance them. For every woman whose hat demonstrated their taste, another ten smothered their hats to the point of vulgarity, and so it has remained. Edward and Alexandra, sticklers for understated fashion, would no doubt be horrified at the travesties now displayed for the cameras (see Ostentatious, page 214).

ROYAL ASCOT, C.1930

[6] Hats have always been associated with rank. It is no accident that soft hats, the traditional headwear of outsiders, became more popular in the United States in the late nineteenth century than in more hierarchical Europe. Barack Obama looks perfectly at home in a baseball cap; nearly all US presidents have been happy to include caps in their leisure wardrobes. The first MPs of the British Labour Party in the late nineteenth century, however, faced a dilemma. The accepted dress for Parliament was a black frock coat and top hat, symbolic of the ruling classes. James Keir Hardie, who became the first socialist MP in 1892, instead wore a working man's suit and a soft brown hat. Tory gentlemen amused themselves by sending him top hats and the names of reliable tailors (see Establishment, page 188).

US PRESIDENT BARACK OBAMA, 2009

[7] The British policeman's helmet, while protecting its wearer, came to project values of decency and authority that now seem to belong to a bygone time. The helmet became a national icon. Adopted in 1837, its closest relative may be the pith helmet, named for its lightweight cork material, which protected jungle explorers while keeping them cool: tall hats have the advantage of allowing air to circulate, as well as projecting status. These two attributes had been combined in 1820, when the chef Marie-Antoine Carême added a cardboard band to the white cap

FIREFIGHTER, GROUND ZERO, NEW YORK, SEPTEMBER 2001

worn by bakers to give a taller hat – the toque – which he thought better befitted his status. The most reassuring tall hat of recent times was probably the US firefighter's helmet, which became a symbol of courage and resilience after the attacks of 9/11.

[8] The cloth beret is made from pressed felt and requires no weaving or sewing. It was for centuries the headwear of peasants. How then did it become a symbol of projection? Traditionally black, the beret was adopted by the revolutionary Che Guevara for its egalitarian roots, and became a symbol of youth rebellion following Alberto Korda's famous 1960 photograph of him. At the same time, the beret remains undress headgear in many of the world's armies, usually colour coded. In World War II British Field Marshall Bernard Montgomery wore berets in order to encourage solidarity with his troops and suggest a no-nonsense, non-status approach to leadership.

POSTER FOR »CHE, HOY Y SIEMPRE«, ARTWORK BY NIKO, 1983

[9] Doffing one's hat is both a display of courtesy by men to women and a projection of masculine status that says, 'By choosing to acknowledge you, I confirm your social position.' The practice has largely disappeared as hat wearing has declined, but vestigial echoes remain in the military salute, which confirms the relative ranks of saluter and saluted (see Military, page 210). The hat is traditionally removed should a funeral pass by, as a mark of respect to the dead, or during the playing of a national anthem to show respect to the nation.

ENGRAVING BY LECLERC, FROM »HISTOIRE DU CHEVALIER DES GRIEUX ET DE MANON LESCAUT«, 1731

[10] Headgear remains common, despite the decline in formal hat wearing. Baseball caps, bobble hats, hoodies: covering the head is part of everyday life, yet it is unusual enough to make a statement. Take the non-status hat of choice, the beanie or Hoxton bonnet (named for a self-styled bohemian area of east London). These soft hats all cling to the shape of the head, with peaks, ear-flaps or other variations. They are far removed from the milliner's art, but they send the same message as headwear always has: they indicate bonding among the young, who use them to underline both how cool they are and their membership of a club that is, in its own way, as exclusive as any Establishment group.

JONATHAN RHYS-MEYERS, 2007

'To be a king and wear a crown is a thing more glorious to them that see it than it is pleasant to them that bear it' – ELIZABETH I, 1601

[6]

[7]

DOCUMENTAL CUBANO DIRECTOR: PEDRO CHASKEL

che che che CHE HOY Y SIEMPRE che CHE CHE

ñiko/83

57

[8]

[9]

[10]

[1]

[2]

[3]

[4]

The hair is magical. No other part of the body apart from the face is so visible or allows the individual so much opportunity for expressiveness. Even in times of privation or suffering, the hair continues to grow. One reason Veronica Lake became such a popular pin-up in World War II, when shortages curtailed almost all forms of glamour, was the reassurance she gave women that luxurious hair was attainable by anyone with soap and water. For the same reason, ancient peoples venerated hair as a manifestation of the life force: it regenerates itself. Barbers of old buried the hair they cut off to prevent it falling into the hands of those who could work magic with it. Lockets containing locks of hair have long been symbols of love and loyalty. Even in the Bible, when Samson has his hair cut by Delilah, he loses his strength – castration by another name.

–

[1] If the hair is expressive, its removal is a demonstration of the rejection – voluntary or involuntary – of individual vanity. Slaves and prisoners have often had their heads shaved. Hair is also a sign of religious commitment: monks of all faiths (and Buddhist nuns) shave all or part of their heads. In some armies the heads of recruits are shaved as a symbol that the individual has become secondary to the group. The shaved head is also associated with masculinity, as long hair is associated with femininity, and so can be seen as an expression of aggression. There is a practical reason for shaving the head, of course – cleanliness – but its main purpose is always symbolic.

[2] More than a fifth of men begin to lose their hair soon after adolescence; by the age of 50 closer to two-thirds of Caucasian men have some degree of baldness. This is inevitable: the chemistry of male hormones deactivates the cells that cause hair to reproduce, particularly on the top of the head. In theory, the balder men go, the more masculine they are. Baldness shows that a male has reached virile maturity; it's a sign of dominance. So why do so many men worry about hair loss and go to all kinds of lengths to cover it up – with comb-overs, wigs, chemical treatments for the scalp

and even hair transplantation or hormone therapy? The answer is that baldness is a double-edged sword. It indicates not just maturity, but also irreversible ageing. Just as its onset signals the start of sexual activity, it also indicates its waning, particularly when combined with whatever hair does remain turning white.

[3] At birth, and until the end of adolescence and the appearance of baldness in men, there is no difference between male and female hair. Nevertheless, hair has become a strong secondary sexual characteristic: with the exception of isolated and rare periods throughout history, men have worn their hair short while women have worn theirs long. In the Bible, St Paul remarked, 'Does not even nature itself teach you that if a man has long hair, it is a shame unto him? But if a woman has long hair it is a glory to her; for her hair is given to her as a covering.' In the twentieth century the 1920s and the 1960s were periods of short hair for women that soon passed; the long tresses of male hippies and heavy-metal rockers are equally passé (see Hippy, page 206). As in all fields of fashion, of course, the democratic spirit of the early twenty-first century gives individuals far more licence to select their own individual style without respect for the dominant fashion. Still, it is unlikely to find a male lawyer with a ponytail down his back, or a bride who has had a short-back-and-sides for her big day.

[4] The artist William Hogarth remarked in the mid-eighteenth century that 'One lock of hair falling across the temples has an effect too alluring to be strictly decent.' Hair has always had a peculiarly sexual aspect – because it is so tactile, because it is a secondary sex signifier and because unrestrained, loose hair has always been seen as a sign of unrestrained, loose behaviour – think of Rapunzel letting down her hair to allow her lover to climb up to her. Tousled, slightly displaced hair is characteristic of the bedroom and licentiousness. That is why the Islamic faith prescribes that women cover their hair, as does Christian teaching in formal religious settings as well as Orthodox Judaism, which forbids anyone but a woman's husband from seeing her hair. Even in Europe as

DAVID LEE ROTH OF VAN HALEN, LONDON, 1978

BUDDHIST MONKS, CHIANG MAI, THAILAND

JOSÉ ORTEGA Y GASSET, SPANISH PHILOSOPHER, 1949

»VENUS, MARS AND CUPID CROWNED BY VICTORY«, PARIS BORDON, C.1550, OIL ON CANVAS

late as the nineteenth century, it was rare for anyone but a woman's husband to see her with her hair down. When hair is visible, it has been used as an immediate indicator of sexual availability: in imperial China only unmarried women could wear their hair long and braided; married women wore theirs combed back from the face and wound tightly at the nape of the neck.

[5] The lion's mane is nature's demonstration of power. So too is a big mane of human hair, and this has been true throughout history. The advent of the huge Afro in the 1960s or of long Rasta dreadlocks in the 1970s can be seen as being linked with political gestures by the oppressed, but as long ago as the Assyrians, a millennium before the birth of Christ, kings enhanced their hair with false additions and grew large beards, which were curled using heated rods. Caesar, the Roman word for 'emperor' (which also gave us kaiser and tsar), meant 'hairy' or 'long-haired'. The world's first written story, the Babylonian Epic of Gilgamesh, recounts the eponymous hero's quest to restore his strength – and his hair – after sickness robs him of both. Long hair requires time washing and grooming, which has always been associated with power and wealth. Women's big hair is subject to similar associations. It appears most often in fashion during eras of female empowerment – as epitomized by Farrah Fawcett and Charlie's other Angels in the late 1970s – and the cost of its upkeep means that it has frequently been the preserve of the wealthy.

[6] The history of hair is, to coin a phrase, tangled. In the main the hair of men and the poor has tended to be shorter, while that of women and the wealthy has been longer. Within the overall story, however, there are many variations. Wigs were common in ancient Egypt, where a shaved skull was easier to keep clean and cool in the hot climate. It was the Romans who introduced the Egyptians to the fashion for wearing their own hair, which they had in turn adopted from the Greeks. In medieval Europe, the Catholic Church disapproved of wigs – because they echoed the carnal temptations of real hair – and argued that men should wear their hair short and straight, in keeping with their gender. Henry IV, who ruled England in the early

fifteenth century, reinforced the requirement by outlawing long hair and wigs at his court. For some time, Europeans hid their hair beneath hats, plucked it to create an artificially high brow (hence the word 'highbrow', idiomatically meaning posh, with refined tastes) or enhanced it with dyes and false extensions. In the seventeenth and eighteenth centuries, wigs again became fashionable among the European aristocracy. The Victorians, however, abandoned wigs and returned to shorter hairstyles, inspired in part by Napoleon's enthusiasm for antique Roman haircuts. In the twentieth and early twenty-first centuries the breadth of influences on hairstyles grew, from Louise Brooks's bob in the 1920s to the cute fringes and 'pudding bowl' cuts of the Beatles, and the long, straight hair of bands like Girls Aloud.

[7] The symbolism of hair is powerful, partly because of its close connections with sex, age and the life force itself, but also because of its evolutionary associations with natural signals. A more prosaic impulse to shave the head is simply to disguise hair loss and maintain a more youthful appearance. On women, shaved heads are startling, highly dramatic statements that combine aggression and individuality with the symbolism of oppression: pop star Sinéad O'Connor made a statement when she appeared on the television show »Saturday Night Live« in 1992 without her hair and tore up a picture of the Pope. The shaving of heads was also the favoured punishment for female collaborators in France after World War II.

[5]

[6]

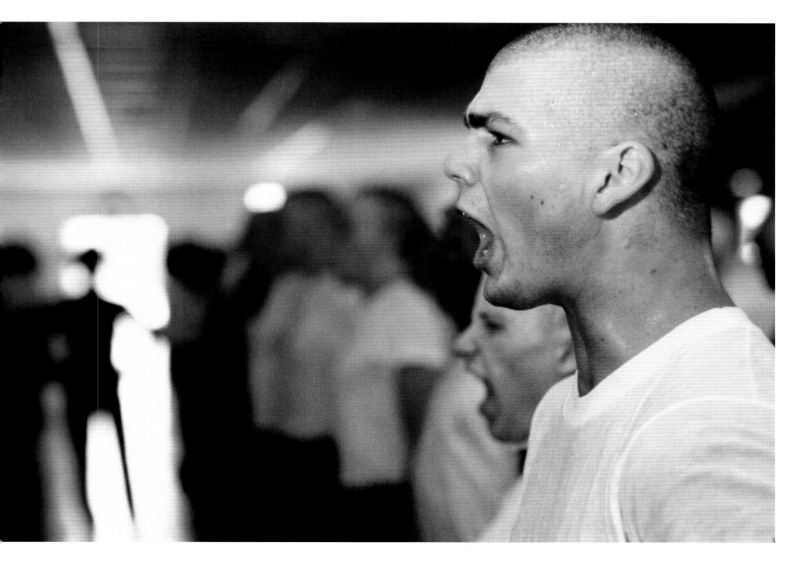

[7]

[1]

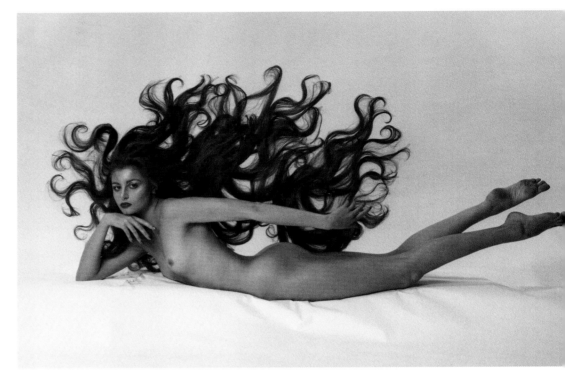

[2]

[3]

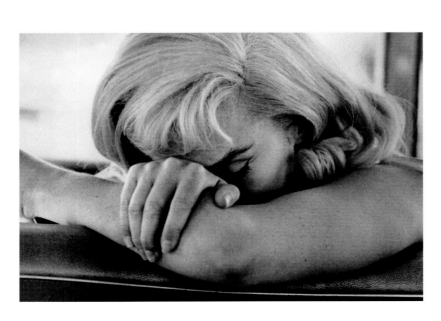

[4]

Hair is always changing; that goes without saying. Any attempt to control the hair can produce only a temporary effect. It is this inherent changeability that links hair so closely with fashion that the two are almost indistinguishable. There are two basic styles for the hair: loose or restrained. All hairstyling attempts one or the other – either to emphasize and enlarge the hair, or to restrain it. According to anthropologists, the reason people spend more time at the hairdresser's than is strictly necessary is a throwback to our primate origins, when our ancestors would have groomed one another just as chimpanzees do today. It is a ritual, as much social as anything else; the Romans had barbers' shops, though largely for shaving male customers. People who altered the hair were important, because of the spiritual associations of hair; in Africa, some peoples believed that the spirit lived in the hair.

–

CARICATURE OF LOUIS XVI DRESSING THE HAIR OF MARIE ANTOINETTE, 1791

[1] In Europe, female hairdressing was done at home – usually by slaves, servants or family members. It was only in 1635 that the first hair salon opened in Paris and caused a sensation. This development opened the way to more elaborate styles, with hair piled up, pomaded and decorated with ribbons, jewels and feathers. Marie Antoinette's hairdresser specialized in the 1.5-m tall loge d'opera style (he took it with him when he fled to Russia to escape the guillotine). Another of the Queen's favourites, Legros de Rumigny, created the »Coiffure des Dames« (1765), a bestselling book of illustrations of the latest styles, and opened an academy to train new hairdressers. The modern profession was born.

APOLLONIA VAN RAVENSTEIN, PHOTOGRAPH BY ARA GALLANT, 1975

[2] The hair has been shaped in thousands of ways by cutting or layering; it has been shaved; it has been tied into braids or ponytails or curled into waves; it has been coloured; it has been tucked into hats or hidden beneath wigs. The ritual remained the same for a genius twentieth-century stylist such as Ara Gallant, who styled shoots and later photographed them himself for magazines such as »Vogue« and »Playboy« in the 1970s and 1980s, as it was for Sumerian women who some 7,000 years earlier had tied their hair in complex braids and tresses. Originally

working with photographers such as Richard Avedon, Gallant used supermodels such as Twiggy, Veruschka and Penelope Tree to achieve a remarkable visual effect known as 'flying hair', in which the model's tresses filled the frame like a dynamic mane.

SPIKED HAIR, UK, 2000S

[3] The sight of a luxuriant head of female hair so alarmed men in medieval Europe that it was considered safer for women to keep their hair hidden. Colouring one's locks would have caused even more fuss; indeed, both the Church and society condemned the practice. That didn't stop it, however. In the fourteeenth century, women bleached their hair. A century later, whores in Venice wore bright red wigs or dyed their own hair that colour. Decent women kept their hair the way God intended. For most British women, this meant staying mousy. As with many style breakthroughs, the situation was changed not by dubious characters but by upper-class women of the early twentieth century. Rich and arrogant enough not to care what others thought, women such as the Marchesa Luisa Casati and Lady Ottoline Morrell dyed their hair their whole lives. Then, in the 1950s, home-dyeing kits enabled any woman to change her hair colour on a whim. However, it was punks in the 1970s who had the most fun. Frightening the bourgeoisie called for green, purple, blue and red hair. It looked fabulous surrounding a spectrally pale face and transformed ordinary youngsters into exotic creatures (see Punk, page 218).

MARILYN MONROE FILMING »THE MISFITS«, NEVADA, USA, 1960, PHOTOGRAPH BY CORNELL CAPA

[4] Blondes have more fun, according to writer Anita Loos. And she may have been right – at least as far as women are concerned. Throughout history far more women have tried to lighten their hair than darken it. The reasons are largely anthropological: blonde hair is finer than darker hair, so is softer to the touch and more 'feminine'. It also tends to be associated with youth and with sunlight: it appears warm and life enhancing. Once the dark-haired Romans came into contact with fairer-haired slaves captured in campaigns farther north in Europe, the women began trying to bleach their hair with a mixture of citric acid and sunlight (see Exotic, page 192). A Roman law forcing prostitutes to wear blonde hair as a sign of their profession was undermined when respectable

matrons (including Messalina, wife of Emperor Claudius) used blonde wigs for disguise to set out on their own night-time sexual adventures. But the connection between blondeness and sexuality remained strong into the twentieth century, continued by pin-ups such as Jean Harlow, the platinum blonde, and Marilyn Monroe, perhaps the most potent sexual icon of the second half of the century.

[5] Few haircuts have been more political than the bob. It's not that women hadn't had short hairstyles before – the wigs of the Egyptians occasionally resembled bobs – but the cut's appearance in the early 1920s coincided with a dramatic change in women's social status. Women were granted the right to vote in Britain in 1918 and in the United States two years later. World War I had seen far more women working outside the home, in offices and factories, than ever before. Now came this short, tidy haircut (in myriad variations, such as the coconut, the shingle and the Eton crop) that expressed women's new confidence. One theory is that it originated from the hygienic short haircuts that military nurses brought back from Europe. It also fitted well with the dynamic spirit of the age: Amelia Earhart's blonde bob was ideal for flying; Louise Brooks and Clara Bow were easy to envisage speeding in convertibles, kicking up their heels in the Charleston or playing active sports. As for the reaction, critics argued that the bob made women look like men; that it could cause baldness by weakening the scalp; or even that it could lead to the growth of a moustache.

[6] For nearly half a century chemistry and technology conspired to allow women to achieve spectacular hairstyles – albeit at a high cost in terms of damage to the hair. The permanent wave, or perm, was invented in 1906 by the German-American Charles Nestle. In a ten-hour process, chemicals broke down the structure of the hair, which was then wrapped on heated rollers and sprayed to achieve the hold, frequently breaking away from the head in the process. Chemical processes in the 1930s and 1940s made it possible to perm the hair without heat and eventually without the salon. The Toni Home Perm, promoted by Gillette with TV variety shows and a bewigged Toni doll with its own home-perm

kit (the bestselling doll in the United States), was marketed on its natural appearance. 'Which twin has the Toni?' asked the commercials. The fashion for perms faded in the 1960s, condemned by the growth of more natural looks and by the advent of hairsprays that held the hair in place with far less effort.

[7] Women's hairstyles have often been elaborate and outsize. In the 1680s, the fontange was invented when one of Louis XIV's mistresses, the Marquise de Fontange, lost her cap while hunting. She tied up her hair with ribbons, to her lover's approval – and the royal imprimatur ensured that the style became the basis for a hairstyle that grew so tall it incorporated a wire frame. In the late eighteenth century hairstyles were first far wider than they were tall but later far taller than they were wide (see Extreme, page 194). The modern version is the bouffant hairstyle, introduced by British hairdresser Raymond Bessone ('Mr Teasy Weasy') in the 1950s. This modified page-boy cut, puffed out at the sides and up to 36 cm across, was adopted most famously by Jackie Kennedy. Larger, backcombed versions of the cut, the beehive and the B52 (named after the World War II bomber) enjoyed shorter vogues in the early 1960s, when teachers complained that beehives prevented pupils seeing the blackboard in class. The beehive returned to popular consciousness (if not to the street) after the 1988 John Waters movie »Hairspray« and, more recently, with media coverage of the tragic singer Amy Winehouse.

[8] For women, tying back the hair is a sign of getting ready for business. Ancient frescoes reveal young dancers with hair tied high on the back of their heads. Tying the hair on the top of the head, at the side or at the neck has been used by women to change their appearance. Most of the time, in the West at least, it has been women who tied their hair back. In Japan during the Edo period of the seventeenth to the nineteenth centuries, however, men wore short ponytails, as they did in Europe and the Americas in the 1700s (even men's wigs came with short ponytails, or queues, tied back with black ribbons). The modern heyday of the ponytail began among young women in the 1950s and lasted until the 1980s; the male ponytail had a more limited vogue from the 1980s onwards.

THE BODY ANATOMIZED

LOUISE BROOKS, ACTRESS, 1920S

VINTAGE ADVERTISEMENT FOR TONI PERMS, 1950S

MRS ELLY ROMETSCH, GERMAN SOCIALITE AND FASHION MODEL, 1963

BRIGITTE BARDOT, FRANCE, 1954–55

'Hairstyle is the final tip-off whether or not a woman knows herself' – HUBERT DE GIVENCHY, 1970s

[5]

Which Twin has the Toni?

BOTH TWINS LOOK ATTRACTIVE—but Pansy, on the left, has the Toni. She chose it because she knew it would be Trouble-Free. Here she's showing her twin sister Janet how quick and easy neutralising can be — as easy as rinsing. With All New Toni she cuts out all that dab-dab-dabbing every curl . . . just pours the neutraliser straight through her hair.

All New Toni is frizz-free too. The lanolin-treated end papers protect your hair from dryness and splitting, so — no frizz.

And odour-free ! All New Toni's 'Fresh Air' waving lotion has no strong ammonia fumes to fill the air and cling to your hair. With All New Toni you don't have to wait all night — the curlers are off in an hour.

All new **TONI**
odour free...
frizz free...
trouble free...
as a wave can be !

61

[6]

[7]

[8]

[1]

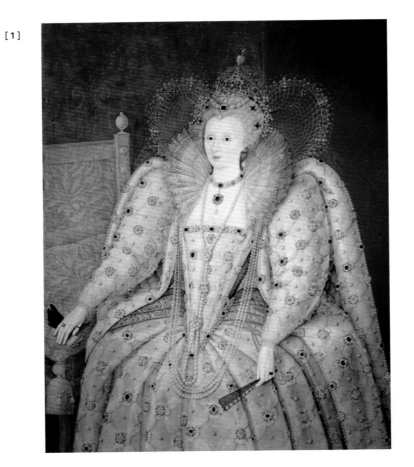

[2]

[3]

[4]

There are any number of ways of decorating the hair, from adding colour to the hair itself or tying in bands and flowers. Our ancestors enhanced their hair with coloured clay, feathers and bones while they still lived in caves. In classical Greece and Rome, flowers were common hair decorations (with hyacinths for the bride on her wedding day), although Roman matrons also wore headbands woven from their own hair or that of their slaves. In Africa, beads and wood and even coins were worn in the hair to demonstrate an individual's social position. As hairstyles grew more elaborate, so did hair decorations: gold, pearls, tiaras and increasingly exotic feathers. There was always opposition, however, from those who believed that ornamentation equalled frivolity (which of course it did) or immorality (a far less direct link). Periods of excess have alternated with periods of plainness. Hair decorations have been highly complex, formal and expensive, but at times have been as casual as the flower you are supposed to wear in your hair if you are going to San Francisco.

—

[1] There is something inherently absurd about shaving off the real hair in order simply to replace it with a wig, but in fashion terms it makes perfect sense. To some extent hair is anti-fashion in that everyone possesses it, and its thickness, lustrousness, even its length – all the most desirable qualities – are available, if not quite to all, then to an entirely random segment of the population based not on social position but on genetics and plain luck. A wig, on the other hand, is a gesture: it allows for a display of wealth, status and fashion-consciousness. It does not even have to be realistic, because most of the time it is not intended to to be an imitation of real hair, like the white-powdered wigs of the eighteenth century (these days worn only by barristers). That is why wigs have been so prestigious that they have often been linked to royalty (see Regal, page 220). Elizabeth I of England sparked a nationwide fashion with her eighty red wigs; her cousin Mary Queen of Scots lost hers when it fell off as she was beheaded. Louis XIII of France took to wearing wigs when his hair thinned; his successor the Sun King, Louis XIV, employed more

than forty wigmakers at Versailles to cover his thinning hair (only ever seen by his barber, Binette).

[2] The fun wig was the staple of the youth rebellion of the 1960s, but it belonged to a long tradition of wigs that did not try to imitate real hair but rather flaunted their artificiality. Realism was the last quality elite Sumerians or Egyptians wanted in an expensive hairpiece. The same was true of the periwig of eighteenth-century Europe, which was sometimes tied in a queue and coloured with off-white powder made from ground starch. It its modern manifestation, the fun wig uses cheap materials such as nylon to achieve remarkable regularity, cut straight like a helmet or teased out in Afro-style curls. It is fun, cheeky and disposable, and associated largely with youth – and particularly with young Japanese fashion followers such as those featured in the magazine »Fruits«. At the end of the twentieth century the tradition was picked up by performers such as Kiss or Cher, whose wigs often echoed the Egyptian style; in the early twenty-first century, Lady Gaga continued the trend as part of her dynamic changes of appearance.

[3] Some forms of hair decorations both enliven the appearance of the hair and hold it in place, as with Japanese 'kushi' (combs) and 'kogai' (elaborate hairpins). They differ from hats, which set out to cover the hair, instead by emphasizing it (see Head, page 52). Hair ornamentation with ribbons, tiaras, pearls and bodkins (gold and silver hairpins, often encrusted with diamonds and emeralds) became so popular in the later Middle Ages that the German town of Ratisbon passed a sumptuary law in 1485 that limited women to owning 'two pearl hairbands not to cost more than 12 florins and one tiara of gold set with pearls'. In the seventeenth century, hair decoration was dominated by the aigrette, an enamelled silver or gold egret feather, while in the eighteenth century Spanish and Latin American women set a style for wearing tall combs in their hair, over which they draped a lace mantilla or veil. In the Regency and Victorian periods, as hair became generally shorter, hair decoration became somewhat more democratic, with silk ribbons, plumes and flowers taking the place of more expensive jewellery.

[4] Headbands have held the hair in place since the Iron Age, if not before. They keep the hair off the face and tight to the top of the head. They are in that way related to the ponytail and other types of hair control that tend to be signifiers of a woman's serious intent or character. They help to de-sex the feminine hair, and are linked with the ingénue and the child: perhaps the most famous hairband of all was that created by the illustrator John Tenniel for the first edition of »Alice's Adventures in Wonderland«. This simple, stiff horseshoe – still widely known as the Alice band – was familiar to generations of young girls. Recently it has made a highly visible comeback on the heads of footballers whose hair has become so long that they cannot play without tying it back. Thus the least glamorous of hair restraints (with the possible exception of the rubber band) has achieved a glamour of its own, if only through its association with the very rich and the supremely athletic.

[5] Extremes of hair decoration have evolved in different parts of Africa, where high temperatures combined with either humidity or dryness place great demands on the natural hair. Many peoples use beads to ornament the hair, either weaving in beads whose size and colour are indicators of status, or weaving beads into intricate bands to tie into the hair or around the forehead. Another form of decoration is the hair extension, as used by the Samburu of Kenya. Young warriors use sisal string to extend their hair, then coat it with animal fat and red ochre to create a stiff fringe that sticks out over the eyes like the visor of a helmet. A similar use of animal fat has been discovered by archaeologists investigating 2,500-year-old mummies from ancient Egypt.

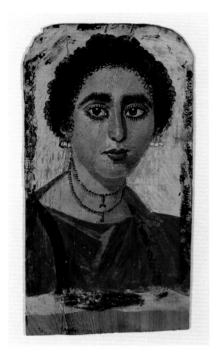

[1]

[2]

[3]

[4]

The face is our most expressive feature; since the earliest times, it has been enhanced, exaggerated, disguised, protected and restored. This is the realm of cosmetics, a catch-all term that comes from the Greek »kosmetike«, meaning 'expert decoration'. (The irony is that only courtesans used make-up in ancient Greece, while in other early cultures make-up was almost universal among women.) Throughout much of history, though, the use of make-up has been frowned upon by those of high moral standing. Cosmetics remained the preserve of women in their dressing rooms until the last hundred or so years.

–

TOMB PAINTING OF A YOUNG WOMAN, EGYPT, C. AD 150

[1] The impulse to make up is older than humans themselves. »Homo erectus«, ancestor of »Homo sapiens«, covered his body and face with ochres to protect it from the elements or from insects (see Skin, page 18). Prehistoric cave dwellers painted their faces red, yellow and white, probably as part of a symbolic process associated with lifeblood or the sun before, attracting a mate eventually became the most important purpose of using colour. By the First Dynasty of Egypt, from 3100 to 2907 BC, women and men decorated their eyes with dark green and black kohl, made from antimony. A couple of thousand years later the Greeks rejected make-up as frivolous, but the Romans took it so seriously that in the second century BC the dramatist Plautus noted that 'A woman without paint is like food without salt.'

ACTRESS JOAN CRAWFORD, 1942

[2] Cosmetics are an acknowledgement that not all women conform to a single ideal of beauty. Since the Middle Ages, each generation has had its particular 'look', based on the appearance of princesses, courtesans and film stars, and habitually achieved with the use of make-up. But it wasn't until the early twentieth century that decent women could allow themselves a little rouge without feeling steeped in sin or being whispered about as one who 'paints'. Then in the 1920s, Max Factor, Revlon and Helena Rubinstein were founded. At the same time, movies entered the arena, and heavily made-up stars (think Joan Crawford or Gloria Swanson) became the ideal. Eyebrows were plucked, lips were reshaped, eyelids were highlighted and the face of modern woman was defined. During World War II the press highlighted the importance of good grooming for morale, presenting cosmetics as being vital for women. By the 1950s, though, make-up was pale and understated, reinforcing the idea of the woman as domestic goddess and male accessory. It came almost to undermine a woman's personality; it even matched her clothes rather than her own colouring.

»KITTY FISHER AS CLEOPATRA«, SIR JOSHUA REYNOLDS, 1759, OIL ON CANVAS

[3] Today we are used to foundation and blusher, which give the skin a healthy colour. For much of history, however, fashionable women were set out to differentiate themselves from the ruddy faces of those who spent their time outdoors. For them, the purpose of make-up was to make the face as pale and white – as unnatural – as possible. Romans used chalk to whiten their complexions; flour fulfilled the same function in the Middle Ages, when women also bled themselves to maintain a sickly pallor. White lead paint became standard, sometimes set by egg white into a glossy mask. It lightened the faces of women from the Greco-Roman period to the England of Elizabeth I. Of course, it was also poisonous. Many cosmetic preparations have proved highly toxic – none more so than Aqua Tofana, which was said to have caused the deaths of hundreds of husbands who had kissed their wives while they were wearing it: the whitening agent contained arsenic. As late as 1767 the British courtesan Kitty Fisher, notorious model of painter Joshua Reynolds, died from the effects of lead-based cosmetics, as had Maria Gunning, one of the famous Irish sisters who led London society in the 1750s.

PAT MCGRATH MAKE-UP FOR JOHN GALLIANO, AUTUMN/WINTER 2007–08

[4] The modern dramatic face took hold in the early 1980s, when Vivienne Westwood and Jean Paul Gaultier distorted traditional fashion make-up in order to set the mood for their clothes. The lead was taken by Pat McGrath for John Galliano; McGrath added elements of Coco the Clown to the chalk-white complexion of the kabuki performer. Now fashion is going further, turning the face into a piece of animated jewellery, with distorted lips in gold and precious stones cascading down cheeks. Perhaps one day every ball will be a masked ball: fashion folk will wear faces jewelled, coloured and more exotic than any mask could ever be. Verging on the grotesque, these garish faces have feminists moaning in despair.

FACE – COSMETICS

[CAMOUFLAGED SOLDIER, 2008]

[5] The painted face has more than one purpose. On the one hand it enhances the natural signals of the face. On the other, it acts as a type of mask. That is why many women are reluctant to go out without it, arguing that an unmade-up face makes them feel 'naked'. Soldiers camouflage their faces, even when there is little military advantage to doing so, to feel that their protection is more complete. This is the result of our innate awareness of the power of the face for communication and an acknowledgement of the difficulty of not giving ourselves away through some inadvertent facial expression. Make-up thus becomes a form of camouflage that strips away individuality and personality, as in the white make-up of the geisha.

[6] Fashion editor Diana Vreeland had a word to describe statement make-up: 'gala'. This is make-up that is shamelessly attention-seeking. These are the bright oranges, the golds and silvers, and the electric blues that one associates with flamboyant fashion figures such as Zandra Rhodes or Anna Piaggi, who put up a technicolour defence against ageing. In their hands, make-up could be part of a performance. It was not intended to be natural: that was the whole point. This approach has throughout history been the preserve of the fashion leader with the courage to rise above ridicule – what could be more ridiculous than to paint one's face and expect onlookers to admire your style?

[7] For most of history, make-up has been an almost wholly female affair. There have been exceptions: for the ancient Egyptians, make-up was the prerogative of the elite of both sexes. The rest of the time, male make-up has largely been seen as effeminate and eccentric. Those who break the mould have usually been in a position of privilege, such as Henry III of France, whose white-and-red painted face and violet-powdered hair made him look like 'an old coquette', or Judge Jeffreys – the 'Hanging Judge' of the seventeenth century, as notorious for his use of make-up as for his harsh sentences. In modern times, the media often trumpet the return of male make-up, but it remains largely limited to those who follow New Romantic pioneers such as Boy George or Leigh Bowery (see New Romantic, page 212). Their make-up tends to draw on the theatrical tradition rather than female cosmetics. David Bowie, for example, whose ghostly face earned him the nickname 'the thin White Duke', learned about stage make-up from the kabuki star Tomaso Boru.

[8] There has always been a close link between make-up and morality. For most early Christian commentators, although the Church rarely banned make-up, the practice was evidence of the sins of vanity and frivolity. (Not for nothing did the over-painted ninth-century BC Hebrew princess Jezebel become a byword for wantonness.) For that reason alone, most people did not dare to paint their faces. At times make-up has been closely linked to prostitution, as well as to privilege. This double-sided nature was summed up in eighteenth-century Europe. In France, make-up was the exclusive domain of noblewomen, while prostitutes left their faces clear. Across the Channel in England, the situation was reversed: the 'painted women' were the strumpets, while the nobility were cleanly complected. The Victorians associated make-up with low moral standing: it only really became popular again in the 1910s. As late as the mid-1920s »Vogue« had to reassure its readers: 'Even the most conservative and prejudiced must now concede that a woman exquisitely made up yet may be, in spite of seeming frivolity, a faithful wife and devoted mother.'

[9] Dick Turpin was no one's idea of a good man, although this eighteenth-century highwayman has become something of a folk hero. One thing is certain: he never painted his face in the kind of dandy highwayman style appropriated by the pop star Adam Ant in the early 1980s. Adam's (or perhaps Ant's) style was a fanciful version of the warpaint put on by Native American warriors before going on raiding parties. The purpose of the paint was to enhance the wearer's bravery and aggression, but also to act as a symbol. Sometimes it indicated status; at others it was used to summon the power of the ancestors: yellow was an indication that a warrior was ready to die. Modern sportsmen, too, paint black strips beneath their eyes to make their appearance more intimidating. Ostensibly the black reflects glare, but as always with male make-up, the symbolic importance is greater than its practical effect.

ZANDRA RHODES, PHOTOGRAPH BY ROBYN BEECHE, 1979
LEIGH BOWERY, PHOTOGRAPH BY NICK KNIGHT FOR »I.D.« MAGAZINE, 1987
»LADY LILITH«, DANTE GABRIEL ROSSETTI, 1868, OIL ON CANVAS
»WASH-KA-MON-YA, FAST DANCER, A WARRIOR«, GEORGE CATLIN, 1834, OIL ON CANVAS
'Cosmetics are not going to be a mere prosaic remedy for age or plainness, but all ladies and girls will come to love them' – MAX BEERBOHM, 1890

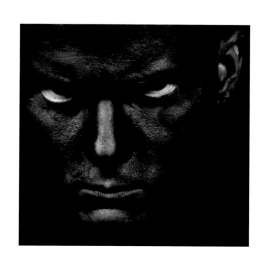

[5]

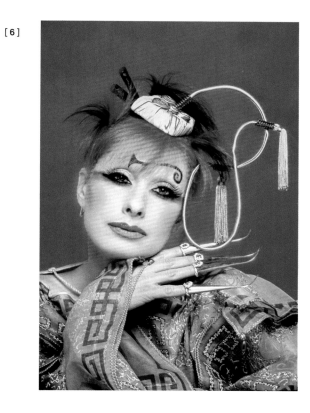

[6]

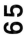

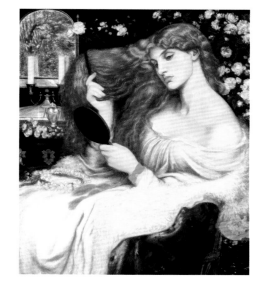

[8]

[7]

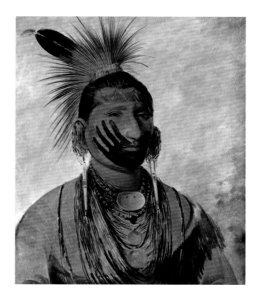

[9]

[1]

[2]

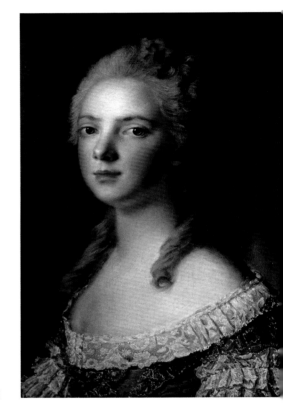

[3]

[4]

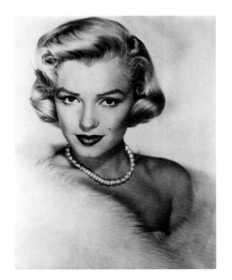

66

Of all the facial features, the eyes and the lips are the most expressive and have therefore attracted most attention in terms of make-up. However, they are just part of a larger whole. The cheeks and brows have been powdered, the chin plucked and shaved, the nose altered by cosmetic surgery and the ears decorated by jewellery – or even, in the late nineteenth-century United States, covered with false ears of different shapes. That innovation came courtesy of B. Altman, the New York department store that in 1867 opened the first 'making up' department, where women could go to have their make-up done (at that time, make-up set out to appear as natural as possible). It is said that when a pharmacy first employed a cosmetician in New York in the 1840s, it was more to disguise men's black eyes than to enhance women's looks. Today, of course, cosmetics is huge business and it is impossible to enter a department store without passing through the cosmetics department; there are beauty parlours even in the most nondescript suburbs; and busy women happily retouch their faces in the rearview mirror or even on the bus.

–

[1] Lipstick is the most coquettish of all make-up. It is traditionally red, and has been for about 4,000 years. The shade not only highlights the natural contrast between the blood-heavy lips and the rest of the face; it also echoes the red of the hidden genital lips of the human female. That, in a nutshell, is the anthropology behind lipstick, and red in particular. It sets out not just to make the wearer kissable, but to mark her as potentially sexually available. There have been brief vogues for different colours, particularly during the 1960s, with shimmery pastels fitting the vogue for rebellion in terms of appearance, and with the black lips of Goths in the nineties, but red remains the dominant tone (see Goth, page 200). The Church has occasionally condemned the practice – red is, after all, the colour of the harlot – but in the main it is tolerant. In fact British GI brides moving to the United States in the 1950s were even advised that lipstick was expected as part of a 'decent' appearance everywhere but in the smallest villages. In that same decade,

an opinion poll suggested that 98 per cent of all women wore lipstick … but only 96 per cent brushed their teeth every day.

[2] Freckles are rarely in fashion. That's about all that can be said with certainty. Virtually any other way of treating the cheeks has been popular at one time or another. Before the modern age, when naturalness became the major consideration for make-up, they were far more prominent in terms of cosmetics. In Roman times and at various points in history since, a pale face was seen as desirable – a sign of wealth and breeding which indicated that a person did not labour in the sun (See Skin, page 18). The antithesis of white cheeks is rosy cheeks, an effect achieved usually by rouge, particularly during the English Restoration when a glowing complexion was seen as a sign of health at a time of widespread epidemics and sickness. Their association with health also links rosy cheeks with youth, giving them an air of demure innocence. The modern equivalent comes courtesy of blusher, introduced as a powder by Revlon in 1963, while the modern equivalent of the historic pale face is the pallid, almost-transparent skin of the heroin-chic models of the early 2000s.

[3] The eyes are essential for transmitting visual signals, so it is inevitable that they have been a primary focus for make-up. Eye make-up has been some of the most expensive and time-consuming make-up of all to apply. It began with the Egyptians, who coloured their eyelids and outlined the eye with black kohl (they extended the outline with a horizontal line to the side of the eye to achieve a feline effect, as they considered the cat a sacred animal). Among the Romans, eye make-up was equally popular. Ovid, author of the first beauty book, noted that women used eyeshadow in black (kohl) and gold (saffron). After the fall of Rome in AD 476, eye make-up virtually disappeared from Europe (it was associated only with courtesans) until the early twentieth century, when the use of a pencil to elongate the eyes was advocated in the little-known but epochal »Daily Mirror Beauty Book« (1910). In the 1960s the use of exaggerated dark eye make-up was revived by designer Mary Quant, and most notably by Barbara Hulanicki, founder of

the iconic store Biba. The style has stayed around since, with variations in colour besides the heavy black outline: bright blue eyeshadow in the 1980s or white in the 2010s, sometimes offset by brightly coloured – and rather alien-looking – contact lenses.

[4] The first beauty spots were moles that highlighted women's facial features. By the seventeenth century women were using artificial spots for the same purpose. In the 1660s women at the French court used spots made of black taffeta to send messages about their martial status and willingness to flirt. The paintings of William Hogarth and his contemporaries satirize the craze for artificial beauty spots. Closer to the present day, Marilyn Monroe always drew in a beauty spot above her lip. Supermodel Cindy Crawford also became known for her prominent mole in the 1990s – which is, after all, what a beauty spot is designed to replicate.

[5] In the twentieth century, eye make-up was disproportionately steered by the ancient Egyptians – via the medium of the cinema. Like theatre lights, movie lighting makes the face pale, so make-up is required to balance this effect; and in the black and white movies of the 1920s, before sound, the face had to convey all of the actor's expression. Eye make-up became more dramatic to enable this, and the Hollywood look spread quickly in a business that at that time had few fashion leaders. Theda Bara appeared as Cleopatra in 1917, with heavy eyelashes made up by Helena Rubenstein based on a combination of Egyptian kohl and French theatre make-up, and caused a sensation. Over 40 years later, history was repeated thanks to Elizabeth Taylor's appearance in the 1963 epic film »Cleopatra«. She sparked a huge increase in sales of eye cosmetics.

[6] There is an innocence to the appeal of natural make-up; it suggests that no make-up is being worn, while at the same time enhancing the features of the face. It gives the impression that the wearer has turned her back on vanity and artifice in favour of a more genuine and wholesome appearance. In part the look is associated with the ecological movement that rose in the 1980s and 1990s with The Body Shop and, later, retailers such as Saffron Rouge in the United States, which used natural

ingredients to produce 'natural' products and a corresponding 'natural' look. Its roots, however, lie in the political gesture of earlier feminists who rejected the idea that women needed to make themselves attractive to men. It is a compromise – a way to make the most of one's face without the danger of becoming what has long been called, in derogatory terms, a 'painted lady'.

[7] The shaping of the eyelashes and brows also began with ancient Egyptians wielding the tweezers to pluck their brows, and blackening their lashes to make the eyes appear larger and therefore more youthful. The fashion disappeared in the Middle Ages, but was re-established by the fourteenth century, when Chaucer noted the highly fashionable plucked narrow brows of the Carpenter's Wife in »The Canterbury Tales«. Today eyelashes are exaggerated by mascara, usually made from a mixture of water, beeswax and carnauba wax. It is a modern invention, less than 100 years old, created after T. L. Williams watched his sister using petroleum jelly on her eyelashes. He formed the Maybelline company to sell cake mascara in 1917; the first mascara for everyday use. The eyelash curler appeared in 1923 and liquid mascara in 1957; it was not until the 1970s that Helena Rubenstein invented waterproof mascara and brought an end to the cinematic staple of a tear-stained face streaked with running make-up. Around the same time, the first instantly applicable false eyelashes made it possible to adopt the 'starburst' look very easily – but their popularity declined with the subsequent rise of the natural look.

THE BODY ANATOMIZED

MARILYN MONROE, 1953

ELIZABETH TAYLOR AS CLEOPATRA, 1962

BRIGITTE BARDOT, 1970S

TWIGGY, 1966

'The most beautiful make-up on a woman is passion, but cosmetics are easier to buy' – YVES SAINT LAURENT, 1975–85

[5]

[6]

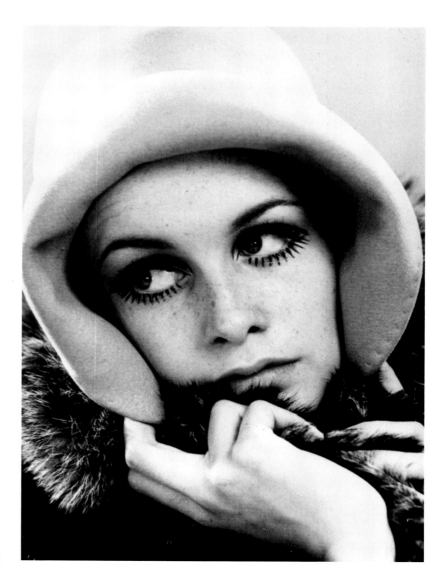

[7]

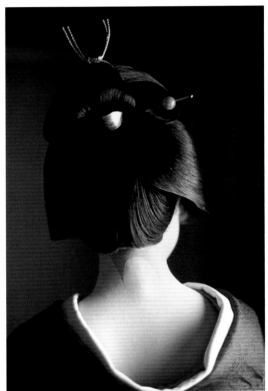

[4]

[2]

[3]

68

[1]

[5]

Two kinds of garments are closely associated with the neck: those that protect it and those associated with formality. Woollen scarves and fur mufflers have for centuries kept the neck warm, but enclosing the neck also helps to disguise its vulnerability. When French men and women wore exaggeratedly high neckwear after the Revolution of 1789, this was an almost instinctive symbolic reaction to the threat of the guillotine. Some sported red ribbons in a conscious reference to the blood of the victims of the Terror. In terms of display, women tend to emphasize the length and slenderness of their necks, while the ideal male neck is thick and strongly muscled. This desire for a slender neck is perhaps most extremely demonstrated by the Padaung of Myanmar, who use brass collar rings to stretch womens' necks to improbable lengths (see Skin and Body Adornment, page 18).

[1] In Western societies, the neck has become a sub-sexualized part of the female anatomy. In Japan, however, the nape of the neck is a fully acknowledged sexual zone. That is why the traditional costume of the geisha is cut high at the front, but plunges at the back to expose the base of the neck and the top of the spine. At the nape, a margin of bare, unmade-up skin is traditionally left around the hairline. One highly suspect theory is that Japanese women strapped their babies to their backs, thus developing in their infants a subconscious neck fixation.

[2] The neck is one of the most vulnerable parts of the human body – that may be why the bite of the vampire has such a hold on popular imagination. Early necklaces – the oldest was worn by Neanderthals some 36,000 years ago – probably had an occult purpose as much as a decorative one: the neck needed to be protected from the Evil Eye. This tradition was continued among peoples such as the Scythians, who wore open-ended neck bands known as torcs. Introduced to Europe in the fifth century BC, torcs were worn by Celtic warriors in battle. Later, Viking warriors wore longer necklaces. A longer necklace is traditionally a place to carry objects of emotional value, such as a lock of a lover's hair, so that they lie close to the heart.

[3] The distant ancestors of the modern necktie were the neckcloths worn by ancient Egyptians as a symbol of status, and later by Roman soldiers to protect the neck from the sun and to absorb sweat. A similar neckerchief, worn by Croat mercenaries in the Thirty Years War (1618–48), gave its name to the craze it started among Europeans: the cravat. Cravats were tied by strings, or else their ends were pushed through a buttonhole or a ring of wood or brass. They gave rise in around 1715 to a new garment, the stock: at its simplest a piece of muslin folded into a band, wound a around the neck and pinned in place at the back. In the eighteenth and nineteenth centuries Macaronis and dandies revived the more formal white cravat (see Dandy, page 182), but the black stock became the neckwear of the ordinary man. Covering the neck was a sign of decency and even the poorest contrived to have a muffler for modesty.

[4] During the eighteenth century, the stock spawned the modern necktie, known as the 'four in hand' for its resemblance to carriage reins. In some accounts, it was French Romantics who first began to wind ties loosely around their necks, leaving long ends to knot together in the front. The necktie took its modern form with the invention in 1926 of the Langsdorf, a tie cut on the bias and stitched together in three sections that became the basis for all later ties. With further variations – the bow tie, which is essentially a mini-cravat, and the Ascot, which is a formal tie with wide flaps pinned in place on the chest – the modern tie has remained in fashion, and covering the neck remains a sign of decency. More formally, the tie often indicates membership of an exclusive body. British army regiments adopted ties with diagonal stripes in the 1920s.

[5] One notable tie variant – the kipper – is said to have taken its name as a pun on that of its inventor, Michael Fish, who worked at Turnbull & Asser in the mid-1960s. It is also, of course, shaped like a kipper. Its extreme width worked well with the deep, soft shirt collars of the period, which threatened to overwhelm ordinary ties. The kipper's breadth – up to 15 cm across – offered a striking canvas for display. Ralph Lauren founded a business

on this epiphany. A tie salesman in New York City in the late 1960s, Lauren designed his own ties: wider, brighter and more expensive than anything on sale at the time. He intuited that men wanted the chance to wear something that was identifiably a status item. The 'Polo by Ralph Lauren' label advertised the fact that the tie was as expensive as most shirts.

[6] Formal neckwear has always been difficult to tie perfectly: its impracticality is part of its role as a signifier of social superiority. There is a story that Beau Brummel once rejected fifteen cravats before tying one to his liking. Brummel's own cravats – always white, and over a foot wide – were apparently austere adornment for his equally plain suit, but were in fact highly ostentatious in their perfection, which could not be achieved without hours in front of the mirror. The 1810s and 1820s saw the publication of the first handbooks on tying the perfect cravat. The quest for perfection continues today with the necktie: the perfect knot remains a male obsession. In the 1990s researchers at the Cavendish Laboratory in Cambridge calculated that eighty-five possible knots could be used to knot a tie, more than twenty of which are in common use. One of the most enduring is the Windsor knot, named after the Duke of Windsor, who filled an empty life with a fetishistic obsession with his appearance.

PRINCE OF WALES, DUKE OF WINDSOR, LATER TO BECOME KING EDWARD VIII, 1910S

[7] The scarf is no more or less than a longish strip of cloth wound around the neck, but such a simple definition belies the variations in length, materials and designs – and also in purpose. In colder climates, the scarf is familiar as a winter garment that keeps the throat warm. In its first recorded appearance, however – as the »scudia« of ancient Rome – it was primarily used to keep the neck clean by mopping up sweat. And in delicate silks and chiffons, the scarf may be worn solely for adornment. The scarf can be little more than a knotted cravat or long enough to threaten to loop around the neck more than once and drag along the floor. Such exaggerated length was famously responsible for the death of the actress Isadora Duncan in France in 1927, when her flowing silk scarves became tangled in the spokes of the wheel of her sports car, breaking her neck.

ASSATEAGUE ISLAND, VIRGINIA, 1971

[8] The neck has often served as a vehicle for displaying the face. The most obvious example is the ruff, which during a century or so of popularity followed an archetypal fashion arc from modest decoration to ludicrous excess. From the middle of the sixteenth century, the small ruffle that held together the drawstrings at the neck of the chemise developed into a separate garment, often of ruffled lace. This ruff could be laundered separately while still protecting the neckline of the doublet. With the increasing use of starch, ruffs became larger; the addition of a wire frame – the supportasse – enabled the creation of the cartwheel ruff, which easily reached over a foot in width. The ruff became a status signifier in some northern European countries, particularly the Netherlands and the towns of the Hanseatic League, where it is still part of the uniform of local officials.

»PORTRAIT OF ADRIANA CROES«, JAN VERSPRONCK, 1644, OIL ON CANVAS

[9] When threatened, the frilled lizard of Australasia erects a flap of skin around its neck to warn off an attacker. In dress, the neck can also be the site of similar displays of aggression. The most potent examples are the 'bling' necklaces and pendants of the A-Team's B. A. Baracus (Mr T) and rappers from NWA onwards – parodied by the Beastie Boys with a single that had teenagers stealing badges from VW cars to wear around their necks (see Aggressive, page 152).

FLAVOR FLAV, NEW YORK CITY, C.1988

[10] The fourteenth-century forerunner of the modern collar was the small ruffle at the neck of a chemise. From this ruffle came the fold-over collar, the Elizabethan ruff, the bib-like jabot and bands, the two oblongs of starched cloth still worn by academics and judges. By the mid-sixteenth century, collars had become detachable from shirts – they would largely remain so until the 1920s and 1930s – so they could be cleaned separately and easily replaced. Typically, collars stood proud from the neck, aided by starch; turnover collars stood around the neck but were folded down on themselves; and falling collars lay flat on the shoulders. Knitwear introduced more variants, including the polo neck, the turtleneck and the shawl collar. The purpose of the collar remains constant: to add an element of display by framing the face and, when appropriate, to add formality even to an ordinary garment.

MODEL WEARING BOW TIE AND WING COLLAR, 1920S

'A well-tied tie is the first serious step in life' – OSCAR WILDE, 1893

[6]

[7]

[8]

[9]

[10]

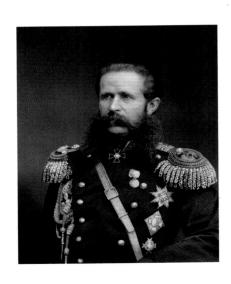

[1]

[2]

[3]

[4]

The shoulders are the armature from which the rest of the body hangs. Above all, they are a support for the arms, but they also have a sexual element – a fact often overlooked by society, but rarely by fashion. Men's and women's shoulders have evolved differently and are dressed accordingly. Male shoulders are up to 15 per cent broader than those of females, and even broader from front to back. The difference is made more pronounced by the tapering male waist and lean flanks, compared to the broader female hips. In men, broad shoulders are an indicator of power and status. They forge a primal link between the human male and the physical strength of animals such as oxen, or even the great hunting cats. They are also a cultural signifier of resilience and perseverance: broad shoulders indicate an ability to carry emotional and psychological, as well as simply physical, burdens. Women's shoulders are more often slender – and certainly slender enough to invite a man's enveloping hug. A sign of femininity and relative physical weakness, they are also a minor erogenous zone for those who are attracted to the delicacy of small bones.

–

[1] The broad-shouldered silhouette has been the ideal body shape for men since ancient times, when such shoulders were associated with arms powerful enough to wrestle a beast to the ground or pull back the string of a bow, which required great physical strength. Throughout history the male wishing to emphasize his masculinity has artificially extended his shoulders, as with the suit of armour or, more recently, with the stiff military epaulette, a strip along the shoulder line that enhances the shoulders' flatness and extends their width with caps that project above the tops of the arms (see Military, page 210). The epaulette is usually given even more focus for observers by the addition of eye-catching adornments such as badges or golden tassels, which signify rank. If the epaulette's chief military function is as a subtle indicator of differences in seniority, it also glamorizes the body of even the weediest man and gives him the illusion of the power of the traditional hunter-gatherer – at least until he removes his coat.

[2] The extreme of today's broad-shouldered male ideal is probably the padded American footballer, whose plastic-and-foam shoulder pads, together with his skintight pants, give him a shape close to the perfect inverted triangle. The outline recalls that of medieval knights, but with one distinct difference: as numerous commentators have pointed out, the footballer's padding is largely unnecessary. There are many full-blooded, full-body-contact sports in which players wear only minimal padding, if any. One calls to mind the vests of Australian rules footballers, which seem by contrast to flaunt the shoulders and arms, or the skin-tight shirts of rugby union and league players. This suggests that the exaggerated male silhouette is just that: an exaggerated display of masculinity, either to bring more weight to a tackle or to look good from the stands.

[3] Whereas the shoulders of men have generally been padded and stiff in order to emphasize them, women's shoulders have frequently been left bare. This underlines not only their vulnerability but also the subconscious eroticism of their smooth, paired hemispheres, which echo those of the breasts and the buttocks. Modern women who wear vests with slips or bras, so that the shoulders are crossed by straps and ribbons, are if anything intensifying the effect, by both exposing a hint of undergarment and leaving their shoulders largely bare (see Bust, page 78). The off-the-shoulder formal gown made its appearance in the sixteenth century, but its modern equivalent was highlighted by John Singer Sargent's painting of »Madame X« (1884) – the subject's exposed shoulders caused a considerable scandal. The exposure of skin highlights the shoulders' intimate role, associated perhaps with shoulder rubbing or with the pleasures of massage. It also tantalizes with the ever-present promise that a garment might slip down further to expose the breasts, which are inevitably covered. In many cultures today, as in the past in most Western cultures, such displays of flesh are seen as immodest and forbidden. That is why the bare-shouldered gown is still above all reserved for the glamour of the ball or the Hollywood red carpet – and is frowned upon or forbidden in religious buildings.

[4] The close association between military prowess and the shoulders is reinforced by the distinctive Japanese garment known as the »kamishimo«, with wings of stiff brocade that almost double the width of the wearer's shoulders (see Armoured, page 162). Today the kamishimo is usually associated with male characters in traditional Japanese kabuki theatre, but its origins lay with the Samurai. This knightly class adopted the fashion in the early seventeenth century as part of their constant effort to mark themselves as superior to other citizens and protect their privileges (an effort aided by laws that banned non-Samurai from carrying iron or steel weapons), and preserved it for nearly 300 years. It is little surprise, then, that broad shoulders characterize so much of modern Japanese fashion by designers such as Issey Miyake – and nowadays, for women too.

[5] Although shawls that wrap around the shoulders for warmth or adornment – now known in fashion circles by their Indian name, pashminas – were woven from wool as early as the third century BC, the industry did not come into its own until the fifteenth century, when the Kashmiri rulers introduced weavers from Turkestan. Although cashmere – the anglicization of Kashmir – was produced only in one relatively small valley, the down came from as far away as Tibet. Cashmere made its fashion arrival, like so many other sartorial phenomena, via Paris, where a French military commander is said to have introduced a shawl from overseas, which caused a sensation. It was painted by Ingres around the shoulders of high-society Frenchwomen and remained in and out of fashion from the 1830s to the 1880s, forming the basis of a French, and then European, cashmere industry.

[6] Women wishing to challenge male social dominance have commonly done so while borrowing the line of the masculine shoulder. This was true of the first generation of feminists of the 1890s, for example – who broadened their shoulders with epaulettes and eventually what were effectively balloon-like bags – and in the 1940s, when women wore squared-off, military-style shoulders as a kind of display of solidarity with men in uniform, while also sharing in the power dressing of the male shoulder line. It was equally true in the 1980s, when businesswomen adopted shoulder pads to give them a more squared-off silhouette. The costumes of Nolan Miller for »Dynasty« in the 1980s, worn by the feuding characters played by Joan Collins and Linda Evans, heralded the high-water mark of the shoulder pad, suggesting that here were women strong enough, bitchy enough – and man enough – to survive in the male-dominated world of the yuppies. Dormant shoulder-pad factories reopened their assembly lines, but the craze was short-lived. It was not long before designers – who normally have a very short concentration span and an unbridled enthusiasm for the next new thing – returned women to a softer silhouette.

[7] Designers have made great play with the shoulders. Yves Saint Laurent's famous pagoda shoulders – introduced in 1977 as part of a Chinese theme to support the launch of the scent Opium – reappeared over 25 years later in 2004, when Tom Ford produced his last Paris show for YSL. 'I felt the pagoda shoulder was right,' said Ford, albeit producing a more rounded version than the squared-off original. The high-cut, squared-off shoulder is a manifestation of the urban businesswoman cult that began in New York in the thirties as an attempt to give a serious Wall Street feel while retaining a degree of femininity. For that reason, it will probably always be in fashion one way or another: it provides proof that women can dress for the mean streets of commerce and not lose any feminine allure in the process.

'Shoulders are pretty things – at least, most of them are. I wouldn't mind betting that there are more pretty shoulders than pretty faces … there are certainly more pretty shoulders than pretty ears, elbows, hands and other bits of themselves which women do not feel in the least shy of showing. Why, then, should we be deprived of the sight of these charming features?' – »PUNCH«, 'In Praise of Shoulders', 1920s

[5]

[6]

[7]

[1]

[2]

ARROW
COLLARS and SHIRTS

SOFT finished for Summer wear. "Nassau,"
a particularly good-fitting outing collar, and
Arrow Shirts in fast colorings and uncommon
patterns.

Collars, 2 for 25c. Shirts, $1.50 & $2.00

Send for booklets. CLUETT, PEABODY & COMPANY, 457 River Street, TROY, N. Y.

© 1912, BY C. P. & CO., N. Y.

[3]

[4]

[5]

No area of the body is covered by such a wide range of garments as the torso. Joining arms to a top requires tailoring skill, which only fully evolved by the later middle ages. Earlier, the torso had been covered in loosely draped material, as in the Roman toga. Standard items of modern dress, such as the jacket, are relatively recent introductions. The shirt was, until the late eighteenth century, worn as underwear, although frequently exposed at the neck and wrist to display its quality. In early civilizations, such as the Minoans of Crete, both men and women bared their bodies from neck to waist. Although the uncovered male torso has become more acceptable in the modern West, flaunting the female torso remains largely taboo.

–

WESTERN UNION MESSENGER #51, PHOTOGRAPH BY LEWIS W. HINE, HOUSTON, TEXAS, USA, 1913

[1] The shirt was originally worn to keep sweat stains off outwear. The white shirt – until the early nineteenth century, the shirt was always white – was cheap, but it did require a laborious wash-day ritual of boiling and steaming that in medieval times took place, even in grand households, only once a year – but which was a Monday ritual for everyone by the mid-nineteenth century. By then, white shirts were worn by the middle classes as status garments, with detachable cuffs and collar stiffened with starch. In the early twentieth century the ironed, starched shirt became a staple of professional dress, as epitomized in the 1910s by the invention by fashion artist Joseph Leyendecker of the Arrow Shirt man. With a few eccentric exceptions, shirts remained largely white until the 1930s, when colour became more acceptable.

FRESCO (DETAIL), ROZMBERK CASTLE, CZECH REPUBLIC, NINETEENTH CENTURY

[2] Garments without sleeves warm the body while leaving the arms free. The tabard – an armless cloth garment pulled over the head and either left open or fastened at the sides – was once worn by those relatively high up in the social hierarchy, such as knights and their squires. In its modern form, the tabard is associated almost entirely with cleaners and factory workers, whose clothes it protects (see Workwear, page 234). Garments without sleeves, as well as being easier to make, offer protection from the weather and also attacks by enemies while leaving the arms free to counter them (up to a point; the cape, though without arms, constrains movement). They have traditionally, therefore, been associated with labour, fighting or, as the singlet, with exercise.

ADVERTISEMENT FOR ARROW SHIRTS, 1940S

[3] The shirt has two basic forms: the open garment pulled around the body and secured with fastenings such as buttons, or the closed tube, which is pulled over the head. The buttoned front is always more formal than the tube, which is most obviously associated with the T-shirt. The ladies' blouse was a variation of the tailored men's shirt, usually in a softer fabric and with a non-stiffened collar. Inspired by sportswear, women began to wear shirts similar to men's by the late nineteenth century, but it was only in the 1930s that they started to go to shirtmakers for clothes for golf, tennis and sailing, based on their male antecedents (see Sportswear, page 226). The tradition that men's shirts have buttons on the right, women's on the left, has a number of explanations, the most convincing being that men's buttons were arranged for the convenience of a man dressing himself, women's for the convenience of a lady's maid standing facing her mistress.

SENIOR PROM, ANACOSTA, MARYLAND, USA, 1953

[4] The dinner jacket, or tuxedo, is often considered the height of formality. It was, however, invented as the complete informal opposite at a time when frock coats or tailcoats were still required for formal society occasions. Gamblers in Monte Carlo in the 1880s, tired of wearing heavy tails in casinos but debarred by convention from removing any clothing but their hats and gloves, came up with it as a more accommodating form of coat – the outer garment which, in one form or another, had been de rigueur for gentlemen for most of the last 400 years. The jacket had silk shawl lapels, while the accompanying trousers borrowed a flash of silk down the leg from the military mess. However the DJ, as it became known, was considered louche because of its connections with show business and shady characters. It was not accepted as suitable dress in the company of ladies until the death of Edward VII in 1910. Even after it became more generally acceptable, its informality was seen by many traditionalists as a threat to the dress hierarchies considered necessary for formal upper-class life (see Establishment, page 188).

[5] In the 1880s, men might wear dinner jackets at home or in all-male company, but more usually they wore tailcoats – the long tails came from riding clothes. Once the ladies had retired after dinner, however, men might change into a smoking jacket, which was usually quilted for additional warmth in the unheated smoking and billiard rooms of country houses. As the smoking jacket's use spread, its quilting tended to be confined to the collar, cuffs and pockets, always in dark shades of velvet. The jacket's name and shape returned to prominence in 1966, when Yves Saint Laurent pioneered Le Smoking, women's trouser suits for evening.

[6] The waistcoat (or vest) is a symbol of the ability of royalty to set fashion (see Regal, page 220). In 1666 it was decreed by Charles II as a garment to be worn under a coat. Samuel Pepys noted in his diary: 'The king hath yesterday declared his resolution of setting a fashion for clothes which he will never alter.' It was only necessary for the length of the long vest to creep up to waist level to become the modern garment. The waistcoat has remained in fashion since, most notably as formalwear in a three-piece suit, a Victorian development of a Restoration fashion. It wasn't until Princess Diana in the 1980s that an English royal exercised such an influence on fashion again.

[7] When Marlene Dietrich arrived in the United States in the early 1930s and came under the wing of Travis Banton, costume designer at Paramount Studios, she wore masculine-cut suits with men's shirts, complete with cufflinks and ties. Dietrich created a sensation – not only because she was 'coming out' as one of Hollywood's first cross-dressers, but also she showed that 'travesty' did not need to look comic, but could be unsettlingly sexy when worn by the right woman.

[8] Knitting was for thousands of years used mainly to produce socks and stockings. It was only in the 1880s that the introduction of new knitting machines encouraged the production of knitted garments for the torso. These sweaters – the word was first used in 1882 to refer to a woollen garment worn for rowing – were light but warm and inexpensive. Outside of sports, they were initially worn mostly by women, as menswear was dominated by the uniform of jacket and shirt. By the 1910s, US college men were also starting to wear baggy sweaters adopted from rowing and cricket. In the 1920s, artist Gerald Murphy began wearing the blue-and-white striped jersey popular with French sailors, and a golfing appearance by the Prince of Wales in 1921 popularized the distinctive Fair Isle pattern of knitwear.

[9] In the 1930s, women's knitwear was developed by two designers of genius: Coco Chanel invented the twinset, of sweater and matching cardigan, while the less well-known Madeleine Vionnet introduced the cowl and the halter neck. Among those who benefited from the popularity of knitwear were Hollywood starlets such as Jayne Russell and Lana Turner, and later Marilyn Monroe, who used the clinging garments to emphasize their figures (see Bust, page 78). It took a later generation of designers such as Sonia Rykiel and Missoni to discover knitwear's real potential for inventiveness. The Missoni family, for example, took the colours and geometric patterns of Africa to create intricate textiles that were romantic and exotic but also bold and modern.

[10] There are few simpler garments than the T-shirt – in essence a tube with one end closed, holes cut for the neck and arms, and short sleeves added to cover the shoulders and upper arms – and few more widely worn. Like other shirts, the T-shirt was originally an undergarment; more precisely, it was the top of the close-fitting union suit, or combinations, and was first separated from the legs in the nineteenth century. The new top was ideal for miners and dockworkers, who engaged in strenuous labour, and in the Spanish–American War of 1898 it was issued to US naval personnel as an undershirt. While the T-shirt became acceptable male wear for physical work, it was not until after World War II that it was widely worn, made fashionable by veterans of the armed services. Its sex appeal became blatantly apparent when Marlon Brando peeled off a soiled T-shirt – worn as outerwear – and pulled on a clean one as Stanley Kowalski in »A Streetcar Named Desire«, first on Broadway in 1947 and then in the 1951 movie. As Stanley explains to his shocked sister-in-law, Blanche, 'Be comfortable. That's my motto up where I come from.'

[6]

[7]

[8]

[9]

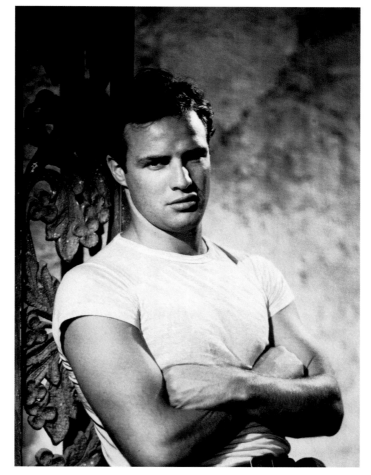

[10]

The torso is, literally, the centre of the body. Protected by the hard cage of the ribs, it is the location of all the major organs, with the exception of the brain. It is the most prominent part of the body, and the major site of display (in the same way, some birds puff out their chest feathers as a form of display to attract a mate). In non-literate societies, such as among the Plains Indians of North America, beaded and other patterns on the torso conveyed important messages about the wearer's status in the tribe and his achievements in the hunt or in battle. In modern times, the same trend has continued with the wearing of orders and military medals on the chest. However, whereas in the past all educated people were expected to understand the semiotics of clothing, most observers today are not educated in the messages of clothes. In the modern commercial age, therefore, those messages have increasingly been spelled out – often literally – by logos and labels across the torso to ensure that they are understood even by the uninformed. In the past twenty years, the torso clad in specialist sports clothing has become a billboard for sponsors.

–

[1] The chest is a natural signboard. It was where the armoured knight held the shield that bore the crest that identified him (see Pomp, page 216). It was where Crusaders wore the red cross on their tabard that marked the holy inspiration of their enterprise, and where medieval pilgrims pinned their crosses of palm leaves. It is where US military uniforms – more democratic than anonymous European uniforms – place the wearer's name, and where for centuries status has been displayed by means of badges, medals, royal orders, brooches and pendants. The braided frog fastenings of officers' jackets – later commandeered by circus ringmasters and Jimi Hendrix – were an instantly recognizable display of authority, even amid battle (see Military, page 210). In sports uniforms, the chest is the location for the club or country crest – over the player's heart, at the core of all his or her sporting loyalties. (In a more cynical view, pride of place goes to the name of the sponsor who pays for the privilege, reflecting the commercialization of virtually all spectator sport.)

[2] When fashion designer Katharine Hamnett dressed models in huge white T-shirts bearing the single word 'Relax', or when she met Margaret Thatcher in 1984 while herself wearing a shirt that proclaimed '58% don't want Pershing', she was acknowledging the torso's power as a means of communication. Hamnett claimed that her slogans allowed the wearers to feel they were participating in 'democratic action'. A cynic might respond that they had done nothing more than buy a very expensive T-shirt – a rival designer sent a similar T-shirt down the runway bearing the slogan '99% don't care what designers think' – but the chest has long been associated with slogans. The first messages were printed on T-shirts when the garment itself had only just begun to be worn as outerwear, in the wake of World War II. The »New York Times« reported in 1948 that the candidates in the presidential election campaign had supporters wearing the respective messages: 'Dew it for Dewey' or 'I Like Ike'. In 2005, Vivienne Westwood added her own wry comment to the political debate in Britain with a shirt that declared, 'I am not a terrorist, please do not arrest me.'

[3] The male chest can be a symbol of physical and social power. In Tudor and Stuart times, the padded male doublet (see Torso, page 76) was conceived not only as a protective garment but also as a display of macho assertiveness. It often featured jewellery or precious threads, such as silks and traces of silver and gold; was made of the finest fabrics, frequently velvet; and was typically slashed to reveal an equally fine linen undershirt or lining within. Today there are only vestigial reminders of such ostentatious torso decoration, in women's brooches or in men's ties and tiepins. Both are ways to add a display of wealth or status to a larger garment. Even though the torso is still used to impress, it does so in a more physical way. Today's display of male power are more likely to involve the exposure of the chest, or at least of its shape, in a blatantly sexualized fashion. The tight T-shirts of gym-built bodies or the open-fronted shirts of boy bands with carefully engineered hairless pecs and six-packs are the male equivalent of the female wet-T-shirt contests popular in the more redneck areas of the Western world.

[4]

TOMMY HILFIGER SPRING 1997 COLLECTION, NEW YORK CITY, 1996

Shirts are emblazoned with
so many messages – political,
humorous, support for a sports
team, souvenirs of holiday bars –
that it was a natural step when US
designers such as Tommy Hilfiger
and Ralph Lauren simply enlarged
their company logo and stamped
it on the front of a shirt. They
were not the first designers to
use logos – the first was Jean
Patou, who used his initials on
trousers in the 1910s – but they
were the first to make the logo the
whole point of the design. The
garment had become the brand. In a
striking reminder of the complex
relationship between designers and
consumers, the customer happily
paid Ralph and Tommy for the honour
of advertising their products – but
in return got the satisfaction of
feeling that they were themselves
part of the brand: sophisticated,
wealthy, tasteful, sporty, sexy …
or whatever line the designer was
peddling. The message they wanted
their clothes to convey about
themselves was summed up expertly
in the qualities associated with
a single logo. There was no reason
for further embellishment. Franco
Moschino wittily stripped the
relationship down to its basics
in 1989, when he sent a model down
the catwalk in a polo-neck jersey
dress with a slogan stitched in
gold threat across the back:
'Questa maglia costa L268,000'
(This dress costs 268,000 lire)
in order to remind people that,
behind the glamour, modern fashion
is about selling clothes at hugely
inflated prices (see Back, page 83).

'The origins of clothing are not practical. They are mystical and erotic. The primitive man in the wolf-pelt was not keeping dry; he was saying: look what I killed. Aren't I the best?' – KATHERINE HAMNETT, 1990s

[2]

[4]

[3]

[1]

[2]

[3]

The torso can often be limiting for designers. It is not particularly flexible, and its shape is often less than ideal for a designer whose first instinct is to create an appearance of slender height and glamour, rather than solidity that might slip into squatness. Yet the torso is also vital in creating the overall profile of an outfit. Shoulders can be broader or narrower, the waist can be tighter or looser, the jacket or coat can be cut to any length from the waist down as far as the thighs or the ankles – or even above the waist, as in the matador's jacket, or bolero. At times, doublets have been padded or waistcoats have been snugly buttoned to emphasize the size and power of the torso; at other times it has been disguised under longer garments like the justaucorps – a knee-length coat of the late seventeenth and early eighteenth centuries, fitted above the waist but flared below – which help to create an impression of slimness.

–

[1] Disguise is an important part of dressing the torso, and has rarely been more effectively accomplished than by the layered, angular, asymmetrical clothes of Issey Miyake in the early 1980s. Miyake wanted to be seen as a global designer whose work broke cultural barriers between East and West, creating clothing that was universal. He was one of the few designers whose work explored the space between the body and the clothing, creating shapes that were far removed from traditional Western clothes, which tended to be more linear and vertical. In the West, designers start drawing at the neckline and work to the hem: left and right, top and bottom all balance. Meanwhile the Japanese see a garment horizontally, asymmetrically and in the round. It is almost an abstract, geometric shape, in which tops, bottoms or sides are barely considered and frequently interchangeable. The Japanese approach has deeply affected Western designers since the early 1980s. Nevertheless, its full impact has yet to be felt in daily dress, possibly because most women rejected the fact that some early Japanese clothing required detailed instructions in order to be correctly worn, thus flying in the face of modern dress lore, which insists on clothes being effortless and simple to wear.

ISSEY MIYAKE, CLOTH KNIT, 1977

»THE TAILOR« ('IL TAGLIAPANNI'), GIOVANNI BATTISTA MORONI, C.1570, OIL ON CANVAS

[2] The doublet began life as a tight, padded lining worn beneath armour (doublet comes from the word 'doubling', meaning to add a layer). But, as with the shirt, not only did it become acceptable not only to see the doublet; in the late fifteenth century it evolved into a major part of the male wardrobe for the torso. By the mid-sixteenth century, the doublet was the major area for displays of male peacockery. Stuffed with bombast – a filler made from rags, bran and horsehair – and ribbed with whalebone, the doublet enhanced the shape of the male torso by broadening the chest (it is the origin of the phrase 'stuffed shirt'). With or without arms, it varied in length and was attached to hose, which it helped to hold up. The garment was either fastened in the front or, if the two sides did not join, brought together over a stomacher. When the doublet became too short – it was tight in the waist, to emphasize the upturned 'V' of the silhouette – the codpiece appeared to protect the wearer's modesty (see Genitals, page 106). The doublet remained in use for something like 300 years.

THIERRY MUGLER, HARLEY MOTORCYCLE BUSTIER, 1992, PHOTOGRAPH BY PATRICE STABLE

[3] One way in which dress changes the shape of the torso is to enclose the soft flesh within a harder shell, just as the bodies of insects are covered by frequently brilliant carapaces (see Armoured, page 162). The padded loose doublet, conceived as a proof against the possibility of an attack with a knife, was a fixed item of male dress for centuries, and the breastplate known as a cuirass – from the Latin meaning 'made of leather' – was still worn by cavalrymen at the outset of World War I, before it became apparent that most body armour was of little use against artillery shells or bullets. Many modern designers have played on this masculine theme for women's dress. Yves Saint Laurent produced a bronze bustier in 1969, while Issey Miyake used hard plastic and Hussein Chalayan chose wood in Autumn/Winter 1995 (see Materials and Texture, page 24). In 1992 Thierry Mugler turned a woman's torso into a machine when he created a bustier in the shape of a Harley Davidson motorbike, complete with handlebars, mirrors and brake levers. In 2012 the young Dutch designer Iris van Herpen used cutting-edge 3D printing technology to fashion a leaf-like bustier-dress from polymer.

[4]

Clothing occasionally seeks to help its wearer escape the confines of the body. The tassled shirt, which is today a standard of Country and Western rhinestone kitsch, has its origins in the long buckskin fringes that often hung from Native American clothes, mainly around the shoulders, chest and arms. It is tempting to ascribe to them a practical purpose, such as keeping away flies in the same way a horse's mane does, or blurring the outline of the body for camouflage while hunting, but anthropologists believe that it was more likely that the fringes had a symbolic meaning. By flaring out and changing the shape of the wearer, the tassels can be seen as representing an extension of the individual beyond his or her body, so that he or she is no longer limited by physical shape. The tassels on the garment reached out into the air and represented the way in which the wearer was joined to the spirit world that Native Americans believed surrounded them. They were an essential means of overcoming the limitations of the human body.

[5]

Cristóbal Balenciaga introduced the modern sack dress – and a similarly shaped sack coat – in 1957. He loosely based the dress on the chemise designed at the start of that decade by the US designer Norman Norell. The style was in many ways a logical outcome of the Spaniard's gradual paring down of the dress, during which he had softened its silhouette and loosened its outline – and it prefigured the simple lines of the 1960s. Balenciaga's sack rejected the hour-glass of contemporary dresses; instead, it hung from the shoulders to the hem like a loose tube around the body. The new style caused a stir – Balenciaga later created less full and shorter versions that were less radically innovative but more commercially popular –but other designers picked it up. Dresses that did not follow the figure were not new. In France in the second half of the eighteenth century, a shapeless sacque dress – sometimes called a Watteau gown, in acknowledgement of the painter in whose portraits it often featured – had also become popular, with small box pleats behind. The emphasis was on loose, flowing lines. A contemporary noted that 'at present, comfort appears to be the only thing the ladies of Paris care about when dressing'.

[6]

There is nothing in the nature of fashion that says that the torso must be slim or athletic. The current fashionable body shape is typical of just a half-century of emphasis on youth and health. Victorians and Edwardians were typically fuller figured than today, although women were still admired for their 18-inch wasp waists. At various times in the past, even as early as in the fifteenth century, female fashion has used padding to create false stomachs. The most famous example is in the Renaissance painting »The Arnolfini Wedding«, painted by Jan van Eyck in 1434. Art historians once puzzled about whether the bride's high, swollen stomach was the result of pregnancy – which would have been something to hide at the time, not to flaunt in a painting. Instead, the woman's shape reflects the prevailing fashion for padding out one's natural stomach in order to attain the fashionable curvaceous silhouette – not the results of premarital intercourse.

[4]

[5]

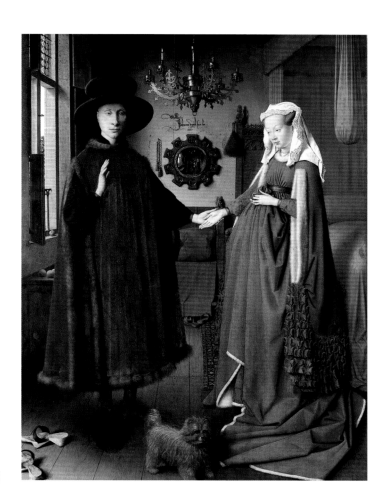

[6]

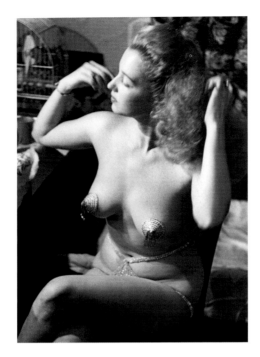

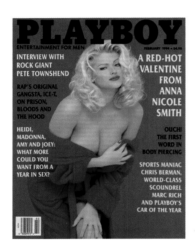

[2]

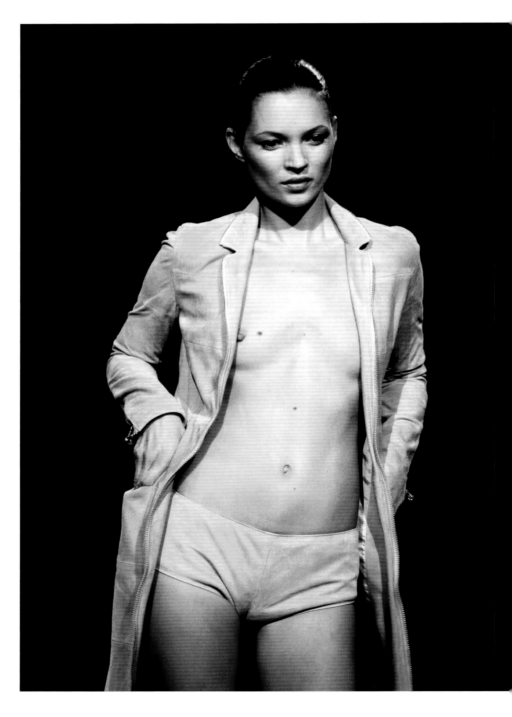

[3]

The female bust is the most obvious of all human sexual zones. Its twin hemispheres evolved in tandem with the buttocks – the most powerful erotic zone before the anatomical changes that accompanied walking on two legs encouraged face-to-face rather than rear-entry mating – and eventually the breasts became more important in attracting a mate. The maternal significance of the bust is manifest, and was celebrated from the earliest times by figurines of fertility goddesses with enormous breasts, but fashion has been more concerned with sexuality than motherhood. The breasts also transmit subconscious messages about a woman's age. (In visual terms, the bust of the 25-year-old, when the breast is at its most rounded, is the ideal, so one role of clothes is to try to re-create, imitate or prolong this state as far into the future as possible.)

–

[1] The most intimate and therefore most tantalizing part of the breast is the nipple. Its exposure is usually considered to mark the line between decency and decadence. When singer Kiki Dee appeared braless on the television show »Top of the Pops« in 1976, she was asked to tape down her nipples. When Janet Jackson inadvertently revealed a breast during the half-time performance at Super Bowl XXXVIII nearly thirty years later, in 2004, the resulting furore was widely seen as reaction against the perceived increase of indecency in the media; CBS was fined a record $550,000, despite the fact that the incident had lasted no more than half a second and Jackson was wearing a nipple shield. This view of the nipple probably has more to do with its association with breastfeeding – and therefore its taboo status for those outside the family – than with sexual symbolism, although it is a more sensitive erogenous zone than the rest of the breast. Revealing the nipple, even beneath clothes, is thus widely avoided, particularly the erect nipple, which can be understood as an involuntary expression of sexual desire. The nipple also ruins a perfectly smooth silhouette. Some women who do not wear bras wear pasties or shields to retain a smoothness of outline. Pasties are often worn by strippers and vaudeville performers, particularly where the complete exposure of the breast is banned. (Pasties' name comes from the fact that they are pasted on to the nipple with weak adhesive.)

[2] Plastic surgery has had more effect on the bust than on virtually any other part of the body, except perhaps the face. A 2009 survey found that 70 per cent of American women were dissatisfied with their breasts. Some 300,000 women in the United States have breast enhancements each year, usually by the implantation of saline or silicone-gel bags, despite continued uncertainty about the safety of the procedure. One result is that breasts in general have become larger and more perfectly shaped: some celebrities are famous entirely for their breasts, despite the fact that they openly admit that they are artificial. Anna Nicole Smith, a former topless dancer, made the cover of »Playboy« a number of times in the early 1990s after having breast augmentation, said to have included inserting two sacs of silicone into each breast. (Smith famously went on to marry a billionaire pensioner). About a third of the women who have breast enhancements seek breast reduction surgery each year.

[3] For many designers in the later twentieth century, the ideal fashion figure was that of the adolescent boy or young man – with breasts. Such a preference had a tremendous influence on couture in general and on dressing the breasts in particular. Fashion folklore tells that, when he used to draw the clothes of US designer Charles James, illustrator Antonio Lopez had them modelled by an adolescent rent boy from the sidewalks of Times Square. In the 1990s models with more mannish figures had silicone implants to achieve the desired silhouette. This made their breasts rigid, with none of the movement of the real thing, but for designers this was preferable: synthetic curves on an otherwise slender frame. The early 2000s saw a change in perception and a rise in the popularity of models such as Kate Moss, with smaller breasts and more naturally boyish figures that allowed clothes to hang as the designer wished. The flat-chested British supermodel Erin O'Connor revealed in 2013 that early in her career agents urged her to have breast-enhancement surgery. She rejected the suggestion – and became one of the most successful models in the world.

BUST – SYMBOLISM

MADONNA WEARING BASQUE BY JEAN PAUL GAULTIER, 1990

[4] Many male designers seem to have a dislike of breasts bordering on fear. They compensate by poking fun at the female chest: how else to describe the outrageously pointed corsets designed by Jean Paul Gaultier for Madonna in the 1990s? Gaultier's corsets bore as much relation to real breasts as do the coconuts a rugby player sticks up his jersey for a party. Gaultier was himself parodying the bras introduced by Yves Saint Laurent in 1967. As part of his renowned African collection, based on stylized African drawings, YSL had introduced a black bra with 8-inch points made of plastic and decorated with beads (see Ethnic, page 190). His innovation was largely overlooked until Gaultier revived the idea. This was a garment that parodied womanhood. The fact that such a strong woman as Madonna – with the approval of many women in the fashion world – was content to wear it raises an interesting question: to what extent was she the victim of the designer's view of women, and to what extent did she flaunt her comic breasts as a sign of female power and the rejection of the male ideal?

SHEER 'CIGALINE' TOP BY YVES SAINT LAURENT, AUTUMN/WINTER 1968–69, PARIS

[5] Exposure of the breasts is not a common theme in fashion. The majority of Western women have little wish to reveal their breasts in public. Women with large breasts may feel self-conscious; those with small breasts may feel lacking compared to the ideal promoted by the media. Overwhelmingly, of course, most women are simply comfortable remaining within the parameters of modesty laid down by society, which they learn to observe from the onset of puberty when their chests first become visibly different from those of their male contemporaries. Fashion has rarely been able to overcome this reticence, despite the occasional attempts to do so. Even when a trend has revealed the breasts – in early-nineteenth century France following the Revolution, say – few women have dared (or wanted) to adopt it. In the 1970s Yves Saint Laurent made great use of sheer tops and topless models to gain attention at his catwalk shows, but these were not clothes intended to be worn in public. In fashion terms, naked or largely revealed breasts look likely to remain firmly on the catwalk and in the photographer's studio, rather than on the high street.

TOPLESS WOMAN ON BEACH, 2000S

[6] In different cultures and in different periods, the impulse has been either to call attention to the breasts – sometimes by baring them completely – or to disguise them to the point of denying their existence, and forcing clothed women into a form of androgyny (see Androgyny, page 158). Even in the last decades, designers have vacillated between idealizing women as ample and pneumatic or as waiflike, with prepubescent or small breasts. Public exposure of the female breasts is permissible, but only in certain highly proscribed social situations, such as when breastfeeding or on the beach. That distinguishes them from the other major erogenous zone, the genitals, which are, in an adult, never to be revealed in public.

JANE RUSSELL IN »THE OUTLAW«, 1943

[7] Clothes often appear to alter the shape of various parts of the body through illusion, making legs seem longer, waists more slender, or feet smaller. Because the breasts are soft, they are relatively flexible, so garments do actually change their shape: they push the breasts together – as with the Edwardian monobosom – or ease them apart; they lift them up and push them forward or leave them lower and closer to the ribs. They give a plumper or a flatter appearance. This is all concerned with the female silhouette – the overall shape and proportion of the body – to which the most important contributions are made by the shoulders, breasts, waist and hips. The first attempt to control the shape in this way was apparently made by the Greek bandolette, a garment consisting of loose ribbons worn over the shoulders and underneath the breasts. One of the most notorious experiments was Howard Hughes's cantilevered bra for Jane Russell in the 1943 movie »The Outlaw«, where he had curved steel rods sewn beneath the breasts in such a way that they allowed the bra straps to fall off the actress's shoulders but her breasts still to be held in place. Russell explained in her 1985 autobiography that in fact Hughes's garment was so uncomfortable that she soon discarded it and replaced it with her own bra, simply pulled tighter, without Hughes noticing.

'Uncorseted, her friendly bust / gives promise of pneumatic bliss' – T. S. ELIOT, 'Whispers of Immortality', 1919

[4]

[5]

[6]

[7]

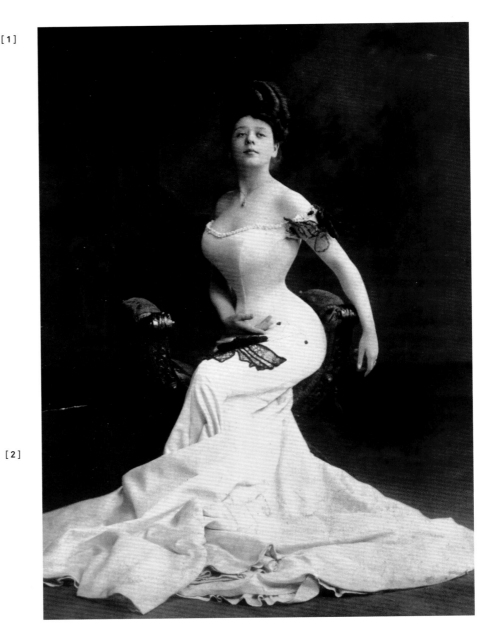

80

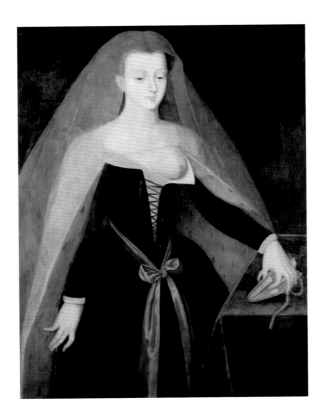

[3]

The story of dressing the breasts over the ages has been a hokey-cokey: in, out, in, out, shake it all about … The Minoans exposed them; the Greeks shielded them with fabric. In fourteenth-century France, the bust was strapped down; a century later, the fashion was for clothes that would push it up and out. The Elizabethans covered it entirely. In the Regency period, it was clearly visible before the Victorians invented the monobosom – a solid, safely sexless mass of flesh. Throughout all the changes, men's fascination with breasts has never dimmed. It goes back to infancy: but does the fascination reveal male vulnerability (snuggling in for a warm drink) or power (receiving it on demand)? And if infant lads were suckled at, say, the navel, would grown-up men still be so excited by breasts?

–

[1] In the last hundred years, the ideal breast shape has changed from that of the mature woman with a heavy bust pushed up by a 'health' corset into the Edwardian S-shape to the more androgynous models of today. That the modern flat-chested look is in many ways as false as that of the plumped and pushed-up Edwardian shape should go without saying. It differs only in this regard: it reveals rather than disguises. This is not a body shape that Edward, Prince of Wales, would have appreciated. In 1910, the year of Edward's death, the fashionable V-shaped neckline sank so low that reputable doctors warned of an increased risk of pneumonia among the great and the good. At the start of the 1920s a surgeon warned that exposing the neck led to an increased chance of goitre, and the US state of Virginia went as far as to forbid women by law from displaying more than 3 inches of their throats (see Neck, page 68).

[2] The brassiere is the successor of the corset, whose whalebone and metal stiffeners held the breasts as firmly in place as they did the stomach. In the early twentieth century the corset split into two garments: the girdle, which gradually died out, and the brassiere. The word »brassiere« first appeared in 1907 (it derives from a French military term meaning 'arm protector', and later became used for both a military breastplate and a type of female corset). There are competing

claims to its invention. One of the loudest came from Paul Poiret, who declared, 'In the name of Liberty' [a strong claim for a Frenchman] 'I declare that I proclaimed the fall of the corset and the adoption of the brassiere … I freed the bust.' But it seems that women had already decided to liberate themselves: Herminie Cadolle displayed a bra and corset set at the Great Exposition of 1900 in France. Caresse Crosby and Lucile (the professional names of the socialites Mary Phelps Jacob and Lady Duff Gordon, respectively) also both claimed to have invented the garment: Crosby registered the first patent for a bra, in 1910. The actual inventor is largely irrelevant. The coming of the bra – and the going of the corset – was the result of wider social changes, mainly the relaxation of social rules about women's appearance and the introduction of more comfortable, less formal clothing. The brassiere was, in every way, less restraining than the corset, while still supporting heavier breasts and preventing them from moving uncomfortably, and still giving the bust a firmer, and therefore more attractive, shape.

[3] A plunging neckline has always advertised sexuality, although usually the décolletage itself has been covered, as by the linen partlets worn with the square-necked, lace-collared dresses of Edwardian times. A similar role is often played today – when underwear can be more relied upon to actually hold the breasts in place – by a T-shirt or shift worn beneath a work shirt. However, those on the market for marriage or an affair used to leave their cleavage exposed, as did those who were openly mistresses, such as the French king Charles VII's mistress Agnès Sorel in the sixteenth century, displaying their breasts as a sign that they were the trophies of men of status. During Elizabethan times virgins ready for marriage wore dresses cut low enough to expose part of the nipple; the English queen herself is said to have exposed her breasts until her middle age to symbolize her virginity – to the disapproval of the French ambassador. Although leaving one's bodice open to tempt a marriage partner was condemned in France and Spain, it was embraced in Venice, where single women rouged their nipples to enhance their appeal.

BUST – EXPOSURE + CONCEALMENT

THE
BODY
ANATOMIZED

[4] Surely everyone is familiar with the brilliantly conceived advertising billboard of the early 1990s with Eva Herzigova looking down at her breasts with the slogan 'Hello boys'. The campaign helped make Wonderbra an underwear sensation in the United Kingdom. It would be a mistake, however, to associate the idea of the push-up brassiere with the contemporary age. The Wonderbra itself was patented in 1941 by an American inventor eager to circumvent wartime restrictions on the availability of elastic, and then taken up by the Canadian firm Canadelle, trading under various names and licences. The modern Wonderbra, model 1300, was designed in 1961 by Louise Poirier. In the late 1960s, Wonderbra led the way in advertising brassieres on television by showing them, not on a mannequin as was usual, but on a woman. The campaign emphasized the garment's role in enhancing attractiveness rather than its functionality or comfort. The tagline was 'We care about the shape you're in'. It was the confidence the garment gave the wearer that accounted for its great popularity. In 2007 Canadians displayed commendable national pride in voting the Wonderbra the fifth-greatest invention in history.

[5] In historical periods when social mores have been particularly repressive, the bust has suffered correspondingly. Puritan women in the American colonies in the sixteenth and seventeenth centuries wore tight-fitting bodices that pushed their breasts flat, so that their chests resembled those of sexless children. In the seventeenth century, women wore stiff boards known as stomachers to flatten their breasts, while in Spain young girls had flat metal plates tied to their fronts to try to prevent the breasts from growing; an echo of the Chinese practice of foot binding. In the twentieth century, the bust also suffered at the hands of fashion. In the 1920s the Flappers tried to achieve a flat-chested, mannish silhouette by taping their breasts and wearing loose shift dresses that fell straight from the shoulders. The bust did not really reassert itself until the 1930s. In the 1960s, designers such as Mary Quant, André Courrèges and Pierre Cardin shifted the female erogenous focus away from the

breasts to the legs and thighs, beginning modern fashion's fascination with extreme youth and the body shape of prepubescent girls. A glance at the majority of the models on any twenty-first-century catwalk would suggest that the large breast has still not entirely recovered.

[6] The brassiere only really became popular in the 1930s. By the 1960s, however, going without a bra had become unusual enough to count as a symbolic gesture. Like the breasts themselves, however, the gesture had a double-edged significance. Feminists urged women to burn their bras, although for all but a few it remained a figurative expression rather than something to settle down to with a box of matches. To get rid of the bra was, in the feminist argument, to turn one's back on the unnatural, sexualized shape that male-dominated society had foisted on women. It was a rejection of male objectification. At the same time, however, fashion designers such as Yves Saint Laurent and Rudi Gernreich – who invented the monokini in 1964 – were using braless and topless models in a blatantly sexual display that they believed struck a blow for feminist freedom. The semiotics of the exposed or undisguised breast remain confused: is it an expression of female power or a pandering to male fantasies?

[4]

[5]

[6]

[1]

[2]

[3]

You could be forgiven for thinking that fashion has forgotten the back. It has rarely been the subject of much attention in the past fifty years. One of the main reasons for this is also the most obvious: the wearer cannot appreciate it. As fashion is at least as much about dressing for oneself as for others, there is little appeal in investing time on decorating a part of the body that is only seen when one is retreating. Yet the back has not been entirely overlooked. It is the largest unbroken area of the body, and therefore an inviting canvas. It is the part of the body that symbolizes hard work ('Put your back into it'). And it is also a subtle sexual sign: the female back is smaller and less triangular than that of the male. In evolutionary terms, the female back shape is associated with rear-entry sexual penetration. The back also links the erogenous zones of the nape of the neck and the top of the cleft in the buttocks.

—

[1] Exposure of the female back in the later twentieth century has echoed designers' experiments with the neckline (see Bust, page 78). In particular, clothes cut lower in the back have tended to coincide with periods when the front neckline has been relatively high, as if providing an alternative cleavage. That was particularly true of Emanuel Ungaro's 1967 jumpsuit, which was cut low enough to expose not only the whole back but also the top of the swell of the buttocks (see Bottom, page 118). Claude Montana was among the later designers who also opened the back of the evening dress and reversed the neckline to call more attention to the exposed flesh. It seemed that, in the sense of having one's cake and eating it, designers were giving women the choice of having both breasts at the front and a suggestion of breasts at the back – an idea that was decisively rejected by women.

[2] Fashion first revealed the back in the early 1930s, the decade when designer Travis Banton dressed Hollywood siren Tallulah Bankhead in a backless number for »Thunder Below«. With Bankhead's sexual notoriety as a stage actress having preceded her move to the silver screen, this was no random gesture of purity. It was charged with sexual significance and heralded

the public acknowledgement of the back as a new erogenous zone by literally opening up an area of flesh normally reserved for the privacy of the boudoir. But Banton was merely expressing a broader trend that probably had its origins in the relentless rise of sport as a key driver of fashion innovation (see Activewear, page 150). Later in the century, women revealed their backs on the beach in swimsuits that were designed to allow easier swimming, quicker drying … and the chance to acquire a newly fashionable suntan (see Skin and Body Adornment, page 18).

[3] Because the back is largely featureless, it is a useful signboard on which to label people whom it is necessary to identify at all times, including police and stewards at major events, for example. It is where we traditionally find the numbers of sports players, although as individuals have become such important and bankable stars, those numbers are more often than not supplemented by the player's name, as if the number were no longer enough. The degree of identification this can achieve is remarkable, with fans choosing to wear a shirt bearing their hero's name rather than their own. When David Beckham joined Real Madrid in 2003, the club shop sold 8,000 shirts with his new number, 23, in just a few hours. In the early 2000s, when cricket – a sport in which traditional white shirts have had no individual identification – sought to improve its public profile, one of the first innovations was the introduction of shirts with names and numbers. And the fans bought them. It's the sports equivalent of wearing a designer's name or logo on the front of a sweatshirt: an attempt to create glamour through association, and raise personal status by the wearer apparently 'belonging'.

[4] In fashion terms, the back is an afterthought. It has the ability to undercut or reframe the initial, front-on, impression created by an individual. Thus it has occasionally been used by more maverick designers as a device to provide a form of ironic commentary on their own business. One of the most successful exponents of this was Franco Moschino, the Italian enfant-terrible who died in 1994. In the late 1980s Moschino's philosophy was summed up in his slogan, 'Stop the Fashion System'. The site for his considered observations on the

**B
A
C
K**

nature of the fashion business – at the time largely banal – was often the back of the garments he made. On the back of a white shirt with long straitjacket sleeves, for example, he printed the message 'For fashion victims only'.

[5] Garments that fasten at the back have been commonplace throughout much of costume history, but are less so today. One reason for this is the decline in private servants, who in the past were always on hand to help lace up the back of a corset or do up the buttons of a dress. Bettina Ballard of »Vogue« recalls Cristóbal Balenciaga helping her husband to fasten a Dior dress with thirty tiny buttons down the back. The frustrated Spanish designer muttered beneath his breath, 'But Christian is mad, mad'. However, impracticality has never been fatal in fashion terms, and there are those who will put up with any amount of inconvenience in order to achieve a perfect appearance unspoiled by buttons (see Convenience, page 176). The first impression, the grand entrance, is what counts. No-one notices the exit. Once the wow factor has been achieved, who gives a hoot what anyone thinks on closer inspection? Fashion is about impact. The fact that the wearer has to be a contortionist to get herself into or out of her clothes is secondary. And in any case, what could be more of an invitation to seduction than a garment that the wearer cannot remove without the help of a partner?

[6] Because the back is usually hidden, it has often been the location of concealed signs. These might be the tattoos of the Japanese mafia, the Yakuza, or the more subtle tattoos that expressed the rebellious nature of upright citizens. (The back was not the only location for this. Winston Churchill had an anchor on his arm, as befits the one-time First Lord of the Admiralty.) The scarification practised by some African and Asian peoples highlights the back's status as an erogenous zone visible – and touchable – only by a sexual partner in certain positions (see Skin and Body Adornment, page 18). In Japan, the female back is considered an important erogenous zone, just as the nape of the neck is (see Neck, page 68). One explanation for the proud collar of the geisha's kimono is that it allows a man to see down the back of her dress when she is kneeling in front of him.

[5]

[4]

[6]

[1]

84

[2]

[3]

Although they may not be sexy as such, the arms are still sexualized in that they are different in men and in women: the male arm tends to be more muscled, the female arm more slender. No one wants short arms or long arms (when knuckles threaten to scrape along the ground in simian fashion). Likewise, no one wants fat arms or old arms. In terms of everyday dress, practicality is the only imperative – above all, the arms need to be free to fulfil their physical role: they work, they balance, they propel. They need to be able to move. In terms of fashion, however, the arms are crucial to the perception of the body; they can help create the impression of a longer or more slender torso.

–

[1] From Popeye and Charles Atlas to today's gym bunnies, the muscled arm has been the symbol of male power, of the martial strength of the warrior, of the authority of the leader, of the determination of the man of action – or of the bully who misuses his physical strength. Women's arms (and the arms of scholars) are more slender, with less defined musculature. Since the early twentieth century the flexed bicep has been the most common symbol of masculine strength: is there any greater symbol of untrammelled masculinity? The exposure of the bicep coincided with the growth of sportswear in the United States, which itself coincided with the rise in popularity of body-building. In fact, the gesture is misleading, as the biceps are nothing like the important muscles when it comes to human power (the largest muscles are in the legs).

[2] Sleeved garments cover the arms; short-sleeved or sleeveless garments do not. That is obvious enough. The decision as to which to wear is often made on practical grounds, such as the need (or not) for protection or warmth. But there is also a symbolic element to the choice: the removal of sleeves from a garment alters its character. Most commonly, in men it emphasizes practicality and readiness for action; in women, on the other hand, it symbolizes a degree of elegance associated particularly with formal- and eveningwear. There are occasions on which bare arms – as is always the case with less formal dress options – would seem

an unacceptable social solipsism: today, the long sleeve remains de rigueur at formal events and for the professions. For women, the sleeve remains an integral element of formality: Queen Elizabeth II never shows her bare arms. When Michelle Obama chose a sleeveless halter-necked top for her first official portrait in 2009, she raised some eyebrows. The garment was not considered formal enough for the First Lady of the United States being photographed in her official capacity.

[3] We live in a world in which bare arms are an everyday occurrence. Throughout most of fashion history, however, the arms have been as hidden as the legs. Men's sleeves have covered the arms down to the wrists, and the same has been true of much women's clothing apart from some evening dresses. From Victorian times until the 1950s, working men such as miners and stevedores sometimes – but by no means always – rolled up their sleeves. No gentlemen ever would, though: it was too obvious a sign of toil and of the weakness that put ease before dignity. The bare arm became associated with manual labour and, by extension, with any hard work. Thus we arrive at the phrase 'to roll one's sleeves up', meaning to prepare for hard work. Though King Henry VIII, Otto von Bismarck or Woodrow Wilson would not have dreamed of exposing their arms in public, more recent political leaders such as Barack Obama and David Cameron lose no opportunity to roll up their sleeves in a sometimes desperate attempt to have people-appeal and youth credibility.

[4] Our arms eloquently reveal our fitness and strength … or betray our ageing bodies (see Skin and Body Adornment, page 18). The older arm in either sex is often none too desirable. The back of the elbow is never attractive at any age; in the old, liver spots are prone to appear on the hands and arms, and the skin becomes looser; the veins become more prominent, the arms thinner and more bony, and the hands more claw-like. In women the so-called 'bingo wings' at the tops of the arms begin to sag and wrinkle. The sleeve thus hides a multitude of sins, and it is unusual for older women to expose their arms above the elbow (in men, the sleeve covers sagging muscles, coarse hair or ill-advised tattoos).

ART DECO POSTER FROM FRENCH MAGAZINE »LA VIE PARISIENNE«, 1924

[5] Having hairless armpits is a modern invention in the West and even today has only a limited cultural range: in many countries it barely occurs. (In Muslim countries shaving has been a religious act since the seventh century, following the Prophet's doctrine of »fitra«, which involves removing hair from the body.) In the West, it came into being soon after the outbreak of World War I in 1914, when cosmetics companies began to advertise depilatory powder for women. They used an advertising campaign calculated to prey on social insecurities, portraying underarm hair as unfeminine, unsightly and – perhaps most powerfully – unhygienic. Armpit hair, the suggestion was, made it more difficult to prevent sweat and odour (in fact, biologically the hair helps to take sweat away from the skin, and reduces the bacteria that cause a smell). Bare armpits really became fashionable, however, when Gillette and other manufacturers of safety razors put their weight behind the campaign in the 1920s. They knew that if they could persuade women that shaving the armpits (and the legs, for that matter) was a sine qua non of femininity, they would double their target market overnight. And that's exactly what happened.

TATTOOED WOMAN, 2010S

[6] In the nineteenth century, tattoos were virtually unknown in the West outside the military and sailors, and were confined entirely to males – hence the fascination with the tattooed lady, a staple of fairgrounds and freak shows. Tattooed women got inked as a means to making a living. Upper-class men and women began to take more interest in tattoos, however, and in the 1920s the fashion for exposed tattoos among women socialites coincided with the aftermath of the suffragette movement and the empowerment of women. Women had themselves tattooed for a reason: to rebel against social expectations of what was feminine. The same remained true in the 1960s and 1970s, when women again questioned what it meant to be feminine in a male-dominated society. In the 1980s, female tattoos generally became limited in size and were confined to hidden sites, such as the wrist, ankle or shoulder. In the 1990s, the enduring influence of punk and the influence of popular music and Hollywood, together with a more independent attitude among women towards their own bodies, led to female tattoos becoming, if not mainstream, then more widespread. By 2012 female tattoists such as Valerie Vargas, Saira Hunjan and Kat Von D had broken into a previously entirely male world, partly because they appealed to what turned out to be a broad swathe of women seeking their own skin decoration.

'I can never bring you to realize the importance of sleeves, the suggestiveness of thumb-nails, or the great issues that may hang from a boot-lace' – SIR ARTHUR CONAN DOYLE, »The Adventures of Sherlock Holmes«, 1892

[5]

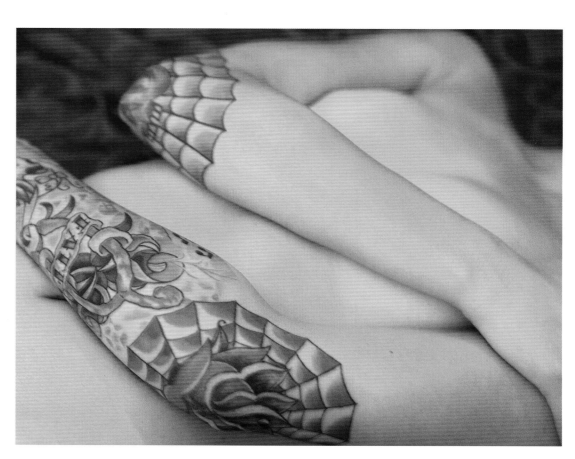

[6]

86

[2]

[3]

[4]

Sleeves are famously where we wear our hearts when it is impossible not to display our feelings. They are also what we laugh up when we take private amusement at another's misfortune. We also like to have something up our sleeves in case of emergency. The phrase does not refer to magicians who produce bunches of flowers – they have nothing up their sleeves; instead it reflects fashion in the Middle Ages, when sleeves were wide enough to be used for carrying items around in. For a part of clothing that is prone to be overlooked, the sleeve has a long and tangled history, rich in symbolism. It has been long and short, plain and fancy, wide and narrow, and sometimes a combination of extremes: think of wide sleeves cinched at intervals by hoops or ribbons that bound them tight to the arm. In skilled hands the sleeve – even when absurdly long or wide – is an integral part of a garment that subtly influences the perceived volumes of the body; in other hands, it is an add-on, an inconvenience that the designer could well do without and one that large parts of the world have done without for much of history. In the ancient societies of Assyria, Egypt and Greece, draped garments hung down over the arms from the shoulders. Sleeves were considered a sign of barbarism by the 'civilized' cultures of ancient Sumer. They associated them with the dress of the peoples who lived in the mountains that rose to the north and east of the alluvial plains, where the colder temperatures made sleeveless draped garments impractical.

–

Sleeves can be cut in different ways. The most practical form follows the shape of the arm as a reasonably well-fitting tube of material (perhaps with a little extra material on the outside of the arm to accommodate the flexing of the elbow). It may be of various lengths, and end in cuffs, turn-backs or a simple hem (see Wrists, page 88). Such a sleeve's main purpose is to protect the arms, either from the cold or from scratches and blows (this is particularly important because major blood vessels run close to the surface of the arm). However, the length of the sleeve also reflects other concerns. The long sleeve is a sign of modesty and formality.

The short sleeve – as on a T-shirt – is cool and allows full freedom of movement but still covers the shoulders and underarms, traditionally seen as undesirable largely because they produce sweat. The three-quarter-length sleeve displays the delicacy of the female forearm and hand (it is worn almost exclusively by women). The cap sleeve is often a sign of masculinity, which emphasizes the width of the shoulders and the size of the biceps. The absence of sleeves, such as in a vest or singlet, is largely a matter of convenience – it is cool – but also highlights either the strength of the male shoulders or the relative slenderness of the female's.

There have always been those who wish to flaunt their lack of practicality, and for them the sleeve has often grown to huge proportions, either at the shoulder or at the wrist. The fourteenth-century cote-hardie had sleeves that were tight to the elbow but then widened to a wrist that could hang to the knees (in the next century, tippets or ribbons hung from the wrist and could reach the floor). Puffed upper sleeves, or leg-of-mutton sleeves, meanwhile, were so large in the 1830s that they were sometimes supported with cushions. All of this manipulation was geared towards one thing: display. Only those who were not working with a plough or a cooking pot could wear such exaggerated clothing, and only those with money could afford the yards of unnecessary material. Just as much as choice of material or decoration, the cut of a sleeve was a social indicator.

There have been numerous periods during which the main purpose of the sleeve was to display what it supposedly concealed: the clothes worn beneath. This was more often than not a chemise, which for the wealthy was made of luxurious linen; crisp and relatively clean. The sleeve was slashed or cut to reveal the chemise beneath, or it finished near the elbow in order to reveal longer sleeves beneath or lace ruffles at the cuffs, as in the mid-sixteenth century. The most direct descendant of such a display of underwear came in the form of the punks of the 1970s, who again tore their clothes in order to emphasize the layers beneath or who wore deliberately short coats or tops to display what would normally be hidden (see Punk, page 218).

[4] As trade flourished among the Italian city-states in the early part of the Renaissance, so luxury became more evident: in homes, in art and in how people dressed. One prime focus for lavish decoration in costume was the sleeves, which could be highly decorated with brocade, embroidery, gold and silver thread and wire or precious stones. Often the sleeves were detachable, allowing the wearer to demonstrate even more clearly his or her immense wealth by displaying different pairs. To that extent the sleeves can be seen almost as the equivalent of modern jewellery: little but a demonstration of wealth, taste – and fashion-consciousness. By the sixteenth century the sleeve had become such a status symbol that men's coats might have double sleeves in different colours, with one pair hanging loose. These »Schaube« – the term is German – became de rigueur for courtiers. Such a style remained associated with status: the vestigial sleeves are still echoed in the academic gown worn on formal occasions by scholars.

[5] The original purpose of making sleeves so long that they overhang the hands was probably to provide protection from cold: the sleeves could be pushed up or pulled down. This practical application was, however, coupled with the opposite result: sleeves that dangled loosely at the ends rendered the hands useless. Garments with extravagant lace cuffs in which the fingers could not even be seen could not have proclaimed more obviously: 'I do not belong to the world of manual labour.' The punks took the style to its logical conclusion, losing their hands in the extra-long sleeves of their straitjackets. The New Romantics and Goths who followed also adopted the flounces of the over-long sleeve, this time in an anachronistic re-creation of the louche styles of the Romantic age.

[6] For women, the puffed sleeve has a demure quality that we have become used to; it suggests modesty and girlishness. 'Puffing' has appeared frequently throughout fashion history, particularly at the shoulder or the forearm. The butterfly sleeves of the 1930s, the Laura Ashley dresses of the 1970s, even the puffed sleeves re-introduced by Frida Giannini after she joined Gucci in 2006, have something innocent about

them (see Romantic, page 222). For one thing, they are a conscious throwback to childhood (a similar thing happened in the 1820s, when the Romantic movement inspired a fashion for puffed shoulders that was thought to echo the Renaissance period, before European life – and fashion – had been derailed by industry and commerce). For another, they tend to remove the emphasis from the body, making it appear leaner and more youthful. Not that they are totally without sex-appeal: it could equally be considered that such exaggeration suggests a heightened femininity. In fact, fashion considers the puffed sleeve jejune and lacking in style. If a highly sophisticated social manipulator like Muiccia Prada uses them, it is with a post-modern irony such that they are not even noticed by the average shopper.

[7] Most sleeves attach to a garment at the armholes; the raglan sleeve is attached directly to the collar, with a seam running down to the armpit. It takes its name from the unfortunate first Baron Raglan, Lord FitzRoy Somerset, whose arm was amputated after he was wounded in the Battle of Waterloo in 1815. Raglan's tailor began using the new style of sleeve, which was looser and more comfortable (it also, incidentally, requires less tailoring skill to create than a regular sleeve). The sleeve has the advantage of being looser than a normal sleeve, allowing the arm to move freely in all directions, which makes it particularly suitable for sportswear and maternity wear; it also creates room for bulky undergarments.

»PORTRAIT OF A GENTLEMAN OF THE ENGLISH COURT«, HANS EWORTH, 1546, OIL ON PANEL

»TWO WOMEN IN EVENING GOWNS BY MAINBOCHER«, EDOUARD GARCIA BENITO, 1952

MODEL IN STRAW 'PICTURE HAT',
PHOTOGRAPH BY EDWARD STEICHEN, 1924

HUMPHREY BOGART, 1940

'To say yes, you have to sweat and roll up your sleeves and plunge both hands into life up to the elbows' – JEAN ANOUILH, 1944

[5]

[6]

[7]

[1]

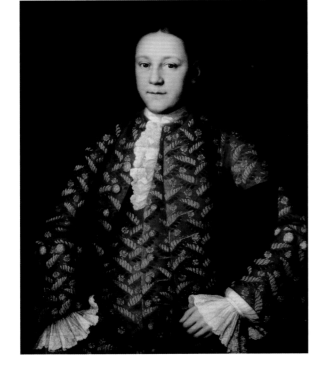

[2]

[3]

Like the arms and hands, the wrists tend to be thicker and stronger in men than in women – but both sexes have an impulse to decorate them. In part, this reflects the fact that the wrists can be safely adorned without affecting the remarkable mobility of the hands. But the wrists also have a psychological significance, and thus an almost magical power, as one of the narrowest and most vulnerable parts of the body. They are one of the few places where the blood passes close enough to the surface of the skin to make the pulse – the life force – accessible. This explains the wrists' association with good-luck symbols such as charm bracelets, which began among high-status ancient Egyptians, who wore bracelets to guard them against the evil eye. The bracelet itself is endless, and therefore a symbol of infinity or eternity; in Hindu religious services, worshippers tie bracelets of coloured wool around their wrists as a symbol of being blessed. The shape of the shirt cuff meanwhile echoes the protective cuff of the knight's gauntlet in the Middle Ages.

–

[1] The history of the cuff reflects the origins of the shirt as underwear; a private piece of clothing. But things slowly changed as linen became seen more as a status symbol – fuelled to a degree by the increasing extravagance of the ruff (see Neck, page 68). It was in the 1500s that small ruffles began to appear at the wrists of men's clothes; they usually drew the sleeve together with narrow strings or ribbons. As the cuff evolved and grew to cover the backs of the hands, nothing proclaimed more clearly that a man was a gentleman who never had to do manual work. For the less exalted, as shirts emerged from beneath coats and jackets, cuffs served a practical purpose: they prevented the sleeve material from fraying and were replaceable, allowing a shirt to be pressed into longer life. Single and double cuffs – folded back over themselves – were often detachable, for easy cleaning and starching (soft cuffs required no starching). When designers send models down the catwalk today with sleeves hanging down over their hands, they are echoing the studied uselessness of eighteenth-century nobles: 'Look, no hands'.

[2] Both sexes traditionally adorn the wrists, but bracelets and other jewellery have become largely a female trait. Men have one non-effeminate option: the wristwatch, and so watches have become the ultimate male jewellery. They are far larger than necessary for merely telling the time; they may be chunky or slender, depending on the style; and they link the men who wear them with a tradition of train guards, aviators and secret agents. The ultimate status symbol is the number of complications: the number of unnecessary functions a watch has in addition to telling the time, such as noting whether it is day or night or tracking the phases of the moon. Luxury watches frequently cost more than most cars and some are more expensive than a small fleet of family saloons. The reverso emerged after World War I to give men one dial for daytime and a more sophisticated dial to enhance evening dress. A few aficionados have worn their watches over their shirt cuffs, including the Italian playboy and industrialist Gianni Agnelli. Watches have become the ultimate accessories of affectation, associated with the crude display of labels: consider how many would pay huge sums for a watch that, although it told perfect time, was free of all branding?

[3] The charm bracelet has its origins in the amulets and bracelets worn for their magical powers by ancient Egyptians. It has been in fashion since then, particularly when promoted by Queen Victoria in the mid-nineteenth century and again during World War II, when charms were popular souvenirs given to wives and sweethearts by servicemen returning from various theatres of war. Today its link with magic and protection is tenuous, although it is still added to with new charms marking important rites of passage. The charms themselves tend to be traditional, and the investment accumulated by adding more charms to a bracelet may indeed be financially lucky for the wearer when she reaches adulthood. The fashion for proclaiming one's support for charity in the shape of a bracelet has something to do with the assertion of identity: the yellow wristband of Lance Armstrong's Livestrong charity remains popular, despite the cyclist's spectacular fall from grace for doping. The bracelet serves another purpose: to

emphasize the slenderness, and thus the femininity, of a woman's arm and wrist. However, bracelets have also been derided by some women, who declare that they in fact symbolize the manacles of female oppression.

[4] The mitten cuff, which pulls down over the hands to protect them, has a pedigree both military and male. Beloved of pirates, for whom it was useful to pull down to protect the hands while on deck, it continues the tradition begun by gauntlet cuffs in suits of armour, which protected a part of the body that was obviously vulnerable during a sword fight, the veins of the wrist being the most vulnerable in the body as they are the closest to the surface of the skin. As armour became obsolete, the wrist was protected by wide bands of leather which were to become a standard item for men who worked physically hard in demanding manual labour (see Armoured, page 162). In recent years, the bands have studs or even nails embedded in them as a proof that the wearer – often a biker or member of a leather cult – is as hard as his bracelet (see Alienated, page 154).

[5] The cufflink might seem to have a longer and more exalted pedigree than the humble button. It suggests class, heritage and formality. But this appearance is deceptive: it was in fact invented as a consequence of mass production in the nineteenth century. The Victorians' reputation for moral rectitude may not be entirely deserved – the era witnessed a little-known explosion in the availability of pornography, for example – but it does have some justification when it comes to clothing. 'Starch is the man,' Beau Brummell is reputed to have declared before leaving the country in 1816 to avoid debtors' prison; and so it continued to be. The starched collar and cuff were the sine qua non of Victorian good taste (see Dandy, page 182), and a starched double cuff was too stiff to be buttoned. Manufacturers mass-produced the cufflink (so called because it linked the gap between the two edges of a cuff), previously a rare device worn only by a few nobles, which was quickly co-opted by the upper and middle classes. The cufflink came in various shapes, from squares and lozenges of metal to balls of thread, and it was worn by Gibson

girls and secretarial clerks just as much as men. Cufflinks remained the norm – most shirts did not come with buttons – until the 1920s, when they began to disappear; the rise of casual sports shirts brought back the soft cuff. But even today a Jermyn Street bespoke shirt will have double cuffs, which can only be fastened with links, unless the client specifies button cuffs – to the pain of the shirtmaker.

[6] The digital breakthrough of the 1970s, which left everyone wearing futuristic Pulsar watches, seemed about to spell the death of the traditional clockwork wristwatch. Instead, an obscure Swiss watchmaking company looking for a new market came up with one of the most influential fashion innovations of the last thirty years: the Swatch. The Swatch was a return in many ways to the vogue for portable timepieces in the late nineteenth century, which had been fuelled by cheap manufacturing. Every head of the household, even in poor homes, and every young man about town saw a pocket watch as almost a symbol of masculine propriety – it was the 'must have' item of the period. The Swatch – accurate, bold, lively, youthful – was affordable enough to become a 'must have', enabling young people to own more than one, to change them according to their mood, and even to wear several at the same time.

TWEED WINTER COAT WITH GAUNTLET CUFFS BY VALMAJOR OF LONDON, 1949

BUSINESSMAN WEARING DOLLAR-SIGN CUFFLINKS, 2000S

MODEL WEARING SWATCH WATCHES, C.2012

'I really think that American gentlemen are the best after all, because kissing your hand may make you feel very good, but a diamond and sapphire bracelet lasts for ever' – ANITA LOOS, »Gentlemen Prefer Blondes«, 1925

[4]

89

[5]

[6]

People have been adorning their hands for at least 6,000 years, with painting, tattooing, jewellery or nail decoration. For much of that time, certainly before mirrors became commonplace, the hands were the part of one's own body that could most easily be seen and appreciated. Our hands are among the most remarkable of anatomical features, with flexibility far greater than any other primate. They are also incredibly sensitive, particularly on the palms and the fingertips, yet they necessarily touch all kinds of unclean things. For that reason, ancient peoples used tattoo or paint to protect them from evil spirits entering the body. Most modern clothing of the hand continues to reflect either practical protection or decoration linked to symbolism.

–

[1] The ideal male hand is broad and strong: it looks suitable for manual labour. In females, the ideal hand is delicate and slender. There is an anatomical reality at the heart of this contrast of ideals. The female hand is generally smaller than the male's, and more flexible. Evolutionary biologists suggest that this difference was made more pronounced by the labour division in early societies, in which men were hunters who carried and threw weapons, while women performed far more intricate tasks associated with gathering roots and berries or, later, planting and tending crops. The power of the male hand is exemplified by the hawker's leather gauntlet or the boxing glove. It recalls the legend of the Gaelic leader Nuada, who lost his hand in battle – and thus temporarily his kingdom, because his people insisted that their king be physically perfect. It was only when Nuada acquired a silver replacement that he was able to reclaim his position.

[2] The fingernails have a practical purpose, protecting the sensitive fingertips and providing an alternative to them for feeling a surface; fashion has little interest in such a quotidian role. In fashion terms, the nails are useful for extending the length of the fingers, thus making the hand seem more slender, or for calling attention to the sexual symbolism of the hand, which is after all often key to arousal – of oneself

and others. Fingernails were first polished or decorated some 5,000 years ago, in Egypt and among the cultures of India. Frenchwomen in the eighteenth century popularized the French manicure – pink on the nail, white on the tip – as a kind of 'more-natural-than-nature' statement. In the late twentieth century scarlet nail varnish became a standard element of male fantasies of domination (more scarlet nail varnish is sold in late November and December than at any other time of the year, reflecting the modern role of Christmas as a sexy and abandoned time). In the early twenty-first century, open artifice was flaunted with the boom in artificial nails. Now brightly patterned nails, often of absurdly impractical length, are the birthright of any young woman; the craze seems particularly fashionable among young urban black women, who often have nails an inch or more long decorated with diamond studs.

[3] Virtually all hand jewellery is today considered inherently effeminate, possibly because it is seen as interfering with the male capacity for manual labour. There are only two exceptions: the wedding band and the signet ring. The wedding band, usually plain and no-nonsense, has its own symbolism as a sign of betrothal and commitment – and of sexual possession. The signet ring carries echoes of centuries of male power. Its flattened engraved face is the relic of the seal once used by high officials to stamp their imprimatur in wax, thus making a document official. It is at heart the most masculine of adornments, perfectly suited to a conformist stickler who fears the flamboyance associated with more expressive forms of decoration (see Authority, page 164).

[4] The ring is used to mark a marriage – a custom begun by the Romans – supposedly because it is infinite, and thus a symbol of never-ending love. This is possible, of course, but not necessarily true, given that until relatively late in history marriage was a largely dynastic or economic transaction, undertaken to cement bonds between families rather than because of personal affection (not that affection didn't often follow). Today the wedding ring is deliberately plain and yet traditionally made of precious

metal; it is a sign of steadfastness
and loyalty and a social signifier
that its wearer is unavailable
to others. By contrast, the modern
gangsta rapper wears multiple rings
that are anything but a sign of
constancy: they are an exaggerated
expression of a rejection of social
values and modesty and a flaunting
of wealth and attitude. They also
carry an echo of the knuckleduster
by calling attention to the fist
and the damage it can inflict
(see Aggressive, page 152).

[5] 'What coarse hands he has,'
says Estella of Pip in »Great
Expectations« by Charles Dickens.
Hands are everywhere in the book
as signs of what characters are
really thinking – or of what
they really are. As exploited by
Dickens, the hands are the giveaway
sign of social status. The hands
of the lower classes – what Pip,
mortified by his first experience of
Estella's high-bred disdain, comes
to see as his 'vulgar appendages'
– are rough and reddened; those
of the wealthy are kept smooth
and delicate, and never allowed
to be burned by the sun. In some
Asian cultures a similar sign of
the renunciation of work is the
spectacularly long fingernail.
This might be on all the fingers
or, more characteristically, it
might be in the form of a single
extraordinarily long nail, as worn
by an Indian ascetic. Either way,
it reflects a different world from
that of the toiler with short,
broken nails and rough skin.

THE
BODY
ANATOMIZED

ALABAMA TENANT FARMER, PHOTOGRAPH BY DOROTHEA LANGE, 1936

'Manuel showed her his open hand: "Look at this finger, how meager it seems, and this other one no stronger, and this one all by himself and on his own."
Then he made a fist: "But now, is it strong enough, big enough, solid enough? It seems so doesn't it?" – JACQUES ROUMAIN, »Masters of the Dew«, 1946

Now every woman can have nails that look lovelier...<u>longer</u>!

Exclusive cream formula puts longer-lasting beauty at your fingertips...*without constant touch-ups!*

Something wonderful happens to your nails with Revlon Nail Enamel. Suddenly, they're *beauties*—transformed by Revlon's fabulous color flattery. *And without constant touch-ups.* Revlon's cream formula makes the difference! It *moulds* to your nails, *flexes* with them— for greater chip-resistance. For longer-lasting, lovelier manicures, get Revlon Nail Enamel.

Have you tried 'Frosted'? When you're in the mood for glitter at your fingertips, Revlon Frosted Nail Enamel is it!

Cream Nail Enamel .65*
Frosted Nail Enamel .75*
*plus tax
© 1957, REVLON, INC.

Revlon Nail Enamel in 33 fabulous colors

91

[4]

[5]

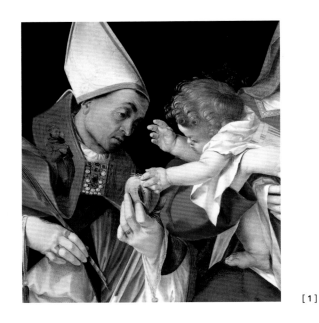

[1]

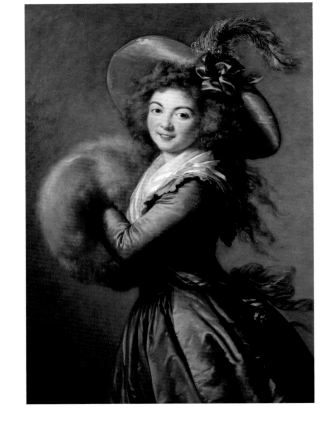

[2]

[3]

92

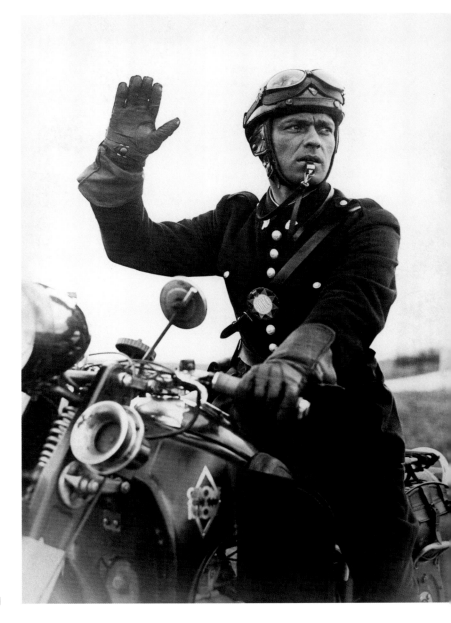

[4]

Hand coverings come in various forms. The basics are the glove – with individual sheaths for each finger and thumb; the mitten, which has a single pocket for all the digits, possibly with a separate sheaf for the thumb; the gauntlet, which has a long cuff covering the forearm; and the muff, a tube of fur or some other insulated material that covers both the hands. Such coverings are necessary for all sorts of reasons. The palm and fingers are highly sensitive to the cold and also to cuts and bruises. The hands are often dirty and transmit infection and disease; they are covered to keep them clean with washing-up gloves, surgical gloves, gardening gloves and so on. But covering the hands is not purely practical; it also has an element of allure. Wearing gloves that are not strictly necessary draws attention to the hands and wrists, which form a secondary erogenous zone because they are the part of the body with which we most frequently come into contact with others. That is why wearing gloves is often seen as a formal gesture, because it is a physical barrier between individuals.

–

[1] Gloves are ancient. A fresco at Knossos on Crete shows Minoan youths boxing in gloves. The Greek writer Xenophon recounts the Persians wearing gloves against the cold. Homer's »Odyssey« records Laertes working in the garden wearing what are probably gloves to protect his fingers from brambles. In most southern climates, however, the male glove retained something of a stigma. Xenophon saw them as proof of the Persians' effeminacy. The first-century Christian philosopher Gaius Musonius Rufus condemned gloves as a sign of worldly corruption: 'It is shameful that persons in perfect health should clothe their hands and feet with soft and hairy coverings.' In the colder north, perhaps inevitably, the glove was questioned less and its necessity more accepted. By the ninth century, gloves were universal, and by the tenth century the glove had become part of the trappings of the clergy, worn during Mass – either as a conscious element of pomp or for the simple purpose of keeping the hands clean for contact with the valuable artefacts involved – as well as a symbol of the temporal power of kings.

[2] The muff was particularly popular during the seventeenth century, when it was carried by both sexes not only to keep the hands warm but also to use as a pocket in which to store valuables (see Portability, page 94). Its origins may have been far older: the word »muffulae« came from medieval Latin and referred to a garment to warm the hands, but whether this was a tubular muff or a form of glove is not clear. The tubular muff emerged in Italy in the 1570s and spread from there to France and beyond. Most muffs were cloth decorated with ribbons, often lined with fur, but in the middle of the century the fashion changed to having the fur on the outside. Paul Poiret brought back the muff for women in the early 1900s, but soon afterwards the cheap, readily available, mass-produced glove had won the battle for supreme carer of the hands.

[3] Most people in temperate to cold climates have a memory of wearing mittens at school, perhaps with the long string that connected the two mittens running up inside their sleeves and over their shoulders. Mittens were far easier and therefore cheaper to make than gloves, and so became limited mainly to children and to the lower classes. To acquire a pair of gloves was to proclaim that one was upwardly socially mobile. The mitten was one of the earliest forms of glove – almost certainly dating back to classical times – but has since been left behind, rejected and ignored by fashion once gloves became cheaper to manufacture and available to all. Now mittens are only widely worn by adults in lands so cold that warmth is the only requirement, where people understand that, by reducing the surface area of the hand and fingers and allowing the fingers to touch one another, mittens actually hold warmth more efficiently than gloves.

[4] The extended, flared cuff of the gauntlet emerged in the Middle Ages as an essential part of the armour that protected the hand and the wrist from blows both in combat and also in potentially harmful pursuits such as falconry or archery (see Armoured, page 162). Although the gauntlet could be made entirely of leather – like the gloves still worn by falconers to protect their wrists from the birds' talons – it was more often made of iron or a combination of both, providing protection

HANDS – PROTECTION

and flexibility. The key was that the cuff could be pulled up over the end of the sleeve of chain mail or armour, so that no flesh was vulnerable in hand-to-hand fighting. Today, the style is mainly associated with practical uses – in fencing, for motorcycle gloves or those worn by welders and workers such as butchers. In fashion terms, however, the gauntlet's flare can add a touch of drama and glamour, as in the seventeenth century when cavaliers' sleeves often had flamboyant frills of lace that covered much of the lower forearm (see Arms, page 84).

[5] For women of any but the lowest classes, gloves were part of everyday wear until the 1950s. To that extent they were, along with hats – also universally worn, even by women working in offices – part of the carapace of formality constructed by men who were still subconsciously wary of the dangers of introducing unconstrained women to the masculine environment. The editors of fashion magazines wore theirs unselfconsciously in their offices, and many of the grand magazines actually had an employee whose title was 'glove editor'. Outside of work situations and the cold seasons, the passing of formality has largely killed off glove wearing. In his 1997 novel »American Pastoral«, Philip Roth used a failing New Jersey glove factory as an inspired metaphor for the changing nature of modern society at the end of the 1960s.

YOUNG HOUSEWIFE SHOPPING, 1950S

[6] The fetishistic appeal of common glove-making materials such as leather, suede and especially rubber is well known. Perhaps the most blatantly sexual gloves are the long over-the-elbow opera gloves, often worn with jewellery outside them, in which the glove is like a tight sheath but is still allowed to wrinkle attractively over the arm. In kidskin or silk, these gloves are the height of elegance (it is interesting to note that the individuals most responsible for promoting their popularity in the past – Napoleon's empress Josephine and the Edwardian actress Lillie Langtry – both wore them for the simple reason that they found their hands and arms, respectively, unattractive). They are a fashion that works only when short-sleeved or sleeveless dresses are the vogue, and so today are exclusively associated with eveningwear.

ENGLISH ACTRESS LILLIE LANGTRY, PRINT FROM »CELEBRITIES OF THE STAGE«, 1899–1900

AT THE PREMIERE OF »TO CATCH A THIEF«, LONDON, 1955

[7] A fan once asked James Joyce, 'May I kiss the hand that wrote Ulysses?' 'No,' demurred the great author. 'It did a lot of other things, too.' The hands are inevitably associated with dirt – not least because of their role in cleaning the bottom. In ancient societies, tattoos and painting helped protect the hands from evil spirits that might enter them from contact with dirt; today, gloves are the new form of protection, not from the evil eye but from germs. That links the gloves issued by employers in the nineteenth century to ensure that their servants' hands were clean with the surgical gloves worn by doctors in the operating theatre. Among the few women who still habitually wear gloves is Queen Elizabeth II. The gloves add protection when she shakes hands with her subjects on a royal walkabout (see Regal, page 220). One of the first changes made to protocol by Princess Diana when she began royal duties was to abandon the wearing of gloves; she explained that she wanted to be able to touch the people she met.

ACTRESS GINA LOLLOBRIGIDA MEETS QUEEN ELIZABETH II

[8] The glove that appears to serve little or no purpose is a well-attested fashion statement. One thinks particularly of Michael Jackson's white-sequinned glove, worn on one hand and widely imitated in tribute after the star's death in June 2009. Jackson was reported to have believed that one glove was 'cooler than two'. But Jackson was no trendsetter when it came to the impractical glove. Gloves, like hats, have the effect of calling attention to the very parts of the body they are concealing, so their symbolism is highly complex. Hence the delicate crocheted half-gloves worn even indoors by spinsters in the nineteenth century, whose fishnet patterns, they hoped, revealed enough flesh to suggest allure, or the lace gloves adopted by the New Romantics in the early 1980s (see New Romantic, page 212).

MICHAEL JACKSON, MADISON SQUARE GARDEN, NEW YORK CITY, 2001

'When he killed the Mudjokivis / Of the skin he made him mittens / Made them with the fur side inside / Made them with the skin side outside; / He, to get the warm side inside / Put the inside skin side outside / Why he turned them inside outside / Why he put the skin side outside / That's why he put the fur side inside / Put the warm side fur side inside / Put the cold side outside / He, to get the cold side outside' – ANONYMOUS, 'The Modern Hiawatha'

[7]

[8]

[1]

[2]

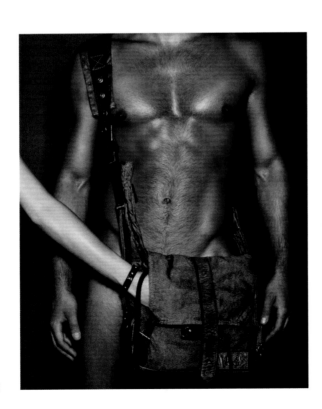

[3]

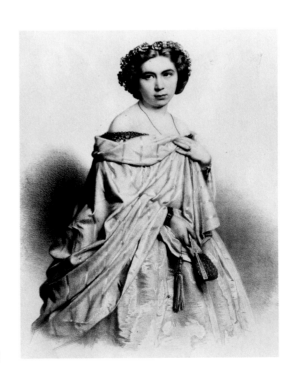

[4]

Pockets and bags were for centuries virtually untouched by changes in fashion. Not having pockets, which require extra time and fabric to make, was hardly a handicap when people had few possessions to carry around. However, when they did begin to accumulate goods of value, such as shells or precious stones, people wanted to carry them: as ornaments; for security; in order to display their status; and as currency – nearly always around their necks. In the same way, modern trendsetters clasp their smartphones as prominent and valuable status symbols.

–

[1] From the fourteenth century, the chatelaine (the female steward responsible for running Europe's grand houses) made carrying things a badge of status. The keys hanging from her belt showed that she was in charge. Today, the link between status and portable possessions continues with icons such as the Hermès Kelly bag, first made in the 1930s but in 1955 renamed to celebrate the wedding of Grace Kelly to Prince Rainier of Monaco, and the Birkin bag of the 1980s, named after the actress Jane Birkin. Rising above more frequently changing fashions, the bags remain highly desirable – and highly expensive. Each Kelly bag has 2,600 hand stitches, and takes about 18 hours to make. Handbags are now, along with shoes, the highest-status items in fashion – not least because they often bear an easily identifiable maker's name or mark. Rivets, chains and metal clasps have been revived in a subconcious link to the past, when saddle bags were part of a gentleman's paraphernalia. Status bags from companies such as Prada, Louis Vuitton, Chanel and Dior frequently have an equestrian theme … and sometimes cost more than a pony.

[2] The first bags were no more than pieces of cloth or animal skin tied at the top to form a pouch, called a purse or pocket. They hung from a girdle around the waist outside the clothes but were later hidden inside, to baffle thieves. The first pockets were merely slits cut into the breeches to allow access to bags inside the clothes. In the eighteenth century women wore their pockets on belts beneath their clothes, and accessed them through slits in their gowns or

petticoats, before dresses became straighter in the 1790s – pockets would have ruined the clean lines. At about the same time as women began to use reticules (small drawstring handbags), the first sewn-in pockets appeared in male trousers. These pockets come in two main forms: the besom pocket, which is sewn inside a garment and accessed by a slit, and the patch pocket, which is sewn to the outside of the garment. Pockets have appeared at the front and back of trousers, inside and outside jackets, on the hips or thighs or further down the leg, and with or without flaps, buttons or zips.

[3] Bags for men were largely confined to the professions in the form of briefcases and satchels, and subsequently changed little before the 1980s. The great bag makers remain the firms that grew out of saddlery: Hermès, Louis Vuitton, Prada and Gucci. The techniques of saddlery – leatherwork, straps and buckles, using rivets and studs to reinforce joins – still form the basis of their business. The idea that bags should change like fashion items comes from sports, with the need to carry around a bag that was cheap enough to be used for dirty kit and thus to be regularly changed. The sports connection gave sanction to the man bag – initially despised by all but 'la dolce vita' Italians who wanted the lines of their clothes to be sleek and smooth as they whizzed around on their Vespas, despite its masculine lineage through nineteenth-century postmen, messengers and military envoys. In canvas or leather, the courier bag has almost entirely superseded the briefcase for any man under 35.

[4] Some clothes have no room for pockets, so there has always been a need for small bags like the reticule, carried by women with their diaphanous Grecian dresses after the French Revolution. Bags remained generally small – a middle-class woman rarely travelled far from home and needed little more than a handkerchief, some small change and perhaps some smelling salts or a vial of perfume in case she was overcome by too much contact with the poor. Or, if she were wealthy, she would have a servant to carry things for her. The poor had few possessions and therefore little need for pockets or bags. A wallet for a man and a wicker or canvas basket for a

PORTABILITY

woman were all that was needed for much of history. The introduction of the modern large handbag around 1900 coincided with the fashion for the hobble skirt, another style that does not permit pockets.

[5] The multiplicity of pockets reflects fashion's fetishization of all things military (see Military, page 210). Field uniforms evolved to enable soldiers to carry as much kit as possible. A joke of World War I had a boy asking his father what a soldier was for. The answer was 'To hang things on, my son'. Field uniform is the direct ancestor of cargo pants, with their multiple pockets, the vast majority of which are unused (or even unusable). The style of wearing a bag strap across the chest rather than over the shoulder is another military echo, essential for a horse-riding messenger or a despatch rider, but less so with a DJ bag on the streets of London. The Sam Browne officer belt, which included a diagonal leather strap looping over the shoulder, emerged to steady a sword scabbard, but had D-rings added to enable other equipment to be hooked on; the same belt proved equally practical for the heavy revolvers carried by officers in World War I.

[6] When then chief executive of Apple Steve Jobs reached for the fob pocket inside the right-hand pocket of his jeans at a launch in 2005, saying 'I always wondered what this pocket was for,' he pulled out the brand-new iPod Nano. The fob pocket has gone twenty-first century. The original purpose of the fob pocket was to hold a watch. With the rise of portable timepieces in the 1400s and 1500s, men had pouches set into their hose or breeches to carry them around. The fob watch and chain remained popular until they were rendered obsolete by the rise of the wristwatch in the 1920s, designed for World War I fighter pilots to enable them to see the time with a flick of the wrist, and later civilianized. But men's fashion is often deeply conservative, and so the fob pocket is still part of many waistcoats … and of most jeans. That it is rarely used does not matter: as early as the sixteenth century, the pockets on fashionable justaucorps at the French court were lowered to near the hem of the coat – well out of arm's reach for the wearer – simply to add another element of decoration disguised as something with a practical purpose.

[7] Eveningwear is more glamorous than daywear: more luxurious fabrics, more spangle, more allure – and less practicality. When Cinders was changed into a princess, she didn't want to worry about where to keep her keys, change and hankie. Like ball gowns, couture garments often lack pockets that would interrupt the designer's line even when empty. The solution is the clutch, a purse designed to be held in the hand (it is small enough to be placed discreetly on the dinner table, but too large to be easily removed by a thief). Unlike the everyday handbag, it lacks a shoulder strap, which would play havoc with ruffles or rub against bare shoulders.

[8] The briefcase has always been associated with authority. When it appeared in the fourteenth century, it was known as a budget, from the Latin »bulga«, meaning 'leather bag' (the budget is named for the bag – now a red box – that contained the documents). The case was a limp, satchel-like bag with a handle, used to carry papers and valuables. In the middle of the nineteenth century, it acquired a hinged metal frame at the top, based on that of the carpet bag. The briefcase got its name from its popularity among lawyers for carrying papers to court. A more box-like version popular among diplomats became known as the attaché case, while a handleless case carried under the arm was named the portfolio.

[9] Like draft animals, humans use their shoulders to lift heavy weights; various types of backpack have been used since early times, originally made from animal skins. The duffle bag was a cylindrical sack closed at the top with a drawstring and carried over the shoulder. Its name came from the Belgian town of Duffel, where the original cloth for the bags was made in the seventeenth century. Sailors who used the cloth for sails realized that its close weave made it waterproof, and began to make simple bags for taking belongings onboard ship. In World War I military forces issued the bags as standard: they had the advantages of being capacious, easy to secure and easy to stow. They were not easy to carry, however, and in 1943 the US military added two webbing straps to go over the shoulders, so that the bag now resembles a more traditional backpack, spreading the weight more evenly.

[5]

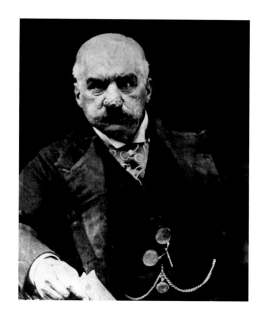

[6]

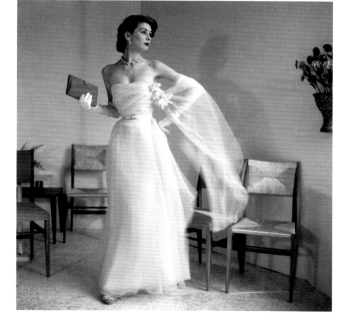

[7]

[8]

[9]

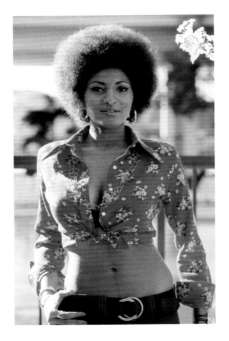

[1]

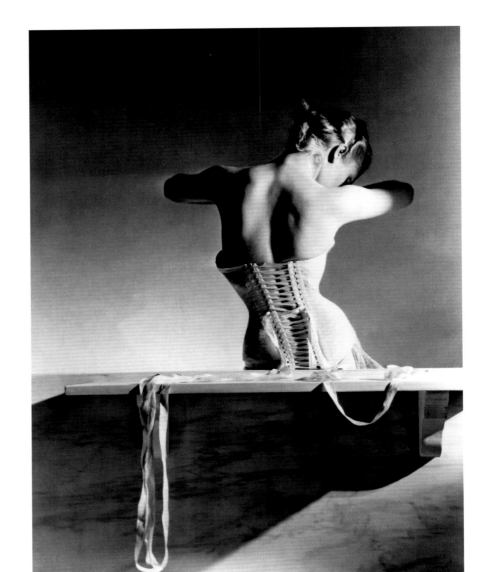

[2]

[3]

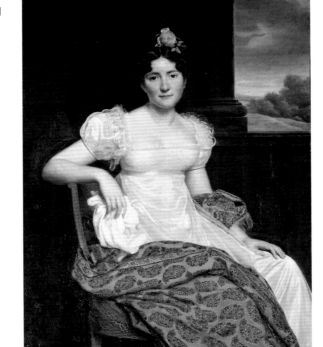

[4]

We are taught from our youth that a small waist is highly desirable. That may well reflect the fact that in the Western world it is largely taken for granted that people have enough food: slimness is thus seen as a sign of self-control and positive body image. In ages when no such assumption about food was possible, the filled-out belly of the successful male was a potent sign of social success and thus a sexual attractor, while the rich man's wife's 'proper double chin' as sung about in »Fiddler on the Roof« (a musical set in early twentieth-century Tsarist Russia) was considered proof of her husband's power and importance. Anthropologists suggest that humans have a deep-seated attraction towards individuals whose waists are smaller than their chest and hips, though the ideal differs between the sexes. In women, the ideal ratio between the waist and the hips is 7:10; in men, it is 9:10. A larger difference is therefore a signal of femininity, which is why female dress has placed so much emphasis on disguising or narrowing the waist or on emphasizing the hips and bust, thereby creating the famous hourglass figure. A woman's waist need not be particularly small, as long as the rest of her body is rounded enough to make it appear proportionately so.

–

[1] It was fashion historian James Laver who in the 1930s articulated the theory of 'shifting erogenous zones'. The theory has been partly discredited, largely on the grounds that women's primary motive for dress is not necessarily to sexually attract men, but its broad principles still hold true for many costume experts. The theory is predicated on the rather old-fashioned idea that fashion tends to concentrate on one erogenous zone at a time: the breasts, for example, during the 1950s; the hips and buttocks during the Edwardian era; the ankles as highlighted by decorative Victorian petticoats; the back being exposed by evening gowns in the 1930s. The 1960s and 1970s bared the upper parts of the female legs. At the end of the twentieth century, according to this theory, the new erogenous zone was the bared midriff. Tops were cut short and trousers worn low on the hips so that the waist and stomach were exposed. This emphasized both

the youthful slenderness of the waist – the style was suitable only for the young and trim – and the maternal curve of the top of the hips. The closeness of the lowered waistline to the top of the female pubic hair only served to highlight its sexual qualities.

[2] When Horst P. Horst photographed a back view of a model in a Mainbocher corset, published in »Vogue« in 1939, the iconic image marked the end of an era. The fashion world had until then been coy about underwear, especially the corset, which underpinned fashion until the 1960s. Even in the 1930s, 'nice' models refused to pose in corsets, especially if their faces might be shown, and so underwear features in women's magazines had to be illustrated with drawings. Horst's image suggested that a corset could be beautiful as well as erotic. Later, in 1947, Dior's New Look was based on a figure constricted by a boned corset that revived the Edwardian bustier with an effect that was glamorously voluptuous and slightly risqué (see Hips, page 104). In the 1980s, after the corset had fallen out of daily wear, it was the paintings of Toulouse Lautrec and Pierre-Auguste Renoir that excited Vivienne Westwood and Jean Paul Gaultier, who made the message much more direct than Dior would ever have dared. Deliberately provocative garments such as Gaultier's corsets for Madonna generated a press storm that seemed somewhat incongruous in that apparently sexually laid-back decade (see Bust, page 78).

[3] The waist goes up and down in fashion. There have been numerous periods when it was either raised so high – and, indeed, dropped so low – that it virtually disappeared. This no-waist look was popular during the Renaissance, when clothes were cut with the waist so high that dresses hung straight from just beneath the breasts. This look reappeared later during the Regency period of the early nineteenth century and again, paradoxically, in the 1960s. It may seem an oddly concealing fashion to reappear during an age renowned for sexual liberation and frankness, but the 1960s were also a decade of naivety and child-like innocence (see Hippy, page 206). For some women, disguising the adult shape of their bodies in this way offered an appealing promise of being able to return to a younger age.

[4] The artificial constraint of the female waist and – less commonly – the male waist in a laced-up iron, leather, whalebone or wooden framework has been practised regularly since the Middle Ages, but its modern incarnation began in the Georgian period. Contemporary cartoons show women being tied so tightly into corsets that they could surely barely breathe. Despite the fact that corsets made any kind of physical exertion painful and tiring, they were desirable because they were the ton (see Impractical, page 208). In fact, costume historians have established that the tiny waists satirized in cartoons were not as common as was once believed. Still, for centuries the corset, in one guise or another, did form the basis of the female shape. The discomfort may not ordinarily have been extreme, but there are enough stories of overheated young women fainting at dances or removing their gowns to find the stays of their corsets stained with blood to reveal the unnatural pressures the garment put on the female figure.

[5] The wasp waist was a Victorian fetish: a transformation of the body that proclaimed to everyone that its possessor was willing to undergo intense pain and privation in order to achieve a silhouette that was idealized to the point of caricature, and completely unnatural. The victims were not only women: some Victorian men enclosed themselves in corsets underneath their clothing in order to appreciate the pain of restriction, but probably no more than in any other period. There are a few modern-day adherents: the most notable is perhaps the corset-maker Mr Pearl, who, we are to understand, has worn a corset day and night for over two decades and boasts a waist of only 14 inches.

[6] The figure that dominated catwalks at the end of the twentieth century was that of the prepubescent child – hipless, waistless, mostly chestless. This is a new ideal based entirely on the appeal of youth. As recently as the 1980s the supermodels at their peak – Cindy Crawford, Naomi Campbell, Christy Turlington et al – had curvaceous figures: tall, slim and voluptuous, with rounded breasts, small waists and sexy hips. These were the traditional hourglass shapes that always made highly structured high-fashion clothes look alluring and showed other women how fashion could actually make them more attractive. Paintings of Minoan women show the earliest recorded examples of the hourglass figure. But for the modern archetype, we must look to Edwardian times, when professional beauties, actresses and grandes horizontales set the standard with figures that carried real flesh. In the 1980s, Crawford and Turlington had vital statistics, respectively, of 34-26-35 and 34-23-36, while the contemporary catwalk model is more likely to measure 30-24-33. The shape of the mature woman has largely disappeared from fashion. One Italian designer in the 1970s once went the whole hog and designed an entire collection that he fitted on his ultra-skinny boyfriend, and was surprised when his clothes were returned by shops because they didn't fit any women.

[7] Leather, metal, heavy canvas, string: the band of material that circles the waist has been made from virtually every kind of material and has varied from the hugely wide to being so narrow that it can clearly not support the weight of the garment it is apparently holding up. But a belt does more than hold up the trousers – although for the vast majority of wearers since belts were introduced in the Bronze Age, that has been its primary purpose. For those whose shape means they do not actually need one, a belt might highlight a narrow waist or serve as a demarcation between the upper and lower parts of a loose garment such as a coat (see Hips, page 104). Belts also have a practical role for hanging and carrying belongings – from military belts to the 'utility belt' beloved by science fiction, which carries equipment designed to fulfil seemingly any function (see Portability, page 94). The decorative buckle positioned just above the genitals also makes the belt an ideal showpiece, as seen in examples ranging from the steer skull at the Country and Western dance to the gold Lonsdale belt awarded to British boxing champions.

[5]

[7]

[6]

HIPS TO FEET

The body between the waist and the toes is the most erotic and also the most active of the human form. It is also traditionally the least visible. That is particularly true of women, whose legs have been not only been covered for many centuries but also had their shape entirely disguised until around the middle of the twentieh century. The legs themselves were thought to be erotic enough to inflame the opposite sex, let alone the sexual organs situated at their junction. Historically, women's clothing fell virtually to the ground, so that even the feet were rarely glimpsed. Not only did this remove a potential source of sinful thoughts: it also suggested an appearance of glamour or, conversely, acted as an inhibitor to fast or free movement. When skirts were at their widest, they allowed women to glide across the ground with the perfection of a swan, majestic on the surface but paddling hard underneath.

Clothing for the lower part of the body has had as its major purposes not just the protection that all forms of covering provide, but also the preservation of modesty – which means that this clothing also plays an important part in titillation. The manner of walking and the legs themselves are sexual signifiers. They differ between men and women and have therefore been exaggerated to highlight and increase the difference. The male stride is bold and long; the female pace is shorter, so women take more steps to cover the same ground as men, leading to a pronounced wiggle of the bottom. A garment such as the hobble skirt emphasizes this difference by forcing women to take even shorter, more mincing steps, rather than the bold strides of men in trousers.

Nothing arouses quite so much as the denial of erotic potential and the creation of mystery. Take, for example, the male codpiece, which emerged to serve modesty by covering the join between two separate legs of hose. The codpiece soon became an inflated symbol of the penis that lay beneath it, and thus of male power, in reality more political and temporal than sexual, and thus invariably speaking more to other men than to women.

Skirts and other loose garments can hide a multiplicity of sins – and also the various stratagems used to achieve the ideal shape, such as the many petticoats, horsehair, hoops and underpinning that swelled out the crinoline of the late nineteenth century. Such was the mystery with which they cloaked the unseen female legs that men were said to be excited to an almost unbearable degree by the frou-frou, the whispering sound the layers of material made as the wearer walked – although, as with so much now assumed about a subject barely mentioned before the twentieth century, we rely on intuition rather than verifiable fact here.

While the legs have sometimes disappeared within huge bell-like skirts, the bottom has often been exaggerated. In the late nineteenth century the bustle helped create the ideal of the S-shape for women by pushing out the bottom in what was often almost a shelf protruding behind the wearer, further emphasized by large bows or frills. The bustle, however, maintained decorum even while drawing attention to the bottom by entirely disguising the shape of the separate buttocks.

Skirts have always been more decorous than trousers – hence the survival against all odds of the vicar's cassock and the lawyer's robes. Bifurcation – the division of a garment into two legs – was also technically more difficult to accomplish than draped skirts, so it was not the most obvious form of dress. It began as a response to the need to ride horses without hurting the insides of the legs. Trousers had other advantages: they did not flap around when the wearer walked or ran; they protected the skin from branches and thorns; they made it easier to do certain types of work. Trousers or other bifurcated garments – like separate hose for each leg, with the join disguised beneath a doublet or emphasized by a codpiece – existed for many centuries before they became acceptable for women, except among the lowest classes in which women did hard physical work alongside men. The breakthrough development for middle-class women was the widespread adoption of bicycling in the 1890s and even more so the requirements for women to work during World Wars I and II. What centuries of moralizing had forbidden was suddenly acceptable when the economic and political imperative made it necessary and the liberation of women made it unavoidable.

The legs are, of course, our means of locomotion. They are what distinguish us from the 'lower' orders of mammals and other animals. That means that practicality has usually been the most important requirement in clothing the legs: we need to be able to move freely. Indeed, that has been the impulse behind most clothing development for this part of the body. Loose skirts allow their wearers to walk and to dance; in the Greek and Roman armies, short tunics allowed men to fight and to run; trousers emerged among horse-riding nomads; hose allowed medieval peasants to work in the fields by giving them a full range of movement; shorts make for more comfortable hiking or cycling.

The same practical imperative applies to footwear. The perennial styles – the boot for riding, the flat shoe for walking, the slipper for indoor wear and, since the early twentieth century, the tennis shoe (also known as the trainer or sneaker) for exercise and casualwear – have evolved to be ultimately practical. The basic shapes, if not styles, are set by the anatomical requirements of upright locomotion and have therefore changed very little since the concept of differently shaped right and left shoes emerged only a couple of hundred years ago (although the so-called Earth shoe, introduced in Scandinavia in the 1970s, in which the heel is lower than the rest of the sole, claims to be a radical new introduction to shoe technology).

Nevertheless, by no means has all clothing for the lower body been practical, because fashion is rarely entirely practical. In particular the desire to enhance femininity has inspired ill-fated attempts to make the legs appear as long and thin as possible (the stiletto, in the hands of a poor designer a guarantee of a damaged ankle) or the steps as short as possible (achieved in various ways from the hobble skirt to the Chinese practice of footbinding, which was a deliberate and permanent attempt to remove women's freedom of movement).

Even in more liberated societies where foot binding would be widely denounced, the determination to make the female foot seem as small as possible has led generations of women to cram their feet into footwear that does lasting damage to their bone structure. On the other foot, as it were, the archetype of male footwear is the modern bovver boot, descended from the huge riding boot and the hobnail boot. Both had a more practical purpose in the past, but today, outside the factory or the quarry, the boots signify little but masculine aggression – or uncertainty.

[1]

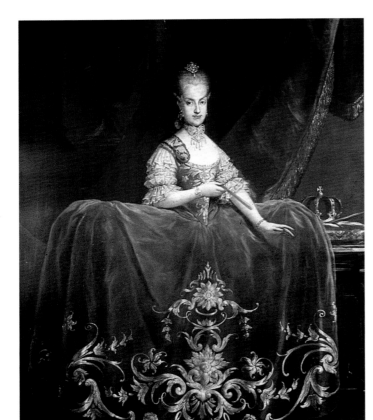

[2]

[3]

[4]

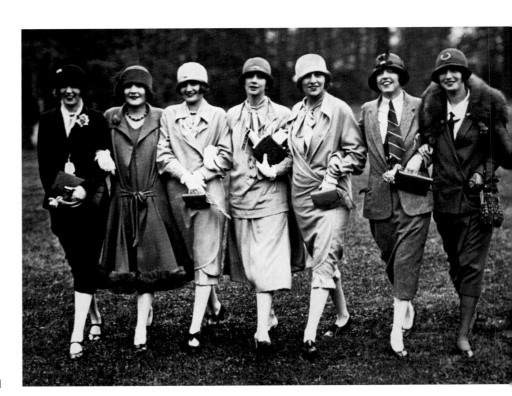

[5]

Women have broader hips than men – an average of 38.9 cm across, as opposed to 35.6 cm – because of the evolutionary development of the pelvic bone connected with childbirth. These broad hips are a highly evocative part of the female silhouette, indicating that an individual has reached childbearing age. In the same way, walks that wiggle the hips – preferably with the wearer in high heels and tight skirt – are also considered marks of femininity. Female dress has as frequently enlarged the hips as it has restricted them. Male clothes, on the other hand, have almost always tended to make the hips as slender and inconspicuous as possible.

–

[1] The hips have worn some of the most remarkable fashion prosthetics throughout history: this is not so much clothing as luggage. The belt that cinches a flared coat in at the waist today echoes the more extreme effects of, say, the 'hip cushions' of the sixteenth century, which were tied around the waist to double the width of the hips. A couple of hundred years later, steel-framed panniers on either side of the hips made women so wide across that getting into a coach or even through a doorway involved highly intricate manoeuvring (see Extreme, page 194). The hips entered their heyday in the Edwardian age, when they were padded in such a way as to call attention to the bottom – although the shape of the buttocks was carefully hidden (see Bottom, page 112). The waist was tightly laced with corsets so that the hips were pushed back, contributing to the famed S-shaped silhouette of the Edwardian female ideal.

[2] Trousers have their natural waistline above the hips, otherwise the movement of locomotion threatens to make them fall down (see Legs, page 120). That's one reason why low-slung jeans have become so popular: the observer does a double take – how do they stay up? Like all fashions that last, it mystifies outsiders and is difficult to copy, particularly for the old. The male body, which fills out proportionately more around the waist with age than the female body, makes these jeans more convincing on youths than on twentysomethings, and beyond

the pale for anyone over thirty. They are a strong statement of the primacy of youth in the ongoing battle of the ages. That's one reason why a fashion that started early in the 1990s as a way to show the otherwise-hidden name on the waistbands of designer underpants – inspired apparently by the trousers of US prison inmates forbidden to wear belts – has actually lasted far longer than other youth looks. It's cool and it's tough, and it makes wearers look as if they couldn't give a damn about what they're wearing while also being sufficiently au courant to ensure that the name on their waistband is the right one.

[3] The hipster look that became ubiquitous in the late 1990s echoes the lowish-slung jeans of the cowboy relaxing in the saddle out on the open range (see Western, page 232). These jeans displayed a laid-back yet active masculinity, like the overalls slipped off the arms and tied loosely around the waist on a hot day in urban factories. There's a less edifying version in the stereotype of the builder, who often tends to be unfit or overweight, with his jeans exposing half his bottom. Alexander McQueen took the builder's bum and made it sexy on women (and on some men) with his notorious bumsters. Little titillates observers more than a glimpse of underwear inside a loose waistline, other than a glimpse of the flesh it is meant to cover – but few women have the perfect youthful shape to carry off the audacity of McQueen's high-spirited joke. The risk of such a low-slung waistline for both men and women is the faux pas dubbed – acidly but accurately – the muffin top.

[4] Belts often have a purpose that is more decorative than practical. For simply holding up the trousers, the notorious piece of farmer's baling twine would be perfectly adequate. But belts have also been status symbols, ever since the chatelaines who ran the large houses of the early modern age first hung the keys to the various parts of their domains around their waists. In the early 1980s, designer belts often sat so low or loosely on the hips that they held up nothing at all. No matter. Designed by Franco Moschino and Jean Paul Gaultier, the belt with the designer's name cut out of steel or brass, or otherwise unmistakably displayed, became a status symbol – a fetish

H
I
P
S

item – for the young who could not afford a whole designer garment. Everyone wanted to proclaim their fashion credentials, not with a logo that was subtle enough to be missed by the uninitiated, but with an unignorable name (see Ostentatious, page 214). Young men who let their shirts hang out over their rear still make sure they are tucked in at the front so that the name on their belt is clearly visible. Like the point at the end of a tie, the belt end that hangs from the buckle and points directly at the genitals is also an unmistakable phallic symbol.

[5] One of the most determined rejections of the hourglass shape and the maternal associations of the curvy hips came in the 1920s, led by the Flappers and It girls of the Jazz Age in the United States. The breasts were flattened and the hips and waist disappeared inside straight sheath dresses whose waists hung on or below the hips, elongating the trunk and flattening out the female silhouette, or making it seem to disappear altogether. For all that such clothing appears as a kind of early feminism and a symbol of emancipation, this was in many ways women dressing to resemble males – and specifically the brothers and fathers who lay dead on the Western Front at a time when three in four families were still in mourning after World War I (see Androgyny, page 158). As one former Flapper explained: 'We didn't want to look capable of childbearing, because we'd seen our mothers' grief.'

[6] The A-line skirt – a term invented by Christian Dior in 1955 – flares out straight from the hips to the hem, but as a dress or coat the A-line flares from the shoulders to the hem without any regard for the bust, waist or hips, which disappear beneath its symmetrical lines. This is strictly called the Trapeze Line, as introduced by Yves Saint Laurent at Dior in spring 1958. It can be seen as a step forward from Dior's New Look of 1947, in that it clearly acknowledged the growing importance of youth and the less-full female figure. The A-line silhouette was common in the 1960s and 1970s, when the emphasis it placed on the legs made it synonymous with the lowering of the age of fashion, but it largely died out thereafter and now makes infrequent reappearances.

[7] The hips, like the waist, are an important demarcation line that marks the division between the torso and the legs, and thus defines what we perceive as the body's proportions. The ideal has always been taller rather than shorter, so designers have used various ways to elongate the appearance of the torso. One is by using a belt as a visual aid; another is to create an artificial visual waistline that disguises the reality. The drop waist, which falls on the upper hips, lengthens the torso and tends to even out the lengths of the upper and lower body. Its period of pre-eminence was without doubt the 1920s, when it fitted well with the more masculine styles popular with the Flappers, who preferred a straighter silhouette with the curves of the bust, hips and buttocks safely hidden.

[8] The peplum celebrates the curve between hip and waist. It's a small overskirt that comes down from the waist over the hips, exploiting details from men's tailoring such as darts and gathers to highlight the narrowness of the waist and the curve of the hips. Such an overskirt had its origins in ancient Greece, but in fashion terms it reached its peak in the 1940s, particularly in the hands of Christian Dior, who made it an important part of the New Look. The peplum highlighted the contrast between the nipped-in waist and the generously full skirts, creating a silhouette that emphasized the bust and hips. The peplum was revived in the 1980s and again after 2010, and seems set for sporadic reappearances.

THE BODY ANATOMIZED

WOMEN AT UNITED HUNT MEET, DELMONT PARK, USA, 1925

PALE BLUE TRAPEZE DRESS DESIGNED BY CLARET, 1967

DROP WAIST DRESS, C.1930S

CHRISTIAN DIOR, 'BAR' SUIT FROM THE NEW LOOK COLLECTION, 1947

'Men have broad and large chests, and small narrow hips, and more understanding than women, who have but small and narrow breasts, and broad hips, to the end they should remain at home, sit still, keep house, and bear and bring up children' – MARTIN LUTHER, »Table Talk«, 1569

[6]

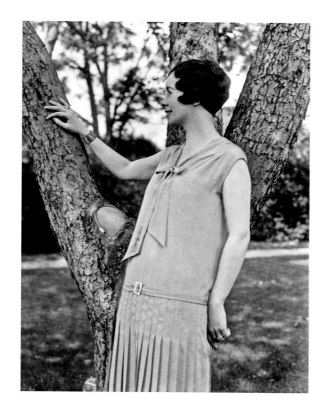

[7]

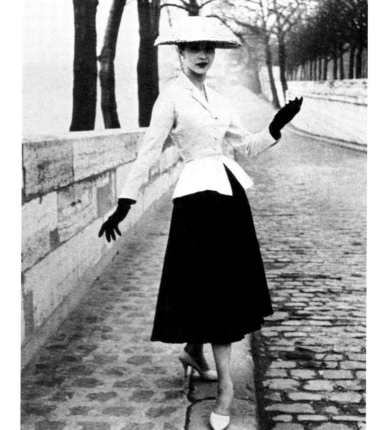

[8]

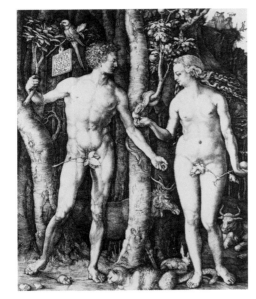

[1]

[2]

[3]

Knickers, bloomers, pants, kecks, shreddies, linens, smalls, undies, drawers, unmentionables … : the number of synonyms for underwear suggests the embarrassment with which it is sometimes still viewed. This is largely a hangover from the highly prudish sentiments of the Victorians, who seemed to confuse undergarments with the parts of the body they covered. In fact, the sexuality the Victorians abhorred had little to do with the history of underwear, according to C. Willett and Phillis Cunnington, who wrote the standard work on the subject, »The History of Underclothes« (1951). They identified five main functions of undergarments. Three are entirely neutral: to protect the body from cold; to support the shape of the costume worn over them; and to contribute to cleanliness by protecting the body from dirt and valuable outerwear from the dirt of the body. Only two of the five functions relate to sexuality. Underwear can enhance sexual appeal, by presenting the body in a semi-clothed way; and it has also been used to enforce class distinction, by introducing considerations of taste and restraint to sexuality.

—

[1] All underwear can be seen to a greater or lesser extent as having descended from the biblical fig leaf. Adam and Eve felt no shame at their nakedness until Eve ate the forbidden fruit; the Book of Genesis records that 'they sewed fig leaves together, and made themselves aprons'. Although a few items of clothing have emphasized the genitals, it is possible to argue that a primary purpose of clothing has been to conceal and protect them. Even tribal peoples who leave their breasts and buttocks bare are usually careful to conceal their penises and vaginas. The impulse has its roots not only in protection but also in the notion of modesty: that revealing the organs of procreation to anyone apart from a partner is a transgression of acceptability. In such hands as those of Hollywood designer Phillip Bloch, who dressed actor Jim Carrey in a fig leaf for a 1998 awards ceremony, or Elie Saab, who featured fig-leaf bikini bottoms in his 2003 collection, this nod to the origins of all clothing surfaces at regular intervals to raise a smile, if little else.

[2] The simplest form of male underwear has barely changed over millennia. The loincloth that wraps between the legs and around the waist was worn some 7,000 years ago and still appears in Asian societies such as India, where it is often worn as outerwear. In the West, variations on the loincloth had by the Middle Ages produced braies, which were loose bifurcated garments that were tied around the waist. Although braies originally fell to the calf, they gradually became shorter to accommodate the fashion for wearing hose around the bottom of the legs. Eventually the braies evolved into drawers, which were loose undershorts that came down to the knee, had a flap at the front and were made in light cotton or, for the wealthier, silk or linen. A further breakthrough came in 1868 when a company in Utica, New York, patented the union suit. Originally intended for women, the all-in-one union suit had emerged as a result of the rational clothing movement; in Britain at about the same time, Dr Gustav Jaeger was also advocating the health benefits of all-in-one woollen suits that the British called 'combinations'. The all-in-one union suit combined long drawers with a chemise, usually in red flannel, buttoned down the front and with a buttoned flap at the back.

[3] Underwear needs to be practical. That may seem to go without saying, but it is not unknown for those on the cutting edge of fashion to overlook such essentials as the need to be able to use the lavatory or, indeed, to be able to wash soiled underwear (see Convenience, page 176). One of the main reasons underwear exists is to prevent dirt from the body getting on to more valuable and less easily cleaned outer garments; and also to prevent dirt from outer garments getting on to the genitals. So underclothes have always had to be easily put on and taken off and able to stand up to frequent laundering. Early underclothes were made from linen or wool, even satin for the more wealthy; the ready availability of cheap cotton in the West after the industrialization of its production made it an ideal material for underwear (see Materials and Texture page 24). Convenience was further improved by unheralded but important inventions such as the elasticated waistband, which was first introduced on boxer shorts by Everlast in 1925.

GENITALS – MODESTY + PRACTICALITY

»PANTIES«, FRANÇOIS BERTHOUD, 2004, MONOTYPE, OIL ON PAPER

[4] During World War I, a shortage of metal for stays hastened the decline of traditional corsetry and led to the appearance of 'step-ins', a shorter, looser form of bloomers and the first step towards modern knickers. Corsetry firms continued to thrive – Italy's renowned La Perla brand was founded in 1954 – but they produced a wider range of lingerie, including underwear whose eroticism was closely linked with luxury: made of lace, silk and satin, all of which have a cachet as the fine clothing of the wealthy and privileged. The smoother and finer the material, the more alluring the underwear. Sex and luxury are closely linked.

FREÔN UNDERWEAR ADVERTISEMENT, C.1940

[5] Outside the bedroom, underwear is usually invisible. Like the brassiere, garments such as control pants or magic knickers are valued for the shape they impart to the clothed body, not for their own appearance. The same is true of girdles or the tops of tights: they exist only to make other garments look better. Girdles, or panty girdles, were almost universal from the 1920s to the 1960s because of their ability to shape the body. The alternative Directoire knickers – closer-fitting than normal underwear, with elasticated waist and legs – might have been dubbed passion killers during World War II, when they were standard issue for women in the military services, but they did the same job. Today, the visible panty line has become a universal fashion faux pas, made more difficult to avoid by the wearing of tighter and thinner clothes, but the various shapes of modern underwear – far more varied than in the past – reflect various answers to the problem, from loose shorts to thongs and pants with lace edges. As ever, the conundrum is whether to favour exoticism and glamour or practicality and comfort.

COOPER'S ADVERTISEMENT FOR JOCKEY BRIEFS, 1950S

[6] Change in modern male underwear has occurred mainly since the 1930s. Previously the dominant form of underwear had been long johns, a descendant of the union suit. In 1925 the boxer short had been introduced, clearly based on the trunks worn by boxers. It had proved popular, but not overwhelmingly so. What men apparently wanted was more support for their genitalia, as provided for example by the jockstrap, introduced in the 1890s for followers of the new craze for cycling, known as 'bicycle jockeys'. In 1935 Arthur Kneibler, a Chicago clothing designer looking for new ideas to help the Coopers company through the Great Depression, received a card from France showing a man in a very short swimsuit and had the inspired idea for jockey briefs, or Y-fronts. Despite misgivings that men might prefer the warmth offered by long johns, they were a runaway success. On their introduction to London in the 1930s, more than 3,000 pairs were sold in the first week.

'Whenever you're sitting across from some important person, always picture him sitting there in a suit of long red underwear. That's the way I always operated in business' – JOSEPH P. KENNEDY, 1950s

[4]

107

[5]

[6]

[1]

[2]

[3]

To emphasize the genitals of either sex through clothing is rare but not unknown; indeed, at periods in the past, it has been far more common than today. In ancient societies it was done to reflect the symbolic importance of the genitalia in reproduction, and later as a way of highlighting male power – as in the Tudor codpiece or tight Regency breeches – or of demonstrating female availability (as in Venetian prostitutes who left their pubic region exposed). Today display is more complex, because in Western society the genitals have become a commonplace of dress. Outerwear that is commonly tighter than in virtually any earlier period, not just in athletic gear but also in everyday clothing such as jeans, means that both the shape of the penis and the swell of the pudendum are frequently casually visible. This is a consequence of the emphasis of fashion on youth and youthful sexuality. In many other societies, including throughout the Islamic world and in southern and eastern Asia, such clothing remains socially taboo: looser clothes continue to conceal the sexual organs.

–

[1] Pubic hair has a number of physiological purposes: to keep the genital region warm and, during copulation, protected; as a visual indicator of sexual maturity; and to accumulate pheromones that subconsciously attract adult mates, which last longer in hair than they do on the skin. (The last is anachronistic now tight clothes trap the scent and quickly make it become stale and unpleasant, meaning that modern people have to wash more often than their forebears.) But although pubic hair may be desirable, it's far from essential. Since ancient times, women have removed or styled their pubic hair (men have begun to do so much more recently). Egyptian, Greek and Roman women practised some form of depilation; women in medieval Europe adopted the practice after Crusaders brought home tales of the habits of the Middle East. Some do so for reasons of cleanliness or religion (the Koran injuncts male Muslims to remove their pubic hair). Others do so for reasons of fashion: a hairless genital region has often been popular because it echoes the appearance of young teenagers; a sexual ideal for many men, and

therefore women eager to please them through the illusion of youth.

[2] During various periods in the past the exposure of the genitals has been far more prevalent than today, not simply because of changes in clothing but also because of changing attitudes towards privacy. Modern life is lived more privately, and bodily functions are performed behind closed doors. In the Tudor and Stuart ages and others, on the other hand, people were more accustomed to seeing one another in states of relative undress: workers occasionally wore nightclothes in the street, while even monarchs received visitors while still in bed and allowed the really favoured ones to attend them while they were being dressed. One area where exposure of the genitals remains relatively common today, though, is on the catwalk. That has only been the case since the 1980s, however, and it generally represents less of a fashion statement than a determination to grab publicity by attracting the attention of the picture editors who dictate what appears in newspapers and magazines around the world. It is a technique that works – but the truth remains that to walk along the street with one's pubic hair on open display would be to invite censure and certainly the attention of the police.

[3] There can be little surprise that the genitals have been fetishized in dress. Modern leather or studded codpieces, 'crotchless' knickers or open thongs: these are garments that exist beyond the realm of mainstream fashion, either on the edges of the straight or gay bondage scenes or as worn in erotic or pornographic performance to emphasize the sexual organs. Strippers are said to have invented the G-string around the 1930s at about the same time as pasties (see Bust, page 78). While pasties remain specialized clothing, the G-string was arguably the precursor of the thong, which became popular in the 1990s and remains so with many today. (Rudi Gernreich is usually credited with its modern inception, in 1974; see Bottom, page 116). There are many other fetish garments associated with the genitals, of course, including paper and even edible underwear, first marketed as 'Candypants' in 1975 (and subjected to numerous investigations on the grounds of its alleged obscenity).

[4] In 1967 designer Mary Quant not only announced that she had dyed her pubic hair green and styled it in the shape of a heart, she went on to anticipate that pubic hair would become a fashion statement in the 1970s. Quant was out to shock but her vision was uncannily accurate: only her timing was off. In fact it took a few more decades, and remained limited to a few hardy souls. But by the late 1990s and early 2000s the profusion of available styles of pubic hair shaving, from the bikini line to the Brazilian and the sphinx – mostly inspired by higher cuts of swimwear or porn starlets, meant that few people, certainly within fashion circles, would dream of not styling their pubic hair in some way. A wannabe designer named Stefan Monzon held a catwalk show at Los Angeles Fashion Week in 2006, featuring pubic hair extensions that included a fan of peacock feathers sprouting a couple of feet high. The whole thing was almost certainly a joke – who knows? – but there is a vogue for decorating women's pubic regions with sparkly costume jewels, in a trend known as vajazzling, which reflects the generally franker attitude towards sexuality in modern society. Conversely, the more frequent glimpses of pubic hair in movies are behind the rise in popularity of the merkin, a wig that covers the real thing but looks just like it, so that film stars can reveal all without revealing all.

[5] The marketing of male underwear in the last 20 years has drawn heavily on homoerotic imagery, particularly in the photographs of Bruce Weber advertising clothes as far apart in spirit as those of Ralph Lauren and Calvin Klein. Klein took the male body out of the gay closet through underwear, which until that time was the least erotic item in a man's wardrobe. Narcissistic models with the torsos of workout freaks gazed at their audiences with the glazed absorption of masculine self-love. Ads such as Steven Meisel's images of rap star 'Marky' Mark Wahlberg revealing his CK underwear were frankly homoerotic and yet appealed to straight men and, equally, to women. Yves Saint Laurent meanwhile understood the eroticism of adding buttons to the fly of underpants to add to the allure of 'unwrapping' the male 'package'. The buttons have

similar symbolism to the small bows often stitched at the waistline of women's underwear as a vestigial reminder of a time when clothing was held on by ribbons and knots, rather than by elastic waistbands (which began to be used in the later nineteenth century).

VIVIENNE WESTWOOD, 'BIG PLANS', AUTUMN/WINTER 1994

TOM HINTNAUS, PHOTOGRAPH BY BRUCE WEBER FOR CALVIN KLEIN, 1985

'It was the loveliest piece of underwear you ever saw – the finest black lace, like a spider web, and the panties were slit back and front… I hesitated because I was wondering if this would not excite the man too much, if he would attack me. He said, "Don't worry. I don't really like women. I never touch them. I like only underwear. I just like to see women in lovely underwear"' – ANAÏS NIN, »Artists and Models«, 1988

[4]

[5]

'Does sir dress to the left or the right?' Every man's penis hangs a little to one side or the other, and in a bespoke pair of trousers it was customary to add a little extra fullness to the leg on that side to accommodate the penis without creating a visible bulge. The original purpose was modesty, but the practice remained a convention for formal clothing even after the youth culture explosion of the 1960s and the ubiquity of tight blue jeans made the pubic bulge an everyday fashion occurrence. Men have always believed that size matters, and the penis has been revealed in outline a number of times in clothing history, mainly during the early Renaissance and again in Regency England. Chaucer's Parson in »The Canterbury Tales« rails against the fashionable combination of short jackets and tight hose, arguing that it draws attention to the penis. Italian cities tried to outlaw the fashion as an incitement to unnatural sexual practices. In the Regency period, meanwhile, young bucks wore breeches so tight that, as »Chambers Edinburgh Review« noted in 1850, they stopped the flow of blood 'in a downward direction' and diverted it instead to the face. The effect might have been lessened had men worn darker buckskins, but the fashion was for white, cream and buff for breeches – and trousers later – and darker colours for jackets. The breeches of the early nineteenth century thus left little to the imagination.

–

[1]	In the main, the penis has remained safely hidden away, as it still is in many southern and eastern Asian societies, where tightly tailored clothing is unacceptable because of the heat and humidity. But there have also been periods when the penis has been celebrated for epitomizing male power. In Western society that was particularly true from the late Middle Ages until the mid-sixteenth century, a period dominated by the codpiece. In the later decades of the twentieth century, the penis was again frankly displayed, this time as part of the process of packaging pop music for young girls. Male performers preened on stage in deliberately tight trousers, on occasion said to have been padded with socks or whatever else was to hand. Even more recently, the display of the shape of the

penis has been the inevitable consequence of the popularity of athletic clothing, from the cycle courier's Lycra to the shortest of running shorts (see Activewear, page 150).

[2]	The codpiece was originally a purely practical garment, which evolved in the 1370s when the two separate legs of men's long hose were first sewn together (see Legs, page 134). A triangle of material – removable for reasons of convenience – covered the resulting gap in response to criticism of the immodesty of a contemporary fashion for wearing hose with very short coats. The area then began to be lightly padded as a form of protection for a vulnerable area not easily safeguarded, even by armour. By the 1500s, by which time male costume had incorporated short-legged slashed-and-puffed stocks to cover the upper leg, what had originally had its roots in modesty had become a manifestation of immodesty. The codpiece closely resembled the penis it was meant to be disguising and was a prominent symbol of male power and social status. This was a brutal and brutalizing fashion that said more to and about men than it did about women and fully deserved its Italian name, the »bragetto«. It was as crude a display of male power as the twentieth-century equivalent – the shuttlecocks stuffed in the tight trousers of rock stars or the sanitary pads pushed into the tights of male ballet dancers.

[3]	Among some highland peoples of New Guinea, men wear penis sheaths known as kotekas. These remarkable garments are made from gourds that hold their penis upright in front of them, at an angle of about 45 degrees – like long, tapering erections. Often they wear nothing else. They are important displays of male status, often worn during ceremonies. It's not entirely clear from where the inspiration came – one is tempted to suggest that it was perhaps from animals' erections. In the West the penis sheath has appeared only as an item of fun – the willy warmer – or as an object of ridicule, like the 'Cleaver Sleeve' marketed unsuccessfully in the 1980s by the former Black Panther party leader Eldridge Cleaver, which was a pair of underpants with a tube of material protruding like a trunk to accommodate the penis.

[4] Lycra cycling and running shorts have brought the shape of the penis back into clear focus – but (perhaps mercifully) mainly among a specific and limited group of young and active, if not athletic, men. Concessions have been made for clothes necessary for sports – and ballet and circus performance, for that matter – since the 1950s, when Speedo added nylon to the swimming trunks now generically referred to by the brand name. Designer Peter Travis was later made a member of the Order of Australia in recognition of his invention of the pouch-like Speedos in 1961, although the first man to wear the new trunks was arrested for indecency. But in 1972 a photograph of a man in tiny Stars-and-Stripes briefs graced magazine covers around the world: Mark Spitz also wore seven Olympic gold medals around his neck. In the dying months of the Vietnam War, here was a new all-American hero whose figure-hugging suit could be viewed without outrage. For superheroes, as well as for sportsmen and women, performance is all. The nature of exertion and competition is such that it removes sexual considerations from clothing and thus makes the display of the penis acceptable.

[5] The most extreme type of penis decoration is piercing. A number of styles are available, but the first is said to have been what is now called the Prince Albert, in which a hole is made in the underside of the penis near the tip and a ring inserted. The fashion's origins lay apparently with German nobles in the seventeenth and eighteenth centuries, who used the device to pull their penis between their legs in order to avoid sword injuries during duels. Prince Albert, husband of Britain's Queen Victoria, is said to have adopted it in order to strap his penis to his thigh in order to achieve a perfectly smooth outline in his skin-tight trousers (today the rings do not have to be strapped to the upper leg, as trousers are usually worn looser). Of course, the story about Prince Albert is highly unlikely, and there is no evidence one way or the other – the private parts of the royal family have never been subjects that are widely advertised or discussed.

[2]

[3]

[4]

[5]

Humans have the largest behinds in the animal kingdom, and the only true buttocks. The buttocks are troublesome for fashion – and for society more generally. At one and the same time the buttocks demand attention because of their role in sexual attraction, and yet they also must be hidden because of their association with defecation and dirt – and, in some cultures, 'unnatural sex', particularly homosexuality. Fashion has at times both highlighted and concealed the buttocks as changing tastes have dictated. The ancient Greeks venerated the buttocks as a feature that distinguished humans from lower animals (they built a temple to Aphrodite Kallipygos, or Aphrodite of the Fair Buttocks, and sculpted the goddess of beauty lifting her robes to show off her behind). In medieval Europe, women baring their bums were carved on church walls as protection against the Devil, who was not human and was therefore thought to have no buttocks and to hate being reminded of the fact. The Victorians, on the other hand, both increased the size of the bottom and disguised its true shape with the bustle, which concealed the buttocks. The bifurcation of garments, and more recently the growth in ubiquity of blue jeans since the early 1980s, mean that the modern age is one of relatively open display of the bottom (to an extent unthinkable even as recently as the 1950s).

–

[1] The bottom is something of a challenge for fashion designers. For obvious physiological reasons, it must be easily accessible, sometimes at short notice. While everyday dress takes account of that fact, it is something that high fashion has at times only acknowledged in passing. Of all the considerations that keep clothes practical, the need to defecate and urinate are among the most pressing. There have been various solutions to the challenge, including button and zip flies, drawstring or elasticated waists, or the button-up flaps in the seat of traditional union suits and long johns. But for some of the more spectacular examples of form over function, the solution has often been more characteristic of the general aproach the fashion industry takes towards its customers: that the wearer must suffer for the sake of style, in

this case by exercising remarkable and often uncomfortable control over her excretory functions until the occasion arises to remove a garment altogether.

[2] The toned male bottom can be a sign of youth and strength; it is a clear demonstration of athletic prowess. The »mawashi« of sumo wrestlers wrap around the waist and between the legs, deliberately leaving the buttocks exposed to underline the wrestler's pushing power. The ballet dancer's tights, like those of medieval huntsmen, modern-day bullfighters and American footballers, are equally frank in revealing the shape of the male bottom. Such displays are overtly sexual, and are not normally acceptable outside the stage or the sports arena. That might be partly because most modern males do not have the derrière to carry them off: the spreading bottom of middle age does not have the same impact. But it is also because the sculpted male butt is a symbol of the ultimate masculine power: the ability to copulate with vigour and endurance.

[3] Stone Age carvers who created fertility figures such as the Venus of Willendorf gave them huge buttocks, along with enlarged breasts and a generally rounded shape. The figures were fetishes associated with childbirth and motherhood. In some of these early statuettes an apron covers the buttocks rather than the genitals, and its purpose was probably not to disguise the erogenous zone but rather to call attention to it. A similar function was fulfilled when women began to bunch their overskirts at the back in the late 1600s, which allowed them both to display the petticoats they wore beneath their skirts and to give more emphasis to their bottoms. The sporadic appearance ever since of variations on the bustle – particularly in the later nineteenth century and in the middle of the twentieth century – underlines the persistent attraction of the large female behind. Anthropologists propose that our distant female ancestors may have been endowed with huge 'super-buttocks' that set a subconscious ideal of fertility and motherhood for the human race. That may be why the Victorians, with their emphasis on the importance of the family, were so attached to the bustle.

BOTTOM – SYMBOLISM

»WILD GALS OF THE NAKED WEST«, FILM STILL, 1962

[4] The bottom has much comic potential.
This is partly to do with bodily
functions but also because the
bottom's display or invocation
is so often associated with
embarrassing – and therefore
often funny – insults or behaviour.
Clowns kick each others' bottoms
– albeit their buttocks are lost
beneath huge trousers held away
from the body by braces and hoops
– in a comic display of harmless
aggression. Students moon their
friends; sportsmen and sometimes
women moon crowds; revellers –
male and female – moon anyone
and everyone. Again, the display,
while ostensibly offensive,
is also generally perceived
as harmless (as long as the
genitals are not displayed).

BROCADE 'BUMSTERS' BY ALEXANDER MCQUEEN, PHOTOGRAPH BY PHIL POYNTER, 1996

[5] In 1992 Alexander McQueen, then
starting his own fashion label,
produced the bumster. The garment
became something of a signature
piece, despite the fact that it fit
poorly with his characteristic
aesthetic; it titillated and
amused in equal measure. It took
the low waistband of contemporary
trousers and made it that little bit
lower for shock value. It hovered
on the edge of fetish clothing,
squeezing the buttocks into their
own cleavage, yet retained an
almost comic sense of innocence.
The bumster itself expressed
something of the tragic paradox of
McQueen. His Savile Row training
gave him a rigour often lacking
in modern fashion, but his easy
crowd-pleasers reflected his often-
expressed determination to sell
as much as he could: 'I have to
make a living out of what I do.'

'The buttocks are the most aesthetically pleasing part of the human body because they are non-functional. Although they conceal an essential orifice, these pointless globes are as near as the human form can ever come to abstract art' – KENNETH TYNAN, »Meditations on Basic Baroque«, 1966

[3]

113

[4]

[5]

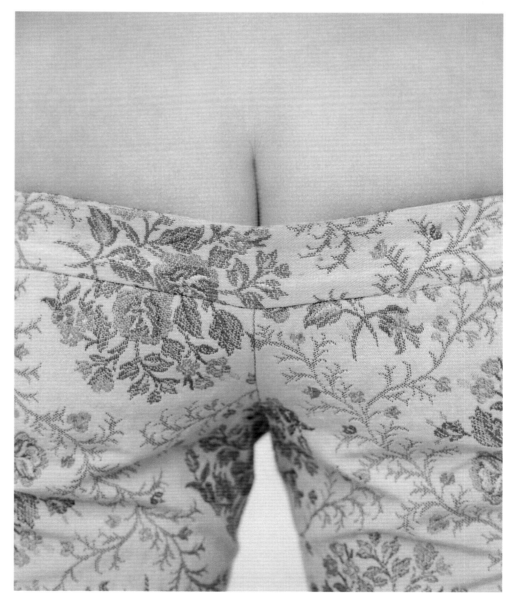

[1]

[2]

Some people love to show their bottoms. The impulse to display the buttocks can be the result not just of their obvious connection with sexuality but also because they are linked with causing offence and humiliation – but not too much. Because the buttocks are considered offensive, but not to the same extent as the genitals, their display somehow manages to remain socially licensed, even harmless, and yet still taboo. Showing the buttocks is therefore in some ways a kind of acceptable rejection of social mores. At various times in history, women have increased the visible size or shape of their behinds through padding, while usually at the same time continuing to disguise the real shape of the bottom. Although the male bum has rarely been enhanced in this way – apart from for comic effect, such as by the bare plastic buttocks worn as part of fancy dress – both sexes have at times worn clothes designed to direct attention to the behind.

–

[1] In 1810 Sarah Baartman, a Khoi from South Africa, was brought from her homeland to London, where she was put on public display as the 'Hottentot Venus' ('Hottentot' was the contemporary name of the Khoi people). Baartman was said to embody the qualities considered most attractive by her own race, including a condition known as steatopygia, in which layers of fat in the buttocks become overdeveloped, enlarging the bottom to unusual proportions. The unfortunate Baartman was dressed in clothing so tight that the effect was as if she were naked, and she had to put up with much poking and prodding from intrigued Londoners who wished to convince themselves that she was not padded. As Queen acknowledged in their 1978 hit 'Fat Bottomed Girls', generous behinds continue to fascinate people, to the extent that there is a sub-genre of Internet pornography known simply as BBW: Big Beautiful Women. Ample-bottomed models remain relatively rare on the fashion catwalk, however. To that extent, designers have always been far more interested in creating an ideal body than in dressing the reality – although retailers know that most mass-produced lines need to be able to accommodate those of more generous proportions in order to be commercially succesful.

»NIGHT PORTRAIT, FACE DOWN«, LUCIAN FREUD, 1999–2000, OIL ON CANVAS

DETAIL, »ST BENEDICT REPROVING FRA VALERIAN'S BROTHER FOR BREAKING HIS FAST«, SIGNORELLI LUCA, FIFTEENTH CENTURY, FRESCO

[2] The great ages of the bottom have been fewer for men than for women, possibly because of society's latent suspicion of homosexuality. Not that men in Western societies have been reluctant to reveal their behinds. There was a period in the fifteenth century when a combination of tight hose and a very short jacket was such a popular fashion that both churches and governments tried to ban it. The bottom then largely disappeared beneath a variety of longer or shorter coats and jackets (never higher than the lower buttocks) until the 1950s, when jeans, T-shirts and short leather jackets became popular. For young people of both sexes, displaying the true shape of the buttocks has been common since the 1980s; many older people, however, still dress to disguise rather than expose their behinds.

SINGER KYLIE MINOGUE, C.2000

[3] The fundamental shape of the ideal human bottom has changed. When Kylie Minogue wore her gold hotpants in 2000 she was following a tradition that was in fashion terms relatively new. The first crotch-high hotpants appeared only in 1970. They would have been unthinkable earlier not so much for reasons of propriety – swimwear and sportswear had effectively led the way in exposing the female bottom some decades earlier – but because the shape of women had changed. Bottoms are generally smaller now than in the first half of the twentieth century, and certainly smaller than in the late Victorian age. The change can be put down partly to improvements in diet and the modern fashion for exercise but also to changing perceptions of the desirable body shape. In the West, today's idealized behind is small and pert – a far cry from the ample flesh of the grandes horizontales of the Edwardian age.

ILLUSTRATION FROM »AMERICAN VOGUE« BY ERIC, 1948

[4] For women, the hip bolster or 'bum roll' was fashionable in the sixteenth century: it called attention to the bottom while at the same time hiding its shape. The same was true for the Victorians and Edwardians with the bustle. The large bust and bottom and the small waist were emphasized by corsetry and bustles, with the buttocks also thrust up by high heels – creating the ideal S-shape of the Edwardian age. At the start of the twentieth century the actress and royal mistress Lillie Langtry patented her own bustle, which had hinges

to enable its metal hoops to ride
up so the wearer could sit down
in comfort. The 'S' shape was not
a natural shape for a woman but
proved an enduring male fantasy,
as testified by the popularity of
full-figured models such as Marilyn
Monroe and Jayne Mansfield into the
1950s or the appeal of Christian
Dior's New Look of 1947, which
benefited from being worn with a
panty-girdle that augmented the
size of the buttocks. In 1981 Yves
Saint Laurent brought the bustle
back to the Paris catwalk, but the
ideal female shape had changed.
This time the prominent bottom
did not catch on.

[5] The earliest loincloths left
the buttocks exposed because it
was not considered necessary to
cover them. That is still true in
some undeveloped societies. The
loincloth is also the ancestor of
swimwear that leaves the buttocks
exposed, originally so that
swimmers' legs were unencumbered,
but now equally to avoid tan
marks. Another descendant is the
G-string, as worn by strippers
and showgirls since the 1920s
to emphasize their behinds. The
most recent example is the thong,
credited to Rudi Gernreich in 1974.
The rear triangle of the thong,
pointing between and separating
the buttocks, is clearly visible,
making it the latest in a tradition
of underwear being worn as
outerwear for erotic effect. Sadly,
too many of its devotees lacked the
figure for such exposure and the
visible thong has lost its sexual
and fashion allure for all but
C-list television 'personalities'.

RUDI GERNREICH, THONG, 1974

'Oh won't you take me home tonight / Oh down beside your red firelight / Oh, and you give it all you got / Fat-bottomed girls you make the rockin' world go round' – QUEEN, 'Fat Bottomed Girls', 1978

[3]

[4]

[5]

[1]

[2]

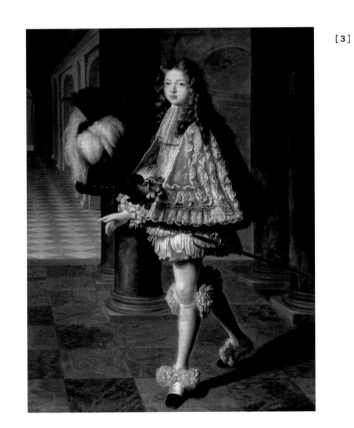

[3]

[4]

[5]

There is something inherently embarrassing about the bottom, in large part because of its association with bodily functions. That is why it has so many slang names – bum, arse or ass, butt, buns, fanny, tush – and why it causes so much amusement. It is also the part of the body that, along with the tummy, people report most often feeling disatisfied with. Witness the popularity of the 2002 chick-lit bestseller »Does My Bum Look Big in This?« by Arabella Weir, the very title of which reflects the insecurity about body image that afflicts even the professional and successful. It is because of this insecurity that fashion has often set out to conceal the shape of the buttocks, particularly during periods of high public prudery and at times when slim, youthful figures have been in style.

–

[1] The bottom's association with sexuality means that it features succcessfully only in fashions for young people. The more august members of society – professors at universities, judges and clerics, for example – still hide the outline of their buttocks securely beneath all-enveloping robes or long frock coats. The same is true of monks and nuns. Such robes often look faintly ridiculous now, particularly if worn outside the specific situation for which they were intended, so out-of-touch are they with modern clothing standards. This invitation to gentle mockery is ironic, given that the garments have survived primarily because of their wearers' impulse to preserve dignity.

[2] Drapery displays the buttocks far less than do tailored clothes. Traditional garments such as the sari or the kimono achieve their elegance by ignoring the shape of the body, which is often imperfect, and instead following the standard form of a tube. In the kimono, the sexual focus is on the neck rather than around the buttocks, genitals or breasts, which are all largely invisible. The Japanese designers of the 1980s, such as Issey Miyake, continued this determination to disguise the bottom by largely ignoring it in clothes that were cut similarly for the front and the back. Some saris use layers, folds and bright colours to envelope and disguise even the swell of the bottom, let alone the shape

of the buttocks, so the garment ultimately appears to have no connection with the female body beneath it.

[3] Loose trousers effectively disguise the human anatomy, from the harem pants introduced by Paul Poiret in 1909, based on traditional Turkish styles, to contemporary baggy jeans that hang low on the waist with a crotch near the knees. Historically this was always so: a similar impulse to swathe the body in unnecessary folds was seen in the 1650s. Rhinegraves, or petticoat breeches, were a male-only fashion for breeches so wide – up to 5 feet around each leg and decorated with lace trimmings – that they resembled baggy skirts. The profusion of ruffles completely obscured both the bottom and the groin, throwing the emphasis on the quality and quantity of the cloth, rather than the anatomy of the man within.

[4] Trousers do not conceal large bottoms well. Societies characterized by fuller physiques tend instead to favour loose-fitting garments, like the muumuu of Hawaii or the kaftans of Greece. These are essentially male dresses that hang from the shoulders and chest to the floor, blanketing the rest of the body and hiding a multitude of sins. The character of Homer is faced with a dilemma in an episode of »The Simpsons«, in which he deliberately fattens himself up in order to be classified as an invalid and therefore allowed to work from home. The store assistant advises him: 'Many of our clients find pants confining, so we offer a range of alternatives for the ample gentleman: ponchos, muumuus, capes, jumpsuits, unisheets, Muslim body rolls, academic and judicial robes …' Homer replies: 'I don't want to look like a weirdo. I'll just go with a muumuu.'

[5] Unlike female buttocks, which have often been highlighted by dress, the male buttocks have more usually been hidden, largely because their exposure has been feared as an invitation to buggery – the precise reason that the Doge in Renaissance Venice forbade short jackets that exposed the male behind. In the French court in the 1660s, the knee-length coat known as the justaucorps became the fashion partly precisely because it covered the buttocks, and the jacket of the modern suit does the same, except for extreme fashion for the young,

NEW GRADUATE IN CAP AND GOWN, 1945

PALOLEM BEACH, GOA, 2008

»LOUIS ALEXANDRE DE BOURBON«, LOUIS BOULLONGE, 1693, OIL ON CANVAS

GREEK SINGER DEMIS ROUSSOS IN A KAFTAN, 1970S

»JEAN-BAPTISTE LULLY«, HENRI BONNART, 1711, ENGRAVING

BOTTOM — CONCEALMENT

such as the jackets of Thom Browne. This kind of formal clothing has the advantage of preserving the status of older businessmen whose physiques can no longer compete with those of their younger rivals (see Establishment, page 188).

[6] The buttocks are not equal opportunity features. Women have a thicker layer of adipose fat and hence generally bigger buttocks than men. That may be one reason cultures or groups that promote sexual equality tend to turn their backs on tight clothing. One occasion came in the 1960s, when the hippies' enthusiasm for long, flowing garments, often adapted from those favoured by societies where religious restrictions urged the concealment of the body, concealed the buttocks beneath drapery and layers of shapeless garments (see Hippy, page 206). Women who wish to dress in masculine styles or non-feminine styles, meanwhile, seek to disguise their most obvious female characteristics: the breasts and the bottom. In the 1920s, flappers bandaged their breasts, wore girdles and adopted waistless sheath dresses that hung straight and did not show their buttocks. While the extreme androgyny of the flappers was never going to be more than a short-lived fashion, the girdle remained part of the wardrobe of 'respectable' women for decades, again because they controlled the hips and bottom while removing excessive curves and doing away altogether with the cleft between the buttocks (see Androgynous, page 158).

THE BODY ANATOMIZED

'Sure, deck your lower limbs in pants; / Yours are the limbs, my sweeting. / You look divine as you advance – / Have you seen yourself retreating?' – OGDEN NASH, 'What's the Use?', 1942

The buttocks are intimately linked with gender, and therefore with sexuality. Women tend to have relatively larger bottoms than men. While the ideal male bottom is small and taut, indicating athleticism and power, the feminine ideal is rounded, softer and more fleshy (and at times has been positively large). According to anthropologists, the female buttocks are, like the breasts, sexual signs. In the primate world, buttock-like pads surround the genitalia of the female baboon and swell and turn pink during oestrus to signal her ability to mate. Such signals exist because rear-entry mating is universal among primates – apart from humans. Humans only began to mate face to face after evolution led to us walking upright. The human female's sexual organs were now hidden rather than displayed, and new signals of sexual receptivity developed instead: the breasts and the permanently swollen bottom.

–

[1] In the seventeenth century, French explorers noted that native women on the Pacific island of Tahiti, in a society where little clothing was worn, painted their bottoms blue in order to call attention to them. Other European visitors to Africa described courtesans in tribal societies who advertised themselves by displaying their buttocks. Today clothing continues to call attention to the buttocks, although only in a very few scenarios to advertise the same kind of sexual availability. Modern signals take far more subtle forms. The small V-shaped notch often cut into the back of waistbands of trousers or jeans is one example, as is the functionally unnecessary and aesthetically questionable embroidery that often adorns the back pockets of blue jeans. In 1970s' gay culture, handkerchiefs hanging from either the right or left back pocket of jeans signified the wearer's sexual preferences. In the 1990s Thierry Mugler and Claude Montana took garments and removed the behind entirely, exposing the male and female buttocks in a way that would be considered obscene – and illegal – anywhere other than the catwalk or the stage. The dancer Michael Clark once tried performing in an outfit with a hole cut out to reveal his bottom, but not to any great enlightenment of the ballet-going public.

[2] Anthropologists associate the sexual signals of the buttocks with smoothness. That gives even the idea of the naked buttocks a sexual power, and explains why visible underwear lines are so unwelcome. In 1980 Calvin Klein caused a furore among moralists when he featured Brooke Shields – then only fifteen – in a commercial, provocatively asking 'You want to know what comes between me and my Calvins? Nothing.' What Klein had realized was that, after decades in which the bottom had become rather anonymous, the blue jean had changed everything. The tightness and smoothness of denim, together with a cut that separated the two buttocks, and pockets or other detailing that called attention to the derrière, would put the bottom back at the centre of fashion as an erogenous zone which could be openly – if not actually nakedly – paraded by both sexes. It was a realization that helped to make him a multi-millionaire.

[3] The buttocks were instrumental in the eroticization of underwear, particularly male underwear, which has happened only since the 1950s. For men, the bottom is the only part of their anatomy that can rival female curvaceousness (discounting the undesirable beer belly). This is what artist Tom of Finland achieved in his homoerotic images of men in tight jeans with short blouson jackets. In fashion, Yves Saint Laurent used clever cutting and added seams to underwear to emphasize the contours of the male buttocks. In the 1980s, it was Calvin Klein who brilliantly exploited homoeroticism to sell male underwear as sexual fashion garments: to such a degree of success that CK became known almost entirely for underwear. When the hero of the 1985 movie »Back to the Future« wakes up in 1955, his new acquaintances call him Calvin because that's the name tag they've found sewn into his pants.

[4] The great appeal of the thong for men and for stylists is in its none-too-subtle highlighting of the erotic qualities of the bottom. When the top of the bum is revealed as is intended if the wearer bends or crouches, the small triangle of cloth at the top of the buttocks creates the so-called 'whale tail' effect, which essentially acts as an arrow directing the viewer's attention down between the

buttocks to the location of sexual
desire. This is an amplification of
the erotic effect created by all
glimpses of forbidden and private
underclothing, which have in more
prudish periods of history been the
ultimate thrill.

[5] Tight breeches and jodphurs evolved
over centuries to make horse riding
more comfortable and safer, by
enabling the rider to exert quicker
and more direct control through
the thighs and calves; their
modern equivalents are silicone-
padded Lycra cycling shorts. In
women, such revealing clothing
has become closely associated
with sexuality precisely because
it exposes the buttocks, but also
because it carries with it a hint
of class exclusivity – think Lady
Chatterley. The huntsman's uniform
of short, brightly-coloured jacket
and pale, tight breeches inspired
Ralph Lauren in 2006, but by then it
was already a staple of sexualized
images of women in the media –
or in soft porn, when usually
accompanied by a snaffle, whip
and aggressive 'power' dog.

THE
BODY
ANATOMIZED

'Some smart man once said that on the most exalted throne in the world we are seated on nothing but our own arse' – WENDELL MAYES, »In Harm's Way« (film script), 1965

[2]

[3]

[4]

[5]

[1]

[2]

[3]

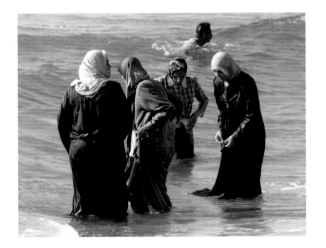

[4]

Legs are one of the most visible parts of the body: in adult men and women they normally make up half of the body length. They are, of course, what separates humans from other animals, none of which live as fully two-legged lives as we do. In clothing, the ultimate requirement is that the legs must be able to move, even in restrictive hobble skirts designed to force women to take smaller, more 'feminine' steps. But clothing also has a role in how the legs communicate through posture and gait. The legs speak loudly because they are powerful secondary sexual signifiers: as boys and girls reach maturity, the male leg becomes hairier and more muscled, while the female leg remains relatively smooth. The legs are also physically close to the sexual organs and the bottom, and therefore are capable of leading the imagination into lewdness. For that reason legs – bared female legs, at least – have been subject to religious injunctions to keep them covered. The slender, long, tapering female leg is still a symbol of sexuality, artificially elongated by high heels or garments cut high on the hips. The symbolic purpose of covering the male legs, meanwhile, is largely to announce that the wearer has reached maturity: in Western society bare male legs are associated mainly with children and sportsmen.

–

[1] In the modern world, the male leg is a symbol of power and authority. The prominent muscles of the calf and thigh are throwbacks to our ancestors who could run with wild beasts when hunting. They are also subconsciously associated with the thrusting movements of copulation. The growth of hair on the legs is a sign of sexual maturity and is also a secondary sexual characteristic that distinguishes the mature male from the female (younger boys and girls tend to have fairly similar legs). It is this gender difference that meant that traditionally shorts were accepted wear for primary school boys, but not suitable for adolescents, who were visibly becoming men (see Legs, page 130). It is only in relatively recent decades that even mature businessmen habitually wear shorts in summer – and in as well as outside the office – or that macho musclemen have begun to shave hair off their legs to display their physique more clearly.

[2] In women, the ideal leg is smooth – often enhanced by the use of stockings – full and rounded enough to suggest that the woman is healthy; and long, because leg-length is a primary sign that a woman has reached sexual maturity (a major evolutionary factor in establishing a woman's attractiveness to men). For men, a woman's legs have been termed 'twin conduits of desire'. One of the reasons that female legs are so attractive and have therefore been so frequently disguised by clothing is said to be that the simple act of walking has a powerful arousing effect on men, given the sexual symbolism attached to the open female legs. Sheer or fishnet stockings, which reveal as much as they conceal, only underline the forbidden quality of this usually hidden area.

[3] The eighteenth-century German art critic Johann Winckelmann was a great admirer of his friend, the artist Joseph Mengs. What Winckelmann particularly appreciated was Mengs's ability to paint knees in a way that rendered what he saw as one of the most unattractive parts of the body as at least acceptable if not positively attractive. There is no doubt that not all legs are perfect. In fact, few are. The weight they have to carry and the work they have to do make them liable to suffer wear and tear, with injuries, scars, varicose veins, misaligned feet, limps, creaking joints … and knobbly knees. It was the couturier Norman Hartnell who remarked that most women have knees like rock cakes. The kneecap is hard and unmalleable. The ankle is frankly no more attractive. So fashion has, in fashion's way, ignored the presence of these bony lumps altogether.

[4] Avoiding immodesty is the main reason for religious instructions to cover the legs, yet few religions have very specific requirements. Rather, they require general covering of the body. Muslim Hadith – the sayings of the prophet Muhammad – tell men and women to cover their thighs at all times. Women should dress modestly, showing only their faces and hands, while men should cover themselves at all times from the navel to the knee. The same is true even in an age of revealing sportswear: Muslim female athletes at the London 2012 Olympics competed

in full tracksuit trousers, a long blouse and a headscarf. The Bible, meanwhile, requires women to 'adorn themselves in modest apparel' – an injunction that continues to be acknowledged in visits to church.

[5] Whether it reflects knobbly knees, the dangers of exposing one's thighs or the fact that older legs often become thin and unattractive, decorum has always required that legs be covered. Shorts and short skirts have no place in the boardroom, the courtroom or the high-class restaurant (it was George Orwell who identified waiters and maître d's as the most snobbish guardians of social traditions and rules). Among the most notorious enforcers of formal dress are the stewards at the Henley Royal Regatta in the UK, who insist that women in the Stewards' Enclosure wear dresses or skirts with a hemline that comes below the knee – and never trousers or shorts. Women are said to be subject to the humiliation of having their dress lengths measured with the intention, according to the regatta, of maintaining 'the atmosphere of an English Garden party of the Edwardian period by wearing a more traditional dress'. Trousers for women were for a long time unacceptable in formal settings. There is a famous but unsubstantiated story about the socialite Nan Kempner arriving at a fashionable New York restaurant in the 1970s wearing a trouser suit by Yves Saint Laurent. On being informed that trousers were not permitted, as they were deemed immodest, Ms Kempner went to the ladies' room, removed the offending garment and returned to eat wearing only her long jacket.

[6] The legs of men and women look different and even cause them to walk or run a little differently, due to their different means of being attached to the pelvic bone (in order to facilitate childbirth in women). For much of ancient history, however, they were dressed in very similar ways, although female clothing has always tended to be longer, not only as an expression of modesty but also as a reflection of the fact that, not being hunters, they required less speed. For the last thousand years, however, the way in which the legs have been covered has been one of the most noticeable differences between male and female dress. To use modern terminology, women wore dresses while men wore trousers. Changes in the second half of the twentieth century have brought male and female clothing closer together again, however – to some extent. While male skirts remain uncommon off, and even on, the catwalk, female trousers have become everyday wear. At the start of the twenty-first century a survey found that up to 84 per cent of women in London preferred to wear trousers to work rather than skirts (see Workwear, page 234).

[7] The well-known story of Victorians covering their piano and chair legs from a sense of prudishness, while it captures something of the enduring fear of legs – particularly female legs – is, alas, untrue. If furniture legs were covered, it was almost certainly as part of a feminine taste for drapery or to disguise cheap furniture; and in better-off homes, Victorians were often eager to show off the fine carving and workmanship of their tables as signs of opulence. But it is true that Cole Porter was right: 'a glimpse of stocking was something shocking'. Legs in Victorian times were hidden beneath layers of rustling skirts and dresses that completely disguised their shape. The crinoline encased the entire lower half of the body in a bell-like shape that hid even the movement of the legs, while ankle boots made sure that even a thrilling glimpse of a foot peeking from beneath did not risk revealing any actual flesh.

MODEL WEARING GIVENCHY EVENING DRESS, PHOTOGRAPH BY GENEVIEVE NAYLOR, 1954

MODEL WEARING YVES SAINT LAURENT TROUSER SUIT, 1967

'SEASIDE DRESS', HAND-COLOURED PLATE FROM »ENGLISHWOMAN'S DOMESTIC MAGAZINE«, 1867

'The woman shall not wear that which pertaineth unto a man, neither shall a man put on a woman's garment; for all that do so are abomination unto the lord thy God' – BIBLE (King James version), Deuteronomy 22:5

[6]

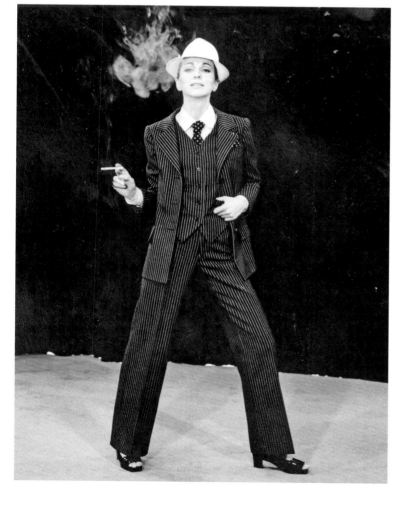

[7]

[1]

THE HOBBLE SKIRT.
"WHAT'S THAT? IT'S THE SPEED-LIMIT SKIRT!"

[2]

[3]

For most of history the female legs – and often the male legs – have been clothed in loose garments that disguise the shape of the limbs beneath. The simplest such garment is the skirt or dress, which at its most basic is a piece of material wrapped around the waist or draped over the body. There are many variations, of course: skirts may be so short that they reveal almost the entire leg; they can change the apparent shape of the legs or the proportion between the legs and hips; they can be layered, pleated or split. Male skirts have largely died out. They survive as peasant wear in some Asian countries, as robes in Arab states and as anachronistic displays of male authority – as in the skirt-like garments worn by the Knights of the Garter (see Heritage, page 204). Ceremonial military skirts are reminders that what have become almost exclusively feminine garments came from a masculine, war-like tradition.

–

[1] There is no inherent reason for skirts to be considered feminine and trousers masculine. The split happened centuries ago, after the evolution of garments from loincloths and tunics into togas and sheath-like dresses. Men walked further and rode horses more, and thus evolved garments that allowed more freedom of movement. Women's dress remained based on the earlier all-enclosing garments, which were easy and relatively cheap to make. When it became more normal for women to ride horses, such as during Georgian times when hunting became a pastime shared by both sexes, they often rode side-saddle in long skirts in order to preserve propriety. Horse riding nevertheless allowed them to overcome the limitations on movement associated with skirts that reached to the ground.

[2] The hobble skirt is one of the few items of dress that has as its purpose the limitation of the body's natural movement. The full stride has long been seen as manly (practical, and a demonstration of strength), and smaller steps therefore more feminine. In China, the extreme practice of foot binding (see Feet, page 136) was used to limit women's ability to move quickly and easily to heighten this attribute. The hobble skirt is said to have been introduced to Europe by Paul Poiret in the early 1910s, based on the idea of the small-strided walk commonly used by geishas. Whatever Poiret's role – skirts had anyway become narrower over the preceding years – the hobble skirt (named after the practice of hobbling horses) achieved great popularity, despite the fact that its arrival coincided with a general loosening of clothing as a consequence of the growing popularity of sports and other outdoor pursuits. Today the hobble skirt is a mainstay of the bondage and club scene, but it also makes frequent appearances on the catwalk – and, rather less alluringly, on red carpets.

[3] A true skirt is shaped to sit on the hips, making it different from a wrap. One basic type is cut straight; the other is gathered to a greater or lesser extent at the waist but remains fuller at the base. The full shape helps emphasize the narrowness of the waistband, while allowing the bottom and the groin area to be disguised. Gathered or full skirts include types such as the dirndl, the traditional dress of the German and Austrian Alps, which combined a full skirt with a bodice, blouse and apron and had its roots in servants' clothing (see Heritage, page 204). The pleated skirt can be long or short, and pleats take various forms including knife pleats, box pleats and loose, full pleats – which may be gathered only near the hips and waist or may fall the length of the skirt. Knife pleats, the most common, overlap and lie flat. The pleated skirt of Christian Dior's New Look of 1947, for example, used 15 metres of fabric for a day skirt or 25 metres for the skirt of an evening gown.

[4] Clothing covers the legs in one of two ways: with either an undivided or a bifurcated (divided) garment. Undivided garments, which can be loosely described as skirts, may in turn be either long or short. Long skirts include robes and full-length dresses; short skirts include the miniskirt and, for men, the Scottish kilt. Bifurcated garments have two legs, either joined as in trousers or separate as in Renaissance hose. Again, they have long or short forms. The long form includes hose, breeches, trousers and jeans; the short form mainly includes various forms of shorts worn for sporting activity as well as some costume oddities

[1] »JOHN AND SOPHIA MUSTERS RIDING AT COLWICK HALL«, GEORGE STUBBS, 1777, OIL ON CANVAS

[2] HOBBLE SKIRT, C.1912, POSTCARD

[3] NEW LOOK COLLECTION, CHRISTIAN DIOR, 1947

[4] »LT MACPHERSON WINNING THE VICTORIA CROSS IN THE INDIAN MUTINY«, HARRY PAYNE, 1857, LITHOGRAPH

LEGS – SKIRTS

such as Bermuda shorts, which outside the Caribbean are largely associated with leisure.

[5] Everyone once wore skirts, or skirt-like robes, and in parts of the world men still wear long undivided garments, such as the traditional dhoti, kimono and changshan of southern and eastern Asia. In the West, however, the division between male and female dress has entered the language to the extent that a young woman was frequently referred to between the two world wars as 'a piece of skirt', while the dominant partner in a relationship is described as 'wearing the trousers'. Male skirts have often been championed on the catwalk, most notably by Jean Paul Gaultier, who sponsored the 2003 exhibition at the Metropolitan Museum of Art in New York entitled 'Bravehearts: Men in Skirts'. The exhibition was a continuation of Gaultier's exploration of the idea that skirts are a way forward for men's fashion – a rich source of playful wit (and of acres of news coverage) – but his espousal of them seems destined to founder on entrenched perceptions of masculinity. (Though there was a brief upsurge in interest in the mid-1990s when David Beckham was photographed in a sarong, few, if any, men were ready to follow his trail-blazing look.)

[6] In the trenches of World War I, the German troops nicknamed the Black Watch 'ladies from hell' because the Scots went over the top with their kilts swirling around their knees and the unearthly bagpipes blowing. Although it represents clear evidence – and is the most often-cited example – of the fact that real men do not have to wear trousers, the kilt is not actually a skirt but a wrap. The modern kilt echoes the short tunics of the ancient Greeks and Roman centurions, designed for quick marching and fighting on the battlefield, but was directly descended from the greater kilt of the late sixteenth century, which was long enough to be draped over the shoulder, wrapped around the body for warmth and even used as a blanket against the cold and wet. The modern Greek Evzones wear a similar short skirt known as a fustanella, which may be derived from the toga, and seems also to have employed excess material in the form of pleats in order to keep the wearer warm in colder regions.

[7] At the opposite end of the scale from the war-like kilt, male religious clothing also takes the form of undivided garments: the priest's cassock, the monk's habit and the scarlet robes of the cardinal are all anachronisms that hark back to a period when the Christian Church was young and everyone of quality in Rome wore robe-like garments. The cassock itself was adopted in the sixth century, originally in and around Rome. While the laity wore short tunics and breeches, the clergy stuck with a more traditional Roman costume of a long tunic worn with an enveloping coat, itself based loosely on the ancient toga. In 572 the Council of Braga in Portugal obliged all Catholic priests to wear a floor-length tunic – the »vestis talaris« – while officiating at the altar, on the grounds that it was more seemly than other forms of dress; the injunction was repeated many times during the medieval period. Today, other anachronisms survive in the shape of the frock coats of judges and livery companies which, although not skirts, nevertheless present a skirt-like appearance and movement (see Establishment, page 188).

'A little while ago it was common for an "advanced" woman to claim the right to wear trousers; a right about as grotesque as the right to wear a false nose ... it is quite certain that the skirt means female dignity.' – G. K. CHESTERTON, 1910

[4]

[5]

[6]

123

[7]

[1]

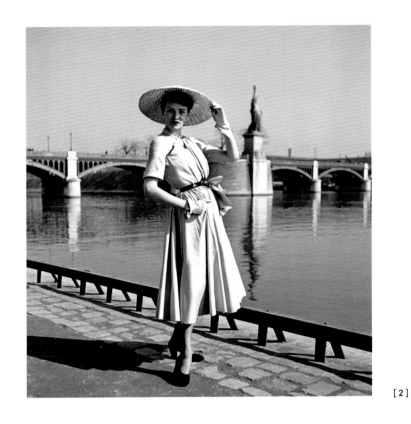

[2]

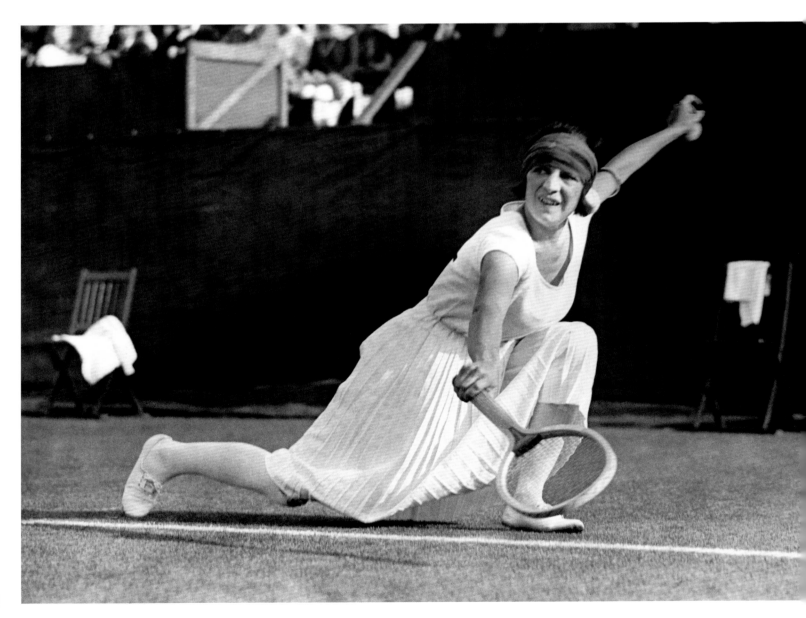

[3]

It may seem obvious that the movement in skirt lengths is generally progressive: that they started out long and gradually became shorter, until the arrival of the miniskirt in the 1960s and the belt-like 'micro' – actually worn by a very few brave souls – soon afterwards. It is certainly true that no garment before the mini had exposed so much of the female legs or made so apparent the shape of the female buttocks, but the story of skirt lengths is more complicated than it might appear. Most changes came in the twentieth century: from ancient times until the 1920s there were few periods when female fashion allowed the exposure of so much as an ankle, as far as most women were concerned. Within the twentieth century skirts became noticeably shorter; in the 1920s, when the Flappers revealed their calves and even sometimes their knees, and then again in the 1960s, the decade of the Great Mini Revelation. On both occasions, the change sparked moral outrage; but on both the offending skirt length soon became accepted as a norm. In between, however, skirts returned to full length in the 1930s and 1940s. Teenage bobbysoxers wore calf-length skirts in the 1950s, as did city workers and women who bought their suits from Jaeger and other high-end stores. And after the mini, the 1970s saw a partial return to the so-called maxi. Some commentators have claimed that shorter dresses are more popular during periods of economic prosperity, but there seems no real substance to the theory.

–

[1] Throughout most of history skirt lengths have tended to be long, so that often not even the ankles could be glimpsed when a woman walked. In Japan, and to a lesser extent elsewhere, this encouraged the development of a unique way of walking in which women seemed to glide across the floor with no visual movement. There were exceptions, however, for practicality. As men's lower garments were influenced partly by the practicalities of riding and walking, so women's were influenced by the need to avoid tripping over one's own skirt. That became a distinct possibility during various dance crazes, such as the galliard of the sixteenth century and the waltz of the late nineteenth century. The galliard in particular was considered

scandalous, with moves in which the man lifted the woman in the air with quite an intimate hold, potentially exposing her legs. Women used their free hands to steady their hooped skirts. In Vienna in the nineteenth century, meanwhile, dancers looped their dresses over their arms, or held them up with straps, thus offering observers a tantalizing peek of the movement beneath.

[2] Skirt lengths and styles change in reaction to what has gone before. The long, tight dresses of the Edwardians were followed after World War I by the looser, shorter dresses of the Flappers. The slim-cut, mid-calf elegance associated with the Depression years of the 1930s was followed by the much shorter cut of austerity and 'utility' clothing during World War II, and then routed with dramatic suddenness by Dior's New Look. In turn, the New Look gave way to the more sober dresses of the 1950s, when working women wore skirts that fell beneath the knee but stopped at mid-calf. The mini changed everything, marking for the first time a radical break with the idea that skirts should be a certain length for everyone. That was one reason why skirt lengths in the 1970s became so confused: from maxi dresses that recalled Edwardian clothing to midis and minis – which remained popular, and to this day seem, like trousers and denim, to have become a standard item in the wardrobes of most young (and not-so-young) women.

[3] One of the iconic women who popularized shorter skirts in the early decades of the twentieth century was French tennis player Suzanne Lenglen, winner of every Wimbledon ladies' final from 1919 to 1926. Dressed on and off court by the notorious purist Jean Patou, Lenglen played in pleated silk skirts that reached only just beneath the knee, an unheard-of thing in all but the most louche (and hidden) societies. She wore rolled-down stockings – held up with garters rather than suspenders – and was rumoured not to wear petticoats or corsets. The shorter skirts fit with Patou's ideas about transferring the simplicity of sports clothing to daywear, and with those of his contemporary Coco Chanel (though the pair shared a mutual hatred, between them they did much to promote the ideal of youthful athleticism) (see Activewear, page 150). Lenglen's

LEGS – SKIRT LENGTHS

tennis dresses were also cited as the inspiration behind Chanel's costume for the character of the Tennis Player in the 1924 Ballet Russes production of »Le Train Bleu«, created by Sergei Diaghilev and Jean Cocteau.

[4] The precise circumstances of the invention of the miniskirt are shrouded in mystery only fifty years after the event. That may be odd, but it is also profoundly irrelevant. The point about the miniskirt and the reason both for its popularity and its huge influence is not that it was created out of the mind of one designer (the two contenders are André Courrèges of Paris – who has by far the more convincing claim – and the lesser designer, but perhaps more savvy media darling, Mary Quant of London). The mini was the culmination of a trend inspired by Cristóbal Balenciaga and his shift dresses, in a way a return to the medieval tabard, which shaped rather than accentuated the contours of the body. Balenciaga (with whom Courrèges had worked) had been followed by Yves Saint Laurent, whose trapeze dress was short but held away from the figure. Both designers were producing clothes to be worn by the unconstrained female body – which at that time meant the young body. Courreges and especially Quant had helped lower the ideal fashion age and thus launch what became seen as the youth revolution of the 1960s. The miniskirt in various guises has been a fashion staple for half a century, and shows no signs of disappearing. It is a genie that will not be put back into its bottle, even if women wanted it to be – which most do not.

[5] Since the coming of the mini, the skirt length barrier will never be reinstated. As a fashion statement, the mini represents more than anything a freedom that is as symbolic as it is practical. It allows women to stride freely and more easily and to enjoy a sense of liberation. It will go in and out of style, no doubt, but it is now solidly confirmed in most circumstances as a permanent element of clothing: it has become one of the standard skirt lengths: full, ankle, mid-calf, knee, mid-thigh and mini. But skirt lengths in general are no longer the forces for tyranny that they once were. In the last fifteen years, most women have largely rejected the idea of

social standards in dress. They do not care whether fashion says that skirts are long or short, or full or tight. They only care about their own personal style – and that may be different tomorrow from today, or this evening from this morning. Short skirts, like trousers, are as acceptable in business as in social settings. This is also why the great fashion designers are becoming increasingly marginalized as the high street look – based ruthlessly on wearability and sales figures – takes over for most women as the driver of fashionable dress (albeit plagiarizing designer-level ideas with apparent impunity).

[6] In the past a woman who displayed her underwear, even accidentally, would feel embarrassed and possibly ashamed; she would risk being criticized as a slattern. In the past decade or two, however, driven by the quest for celebrity and the growth in popularity of titillating 'lads' mags', wearing skirts so short that they expose the underwear has become habitual and accepted behaviour among a certain type of female celebrity. Magazines are full of 'up-skirt' shots of young women getting out of limousines, something almost impossible to achieve without displaying a glimpse of underwear. Magazine editors who understand the appeal of the forbidden and hidden to young men fall on such photographs; the young women have not actually revealed anything, but the readers have something new to fantasize about. Where's the harm? The harm is that the day will come when exposing their knickers no longer gets women into magazines – so what will they expose then?

'Fashion is born by small facts, trends, or even politics, never by trying to make little pleats or furbelows, by trinkets, by clothes easy to copy, or by the shortening or lengthening of a skirt'
– ELSA SCHIAPARELLI, 1954

[4]

[5]

[6]

[1]

[2]

[3]

The skirt has often served to disguise the true shape of the legs and of the area around the waist and hips, while at the same time enhancing the physical attractiveness of the wearer. In early periods when materials were thick and heavy, the weight of garments obscured the legs and their movement. As materials became lighter, with the associated danger that they might cling to the leg and thus expose its shape, dressmakers began to use artificial shaping such as hoops to lift the skirt away from the legs altogether. Even when skirts have risen short enough to expose the female legs up to the middle of the thigh, they have invariably used a variety of shapes and styles to disguise or emphasize the waist, buttocks and pubic region. These variations have depended on the fabrics used as well as on different dressmaking techniques. There still remain, however, just two basic types of skirt: straight and gathered. Even the simple tie-around skirt can be worn in these two ways, depending on the amount of material used.

–

[1] The crinoline was one of fashion's more absurd developments. The result of this framework of hoops, which created a shape something like a narrow bell, was to liberate the female legs and enable a full range of movement while masking them from the outside. This Victorian development was less formal than the earlier farthingale and panniers, but it did grow to enormous widths – up to 6 feet across – which made it difficult for the wearer to pass through doorways or to sit down without having the whole thing rise up in her face (see Impractical, page 208). Having become so impractical, it was perhaps inevitable that the fashion had declined by the 1860s, to be replaced by the far more modest bustle (see Bottom, page 112). In 1985 Vivienne Westwood revived a smaller version, the mini-crini, inspired by the ballet »Petrushka« and based partly on the shape of the tutu. Westwood was working with ideas of changing the shape of the body, but the mini-crini also had echoes of nostalgia. As much as anything, the child-like skirt recalled a party frock, which was in itself an echo of the innocence and charm of the Christmas tree fairy.

[2] Legs are powerful communicators. Whether sitting or standing, our legs can communicate relaxation or formality, receptiveness or defensiveness. Finishing schools used to forbid young women from sitting with their legs apart in order not to give out the wrong signals to men, but to sit instead with their knees close together – a pose also advised for getting out of a motorcar. Even crossing legs was often discouraged on the grounds that it is inherently masculine, that it can cause clothing to ride up or bulge unattractively, and even that, some medical opinion maintained, it could cause varicose veins. Just as eloquent as the way of sitting is the way of walking. In general, women tend to take smaller strides than men but share many of the same walking styles; there are said to be thirty-six gaits in all. For women they include the hobble, the glide, the mince, the bounce, the wiggle and the stride. Some gaits display strength and determination – like the stride – while the bounce and the prance are clear demonstrations of health and vitality. The wiggle is a sign of sexuality that easily fades into parody: witness Marilyn Monroe in her high heels and tight skirts, or the mincing wiggles adopted by her co-stars Tony Curtis and Jack Lemmon when they pose as women in »Some Like It Hot« (1959).

[3] For all its simplicity, the skirt is as open as any other garment to misappropriation by fashion. Few designers are as culpable – or as successful – as the British designer Laura Ashley in the 1970s. Ashley combined gingham, floral prints, petticoats, full skirts, puffed sleeves and lace collars to create a vision of an English country milkmaid (see Escapism, page 186). The whole fantasy was as bogus a tradition as the infamous ploughman's lunch, a marketer's dream never eaten by an actual ploughman. It was Ashley's masterstroke to realize that urban dwellers felt removed from the rural world and wanted to recapture its supposed innocence. So she dressed them in full skirts and layers of frothy petticoats to recall an idealized past. Despite its doubtful credentials this look still has great appeal at music festivals and in tepee villages as an alternative to the slavery of commercially-driven fashion change (see Hippy, page 206).

LEGS – SKIRT SHAPES

[4] The tutu may seem like a superfluous piece of clothing. It covers barely anything: indeed, it would be useless for its purpose if it did conceal the legs of the ballerina whom the audience has come to watch. And yet it answers the basic social requirements of all dress by making the dancer's appearance more modest and therefore more acceptable than it would be in a leotard and tights alone. It also serves to make the legs look longer without obscuring them, while its movement emphasizes the dancer's lift and elevation. It is in essence a form of athletic dress conceived to enable a job to be done efficiently. Ethereal Swan Lake corps de ballet more frequently wear a calf-length net skirt, however, because even balletomanes do not need to concentrate on their movements as much as they do with the prima ballerina assoluta.

[5] Dresses have often been adapted to the requirements of dance. In late-nineteenth-century Vienna, the small train at the back of a ballgown had a loop of string that enabled the wearer to lift it off the floor while dancing. In the 1920s the flappers' shorter dresses freed the legs for the Charleston (named for the town in South Carolina) and exhilarating new athletic dances, such as the Lindy Hop (named for aviation pioneer Charles Lindbergh), that swept across America. In the 1950s rock 'n' rollers wore simple circle skirts and full petticoats, pleated and gathered at the waist. Today clubbers wear short, tight dresses that expose the lower part of their thighs, a kind of performance dress for a form of dancing that more closely resembles an aerobics class, in which the energetic movement of the legs demands to be seen. The ballgown or prom dress may be the single most formal garment worn by many young women with the exception of their wedding dress and, like it, only once – if at all (see Romantic, page 222). Its full-length wide skirts lend grace to movements by hiding the legs beneath, creating an impression of swan-like gliding, in theory at least. The fact is that the modern woman walks in a way much more like men than the graceful, prim movements of 'Miss Austen's young ladies', crippled by a middle-class sense of propriety imposed by men and endorsed by older women, in the hope that virginity could be maintained until 'wedding and

bedding' had taken place. (These guardians of propriety chose not to admit the fact that even a voluminous skirt could be lifted in a minute.)

[6] The straight or pencil skirt has always been associated with formality. It derived from the Edwardian hobble skirt, itself a re-invention of the high-waisted Directoire style of the early nineteenth century, but was somewhat shorter – though still below the knees – with a slit in the back to make walking easier. By the 1920s and 1930s the pencil skirt had been adopted for wear by women in offices, but it reached its apotheosis in the 1950s, when it was worn in a straight form for business (see Workwear, page 234). It was resurrected in the 1980s, when it became part of female 'power dressing', along with masculine-cut jackets with shoulder pads, and it has now become just another alternative choice for women – the development of which has written the history of dress for the last 100 years.

[7] Layering dresses gives them fullness and also helps create a sense of sexual anticipation by enfolding and disguising the shape of the legs and even their precise location within billowing folds of petticoats. In the Victorian and Edwardian eras this erotic charge was widely recognized, especially in Paris, seen as the city of sin and sexual licence. This was the world of the Folies Bergère and the cancan, the scandalous dance in which the legs were framed by the rippling layers of cloth. A word was coined – 'frou-frou', meaning frilly – for the tantalizing whisper made by petticoats as they moved across the floor. The sound alone could stir men to erotic thoughts. For all its allure, however, layering began with more practical purposes: helping to keep the legs warm without the need for hosiery, and also protecting the valuable dress itself.

[4]

[5]

[6]

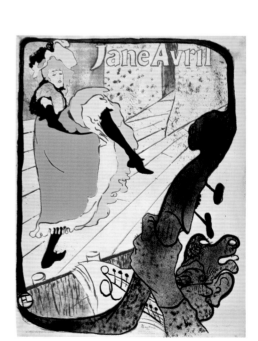

[7]

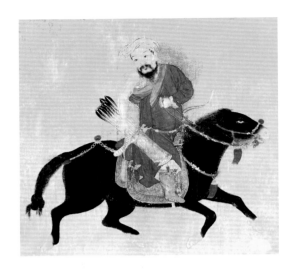

[1]

[2]

[3]

[4]

Dividing a garment into separate legs – bifurcation – involved a long process of technical innovation. It was often desirable for each leg to be covered separately: for horse riding, for example; for running; or for many forms of work. And it was easy to dress each leg separately, either in hose or with straps wrapped around the leg: the difficulty came in joining the two garments together in a way that would preserve modesty, allow a full range of movement and still allow the wearer to attend to calls of nature. There were various solutions, such as joining the legs of hose with a front flap that developed into the notorious codpiece (see Genitals, page 106). As tailoring skills developed in the later Middle Ages, however, it became easier to stitch the legs together into a form of knee-length breeches, worn with long stockings; breeches were followed by trousers. For women, however, bifurcation remained a scandalous prospect until the late nineteenth century. The efforts of clothing reformers, allied with the social revolution heralded by the invention of the bicycle, provided the impetus to introduce bifurcation for women. Even so, bifurcated garments remained specialized female wear until well into the twentieth century, when women arrogated trousers as the clothing of the dominant gender.

–

[1] MONGOLIAN ARCHER, CHINA, FIFTEENTH–SIXTEENTH CENTURY, INK AND COLOUR ON PAPER

The invention of trousers is conventionally attributed to the Scythians, who came riding out of the steppes in about the sixth century BC. The fact that the Scythians were horsemen was instrumental in shaping their costume. Horse riding, and particularly fighting on horseback, influenced the development of male costume for centuries – until as late as the nineteenth century. This is one reason why men in Western Europe tend not to have worn such loose-fitting clothes on their legs as men in cultures where the horse was not a common method of transport, such as the Middle East and South Asia. Until at least the time of the Mongols and the development of specialized military uniforms, the cavalry who could best control their mounts were dominant on the battlefield: the bands of raiders who encroached on Europe from the east – setting off profound migrations of peoples

within Europe – were without exception horse riders: and they all wore a form of garment similar to the modern trouser.

[2] FRENCH MANSERVANTS, 1852, PRINT

Among the earliest types of bifurcated garment, breeches have had a long and surprisingly persistent history. The word is known from the early thirteenth century, but was often used to describe underwear until about the sixteenth century, when it took on its current meaning of a bifurcated garment that reaches to the knees. Breeches were at different times full or tight to the thigh, and were worn with stockings; long socks that were the descendants of medieval hose. Such was their symbolism that it was a notable occasion when young boys were 'breeched', or given their first pair of breeches, when they abandoned dress-like garments at the age of six or so. The beginning of the end for a fashion that on a good figure could look both flattering and commanding came at around the time of the French Revolution – responsible for upheaval in so many forms of cultural life – when breeches were seen as a symbol of the aristocracy. The revolutionaries styled themselves sans-culottes, 'without breeches', to emphasize the difference. Trousers replaced breeches in all but specialized contexts: riding breeches of various types, servants' livery, court dress and children's knickerbockers (see Heritage, page 204).

[3] MILITARY OFFICERS, PRUSSIA, EARLY EIGHTEENTH CENTURY, COLOURED ENGRAVING

Petticoat breeches were neither fish nor foul. They were short trousers, but they were constructed to look like a skirt, with layers of ruffles that pressed together to give the impression of petticoats. These remarkable garments came into fashion in France in about 1652 – though their alternative name, rhinegraves, betrays their German origins, which possibly lay with the eccentric Count Palatine Frederick V. Each leg was nearly a metre wide, creating such full folds that the bifurcation was entirely hidden, and trimmed with lace or loops of ribbon to fill out the silhouette; the breeches were attached to equally flouncy stockings, known as cannons. The style did not spread far beyond France – though they were briefly a craze in Britain around 1660 – and died out around 1675. For over twenty years, France's fashion leaders had aped the appearance

LEGS – BIFURCATION

THE
BODY
ANATOMIZED

of women's clothing, and faced ridicule and moral opprobrium for so doing. The obvious question is 'why?' The answer lies in the male impulse to display and to draw attention to the legs (in a way that was not open to any woman of the time), but also in the tendency of both sexes to envy the clothing possibilities of the other.

[4] The early twentieth century saw a curious return to trouser-like garments that were not quite trousers. They included knickerbockers, named by the American writer Washington Irving, who used the word to describe high-class New Yorkers who clung to the culture and dress of their Dutch ancestors, including loose knee-length breeches. Knickerbockers were worn by schoolboys during the winter, and had been a fad with Oscar Wilde and members of the Aesthetic Movement in the late 1870s, who saw them as part of a relaxed and fluid appearance with an 'artistic' line (see Dandy, page 182). But in the first decade of the twentieth century the ease of movement they allowed led to their adoption by many sportsmen, including cyclists, baseball players, climbers, skiers and golfers. In 1924 Edward, the fashion-conscious Prince of Wales, delighted the people of the US with his plus-fours: traditional knickerbockers extended 4 inches below the knee (hence the name plus-fours; plus-twos, plus-eights and similar, following the same pattern). The extra length added a dash that fitted perfectly the youthful dynamism of the Jazz Age, and plus-fours were rapidly taken up as leisure wear, particularly on the golf course (see Activewear, page 150).

[5] Modern bifurcated garments for women begin with bloomers. This all-enveloping garment – the bifurcated legs came down to the ankles, hanging loosely so as not to betray the shape of the limbs inside, and the top half of the garment was covered with a skirt-like petticoat for modesty – was dreamed up by the temperance campaigner Libby Miller in 1851, based on Asian female costume. It was taken up by a number of campaigners, but will forever be linked with the woman who gave it its name, Amelia Bloomer. Like other contemporary advocates of rational dress, such as Gustav Jaeger and his all-in-one knitted

suits, Bloomer was dismissed as a crank. From the start, the garment was singled out for ridicule – as it has been ever since – for no reason other than rampant male chauvinism. Bloomer herself had given up on her invention after only a decade, adopting the crinoline instead which if anything, amused the men even more; they were pleased that their ridicule had removed a threat to their sexual sovereignty.

[6] During the French Revolution of 1789, culottes were the symbol of the aristocrats of the Ancien Régime in France; while the nobles wore breeches fastened around the knee, the revolutionaries wore trousers and called themselves 'sansculottes', or 'without breeches'. The name culottes survives in the rather unlikely form of women's leisure shorts which, unlike the historical male garments, are loose and hang like skirts. The reason is that modern culottes did not descend from breeches but from long skirts that were divided to allow Victorian women to sit astride a horse rather than riding side-saddle. These culottes disguise the upper part of the legs in the way usually associated with formal wear, making them acceptably modest dress for pursuits such as bicycling (see Sportswear, page 226).

[7] In the second half of the nineteenth century cavalries and other horse riders adopted the ankle-length jodhpurs that originated in the Indian city of Jodhpur, which were loose around the thigh but fitted from the knee to the ankle. They were a development of riding breeches that allowed the rider more control over the horse, and could be adapted with further refinements such as leather patches inside the knees. The flapping material of the upper thighs made jodhpurs seem absurd when the wearer was not on horseback. Like the penguin or seal of the fashion world, they were ungainly outside their natural setting, but perfectly functional within it. With the introduction of stretch fabrics such as Lycra in the 1960s, the shape of the jodhpur became more regular, but still retained the traditional contrast between the comparatively loose cut of the thigh and the close fit of the lower leg, which needs to allow the rider to 'feel' the horse's side in order to control it.

[5]

[6]

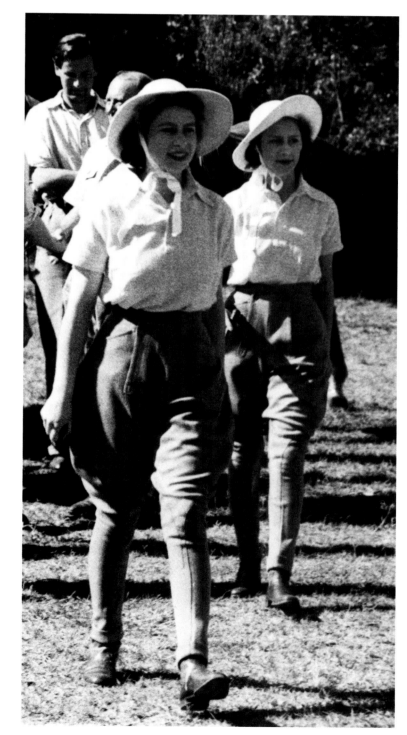

[7]

[1]

[2]

[3]

[4]

It may be difficult to remember when standing on a city street on a summer day, but the idea of exposing the bare legs is little over a century old outside specific settings such as nineteenth-century music halls, with their notorious near-naked dancers. Even swimsuits covered the legs when they first appeared – but that did not stop women from being arrested in carefully staged police raids on the beaches of Coney Island. Some performers had licence to reveal their legs, such as ballet dancers, or circus acts who performed in leotards and tights. Things changed in the early twentieth century. Boy Scout founder Robert Baden-Powell popularized modern shorts for men; meanwhile in Hollywood Mack Sennett promoted his Bathing Beauties, who caused outrage but also achieved huge popularity for flaunting their legs (they included future movie stars such as Gloria Swanson, Carole Lombard and Mabel Normand). Sennett's women became pin-ups for the US Doughboys fighting in World War I. From this breakthrough, it did not take long before sportswear led the way in encouraging athletes to bare their legs as and when they felt it necessary (see Sportswear, page 226).

–

[1] Shorts are a relatively new item of clothing, although there is some evidence that tight shorts were worn in Iberia after the fall of the Roman Empire. In the nineteenth century shorts were sometimes worn by European servicemen overseas, particularly in India. They were introduced to Europe around 1910, when Robert Baden-Powell sought a universal, classless uniform for his new Scout movement. Shorts were practical, but also emphasized youth, athleticism and good health: they were clearly outdoor wear. However, shorts were slow to catch on, even for sport. It was only in 1932 that the first male tennis player wore shorts – Bunny Austin at the US Open – followed by the first woman, Alice Marble, two years later. Later that same decade, British men and women adopted shorts for camping, hiking and cycling. They were accepted at home – the British have always been rather proud of their practicality – but the idea of women exposing their legs continued to attract protests when cycling clubs toured foreign countries.

[2] Sportswear has its own fashions and, to a large extent, must observe the social norms governing dress at a particular moment. The story of football shorts, for instance, tracks changing social attitudes. The first players – the world's first professional league was formed in northern England in 1888 – wore three-quarter length trousers that overhung or were tucked into long stockings. By the early 1900s the shorts were knee length, again with long socks, but sometimes exposed part of the players' legs. Shorts then grew shorter, but only slowly (hence the impression of so many knobbly knees given by film of the 1950s). In the 1970s and early 1980s, however, they made a sudden rise to expose most of the thighs; they also became revealingly tight. Such a development served no practical purpose – the speeds at which soccer is played do not require aerodynamic adjustments – instead, they reflected the triumph within society of the ideal of the young, athletic male body.

[3] It is acceptable for children to bare their legs (although this development is no more than a century old). The transition from short trousers to long trousers has in Western society become part of the ritual of growing from a boy into a man, or at least a teenager. Many people will remember any boy unfortunate enough to attend the first day of secondary or high school wearing shorts that were perfectly acceptable only a few months earlier at junior school. The increasing informality of dress, however, has seen a growth in the popularity of shorts among older men, too, ostensibly for the practical reason of keeping physically cool, but also because of shorts' association with youth, action and adventure – which makes it possible for even the middle-aged and out-of-shape to convince themselves they are 'cool' in every sense of the word.

[4] Perhaps, since we are always told that the planet is getting warmer, shorts will eventually become universal wear for men during the summer. Around a century ago, the British government invented so-called Bermuda shorts – actually dreamed up in London by bureaucrats whose minds were clearly not on fashion statements – as daywear for men serving in tropical colonies. Today, there are periodic reports in the press that the day of the

shorts business suit has arrived: the most recent was in 2008, although the early 1980s briefly saw young London fashionables pairing shorts with a jacket or blazer, shirt and tie and even sockless loafers. This is an utterly sensible approach to dress – and, like all male fashion innovations, is proving slow to be widely adopted. Apart from male mistrust of the new, especially if it exposes parts of the body normally covered, the workplace requires a degree of formality (even though the business suit is now required by only 24 per cent of US companies). Few men would wear shorts to a funeral. Why wear them for business? Middle-aged men who wear shorts to flaunt their relaxed approach to a meeting with the bank manager, for example, might be taken aback if the man on the other side of the desk was also sitting in shorts.

[5] Shaving the legs is an almost exclusively female preoccupation, apart from among male cyclists and swimmers, who claim that it reduces wind and water resistance, respectively (there is no real suggestion that the practice has any measurable effect). For women, the removal of unwanted hair reflects nothing but social expectations and pressures. Leg hair is primarily associated with masculinity and maturity; therefore, its removal heightens the appearance of femininity and youth. This is not a universal practice: in South America, China and Japan, it remains infrequent. But it has been practised off and on by women since ancient times in the Western world: both the ancient Greeks and Romans used razors, tweezers and creams to remove leg hair. The practice fell into decline when women's legs disappeared from view in the late Roman Empire. The modern history of shaving began in the years around World War I, when safety razor manufacturers ran advertising campaigns to convince women that leg hair was unsightly, just as they did for armpit hair.

[6] Film stars' bare legs were some of the first legs that many people saw outside their family: they thus made a profound impression. These women were archetypes of glamour throughout the Great Depression of the 1930s and the world war of the 1940s (see Glamour, page 198). Hollywood actress Betty Grable insured her legs for $1 million;

Jamie Lee Curtis and Brooke Shields also later insured their legs. This objectification of the legs, and of long legs in particular, reflects a particular form of fetishization. For all those who complain about size-zero models and the negative influence of fashion on the self-image of young women, few complain about the relentless championing of the tall over the short. The average woman has not grown taller over the last hundred years, but to look at catwalks and fashion magazines, one might be forgiven for thinking so.

[7] Short city shorts are a relatively new take on urban sexuality. Like so much of our leisure wardrobe, they come from the sports locker. Adored by female tennis players in 1920s California, they were an even bigger hit with women on the beach. But short shorts remained confined to sports and frolics until they hit London in the 1960s. As hotpants, they enjoyed a brief glory on the King's Road and Carnaby Street. At their best in shiny satin (top colours: hot pink, magenta and purple) and very short, they even appeared in sparkly Lycra knit. At the time, they made such a daring statement about youth and femininity that colonels' wives wrote to the papers expressing their horror. Micro shorts have been in and out of style ever since, although more often onstage at pop concerts than on the street.

[8] One of the first purposes for which the legs were commonly revealed was swimming. In the early decades of the twentieth century the tank suit – and its female equivalent, more commonly known by its French name, maillot – was a one-piece costume with a sleeveless top and shorts cut high on the leg for freedom of movement. It left the arms and legs free while safely covering the rest of the body. The maillot often had a short skirt for added modesty. The tank suit (the name came from the contemporary name for a swimming pool, the swimming tank) was worn by such legendary swimmers as Johnny Weissmuller and the Hawaiian Duke Kahanamoku in early Olympic Games. Its stretch jersey, while figure-hugging when dry, became heavy when wet – a far cry from the synthetic bodyskins worn by modern swimmers in an effort to cut through the water that split-second faster.

ADVERTISEMENT FOR GILETTE RAZORS, 1969

BETTY GRABLE, C.1940

MODEL VERUSCHKA WEARING GUCCI, WITH BOOTS BY MARION VALENTINO, ROME,
PHOTOGRAPH BY HENRY CLARKE, 1971

JOHNNY WEISSMULLER WEARING ELASTICIZED TRUNKS INVENTED BY KNITWEAR DESIGNER
CARL JANTZEN, SAN FRANCISCO, CALIFORNIA, USA, 1924

'The uglier a man's legs are, the better he plays golf – it's almost a law' – H. G. WELLS, »Bealby«, 1915

[5]

Shower with a friend.

The Gillette Techmatic® Razor for men has turned out to be a girl's best friend. It's lighter than other razors. Much less likely to nick you. And it doesn't use razor blades. The shaving edge is on a flexible steel band inside a cartridge. You change it with the flip of a lever, in mid-shower, if you like. The Techmatic is adjustable. From tender to very, very tender. Some razors may look more feminine, we admit. But the Techmatic is definitely the most friendly.

The Adjustable Techmatic by Gillette.

© The Gillette Co., Boston, Mass. 1965.

[6]

[7]

[8]

[1]

[2]

[3]

[4]

Trousers have been with us for centuries. For most of that time they have been associated with peasants, who wore loose, lightweight trousers as workwear. It was largely after the French Revolution of 1789 that men began to wear trousers: the garments reached from the waist to the ankles, and possessed a waist-belt and some kind of fly joined by buttons or, later, zips. They were often pleated at the waist and ended in turn-ups to protect them from fraying through contact with the ground. Trousers quickly became standard wear, to the extent that they have almost entirely replaced their forebears throughout the world in one of the most wholesale costume developments in history.

—

[1] Jeans had an unpromising start as workwear during the Gold Rush of the 1850s in California (see Workwear, page 234). The trousers themselves had been around for a couple of centuries, made using a cotton twill – denim – from Nîmes in France and almost always worn as workwear. The breakthrough came when Levi Strauss, a German-American merchant, and tailor Jacob Davis patented the use of copper rivets to reinforce stress points to make the trousers harder-wearing. Jeans' popularity as practical workwear was assured, to be further increased during the world wars, when they were often worn in factories. In the 1950s jeans became a sign of rebellion – in part because of their appearance as worn by James Dean in »Rebel Without a Cause« (1955) and partly through their association with motorcycle gangs (see Alienated, page 154). Nevertheless jeans moved from the factory floor up through the classes, as people were attracted to their casual appearance, to become the socio-sexual statement that they now are for both sexes.

[2] Jeans as separate garments for women did not really come into their own until the 1970s and 1980s, with the emergence of designer jeans. The driving force behind the development came from labels such as Lee, Wrangler and Jordache, and designers such as Calvin Klein, who had so much influence on modern clothing and retailing in the late 1970s and 1980s. But once jeans were established, many famous fashion houses turned to them in the same

way they had to perfumes: as a way to broaden their market by taking the dream to a wider group of people – and to make more money. Those who could never afford high-end designer wear could stretch to a pair of jeans, which were after all appropriate in any setting beyond the most formal. Soon all designers had to have their own jeans range: they were too lucrative not to. Roberto Cavalli and Dolce & Gabbana were major players; Canadian brothers DSquared are a modern equivalent. Such designers make jeans overtly sexy – to the great benefit of sales figures.

[3] When women first started wearing trousers is impossible to declare with confidence. A few women wore loose harem pants around 1910, inspired by Paul Poiret's love of the oriental, but like bloomers before them they were worn only under skirts – and even then only by the boldest. Dungarees – acceptable in the factory during World War II – were a social solecism outside. So perhaps it was as late as the 1960s that trousers became acceptable for most women, with the trouser suit introduced by Yves Saint Laurent and the ready-to-wear designer Charles Maudret in 1966. Jackets cut low on the thighs allowed the new fashion to be worn even by women without particularly thin legs. This was a fashion scene dominated by youth and a time of social upheaval, when the old power structures – of seniority of age, of the primacy of men, of the wisdom of tradition – were under threat. The trouser suit, which was women claiming for themselves a parody of male business dress, was as much a visual expression of the 1960s social revolution as the miniskirt.

[4] The shape of trousers varies widely, but the primary distinction has always been between those that outline the legs and those that are so loose they do not. The flared leg originated as a practical solution to accommodate boots – like boot-cut jeans today – but also improves the silhouette of people with larger bodies or shorter legs. The most extreme form of flared trousers, bell-bottoms, originated as workwear for the US Navy in the early nineteenth century. Various explanations have been offered for the style, including the ease of rolling up wide trouser legs when working in wet conditions. They have remained a distinctive naval garment for nearly two centuries.

JAMES DEAN IN »GIANT«, 1956

DIESEL JEANS ADVERTISEMENT, 2012

CHARLES MAUDRET TROUSER SUIT, 1967

'BELL-BOTTOM TROUSERS', USA, C.1900, SHEET MUSIC

At the other end of the scale, Oxford bags were adopted in Oxford and Cambridge in the 1920s (see Eccentric, page 184). The trousers, which could measure up to a metre around each leg, were associated with privilege (one story is that they were invented by the aesthete Harold Acton, though they were more likely inspired by loose trousers pulled on after playing sports) and soon spread to US universities. There was so little call for the voluminous style elsewhere that it could be called more a lunatic fringe manifestation of effeteness than a real fashion movement.

[5] 'Never too rich or too thin' was Wallis Simpson's pithy summation of the fashionable life. One of the enduring sacrifices female – and male – followers of fashion have made in pursuit of the ideal has been squeezing into trousers that are essentially too small for them: the tightest waists, the thinnest legs. The modern equivalent is perhaps getting into a favourite pair of jeans after they have been washed (in the 1980s a Levi's ad campaign suggested that the only way to get a perfect fit was to wear your new jeans in the bath until they shrank to fit your body). For those who want to maintain such tightness, there are so-called skinny jeans, intended to cling to slender legs. (Among other variants are pre-distressed jeans. The characterful marks worn in over time that once made jeans such a graphic map of an individual's life are now created identically in huge factories.)

[6] Elegance in fashion lies in line, proportion and glamour, and for much of the twentieth century truly elegant women aspired to items such as extravagantly wide trousers of, say, white crêpe de Chine. These implausible garments may look sophisticated in photographs, but lost such sophistication outside the fashion pages. When women try to walk in them the excess cloth wraps itself around their thighs or catches in their heels. Such an outfit is fashion with a capital 'F' (some might say for 'foolish'), produced for women who spend their summers on luxury yachts or in country homes – or wish onlookers to imagine they do. Fashion requires the heightened moment – and wide-cut trousers tend quickly to lose their social cachet around an inflatable backyard paddling pool.

[7] What changed trouser shapes in the twentieth century was, above all, performance and practicality. Few other garments put so much emphasis on ease of movement. That is why, ultimately, social strictures against women's trousers were overcome – and why different trouser variants evolved. Capri pants, said to have been invented by Sonja de Lennart in 1948, derived from the three-quarter length trousers, or pedal pushers, worn by cyclists to avoid oil and dirt from the chain. Cotton cargo pants and shorts were highly practical, with far more pockets than any sensible person could possibly require (see Portability, page 94). Chinos or khakis were ultimately relaxed trousers, usually of cotton twill, that could be worn for both formal and informal occasions (see Generic, page 196).

[8] Many women's first experience of wearing trousers came during the world wars (see Workwear, page 234). In World War I dungarees were worn by the canary girls, whose skin turned yellow from the effects of handling TNT. In World War II they were worn by everyone from Britain's Land Girls to the poster-girl Rosie the Riveter, who encouraged women in the United States to volunteer for industrial work. Dungarees – the name comes from the undyed calico of which they were made, from Dongari Killa in Mumbai, India – became common in the 1890s, and consisted of a pair of trousers with a bib at the front, held up by braces over the shoulder.

[9] There have usually been injunctions against cross-dressing, but there is a long tradition of men dressing as women for entertainment: all Shakespeare's female characters were played by adolescent boys. In the early 20th century a fashion for male impersonators produced stars like Vesta Tilley. But when Tilley performed in trousers at the Royal Variety Show in 1912, Queen Mary averted her eyes by raising her fan throughout the entire act. Cross-dressing was still shocking, and its louche associations continued well into the late 1940s. Women made male dress a statement of sexual intent. It remained disreputable when it was adopted by Hollywood stars such as Marlene Dietrich and only really came into favour during World War II, when vast numbers of women realized through working in men's jobs just how comfortable and convenient trousers could be.

MADONNA, NEW YORK CITY, 1979

SATIN EVENING TROUSERS, BARKERS SPRING FASHION SHOW, 1931

AUDREY HEPBURN, PROMOTION PORTRAIT FOR »SABRINA«, 1954

LAND ARMY GIRLS, UK, 1939

VESTA TILLEY, MALE IMPERSONATOR, 1890S, BROMIDE POSTCARD PRINT

'I have often said that I wish I had invented blue jeans: the most spectacular, the most practical, the most relaxed and nonchalant. They have expression, modesty, sex appeal, simplicity – all I hope for in my clothes' – YVES SAINT LAURENT, 1984

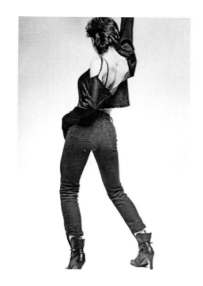

[5]

[7]

[9]

[8]

[1]

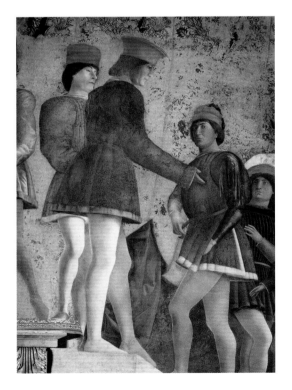

[2]

[3]

Hose – knitted garments that cover the legs and feet – were the dominant form of leg covering from the ninth century. They provided warmth and protection and could be worn as both underwear and outerwear. Originally they took the form of separate bandage-like strips of fabric wrapped around each leg. Hose – the word comes from »hosen«, Anglo-Saxon for 'covering' – were generally close-fitting enough to reveal the shape of the leg, and thus to attract moral censure. Although male hose died out in the late sixteenth century with the development of breeches – apart from for intentionally anachronistic display, such as when worn by the Knights of the Garter – they survived as an important element of the female wardrobe in the form of stockings or tights (more usually known as hosiery). These support and shape the leg, provide warmth and also vary the leg's colour or feel. Hosiery is capable of being all things to all women: woolly tights are associated entirely with comfort and warmth – and maybe sometimes a degree of dowdiness – while the sheen given to female legs by sheer black stockings is perceived as highly erotic (see Sexy, page 224).

–

[1] All the different types of hosiery derive from ancient garments. There are three basic kinds: stockings, tights or pantyhose, and half-stockings or socks. By the 1400s stockings were a knitted or woven garment made of two parts: the upper stocks and the nether stocks. The two parts later divided into breeches and stockings in the sense of separate coverings for each leg, held up by a form of garter or by an elasticated top. In the 1940s women began sewing stockings to their underwear, and early in the 1950s tights, or pantyhose, were invented as a garment that combined two stockings with a waist-piece. Socks cover only the foot, and the calf to a greater or lesser extent up to the knee. The materials used are chosen for comfort, warmth and support, and have included wool, silk, cotton and nylon (see Materials and Texture, page 24). Nylon helps to shape the leg with the addition of the seam up the back of the calf (famously said to have been drawn directly on to the leg in order to simulate stockings by women during World War II, when nylon was in short supply). The same is true of fishnet and other net materials: the grid clings to the leg, defining its curves, while at the same time offering the titillation of bare flesh.

[2] Early hose were cut from linen or wool cloth, because knitting was unknown until the sixteenth century. But in 1560 Queen Elizabeth I was given her first pair of silk stockings, and barely thirty years later the Reverend William Lee revolutionized the industry by inventing the framework knitting machine, first to produce coarse wool for stockings, and then a silk with 20 stitches per inch. Lee did not profit greatly from his invention – the British were nervous about its impact on the hand knitting industry, while in France his fortunes disappeared with the assassination of his patron, King Henri IV, in 1610. However, Lee's Huguenot (Protestant) workers fled Catholic France and brought silk weaving to England, settling in Spitalfields (then a village near London); eventually they gained a charter for the London Company of Framework Knitters to enable them to protect their business. Hosiery was an international concern: those whose work failed to come up to the guild's standards were not allowed to practise. As the price of knitting frames rose, however, the wealthy men who could afford them increasingly disregarded London's authority and the heart of hose production shifted north to towns such as Nottingham, already the centre of the lace industry. When Edward Arkwright mechanized cotton spinning in the late 1750s, hosiery manufacture became even more widespread.

[3] Stockings have always been prized objects. In the Middle Ages, silk ones were the privilege of the greatest in the land. In fact, a gift of stockings could get even Queen Elizabeth I smiling, as canny courtiers knew all too well, especially if they were embroidered. Lesser folks had to put up with coarse woollen ones, a situation that lasted until the early twentieth century, when lisle stockings came on the market. But really it is the decorative stocking that has been most admired by men and women. In the eighteenth century, embroidered clocks and flowers were the rage, and the most popular colours were white and red.

DETAIL FROM THE CAMERA DEGLI SPOSI, DUCAL PALACE, MANTUA, ANDREA MANTEGNA, 1465–74, FRESCO

YOUNG WOMEN GETTING DRESSED, 1962

STOCKINGS BY HUDSON HOSIERY, SHOES BY CHARLES JOURDAN, PHOTOGRAPH BY LOUIS FAURER, 1965

LEGS – HOSIERY

Cut to the 1960s, and the colourful tights explosion was in full swing. After a period of boring browns, biscuits and beiges, from the 1920s to the 1940s, any shade under the sun was suddenly technically possible (see Colour and Pattern, page 36). Kaleidoscopic stockings featured in magazines everywhere. But rainbow-hued legs were only ever a fringe fad. Most women realized that dark, neutral colours were more flattering than stripes, spots or 'amusing' motifs. And the bitter truth is that this remains the case, despite the determination of Marc Jacobs and a host of other designers to give them a new lease of life.

»DR SYNTAX WITH A BLUESTOCKING BEAUTY«, THOMAS ROWLANDSON, 1820, AQUATINT

[4] Bluestockings were not originally the figures of fun or dowdy spinsters they are commonly seen as today; they were not even solely women. The Blue Stockings Society, formed by Elizabeth Montagu in England in the 1750s, was a place for intellectual discussion among the leading women of London, often with men in attendance. The society's name is said to have been taken from one male attendee who could not afford the formal black stockings a social occasion demanded, and so attended in the blue worsted stockings he kept for everyday wear. The name thus symbolized the fact that the society prized intelligence and conversation over appearance and fashion. As such it was directed back at women by men who believed that women should know their place – which was not, they arrogantly assumed, in a literary salon. The writer William Hazlitt pronounced that 'The bluestocking is the most odious character in society.' But the name stuck, both as a negative term and as a fashion option for women who wanted to signal their rejection of the shallowness of fashionable life.

FRENCH TRAPEZE ARTIST JULES LÉOTARD, C.1850

[5] Performance clothes have always had more licence than street clothes, in the same way that outfits seen on the catwalk do not obey the rules of everyday dress. The leotard and tights were pioneered by the French trapeze artist Jules Léotard in the mid–nineteenth century as a garment he called a maillot. Circus performers, ballet dancers, showgirls and other performers were all wearing similar combinations of body garments and hose by the early twentieth century. These were specialist garments, particularly

for men, and were never seen outside the theatre or the Big Top. They underwent a change in the 1970s, when they were worn by rock stars, including David Bowie when he performed as Ziggy Stardust. In the 1980s, Lycra made the garment even more figure-hugging. Apart from a brief fashion for men to wear Lycra tights for aerobics classes in the 1980s, however, male hosiery has become the subject of ridicule. Take, for example, the explicit joke of the title of Mel Brooks's spoof 1993 movie, »Robin Hood: Men in Tights«.

WOMAN PAINTING ON NYLONS DURING WORLD WAR II, 1940

[6] In 2003 the BBC reported on a fashion in Japan for spray-on stockings for working women. Traditional Japanese values discourage, if not forbid outright, bare legs in the workplace, condemning millions of workers to wearing tights or stockings on even the hottest days in the Japanese summer. Yoshiumi Hamada had problems getting stores to accept his invention before he mounted a PR campaign via the fashion magazines. Hamada's aerosol spray allowed women to observe the required modesty while still feeling cooler. This is an indication of the strength of the male fear of naked female flesh: that it becomes acceptable as soon as it is covered with the thinnest layer of paint. To some extent, the invention was a throwback to the practice of European women using food colourings to dye their legs during World War II, when stockings, especially made of nylon, were in short supply.

FISHNET STOCKINGS

[7] Unlike the crocheted half-gloves of old maids in TV adaptations of the novels of Mrs Gaskell and George Eliot, fishnet stockings really do create allure by both exposing and covering the skin at the same time (possibly due to being worn on the legs). Fishnets have become the last word in sexy dressing for the female legs (see Sexy, page 224). The fishnet appeared in the early 1930s (the first nylons were made by DuPont later in the same decade), after the introduction of synthetic fibres had made hosiery sheerer than cotton and cheaper than silk. The mesh of diamonds highlights the contours of the flesh, thereby increasing its appeal. The fishnet thus echoes the appeal of the original stockings and garter belts, which both lent form to the legs and suggested hidden ruffles and forbidden flesh.

'In olden days a glimpse of stocking / Was looked on as something shocking / Now heaven knows, anything goes' – COLE PORTER, 'Anything Goes', 1934

[4]

[5]

[6]

[7]

[2]

136

[3]

[4]

Few items of dress are more laden with symbolism than the shoe. It literally shapes what people do: how they move around; how long they can stand up. It can make them taller, or change their posture. Its shape may not vary too far from the imperative of the form of the human foot, and yet countless variations – in length, width, height, colour and style – give out complex messages. The human foot – hailed as a 'masterpiece of engineering' by Leonardo da Vinci for the way its 26 bones, 114 ligaments and 20 muscles support our weight throughout the 270 million steps of an average lifetime – is different in males and females. The male foot tends to be larger in both length and breadth, possibly as an evolutionary consequence of the advantage of having large feet when chasing animals during the hunt; the female foot is smaller, shorter and thinner, particularly in the heel. If the small foot is considered feminine, then clearly a very small foot is more feminine still, and female footwear has usually sought to emphasize this gender difference. It typically squeezes the foot too thin, makes the toes more pointed than they actually are and uses high heels to make the whole foot seem smaller.

–

[1] No other item of clothing has been at the heart of so many traditional stories as the shoe. The seven-league boots (which allow the wearer to take strides of up to 21 miles, and so move very quickly), the elfin shoemakers who secretly make footwear overnight, Puss-in-Boots, the glass slipper, the old woman and her children who lived in a shoe: these tales are testimony to the central place of footwear in European folklore. Even today, more superstition is attached to the shoe than to any other item of clothing: small shoes are symbols of luck, given to newlyweds or used on charm bracelets. And only the unwary would put new shoes on a table … This close association of shoes with magic and superstition probably has its roots in what was seen as the need to prevent evil spirits from the earth entering the body through the soles of the feet. Some peoples in North Africa, whose feet are so accustomed to the hard ground that they need no practical covering, still use tattooing for the same purpose (see Skin and Body Adornment, page 18).

CONSTANCE JABLONSKI, PHOTOGRAPH BY GIAMPAOLO SGURA, FROM »ANTIDOTE MAGAZINE«, ISSUE 2, 2011

[2] The foot is an erogenous zone, and shoes are common fetish objects. This relates in part to the sensitivity of the skin of the sole, and partly to the obvious phallic symbolism of the feet. In the original French version of the Cinderella fairy tale, the prince's slippers are made of fur (the glass slipper was introduced to the story as a result of a mistranslation in the late seventeenth century). The fur-lined slipper thus represented the female genitalia, which could be entered only by the appropriate 'foot' (see Genitals, page 106). The shape of a shoe can also create an erotic charge: for instance, high heels change the female shape, thrusting out the bottom and pushing the torso forward in an obvious sexual signal. Lacing and unlacing are also highly erotic, relating to the idea of freeing the body from confinement, ready for sexual abandonment. Lacing has been connected with shoes since ancient times, when it was used to bind the sandals of Roman legionaries to their feet: the higher the lacing, the more senior the rank. And superior rank, just like the feet themselves, has always been inherently sexy … When high heels and tight lacing or zips are associated with close-fitting thigh-high boots, the effect is particularly powerful – which is why the dominatrix wears them as her standard uniform (see Sexy, page 224).

[3] Few items of clothing arouse such adoration as shoes. At one time, wealthy women had special chests built with dozens of drawers to carry around their multiple pairs of footwear. Today there are still those who buy two identical pairs of Manolos: one to wear, the other to put on display like a treasured object in a museum. Such behaviour may not seem entirely sensible, but it reflects the deep social significance that many forms of footwear retain even after a century of democratization in fashion. Good shoes are costly, so throughout the history of shoemaking being well shod has been an indication of high wealth and social status. Lobbs are Lobbs, Louboutins are Louboutins: imitations are simply not the same. Comfort demands excellent design, a high level of practical skills, top-quality materials; as a commodity, comfort for the feet is expensive enough to be the prerogative of the wealthy.

»THE SEVEN-LEAGUE BOOTS«, GUSTAVE DORÉ, C.1868, ENGRAVING

»AT THE SHOEMAKERS«, PATTISON'S SHOE SHOP, OXFORD STREET, LONDON, C.1825 (UNKNOWN ARTIST)

FEET – SYMBOLISM

DETAIL FROM »GRIFFONI POLYPTYCH: ST JOHN THE BAPTIST«, FRANCESCO DEL COSSA, C.1470, TEMPERA AND OIL ON PANEL

[4] The first shoes were simple sandals, and a simple form of sole and binding dominated footwear throughout the ancient and classical periods, before more robust (and warmer) pouches of leather or woven material emerged that were tied over the feet. In the Middle Ages thicker wooden soles emerged, and flaps and drawstrings enabled the uppers to be better fitted. Demand from the rich encouraged shoemakers to introduce new styles – often featuring remarkable decoration or highly exaggerated proportions. Boots developed in parallel, driven by the demands of travellers and horse riders to protect the lower legs. By the seventeenth century the shoe had become customarily divided into a sole and an upper, sewn together: the technique remains almost universal today. Materials used for shoes remained similar – cotton, leather or canvas for uppers; wood or leather for soles – until technology introduced rubber and plastics in the late nineteenth and early twentieth century, enabling the development of the original training shoes, the forerunner of most modern informal footwear.

CATALOGUE ADVERTISEMENT, NEW YORK CITY, C.1873

[5] Shoemakers were traditionally sober and industrious – and often nonconformist in their religion and politics, which brought them into conflict with the authorities. George Fox, for example, the seventeenth-century founder of the Quakers, had been a shoemaker's apprentice. Shoemakers seeking religious freedom were among the early migrants to the American colonies, where they soon became influential. The result was that shoemaking is one fashion area – the others being sportswear and leisure wear – in which American skill became comparable with, if not superior to, that found in Europe. American shoemakers led the way in modernizing the industry. In 1792 a New England cobbler abandoned measuring his customers' feet and began making shoes in standard sizes, long before Europeans did the same. The first ready-to-wear boot and shoe store opened in North American in Boston a couple of years later. By the nineteenth century, they were well advanced in mechanization over their European rivals. A shortage of skilled labour drove manufacturers to develop mass-production techniques that eventually brought an end to shoemaking by hand for all but

the very rich. In 1858 the Blake Sewer was invented, which mechanized the process of sewing the soles of shoes, and by 1901 more than a million pairs of cheap, well-made American shoes were being imported into Britain a year, forcing British shoemakers to adopt the latest in technology in order to compete. Meanwhile, within the United States shoemaking flourished with the rise of mail-order companies such as Sears, whose 1895 catalogue first included shoes and boots, allowing anyone to purchase the finest footwear from the East Coast. One American commentator in the 1930s was moved to observe that shoes in England, by comparison, looked as if they had been made by someone who had heard a shoe described but had never actually seen one.

SALVATORE FERRAGAMO AND AUDREY HEPBURN, 1954

[6] In Europe, cobblers have enjoyed a historical reputation as being among the most intellectual and literate of artisans, with one cobbler often spending part of the day reading the newspaper to the others as they worked, and this tradition of mental superiority continues today. Alone of all designers, the shoemaker must be a master engineer, balancing forces and support to make even the highest shoes comfortable, as well as a witty creator. Men such as Andre Perugia, Roger Vivier, Manolo Blahnik and Christian Louboutin, versed in both the world of fashion and the mechanics of the human body, are as concerned about the aerodynamics, weight distribution and balance of a shoe as its colour, pattern and decoration. They are also much more interested in the comfort of a shoe than most dress designers who create a footwear range seem to be.

'Boots and shoes are the greatest trouble of my life. Everything else one can turn and turn about, and make old look like new; but there's no coaxing boots and shoes to look better than they are' – GEORGE ELIOT, 1857

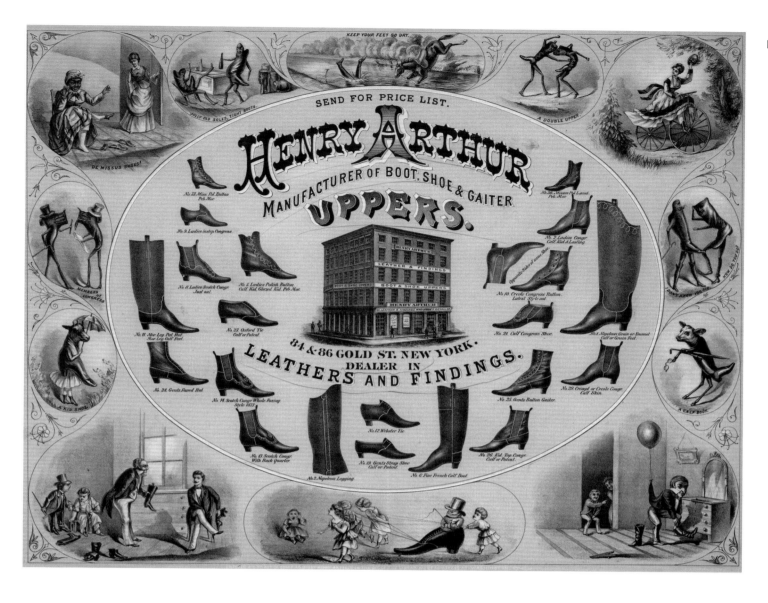

[5]

137

[6]

138

[2]

The quality of a person's shoes has long been seen as an instant indicator of his or her position in society. This has given rise to the suggestion – still occasionally heard today, including from those who recruit executive trainees – that a man may be judged by the shoes he wears more than by any other individual piece of clothing. The shoes of the upper classes have tended to be more exaggerated in shape, from the pointed sandals of Egyptian nobles to the 15-cm-plus wide shoes of Henry VIII's courtiers. Typically, the wealthy have also been able to break away from the drab palette of most footwear to experiment with colours and embellishment. The form of the shoe was only part of the story, however: equally important was how a shoe was kept. A gentleman always ensured that his shoes were clean, polished and never 'down-at-heel' – although the phrase remains common, however, the actual sentiment is an anachronism in today's era of ubiquitous trainers.

–

[2] Is it any accident that versions of the gold-soled shoes of Roman emperors are today worn by sportsmen and women, who are in many ways the new masters of society? At the 2000 Sydney Olympics, US athlete Michael Johnson won gold in the 400 metres in Nike shoes covered with reflective 24-carat gold. Wimbledon champions Maria Sharapova and Roger Federer have similar footwear. Brazilian football player Ronaldhino and members of the Italian national team play in golden boots. Other players wear equally attention-grabbing colours, such as the Portuguese striker Christiano Ronaldo's distinctive red boots. Colour may help spectators appreciate the players' footwork, but it is perhaps more about breaking away from the anonymity of most team sports, as much for the boot-makers who sponsor the wearers as for the players themselves. It sometimes seems that it can only be a matter of time before sportsmen begin living up to Muhammad Ali's famous boast – 'I'm so pretty' – and appear in public in twinkle-toed crystal-smothered boots and sports shoes.

[1] Before the nineteenth century, there were very few mass-produced shoe styles and no differentiation in shaping for left and right feet (these shoes are now known as 'straights'). For the vast majority of the population, badly fitting footwear was the norm. Even among the wealthy, aristocrats sometimes needed to have their valets break in new riding boots for months to avoid the extreme discomfort of the stiff leather. Better-off customers could afford more comfortable and durable materials, such as higher-quality leather, and a superior level of workmanship, meaning that their shoes usually fitted better. Village shoemakers meanwhile produced cheap shoes for workers: soft-soled moccasins, peasant shoes woven from reeds, wooden clogs or wooden soles with felt uppers. Clogs and wooden-soled shoes have usually been worn for protective purposes. The workers of northwestern England wore them for safety on the wet, greasy floors of mills (and also evolved their own tradition of clog-dancing). While most continental clogs – the French sabot, the Dutch clog and the German Klomp – were made from a single block of wood, American and British clogs were more often made with a separate wooden sole and leather upper.

[3] In modern society, the rich and powerful have traditionally turned to subtlety to ensure that their shoes unmistakably confirm their social status while at the same time not seeming gauche. In men's shoes, high position does not usually permit fashion excess: company directors do not wear yellow shoes or white sneakers. The telling markers of the firms that clothe such social status, such as Prada and Gucci, are usually modest: the red strip on the soles of Prada shoes or the Gucci stripe on the classic loafer. Even in other male footwear, colour has often kept to a minimum against the blacks, browns and tans. It might be used for details such as the barley-sugar yellow and brown laces of Caterpillar and Timberland boots. But there are signs that this reticence is changing, particularly among the young. Even men's shoes may now be brightly coloured – but only if they are casual wear … and as long as there is still a badge to confirm their status. For women, on the other hand, the message is far less clear. Any permanent identification with a single regular style is increasingly rare in any form of fashion footwear.

FEET – STATUS

[4]

DETAIL, »PORTRAIT OF KING LOUIS XIV«, HYACINTHE RIGAUD, 1701, OIL ON CANVAS

Coloured shoes were always the prerogative of the rich. Throughout history, the shoes of hoi polloi have been black and brown, partly because any shoes became filthy after only a short time on unmetalled roads and pavements, which were still common in many parts of the West as late as the 1930s, and partly because dyeing leather or other material was expensive. Louis XIV wore high-heeled shoes with his sun symbol painted on the red leather heel (he had adopted red as the colour of kingship, an idea borrowed from James I of England, and ruled that only the nobility could wear it). Louis – a mere 163 cm tall – wore heels up to 13 cm high (no one was allowed to wear higher heels); these prototype kitten heels were occasionally decorated with elaborate battle scenes. Even today, the colour of footwear sends codified signals about status: compare the green Wellington boots made by Hunter, closely associated with the rural upper classes, with the ordinary black variety popular with everyone else.

[5]

ACME BOOTS MAGAZINE ADVERTISEMENT, 1951, USA

The cowboy boot is a rare example of work footwear that has acquired status, with fancy versions being worn with suits by oilmen in Texas. The practice of decoration began soon after the 1860s, when the cowboy boot became distinct from the mass-produced Wellington boot on which it was based, with a smooth tread for sliding the foot into the stirrup, a tall heel to keep it there and a long shaft to hold the boot on the foot and to protect the leg from thorns and snake bites. Topstitching, geometric cutouts and exotic materials such as alligator skin were used to decorate the high sides of the boot. Soon, cowboys themselves kept their valuable dress boots to wear only in town, and wore plainer – and cheaper – boots when out on cattle drives. By the 1880s bootmakers in Texas and Kansas were producing custom-made boots, and the tradition was continued in the twentieth century by craftsmen such as Tony Lama, of El Paso, Texas, whose hand-crafted boots were promoted with the slogan, 'Every pair a masterpiece'. With the increasing mythologizing of the old West and the widespread popularity of Hollywood cowboys, the cowboy boot acquired its own cachet far beyond the Western states, where it had never ceased to be widely worn. In 1946 the

Tony Lama Company produced 'El Presidente', a pair of boots inlaid with gold and silver for President Harry S. Truman, and the ultimate evidence of the status of the once-humble footwear.

[6]

DOROTHY'S RED SLIPPERS IN »THE WIZARD OF OZ«, 1939

Red is a power colour for footwear, and consequently has since Roman times often been reserved for officials and rulers (see Colour and Pattern, page 26). Its erotic charge makes it one of the most glamorous colours for evening shoes – but also dangerous, because it encourages self-conceit and vanity. In 'The Red Shoes', an 1854 fairy tale by Hans Christian Andersen, the heroine becomes so vain that she can think of nothing except her new shoes. When she puts them on, they make her start dancing and she is unable to stop. Half-dead, she must have her feet cut off in order to be saved. The most famous of all red shoes, Dorothy's ruby slippers worn by Judy Garland in the 1939 movie »The Wizard of Oz«, are among the most popular American icons in the Smithsonian Institution in Washington, DC. In the original 1900 book by Frank L. Baum, however, the slippers were silver. The colour was changed by MGM Studios: tradition has it that the decision was taken by scriptwriter Noel Langley. It is the shoes' magic that eventually gets Dorothy home to Kansas, when she clicks her heels together three times, saying 'Take me home to Aunt Em.'

'Elegance and comfort are not incompatible, and whoever maintains the contrary simply doesn't know what he's talking about' – SALVATORE FERRAGAMO, 1950s

[3]

[4]

[5]

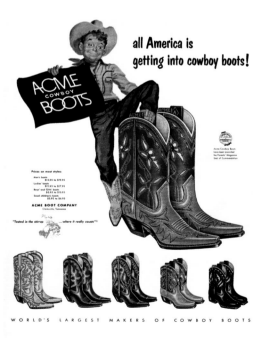

[6]

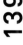

[1]

[2]

140

[3]

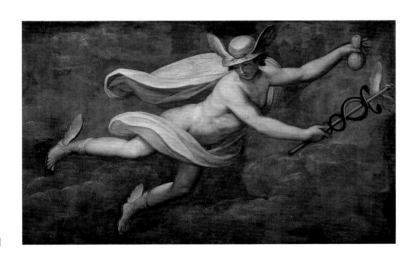

[4]

There are two basic forms of footwear: the shoe, which covers the foot, and the boot, which also covers a section of the leg. The shoe has two basic variations: soft and hard. Other important distinctions are between open and closed toes – the difference between shoes and sandals – and between slip-ons, or loafers, and lace-ups. The slip-on grips the foot through elastication or buckling; laces fasten together flaps on the shoe to attach it to the foot. In 1925 the B. F. Goodrich Company in the United States created another fastening variant when it replaced the seam on galoshes with a new invention that it named the zipper. Other variations come in the sole and heel – whether flat or raised – and in height, which ranges from the ankle to the mid-calf, the knee or even the mid-thigh. The basic styles – sandals, boots and soft slippers – are among the longest-lived of all footwear. Today the word 'shoe' refers to a wide range of possibilities. For men, it most often refers to the slip-on or three styles of lace-ups: the Derby; the Oxford (distinguished by a closed facing, meaning that the two flaps that lace up are stitched together at the bottom of the tongue, while those of the Derby are separate); and the brogue. For women it commonly describes low-cut court shoes (known as pumps in the United States, even if they have heels).

–

For most of history, male footwear in the West has been dominated by the boot. It protected the foot for agricultural work, but during centuries when gentlemen spent more time on horseback than on their own feet, the boot's real usefulness was for riding. (Charles I of England, who famously spent as much time on a horse as he could, popularized high boots because rickets had left his legs so weak the boots acted as a brace to keep him upright.) The riding boot's raised heel had the purpose of keeping the shoe in the stirrup, but even the grandest of horsemen occasionally had to dismount. This meant that male heels rarely became very high, allowing the wearer to walk as well as ride. This balance can also be seen in the mid-height Cuban heel that dominated male boot styles in the twentieth century, and today in cowboy boots and Chelsea boots.

In the late nineteenth century the invention of vulcanized rubber made a sole available to go with inexpensive white canvas uppers, creating the tennis shoe. In 1917, the US shoe manufacturer Converse began making shoes for basketball. Until the 1960s, the shoes were available only in black, white and red, but in 1966, under pressure to match team strips, the company introduced more colours – black, white, maroon, scarlet, kelly green, navy blue, royal blue, pink, gizmo green, thunder grey – supplemented by seasonal colours and prints. The canvas shoe, also known as the sneaker, particularly appealed to youth as a gesture of defiance towards their elders who preferred formality – and a relatively cheap gesture at that. The shoe eventually lost much of its association with sport and became ubiquitous among people of all ages (see Activewear, page 150).

Slip-on shoes only work if they don't slip off. Even the moccasin, one of the earliest forms of soft-soled shoe, often had a leather cord at the top to allow for some tightening. Its direct descendant, the loafer, has made numerous appearances as a casual shoe. The first was as country-house wear among the English upper classes in the early 1800s. The modern manifestation was introduced as summer wear in Norway in the 1930s and took its name from loafing sheds, used to shelter livestock, because it was often worn by farmers. On reaching the United States, the shoe was taken up commercially, with the addition of a band of leather across the saddle (students slid silver pennies into the band, creating the 'penny loafer'). In 1966 Gucci changed the band to a metal horse-bit and, with the addition of its name, hastened the shoe's rise to a new level of sophistication. The loafer is now seen as perfectly acceptable for both men and women when worn with business suits.

Sandals were the original form of footwear: the world's oldest known shoes were sandals woven from tree bark in what is now Oregon in the United States some 10,000 years ago. Worn by the Egyptians, idolized by the Greeks – Greek sandals had a complex hierarchy, with the winged »talaria« of the god Hermes occupying the highest rung – sandals remained the fighting wear of the legions at the fall of Rome.

FEET – SHOE FORMS

Since then these open-toed shoes, comprising a hard sole attached to the foot with straps or thongs, have been a constant, particularly in warmer parts of the globe. Not only are they not as confining as enclosed shoes; they are far easier to construct: they make achieving a good fit simply a question of adjusting the straps.

[5] Until the middle of the twentieth century, the technology to support the weight of a body on an area no bigger than a coin did not exist. In the 1950s, shoe designers Salvatore Ferragamo and Roger Vivier used the principles of engineering to produce an entirely new heel (with metal rods inside), and the stiletto has never gone away since. There are two reasons for its popularity. First, it empowers women with its messages of toughness and sexiness. A US survey found that more than 70 per cent of women felt that stilettos made them move differently and feel more sexy. This is to do with bearing; in stilettos you walk tall, or not at all. Second, the stiletto can tell many different tales: add satin ribbons and it suggests the bordello; with narrow spaghetti straps it hints at a garden party. Put a stiletto heel on a classic court shoe and it is the epitome of the high-powered businesswoman.

HIGH HEELS AND HOSIERY, C.1959

[6] The two-tone show has unavoidable political symbolism. The so-called spectator was a popular style for most of the twentieth century, but is most closely associated with the 1920s Jazz Age. Although a sporting day shoe seen at Saratoga, it was also perfect for informal garden parties. Its traditional bringing together of black and white made it ideal for an age during which, in venues such as Harlem's Cotton Club, whites and blacks played music and danced together. In the 1930s, the shoes were nickamed correspondent shoes and were seen as the personification of behaviour of the sort that often ended up in the divorce courts. They died away during World War II, but were revived in the 1950s by Coco Chanel as part of her appropriation of the male wardrobe for women. The two-tone Chanel shoe was derived from the footwear of the rake, because Chanel wanted women to be as boldly predatory as men. The two-tone shoe was her way of giving them the confidence to be so. Both racy and stylish, it was a triumph of modern design semantics.

TWIGGY IN SHOES BY GEORGE CLEVERLEY, EARLY 1970S

[7] The brogue may be the most uncompromisingly masculine item in the male wardrobe. This is hardly surprising considering its history, which is linked with that favourite male pastime – killing animals. The brogue began as a hunting boot for stalking deer and shooting game in Ireland (where the name comes from) and Scotland, and the holes that are now entirely decorative had a practical purpose. Bogs and rivers had to be crossed and, in doing so, the shoes became waterlogged, which made them very heavy. The obvious solution – men are nothing if not pragmatic when it comes to their wellbeing – was to punch holes in the surface to allow the water to drain away. After a couple of centuries the style is now a universal classic; Chanel hijacked the brogue for women, too.

BROGUES, USA, 1955

[8] Anyone who has seen Audrey Hepburn in Billy Wilder's 1954 movie »Sabrina« will remember the kitten heel; a medium-height, curved answer to the stiletto often called the Sabrina. The heel was designed by Roger Vivier, king of twentieth-century shoemakers, who achieved the shoe equivalent of breaking the sound barrier by taking a dowdy heel height (2.5–4 cm) and making it both sexy and comfortable. Every woman wanted a pair in her wardrobe. The kitten heel has never been out of fashion since.

POSTER FOR »SABRINA«, 1954

[9] There is something so 1960s about the Chelsea boot that it comes as a surprise that the style has been around for some 175 years. The tight-fitting ankle boot with Cuban heel and elasticated side panels from the heel to the top was a Victorian innovation – literally. The style was created for Queen Victoria by the bootmaker Joseph Sparkes-Hall in the year of her accession, 1837, as a boot for riding. Victoria was then considered one of Europe's great beauties, and her imprimatur guaranteed the boot's lasting fashionability. It also appealed because, unlike many boots, it was easy to put on and take off and not too heavy to wear. The style was adopted 130 years later, with the addition of a zip, by pop groups including the Beatles. Like so much of the Fab Four's image, this was not quite as radical as it might have seemed: after all, the conventional suit the Beatles also adopted, albeit without a collar, has never been the uniform of the true fashion revolutionary.

THE DAVE CLARK FIVE, CENTRAL PARK, NEW YORK CITY, 1964

'A naked woman in heels is a beautiful thing. A naked man in shoes looks like a fool' – CHRISTIAN LOUBOUTIN, 2000s

[5]

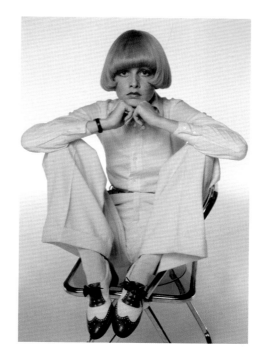

[6]

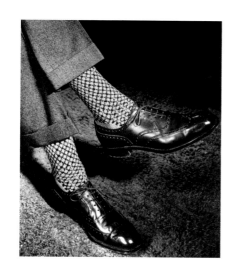

[7]

[8]

[9]

142

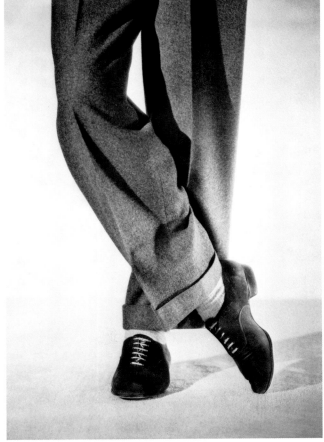

[1]

[2]

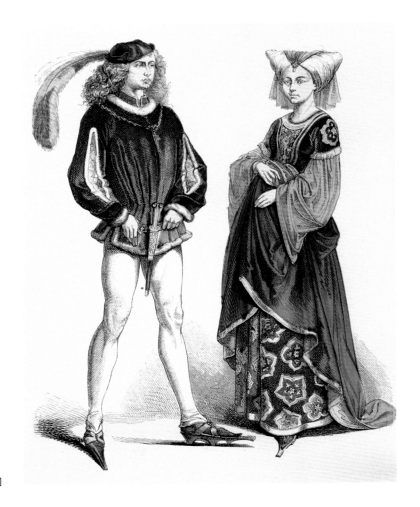

[3]

The modern high-fashion shoe, nicknamed the 'limo' in acknowledgement of the fact that it is so impractical as to make walking any distance impossible, is only the latest manifestation of the triumph of style over practicality in footwear for fashion-obsessed women. At the court of Louis XIV at the turn of the eighteenth century, carriers brought sedan chairs into the palace so that their mistresses did not spoil their embroidered white slippers in the dirt outside. But such impracticality can be a double-edged expression of privilege. For many European women in the late eighteenth and early nineteenth centuries, the impracticality of their footwear effectively kept them housebound – isolated from society, which remained an entirely male preserve, apart from indoor events such as balls. Paradoxically, many of the great ladies of society – even among the royal family – passed the long hours confined at home by making themselves simple slippers to wear indoors. Impractical shoes remain common, even in modern life. When Naomi Campbell fell off her Vivienne Westwood platform boots on the catwalk in 1993, she endured the humiliating kind of pratfall that is the nightmare of any woman in high heels (see Impractical, page 208). Heels might break or become stuck; it is remarkably easy to turn an ankle. Yet achieving as great a height as possible has always been – and remains – an aspiration of fashionable shoemakers.

–

[1] Narrow, long feet have always been taken as a sign of aristocratic elegance and breeding; hence the popular appeal of the sentiments behind Fats Wallers' 1939 hit 'Your Feet's Too Big', which comically suggested that the woman the song addressed was not attractive because she was lacking 'class'. The impulse to make the foot appear dainty explains why women are frequently determined to squeeze themselves into shoes that are a size too small. Even Fred Astaire, who was a dandy as well as a dancer, is said to have deliberately worn his dancing shoes half a size too small to emphasize the delicacy of his movements. Fashionable women throughout history have bound their feet tightly in gauze or ribbon to make them seem smaller.

In China, the vogue for foot binding became as early as the tenth century, under the Song Dynasty, first a fashion obsession and then often a form of torture inflicted upon unwilling high-society girls. As well as forcing a woman to take mincing steps that were thought highly sexually attractive, the resulting crevasse between the heel and the sole of the foot was so highly sexualized it was reputedly used to masturbate men.

[2] In the seventeenth century, Louis XIV wore huge gold rosettes on his shoes. His contemporaries also wore rosettes, which became far bigger than the shoes themselves. For lesser mortals, the look was made affordable by more modest silver buckles. By the middle of the eighteenth century, rosettes were entirely replaced by buckles as a sign of the social stature of the wearer. Dandies might possess up to fifty buckles – plain or gilt silver, covered in jewels (or, more normally, paste), and even made from cut jet to wear at funerals. They were a true craze. The late eighteenth-century playwright Richard Sheridan observed that 'the shoe is of no earthly use but to keep on the buckle'. It was a fashion which, although it largely died out for men by the nineteenth century, remained as a decorative device for women's styles. Today, buckles are a constant in women's shoe design and also sometimes re-emerge as a male fashion.

[3] Although pointed toes make regular reappearances in fashion for both sexes, they were originally for men only: their phallic symbolism is obvious. The style first appeared in the twelfth century among urban dandies throughout Europe. Named the poulaine or crackowe – because of its supposed origins in Krakow in Poland – the shoe soon reached absurd lengths – up to 60 cm long (see Extreme, page 194). Men wiggled them lasciviously at ladies, or poked the toes beneath their skirts, and commentators suggest that the shoes were even made in suggestive flesh-coloured tones. As a result, throughout Europe, laws set limits on the length of shoes. Although pointed women's shoes regularly return to favour, men's shoes have largely remained broader, until more recently. 1960s winklepickers, which project male sexuality, have been revived and have remained a fashion for several years.

[4] Wedge heels have had a louche feel ever since their ancestor, the chopine, was imported to Venice from the bathhouses of Turkey in the fifteenth century. Originally, the wooden soles and heels of this tall platform shoe were simply meant to raise the feet above the damp floors in Turkish baths but, in Italy, they quickly became the footwear of prostitutes – the towering, solid heels gave them visibility above the crowds and made it easier for them to ply their trade. Some were raised so high that they had to be supported on either side by male servants as they tottered through the streets. Modern wedges have more in common with eighteenth-century pattens, devised to raise Madame out of filthy urban streets or country lanes. They were re-invented in their present form during the early 1930s by Salvatore Ferragamo as a more sophisticated alternative to the peasant espadrille, which had excited socialites in the 1920s when they were first discovering the simple joys of Riviera fishing villages. The style never looked back. In World War II, when leather was scarce and craftsmen even scarcer, many women made their own shoes. The base they used was the simple wedge heel, made of cork or light wood. The wedge became so completely 'the look' that ordinary heels began to seem outdated. But post-war, wedges went rapidly out of fashion and have only occasionally reappeared since.

[5] It is no coincidence that up to 80 per cent of foot surgery is said to be performed on women. The fear of having large feet – of being a 'clodhopper' – has convinced women throughout much of history to cram their feet into shoes that are, frankly, too small. Either that, or they are perilously high in order to make the foot appear smaller. This is not necessarily true in the case of shoes by masters such as Pietro Yanturni or Manolo Blahnik, which may look painful to wear but are claimed by their wearers to be extremely comfortable, but for most women the luxury of such precise engineering is not available. Small feet also encourage a more feminine hobble, by forcing the wearer to take small, mincing steps, which increases the sway of the bottom. There is a theory that men enjoy the idea that a small-footed woman is somehow rendered helpless – almost literally unable to get away. In

China the logical conclusion was the aforementioned practice of foot binding; its painful process deformed the foot into such a misshapen stump that walking was practically impossible, thus achieving many men's ultimate dream of a female completely incapable of unaided motion.

[6] The skinhead's eighteen-hole Dr Marten boot in black or cherry red is a defining form of aggressive footwear (see Aggressive, page 152). Part of its appeal is that it fits into a tradition of heavy male footwear: hobnail boots, the brothel creepers of the Teddy Boys, motorcycle and cowboy boots, platform boots, the swollen spoon-like shoes of the 1970s … all make the male foot appear more like what rhyming slang so appropriately labels 'plates of meat'. This is the footwear of the butch aggressor – it's no coincidence that the iconic gay construction worker of the 1970s and 1980s teamed his plaid shirt and jeans with sand-coloured Timberland or Caterpillar boots. The tall Dr. Marten accentuates the size of the foot by being laced so tightly that the leg and ankle appear proportionately thinner. Elton John's turn as the Pinball Wizard in the 1975 rock movie »Tommy« parodied the vogue for the huge boots that laced tightly up to the knee. British skinheads, in particular, appropriated what had previously been symbols of the male establishment – associated with the police, the army and the power of manual labour – and turned them into a shorthand for aggression, focusing attention on their lower legs and, frequently, reinforced toe caps: 'All the better to kick you with.'

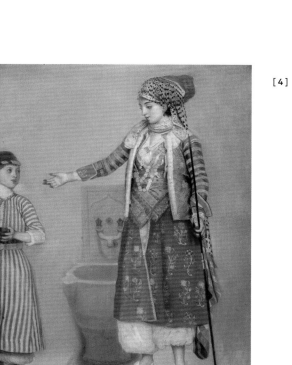

[4]

[5]

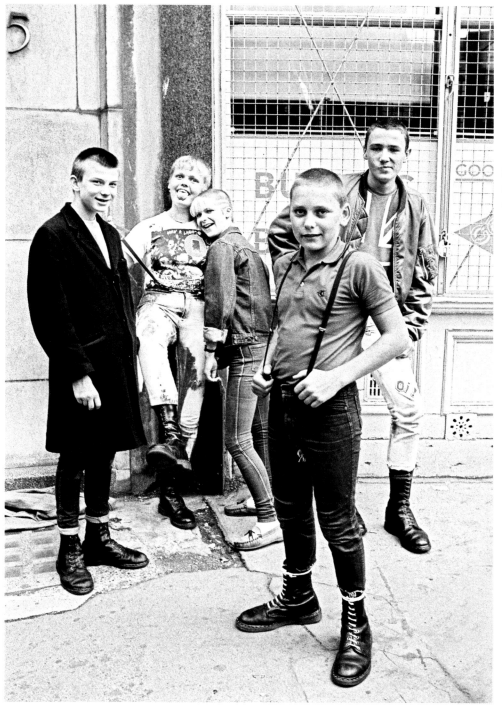

[6]

144

The Body Clothed

What do our clothes say about us? Individual garments might hide our spreading stomachs or gracefully elongate our necks, keep our hands warm in the cold or protect our feet from falling objects, but we wear clothes as parts of ensembles – and others perceive them in the same way. What shapes the way we put clothes together to create an overall look? Clearly, financial considerations, climate, activity and mood all contribute, but the real motivation is more personal and emotional. Our dress is a carapace to shield us but also a billboard to project what we wish the world to know about our physical, social and economic status. It is about our self and how we see our position in the world.

Given the sheer choice of garments available to us all, it might seem surprising that the vast majority of clothing falls into quite a limited number of readily identifiable 'looks' or reflects particular traditions. In fact, this reflects the fact that we are most comfortable when we and others can place us most easily. Clothes are one of the most common forms of visual communication and their language is universal. Everyone can distinguish at once the soldier from the monk, the builder from the judge, the duchess from the bag lady. At periods of history when clothes threatened to blur such clear distinctions, governing classes have not hesitated to reinforce them with sumptuary laws that required everyone to dress according to his or her status.

The language of clothes is not only universal. It is also constant. From the time we are born, everyone around us is speaking it all of the time. We learn to understand it at an early age, and we use its grammar and vocabulary every day to subconsciously judge those with whom we come into contact – and it functions perfectly well, because others speak the same language.

In the main, the shared vocabulary of dress prevents us from departing too far from the norms. A large part of the message of clothes is that we want to belong. Most people tend to dress in similar ways and their clothes thus become a form of voluntary

uniform (although some people wear proscribed uniforms, of course). Society is divided into many subcultures, some of which are more consciously organized than others. Youth cults have dominated recent decades – from the Teddy Boys and hippies to the punks, New Romantics and Goths – but the tradition of groups marking themselves out through dress goes back centuries, to the Landsknechte in the early sixteenth century with their slashed and ragged clothes, or the bucks of Regency England in their skintight pantaloons and high-necked collars.

The elements of cult clothing often have qualities in common that reflect their shared roots: a desire to indicate on the one hand a disaffection with and separation from the mainstream of society; and on the other a choice to indicate membership of a far smaller subgroup. This kind of clothing can be blatant but can also use tiny signals that can only be recognized by other insiders, such as the club or 'old boys' tie and even the method of tying it. The desire to bond through dress attitudes has been for centuries a predominantly male fetish, from the inanities of Masonic dress to the incredibly subtle nuances – the twist of a belt, the length of a leg – in urban gangs of feral young men from the Crip and Bloods gangs of LA to the Malandros of Venezuela.

All clothing seeks to protect our fragile inner selves from the 'slings and arrows of outrageous fortune', but it also projects our inner vision out to the world. Both functions are central to the history of dress. Protection has often been a purely practical consideration, as in the evolution of battlefield armour that is still echoed on the catwalk in tunics, gauntlets and even breastplates. For most people, protection from the elements has been a far greater consideration than protection from blows. For the majority of the world's population, certainly in the ancient world, protection from the sun was far more pressing than protection from the cold, the snow or the rain.

Projection allows us to make an impression on the world and the people around us. There are various forms but at heart they all reflect a concern with social position. Much of the history of projection in clothing has been associated with political power, which is why the clothes associated with monarchy and political establishments tend to be some of the most closely controlled and formulaic. This form of dress tends to be both highly conservative, being based on traditions of chivalry, class and the shibboleths of good taste, and hyperbolic, as with the rows of decorations and medals worn by princes of the blood, dictators and potentates.

The opposite form of political projection – alienation and protest – has become closely associated with clothing only in the second half of the twentieth century. It was the rise of the teenager and the rock and roll generation that signalled the emergence of a new visual language in which personal appearance could be an effective political gesture. Young American teenagers turned their backs on the glamour dressing of their parents in fashion's first large-scale rejection of dressing as well as one could afford. The trend led to the rise of the Hells Angels, Mods and Rockers in the late 1950s, the hippies of the 1960s and the punks of the late 1970s.

As well as arising from within, uniformity can also be imposed from outside. Military uniform has evolved consistently over centuries to reflect new forms of warfare, and changed from being gaudy and brightly coloured to being camouflaged according to highly scientific principles.

The evolution of military dress illustrates the complex ways in which clothing looks have evolved. At one time a symbol of the Establishment, military dress has in the last forty years been coopted by young and disaffected. Similar twists and turns have shaped the types of clothes we consider sexy, or romantic or glamorous, so that virtually every aspect of how we dress today is often the result of surprising origins or reflect themes that have in fact changed very little in their essentials.

Suzanne Lenglen by René Vincent, 1921

THE
BODY
CLOTHED

A
C
T
I
V
E
W
E
A
R

'Everybody wondered about Suzanne, what she would wear, what she would look like. I would love to be like that. Everything is too simple in tennis now. Wouldn't it be neat to be a mystery woman and bring high fashion back to the sport?' – MONICA SELES, 1991

Adidas magazine advertisement, 1980s

When Lord Byron did his fencing practice nearly two hundred years ago, he simply stripped down to his undershirt and proceeded in the clothes he wore every day. The idea of wearing special garments for most forms of exercise emerged at the end of the nineteenth century, and then very slowly. Almost as soon as universal activewear emerged, so too did wearing it for situations that were not related to sports. Such a development was in many ways inevitable. Activewear was associated with free time and leisure – in those days both largely the preserve of the elite – and thus had a social desirability that in many ways prefigured the desire of young people today to wear clothes associated with their sports heroes.

But if the touchstones today are football, baseball and Olympic track events, in the early decades the driving force in the development of sports clothing came from status sports such as sailing, tennis, golf and cricket. The elite students of the Ivy League colleges in the United States have always had a strong sporting tradition (the Ivy League was itself a sports competition among the colleges). In the early twentieth century the 'jocks' co-opted baggy cricket jerseys and the tops rowers wore with scarves and jackets to warm up. In the 1920s it was a pair of brothers, Abe and Bill Feinbloom of the Knickerbocker Knitting Company, who invented the modern sweatshirt; as the name implies, one of its major purposes was to absorb the sweat generated by physical exercise. Made in loose-fitting cotton jersey for warmth and ease of wearing – the V-shaped insert at the neck of the sweatshirt allows the collar to stretch over a football helmet – the sweatshirt became common exercise wear. In the 1930s, the Feinblooms' company – by now called Champion Sportswear – produced the zip-front hoody, originally to keep warehouse workers warm as they worked. (The designer Claire McCardell came up with a form of hoody, like a pixie hood attached to a coat, at about the same time.) The garments soon spread to sportsmen and women who wore them for exercise.

Along with sweats, the predominant activewear garment is the polo shirt. Despite its name, its origins lay in tennis rather than with polo. Both sports were then played wearing long-sleeved, collared shirts (for polo, buttons held the collars in place to prevent them being blown into the player's face). In the mid-1920s French tennis champion René Lacoste invented a shirt better suited to the exertions of the game: made from knitted cotton and with short sleeves, to prevent overheating, with a soft collar that could be pulled up to protect the neck, a buttoned placket and a long tail that could be tucked into a player's trousers. The shirt was soon taken up by polo players and developed its own name; in 1933 Lacoste began a company to sell his shirts, sporting a monogram inspired by his nickname as a player: 'The Crocodile'.

Lacoste was not tennis's only fashion pioneer. His contemporary, Suzanne Lenglen, was one of the first women athletes to wear shortened skirts. And in 1952 the British tennis champion Fred Perry designed his own sports shirt. While Lacoste's shirts were adopted by the bon ton, Fred Perry's were allied to urban, working class youth, particularly after their adoption by the Mods in the early 1960s and the skinheads and Northern soul followers in the 1970s (see Aggressive, page 152). Both brands benefited from the rise of preppy activewear in the early 1970s, spearheaded by a new label Ralph Lauren called, simply, Polo, which drew together the traditional class and wealth associated with the game – and the social power they bestow – with the informality of modern fashion.

That informality has helped make activewear widespread. Perhaps the most unbiquitous form is the trainer or sneaker. The first rubber-soled shoe appeared as early as the 1830s (it was designed to be worn on the beach), but it was not until the early twentieth century that the shoes were adopted for sports. Keds first appeared in 1916, and Converse began making basketball shoes a year later (see Feet, page 140). In 1920 the German firm Adidas started making trainers in response to a growing interest in international sports after World War I. By the 1950s, when school uniform codes relaxed in the United States, sneakers were common for everyday use, not simply for sports. The pehenomenon reached its peak in the late 1980s, when the launch of the Nike Air Jordan, sponsored by basketball star Michael Jordan, started the 'trainer wars' in which multinationals including Nike, Reebok and Adidas spent fortunes on promoting rapidly changing models of trainer and developing an eager market of mainly young, urban males.

Fashion is now rarely about formality. It is about youth and vigour – and it is the more youthful, vigorous sports that drive activewear. Football jerseys and baseball tops have taken the place of cricket jerseys and rowing scarves, but those garments that most reflect their connection with action – sweatshirts, polos and trainers – continue to dominate young people's leisurewear.

Woman in tennis outfit, photographed by Toni Frissell, c.1947

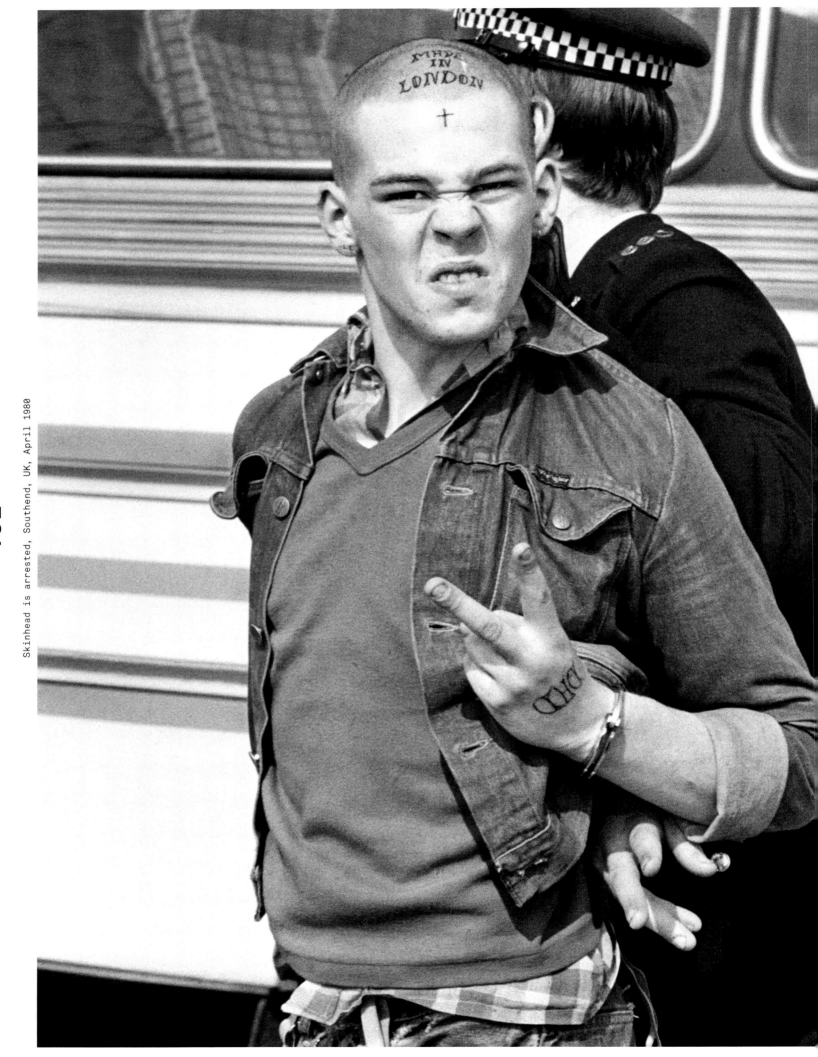

Skinhead is arrested, Southend, UK, April 1980

Nature is full of signs that say 'Danger, stay away', so it is no surprise that clothing is also full of warnings to keep one's distance. Just as important as our clothes' ability to attract others is their ability to fend them off by projecting an intimidating image of menace or superiority. The skinhead's shaved head or the mobster's black shirt and white tie are the sartorial equivalent of the horns of the stag beetle. The chains clanking on a punk's jacket mimic the rattlesnake's tail. Real killers don't advertise their occupation, though – so dressing to intimidate is often as much a defence mechanism as an overt act of aggression.

Clothes allow us to counter a potential challenge by projecting our own threat: such is the aura of menace that surrounds gangs, enhanced by the use of visual signs that identify members to one another and to everyone else. The most powerful signal of all is some kind of uniform, with its overtones of military discipline and the subservience of the individual to the group. That's why gangs traditionally adopt easy-to-read garments, such as colour-coded bandanas.

This kind of clothing takes us back to a tribal world. Just as each village among the highland Maya of Guatemala has its own distinctive pattern of »traje«, the bright tribal costume, so the hooligan followers of particular football teams develop an identifying uniform. In the 1980s they began to appropriate classic clothing labels, such as Aquascutum (see Classic, page 172). Burberry check, which between the wars was part of the wardrobe of the quintessential English gentleman, was co-opted by football fans in the early 1990s (see Colour and Pattern, page 36) and fake Burberry flooded the market. The brand was in danger of being destroyed – to the extent that under Christopher Bailey in the 2000s, Burberry abandoned the famous pattern as a major part of its fashion statement.

Aggressive dressing often involves the subversion of the trappings of social authority. One manifestation of the phenomenon came in 1960s Britain, with the emergence of the Mod youth movement, who adopted the bourgeois work uniform of suits, collars and ties, and short hair. What transformed the neutral into the aggressive was a combination of uniformity, an obsessive degree of smartness and group solidarity. The Mods' precision contrasts with a type of studied indifference to one's appearance that also suggests that society's rules do not apply. Its roots lie in the rags of beggars or the motley tunic of the jester – both considered beyond the social order – but also echo the tattered clothing of battlefield veterans. In the fifteenth century, members of the Landsknechte of Germany patched up their torn garments with fabric taken from banners, tents or their enemies' clothes. This was an overt code for power, which is why it was cleaned up by the fashionable classes and adopted as the basis of costume for the next century. They have clear modern equivalents: the hippies of the late 1960s and early 1970s, with their ragged jeans and unkempt hair; the punks of the late 1970s and early 1980s; and in the 1990s, the grunge movement.

The message is clear: lack of conformity in dress suggests a lack of respect for society's rules. Take the skinhead, a sinister figure throughout Europe. Skinhead clothes are styled on paramilitary uniforms, with trousers cut short to show off high, tight-laced Dr Martens and denim or bomber jackets (see Feet, page 142). The clothes are adorned with symbols such as the swastika, adopted from the Third Reich (it was promoted by propaganda minister Joseph Goebbels). The shaven scalp, meanwhile, has throughout history been more often the sign of a holy man than of an aggressive one. For both types, it represents a rejection of worldly vanity: but in one case to demonstrate spiritual devotion, and in the other to serve as a warning that society's rules do not apply (see Hair, page 58).

Like the military uniform, the faceless is almost invariably something to be feared – think of the executioner, the criminal, the paramilitary or terrorist – which is why young people with faces hidden by their hoodies cause such social unease. Their lack of visible personality makes them somehow less human. The balaclava began life as a functional garment – developed for soldiers in the Crimean War (1850–53) – but it has now become almost entirely associated with aggression and threat because it completely obscures the face, and thus the identity.

Aggressive clothing is intended to suggest that the wearer operates outside of normal social rules. Its wearers either reject normal dress, as the punks did, or exaggerate it to the point of obsession, like the Mods. The purpose is to set the individual or the group apart from everyone else – hence the adoption of informal uniforms among gangs and cults – and often to subsume the identity of the individual, either by masking the face, or more abstractly, by making the wearer just one of a group.

'A guardsman in a dress uniform is ostensibly an icon of aggression; his coat is red as the blood he hopes to shed. Seen on a coat-hanger, with no man inside it ... to the innocent eye ... it is as abstract in symbolic information as a parasol to an Eskimo' – ANGELA CARTER, 'Notes for a Theory of Sixties Style', 1967

Masked youths, Notting Hill, London riots, August 2011

A
G
G
R
E
S
S
I
V
E

THE
BODY
CLOTHED

Chicago underworld boss Salvatore Giancana (left) leaves court, May 1965

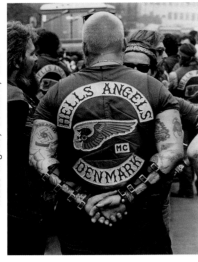

A L I E N A T E D

The clothing of the majority always encapsulates society's views of what is or is not acceptable. To reject those clothes is an easy way to express a feeling of not belonging. This might take the form of the young growing their hair, or Goths or punks adopting a cult uniform, or even the Eleanor Rigbys – all the lonely people – whose tight anoraks, tank tops and too-short slacks are badges of their refusal to follow mainstream fashion. Veterans of Vietnam haunt the Mall in Washington DC wearing a ragged approximation of their previous uniform – denim and leather jackets – to express their rejection of the society that sent them to fight.

The overt alienation of youth is a relatively recent development. It coincided with the 1950s evolution of the teenager as a social and economic phenomenon. Previously, most young people had dressed more or less like their parents. Then along came rock 'n' roll, Elvis and »Rebel Without a Cause« (1955), and the battle of the generations began. The young wore long hair, picked out suits that were baggier or longer than those of their fathers, put on pleated dresses with bobby sox that showed off teenage legs, and generally expressed their rejection of established values. Their kids would go on to do the same – maybe they grew their hair longer still and wore kaftans – followed by their kids, and so on.

Some of the first youth to display alienation through dress were the zoot suiters of 1940s' America. These young black men and their Hispanic equivalents – the pachucos – adopted the suits of the establishment, but cut to ridiculously exaggerated proportions, with long jackets, baggy trousers and dangling watch chains. In Britain, meanwhile, the Teddy Boys surfaced off the back of rock 'n' roll. These working-class lads took their name from the trend-setting King Edward VII, and wore a pastiche of neo-Edwardian dress that first appeared on Savile Row as a patriotic gesture at the end of World War II.

In the 1960s the youth scene diverged with the rise of Rockers and Mods. The former emerged from a biker subculture that grew up among the young working class in the late 1950s, presenting themselves as being outside the law. They customized their leather motorcycle jackets with metal studs and wore Levi or Wrangler jeans and biker boots. Mods, again, tended to be disaffected youths with few prospects, but they displayed their alienation by paying an exaggerated attention to smartness that had begun in Italy in the late 1950s, with pointed shoes, slim-legged trousers and short jackets (see Aggressive, page 152).

In the United States, the equivalent of the Rockers was the Hells Angels, a far more organized – and far less pleasant – group whose age range was also greater, not being limited to youth. Again, they wore a practical uniform for motorcycling, based on leathers and denims that were often torn, patched or dirty. But while Marlon Brando summed up their romantic appeal with his appearance in »The Wild One« (1953), their alienation went far beyond their clothes: it was as real as their threat of violence and their involvement in organized crime.

In many ways, the hippies were another manifestation of the alienation of youth in the late 1960s and early 1970s: more interested in getting high than in getting angry, maybe, but still excluded from the mainstream of society (see Hippy, page 206). Their flipside were the defiantly working-class, morally conservative skinheads, who emerged in London between 1968 and 1970. Rejecting what they saw as the effeminacy of hippies and prog rockers, they adopted steel-capped Dr Martens, straight-leg Sta-Prest trousers, button-down shirts and shaven heads.

No matter how resentful youths' feelings toward society, it was not until punks came along in the late 1970s that people actually spelled out obscenities on their clothes (see Punk, page 218). 'Fuck you' is a message no one can fail to grasp. It was shocking, of course, but in the middle of a recession young people had decided that no one was listening: they had to shout louder. So they took bin liners and turned them into clothes to show how they saw themselves as trash or society as trash (the philosophy was not clear). Their DIY approach allowed them to write their own slogans on their clothes – 'No Future', 'Anarchy in the UK' – with a directness fashion had not encountered before.

The gangs that emerged in US cities in the 1970s and 1980s were alienated twice over: they were poor, and they were usually black or Hispanic and, therefore, largely outside society and its benefits. Still, their obsessive approach to their dress, including the exaggerated jewellery that led to the cult of shiny excess known as bling in the 2000s, expressed a desire to replace society's rules with a whole new set of values. Even the alienated want to feel that they belong to something, and clothes give them the chance to achieve a form of fellow feeling.

Members of the Crips street gang, Los Angeles

Dutch football fans, UEFA European Championships, Kharkiv, Ukraine, 2012

Every time we put on clothes we make a gesture about how we see ourselves and wish others to see us. Sometimes this gesture is on such a scale that it becomes political; a comment not so much about ourselves as individuals – although it is inevitably that – as about the whole of society, as in the wearing of colours to express political loyalties. Clashes of colour increasingly summarize elections around the world, while colour is also frequently seen in the wristband or the loop of ribbon pinned to the chest to display support for one cause or another. These instances all hark back to the original yellow ribbon tied around a tree to remember those away at war, said to come from a Puritan tradition that may have originated in the English Civil War and was later taken up by the US armed forces.

This use of colour to show loyalty is not new. In Renaissance Florence, the colour of servants' livery denoted their employer and thus, at times when noble families were at each other's throats, often provoked violence between different camps. In modern times, the practice was echoed in the aftermath of the disputed presidential election in Ukraine in 2004, when supporters of the unfairly defeated Victor Yushchenko wore orange ribbons to pledge their loyalty until the result was overthrown; in Iran, green ribbons and wristbands signalled dissatisfaction with the result of the 2009 election that returned unpopular president Mahmoud Ahmadinejad to power.

Colour is a powerful weapon in dress at many levels. The smallest splash can declare the wearer's loyalties as strongly as a whole uniform. Perhaps the ultimate manifestation came in the late 1970s and early 1980s in Los Angeles, when the colour of your clothes could get you killed. Blue was the colour of the Crips; red belonged to the Bloods (see Alienated, page 154). As the gangs fought to take over the drugs trade, sporting the wrong-coloured bandana in the wrong place was an invitation to trouble in the territorial wars of southern LA.

Patterns can be as distinctive as colours. There have been plaids – woven patterns of checks and stripes – for almost as long as there have been textiles (see Colour and Pattern, page 36). They were woven by people of the Taklamakan Desert in what is now China some 3,000 years ago, and by the Celtic peoples of the Halstatt culture in Central Europe around 400 BC. And since the Middle Ages plaids have been worn in Scotland: the word itself comes from the Gaelic word for 'blanket', referring to a shawl-like garment that was wrapped around the body and even slept in. However, clan tartan is surprisingly recent. It was the British army, eager to recruit Scots to serve in colonial postings overseas, that introduced the idea of regimental tartans in the late eighteenth century.

Using clothes to demonstrate political allegiance goes beyond mere colour or pattern. When Yankee Doodle 'put a feather in his cap and called it Macaroni' he was, the original English version of the old song implied, an unsophisticated colonial failing miserably to ape cosmopolitan fashion. In London in the 1760s and 1770s, the Macaronis adopted Continental affectation, wearing huge wigs dressed with bows and powder and red-heeled leather slippers with diamanté buckles (see Cult, page 180). Like so many other male fashion movements, the gesture was political. The Macaronis were expressing discontent with the ruling classes (similar dissatisfaction in France would eventually spill over into revolution). It was apt, then, that the leading Macaroni was the Whig politician Charles James Fox. Above all, the Macaronis loved exaggeration, especially in scale: hence, towering wigs and ludicrously minute hats at a time when masculine authority resided in the dressing of the head in a 'decent and seemly manner'.

Beyond politics, the most popular displays of allegiance through dress are associated with sport. In the first week after David Beckham signed for US soccer team LA Galaxy in 2007, Adidas sold 200,000 replica shirts worldwide: not bad considering that LA Galaxy's average home crowd is 23,000. Sports increasingly drove fashion from the early twentieth century, but the need to dress like our sporting heroes is comparatively new. The craze for replica football shirts began only in the late 1980s, when the game was taken over by savvy marketing men. It was clever hype: previously, no one had felt the need to wear a Brazil shirt with Pelé written on it (not even Pelé). But the sheer numbers of fans who dig deep for the latest replica kit suggests that it answers a real need for identification, albeit among the immature. Even cricket, traditionally played in white, introduced team colours – pyjama-like tracksuits – for the shorter forms of the game in the 1990s, as part of an attempt to make itself more commercial. This seems like an acknowledgement that sport cannot appeal without making a physical distinction between the contenders in order to kindle spectator allegiances – and rivalries.

'While the storm clouds gather far across the sea / Let us swear allegiance to a land that's free / Let us all be grateful for a land so fair / As we raise our voices in a solemn prayer' – IRVING BERLIN, 'God Bless America', 1918

Postcard of a woman in patriotic dress, c.1908

A
L
L
E
G
I
A
N
C
E

Scotland fan, Scotland vs Norway,
World Cup, Bordeaux, France, 1998

THE
BODY
CLOTHED

A
N
D
R
O
G
Y
N
Y

'It is fatal to be a man or woman pure and simple; one must be woman-manly or man-womanly … some marriage of opposites has to be consummated' – VIRGINIA WOOLF, »A Room of One's Own«, 1929

'Androgynous' is a modern term for an age-old state. There have always been boys who wish to look like girls and girls who wanted to wear men's clothes – or something as near as they dared, the fact being that society has always been hostile to cross-dressing because it was seen as something that could destabilize the order on which it is based. To be »en travesti« was to put oneself outside of the rules of behaviour approved by common consent in most societies in the West (the situation rarely appears in more primitive societies, where the difference between male and female dress is often not nearly as pronounced).

In the past in the West, members of both sexes have been imprisoned for dressing as the other sex; the guardians of morality feared anything that would undermine rules evolved to foster social consensus and cohesion. The greater fear was of men dressing as women, and their greatest crime was to wear make-up in public. It is a taboo still strong among most men. Unless sanctioned by some sort of buffoonery to take away the sting – usually associated with collecting funds for charity – men in women's clothing are generally viewed with distaste.

That is not to say that things have not changed; show business led the way. In 1972 David Bowie introduced his alter ego Ziggy Stardust, the alien rock star, with make-up by Pierre Laroche and an androgynous costume of jumpsuit, platform shoes and red hair. The look encapsulated changing attitudes to sexuality. Men – young men at any rate – realized that flamboyance did not necessarily equal effeminacy. The subversion was continued at the end of the1970s by the vogue for make-up and flashy clothes championed by Boy George and the New Romantics, and today by Brandon Flowers's eyeliner (see Face, page 64; New Romantic, page 212). High-profile cross-dressers such as the comedian Eddie Izzard or the artist Grayson Perry have also made a touch of the camp more acceptable, although Perry's Bo-Peep looks are more cartoonish than cool.

Women, meanwhile, have come a long way since Amelia Bloomer popularized pantaloons for cycling (see Legs, page 120). She was ridiculed, but she was also the first person to break a taboo that seemed set in stone. The high-minded Victorians might have been disturbed by male impersonation but they loved the fact that female music-hall stars wore men's clothes to allow them the freedom to sing songs laden with saucy double entendres. The showbiz cross-dressing tradition grew, with Hollywood movie stars such as Marlene Dietrich and Judy Garland doing some of their most impressive work while looking glamorous in top hat and tails. Katharine Hepburn was another star who showed that a male jacket and trousers on a woman can be not only glamorous, but positively sexy.

Among the appeals of androgyny are the idea of sharing, and the oversize look that is often the result when a woman borrow items of her partner's clothing. Coco Chanel always borrowed her lovers' sweaters and sports coats. When she wore the Duke of Westminster's tweed sports coat in the 1920s, his female English friends considered it only what could be expected from a woman who, it was correctly whispered, had been born a peasant and was actually in trade. As always though, Chanel was right. She captured the zeitgeist quicker than anybody else, and wasted no time in exploiting it. Other couturiers were too busy tut-tutting about vulgarity to keep up. It is uncanny how right Chanel got the ingredients: little tweed jackets, Norfolk or hacking style; Fair Isle pullovers, flannel, tweed or cord trousers with braces; shirts and ties; tuxedos. The panoply of twentieth-century male dress was commandeered in her wake, by designers as varied as Ralph Lauren and Miuccia Prada, Calvin Klein and Giorgio Armani for their women's ranges. Other barriers were also broken down: women adopted boyish haircuts, trousers, boots and figures like those of adolescent boys. And so, there is no fear of female androgyny in most societies today.

High fashion occasionally toys with androgyny – designers such as Jean Paul Gaultier love to play with gender stereotypes – but dressing the sexes the same contradicts one of fashion's main purposes: presenting the body in the most attractive way possible to the opposite sex. There was an exception in the 1960s, when designers such as André Courrèges tried to reduce clothing to a practical, unisex uniform. The idea never really caught on, and androgynous dress, although it has become relatively widespread, has done so less because of idealism than because of practicality. Some forms of workwear, such as dungarees, overalls and even waiters' white shirts and black trousers, are so fit for their purposes that they have been adopted by both sexes (see Workwear, page 234). Meanwhile it is the economics of multi-national retail chains rather than urges for social revolution that have led to the global adoption of variations on the 'uniform' of T-shirt and jeans or khakis for men and women of all ages (see Generic, page 196).

Bartow County State Highway prisoners relax on bunks, 1942

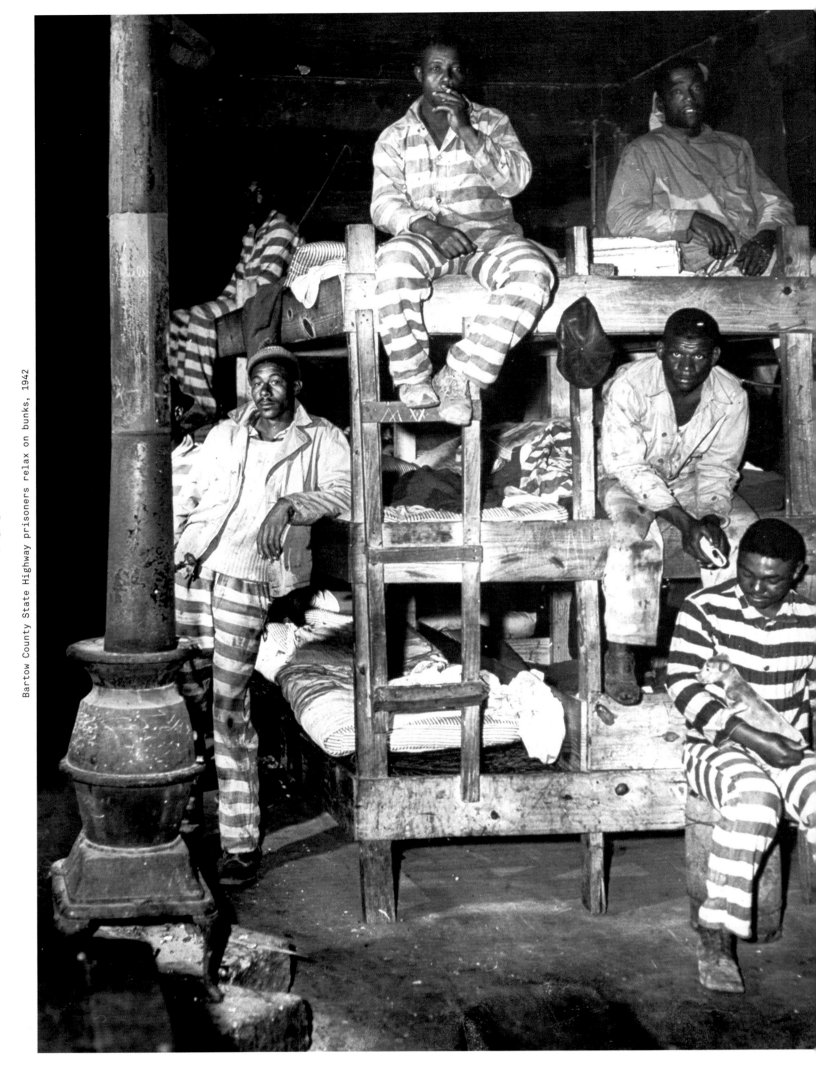

Clothes can be a form of social disguise that helps the wearer blend into the background. Wearers may choose to surrender individual distinction in favour of belonging to a safe, homogeneous group – such as sports fans who all wear their team's shirt – or they may even make themselves unremarkable enough to go virtually unnoticed (see Allegiance, page 156). Sometimes this anonymity is deliberate, among reserved people who find comfort in the idea of being lost in a crowd. At other times, anonymity is forced upon individuals, often as a condition of membership of an institution. Governments, employers and exploiters alike all find anonymity desirable. One of the first steps in getting a group of people to act the same way is to get them dressing the same, whether they be the staff of a fast-food restaurant, the security services or a platoon of soldiers.

This is the reason why promoting anonymity in dress is so often one of the goals of revolutionary politics. It was in 1912 that the tunic suit, or Zhongshan suit, became acceptable in China, with its Western-style trousers allied with oriental jackets with button-up collars and four pockets. Inspired by the nationalist leader Sun Yat-sen, urban Chinese wore these suits as a sign of loyalty to the nation. Later, after Sun had been driven to Taiwan and Mao Zedong had proclaimed the People's Republic of China, everyone wore a looser version of the Zhongshan suit – with only five buttons rather than seven, because Mao's communist ideology prized simplicity. The suits were navy blue, grey, green or black, and were identical for formal and informal wear. To fail to conform by wearing something else was to risk calling attention to oneself and being singled out for punishment as a potential troublemaker and political deviant.

Erasing one's personality is often an expression of deference, albeit not always to a higher political power. The robes of parish priests and Buddhist monks similarly disguise the body of the wearer in drapery. The ultimate anonymity in dress, in which the wearer is obscured altogether, comes from a desire for modesty. Islamic hijab, in which women swathe their bodies in gowns such as the chador and veil their faces with the Arabian niqab or the Afghan-style burqa, is an acknowledgement that the shape of the female body itself is a temptation to sin that must be removed from view. This is not so much disguise as sartorial annihilation. Yet clothes stores in Damascus and Amman sell exotic lingerie that women wear beneath their robes in order to assert their individuality. Designer Hussein Chalayan expressed this paradox in a fashion show in 1996 in which he dressed models in mid-length veils that hid their faces yet left their naked genitals visible – a simultaneous protest against both the dehumanizing of the individual and the sexual obsessions of the modern, and indeed ancient, world.

One great advantage of anonymity is secrecy. The masked balls of the Venetian carnival were not only a way to create freedom for sexual licence; they were also an echo of past rituals in which shamans wore masks to communicate with the spirit world. Shakespearean theatre makes great play of confusion of identity, not only between individuals but also across genders and between social ranks; in the modern world, identity theft has made such confusion more sinister. Secrecy also implies threat, and the threatening quality of anonymity has never been better expressed than in Stanley Kubrick's movie »A Clockwork Orange« (1971), when Alex and the droogs don white shirts and trousers, bowler hats and clown-like masks for their odysseys of violence, confident that their horrific appearance will make individual identification impossible.

If anonymity has a colour, then surely it is black. The plain black suit has been adopted most notably by the G-Men of the FBI, yet also by puppeteers and undertakers whose black clothing allows them to disappear into the background – one literally and the other metaphorically. The black clothing adopted by the beatniks in Paris in the 1960s, meanwhile, related anonymity to a political view (see Colour and Pattern, page 36). The uniformity of colour was an attempt to sweep away distinctions between men and women and their respective status, as well as to concentrate attention not on appearance but on intellect.

Sadly, this philosophy was too narcissistic and self-regarding to have any lasting impact, but a similar impulse underlies more recent examples of uniformity of dress, such as the fashionistas' adoption of black in the 1980s, as seen at shows by Giorgio Armani, Gianni Versace, Karl Lagerfeld and Dolce & Gabbana. No matter what colours came down the catwalk, the audience wore nothing but black. Not only did a black wardrobe make fashion decisions easier in busy lives; it was suggested that the uniformity was classless, a form of social levelling in an industry in which the traditional hierarchy – think Paris, Milan, couture, »Vogue« – was increasingly being challenged by fashion upstarts.

'From now on you'll have no identifying marks of any kind. You'll not stand out in any way. Your entire image is crafted to leave no lasting memory with anyone you encounter … You're no longer part of the System. You're above the System. Over it. Beyond it. We are the Men in Black' – »Men in Black«, 1997

Mao Zedong with workers and Party members, Chinese poster, 1950s

A
N
O
N
Y
M
O
U
S

THE
BODY
CLOTHED

Buddhist monks, Jogyesha shrine, Seoul, South Korea, 2010

A
R
M
O
U
R
E
D

'After victory, tighten your helmet cord' – Japanese proverb

All clothing is, to a greater or lesser extent, armour. Its primary purpose is to protect us from the outside world – if not from real blows, then from the slings and arrows of outrageous fortune. When we put on clothes we not only create a physical barrier; we also cocoon our personalities. We prepare ourselves for our daily combat with the world and send out signals to onlookers as clearly as the Black Prince (Edward, Prince of Wales, 1330–76) with the plumes on his helmet.

The origins of armour lie in nature, in the shell of the tortoise – a common material for fashion accessories – and the carapaces of insects and arthropods. These coverings are strong, yet light and flexible, and above all beautiful, with iridescent colours shimmering beneath. The London designer Marios Schwab even produced a 2010 collection inspired by the colouration of beetles. (It was the ancient Egyptians who first recognized the power of the scarab, the beetle they identified with the god Kephri, carvings of which they buried with their mummies.)

The medieval knights' armour sacrificed all other considerations to bodily safety. The metal plates were so heavy that a knight could not walk easily (although in extremis he could actually run short distances), so he required not only a horse in order to fight (and a crane to lift him on to it) but also stables and grooms; he could not dress himself, so needed squires; and he could not afford to fight at all without the support of an entire social system. That system – known as feudalism – channelled wealth to the fighting elite at the expense of those who, in return, benefited from the protection of the lords. Feudalism dominated Europe from the early Middle Ages until the Black Death in the mid-fourteenth century. There are few articles of clothing so closely linked not only with the status of wearer but also with the whole society that gave rise to them than armour.

Plate armour died out with feudalism, and was made obsolete by gunpowder weapons. Chain mail lasted far longer. Its genesis goes back to the Celts in the third century BC, who mastered the craft of riveting iron rings into relatively lightweight sheets. It remained a staple of military wear for over 1,500 years. Mail fascinates because it joins the past with the future. For Paco Rabanne and André Courrèges in the 1960s it heralded the space age, in which metals and plastics would be used as textiles, replicating qualities found in the natural world. Since then, it has been taken up by designers such as Gianni Versace for its shimmering effects, like the glimmering of fish scales (see Materials and Texture, page 24).

Metal plates are too impractical to feature often in dress – their weight threatens to snap the average fashionista in two. Yet there are constant reminders of our armoured legacy: the wooden or iron stomachers used to keep Spanish infantas looking slim in the seventeenth century; the shoulder pads on power dresses; the high-collared turtleneck that resembles the shape of a modern bulletproof vest; the extended cuffs of the gauntlet; the shape of the leg warmer and the snood. All refer to the shapes of bodily protection, or the manner in which armour split the body into articulated sections.

There is something inherently sensual in combining armour with the softness of human flesh, particularly female flesh. The bustier, the fetishistic garment of the 1980s and 1990s, built a carapace for the breasts that made women resemble something from the insect world – both predatory and vulnerable. The experiment that culminated in Thierry Mugler's Harley Davidson bustier of 1992 – complete with handlebars – began with Yves Saint Laurent in 1969, when he had a golden breastplate moulded by the sculptor Claude Lalanne (see Torso, page 76). In the early 1980s Issey Miyake went on to mould polystyrene bustiers and to enfold the female body in cane tops that owed their inspiration to samurai armour, which was formed by tying together small metal plates with laces to form a cuirass.

The silhouette of the samurai, Japan's elite warrior knights, underlay the new concept of the body with which Japanese designers revolutionized Western fashion in the 1980s. They made clothes a 'box' for the body, with squared shoulders and the appearance of straight edges. The »sode« that protected the samurai's shoulders gave them a squared-off appearance which was amplified by the kusazuri, an armoured leather skirt that hung down to the knees. For centuries this had been the silhouette of military and social power – especially topped with a »kabuto« helmet (now mainly familiar from the appearance of Darth Vader in the Star Wars movies) – and its replacement by a softer form of dress was perhaps inevitable.

Dress by Thierry Mugler, Haute Couture Autumn/Winter 1997-98

Stationmaster of the Great Central Railway Company, Finmere Station, Oxfordshire, UK, 1904

In modern society, dress is the shorthand for showing unequivocally where we belong – and also for proclaiming what we are not. It instantly reveals our attitudes, values and standards. Nowhere is this more apparent as in the use of clothes to reinforce the hold that our 'elders and betters' have over social order. During the Elizabethan period, for example, apparel was like a visible form of politics. Both Henry VIII and his daughter, Elizabeth I, wore clothes as a proof of their social authority. This was real power dressing. The magnificence was intended to strike awe and fear into those who saw it, and who understood the ruthlessness and disregard it represented.

The decline in the absolute power of the monarchy and the rise of the middle classes confused the issue. Elizabeth I dressed in a way that was clearly different from her subjects. By the end of the seventeenth century, though, the dress of rulers differed much less from that of their subjects in the higher echelons of society. This diminution of the power of clothes contributed to a view of fashion as a trivial pursuit that no longer had any connection with real power.

Outside the military, uniform is often a cloak for social authority. In this sense, its most ubiquitous form is the business suit, as almost universally worn by those who have reached senior positions in the professions (see Tailored, page 228). A more distinctive form is the dress of officials such as senior clergy or judges. The clothing is a symbol of both the power of the individual and of the organization that bestows it. Once established, such forms of clothing often change only slowly, and may even become consciously anachronistic. From earliest times, there were standard ways of dressing to distinguish priests and indicate the hierarchy among them. But by the time of the Renaissance, scholars, lawyers and politicians also wore clothes that set them apart and acknowledged their social and intellectual power. It was the growth of great organizations and institutions, from universities and guilds to the national governments that emerged in Europe from the sixteenth century onwards, which encouraged the adoption of civil uniforms. In an industrial society, the uniform of the stationmaster became as much a symbol of his authority as its most important element, a large watch. Some uniforms can be threatening – think of the traditional black and yellow of the traffic warden, which mimics the colours of the wasp or the hornet, poised to sting. Others are reassuring, like the gold braid around the cuffs of an airline pilot that signifies at least five thousand hours of flying experience.

The most eye-catching uniforms are often the oldest. Velvet knee-length breeches, satin coats, cape-like crimson collars, ermine trimmings: this extreme heritage dressing belongs to the Knights of the Garter, founded in 1348 by Edward III, reputedly by picking up a lady's dropped garter and tying it around his own leg, saying 'Honi soit qui mal y pense' (Evil to those who think ill of it). Only twenty-four people are entitled to wear this uniform at any one time, and they come from the top echelons of the British Establishment. This is pantomime dress; a gaudy spectacle for the middle and lower classes. It offers observers a glimpse into a Toytown, fantasy world of tradition – all pomp and no substance, as most Establishment dressing is today.

Justice, too, depends on appearance, from the variations on police uniform around the world to the outdated clothes of many legal systems. Judges' robes and wigs not only project their status, but are also intended to intimidate the judged. The colonial influence means that judges in many parts of the world still dress as eighteenth-century European gentlemen, such as the nine members of the US Supreme Court with their black gowns, occasional white collars or jabots, and outdoor black skullcaps (January inaugurations are notoriously cold for the bare-headed). Justices in some countries still wear wigs – and 'big wigs' for ceremonial occasions – recalling the Victorian observation that 'Dignity cannot embody itself within little things, hence the custom of wearing large wigs.'

The training for this kind of dress starts early, with the archaic uniforms of many public schools, which might incorporate brightly-coloured knickerbockers for boys or flowing capes for girls. Then at the University of Oxford, for example, the governors of tomorrow dress for formal occasions in subfusc: black or dark grey suits or skirts, white shirts, white bow ties or black ribbons (for women), academic gown (its length reflects the student's academic prowess) and mortar board (usually carried, rarely worn). Such formality may appear vaguely ridiculous, but it marks the students out as special; it reminds everyone that these young people are part of an exclusive club. The occasions at which it is worn – entering the college and graduation – are the rites of passage they must clear to claim their place in the Establishment (see Establishment, page 188).

'For heaven's sake discard the monstrous wig which makes the English judges look like rats peeping through bunches of oakum' – THOMAS JEFFERSON, c.1775

Judges and barristers, London, 1938

A
U
T
H
O
R
I
T
Y

THE
BODY
CLOTHED

Highway patrolman, Winter Olympics,
Salt Lake City, Utah, 2002

THE
BODY
CLOTHED

C
A
M
O
U
F
L
A
G
E

'One of my favourite clothing patterns is camouflage. Because when you're in the woods it helps you blend in. But when you're not, it does the opposite. It's like, "Hey, there's an asshole"' – DEMETRI MARTIN

Hunters, Utah, c.2010

Camouflage – the disguising of an object or person, usually through the use of colour – was first adopted by the earliest hunters. In its most extreme form, the hunter wore the skin of a dead animal to allow him to get close to a living one. For centuries, camouflage remained the art of the hunter: soldiers on the battlefield were more often dressed in bright colours to make their whereabouts obvious to their commanders. In military terms, camouflage emerged in the early twentieth century, when drab colours were adopted to make soldiers less conspicuous to enemy gunners: in the age of the machine gun, becoming less visible was a vital form of protection.

The first formal study of camouflage in nature came in 1896, when American artist Abbott H. Thayer published an article entitled 'The Law Which Underlies Protective Coloration'. Thayer brought an artist's eye to dissecting how an animal's coloration helped to disguise it in the environment. The stripes of the tiger, the spots of the leopard and the silvery scales of the fish are all methods of breaking up an animal's outline, flattening it and making it blend into the background (see Colour and Pattern, page 36). These methods could be replicated artificially, Thayer suggested. Camouflage innovation was speeded up dramatically by the arrival of World War I in 1914 – in fact the word was first used during the conflict, in 1917.

Governments employed leading artists to create the most effective camouflage designs, starting with the French Camouflage Division of 1915, and the US Camouflage Corps, a company of the 40th Engineers. Among the renowned artists who worked on camouflage patterns in the two world wars were Franz Marc, Ellsworth Kelly, Grant Wood, Jacques Villon, Arshile Gorky and László Moholy-Nagy. In visual terms, their work can be seen as a curious echo of the contemporary geometric work of the Cubists, based on their desire to understand and disrupt normal patterns of seeing.

In 1927 Louis Weinberg – an advocate of colour studies at City College, New York – applied the language of camouflage to regular fashion, explaining how the patterns and shapes of clothes disrupt the perception of the body beneath. He noted the use of 'horizontal parallelism, broad shoulders, wide collars and all over pattern, [to] emphasise width' and suggested that 'vertical parallelism offsets heaviness and creates the illusion of greater length'. Weinberg's dicta were an early formulation of what is now a golden rule of fashion: vertical stripes make you appear thinner; horizontal stripes make you look shorter.

Today, the most obvious differences in camouflage patterns lie in the broad palettes used for forested areas (greens and browns), deserts (khakis and browns), snowy mountains (whites and greys) and, in many countries, sky blue. But there are also variations in the patterns themselves. Some use 'traditional' patches of colour like irregular jigsaw pieces; others, like the German and Danish Flecktarn, use a more stippled effect (Flecktarn means 'spot camouflage'); forces in the former Yugoslavia wear an 'amoeba' pattern; while the Canadians and Americans pioneered the widely-copied 'digital' patterns, in which the colours appear pixellated.

Camouflage in civilian life is almost entirely limited to the male: women do not seem to feel the same need to identify themselves vicariously with the military. It entered the fashion mainstream in the 1990s via youth-oriented companies such as Diesel and Maharishi; they brought camouflage to customers who would never go near a battlefield nor, for that matter, a wild animal. Such firms picked up on the popularity of terrorist chic and army surplus clothing from the 1970s and 1980s. The military, as with workwear and the American West, is a source of fashion that can be revisited many times. In contemporary urban settings, camouflage reflects not only an appeal to the disaffected: it also gives out a message that the city is itself a jungle, in which it is necessary to hide to survive.

»Lutz, Alex, Suzanne and Christoph on the Beach«, photograph by Wolfgang Tillmans, 1993

167

168

Donna Karan, two-piece variations, Autumn 2009

The concept of a capsule wardrobe – in other words, a limited range of clothing, the components of which are dictated by practicality and compatability – began with modern warfare, when mobility and speed of movement were of the essence for troops who could not carry any item of dress not totally necessary in the field of battle. In civilian life, the advent of air travel and the need for weight control on board meant that the number of changes of clothes even the relatively wealthy could take on a journey was greatly reduced. No more cabin trunks and cases full of items labelled 'Not wanted on journey'. The streamlining has now reached the point at which frequent travellers can carry everything they need for a week way from home in a case small enough to carried as hand luggage.

In its modern guise, the real capsule wardrobe evolved from the middle of the twentieth century in the United States, the origin of so much of the streamlined practicality we associate with contemporary sportswear – in fashion terms, leisurewear rather than activewear (see Sportswear, page 226). This was a wardrobe of relatively few pieces that could be worn in numerous combinations, were easy to store and look after – even in tiny urban bedsits – and that were classic enough not to pass quickly in and out of fashion. The term 'capsule wardrobe' is generally attributed to Susie Faux, owner of the London boutique Wardrobe, who is said to have come up with it in 1965 to describe her approach to selling clothes. But the idea, if not the phrase, had originated in the previous decade thanks to an unsung but seminal figure in US fashion design, Claire McCardell, who worked as chief designer for a mass clothing manufacturer, Townley Frocks, Inc.

Throughout the 1940s and much of the 1950s McCardell dominated American ready-to-wear with an approach based on practicality, ease and lack of fuss. She produced clothes for women dressing for themselves rather than for their husbands. At a time when the rich still took steamers and filled their trunks with outfits complete with matching hats, gloves and scarves, McCardell pioneered the idea of a wardrobe of half a dozen garments that were all compatible with one another. It was not her only breakthrough: she also sewed clothes with double stitching, previously only seen on jeans; gave dresses and skirts hardware closings such as zips and poppers; and invented the 'monastic'. This dress, cut on the bias with no waistline, was shapeless until belted – but it was perhaps the most enduring, classless and ageless female garment of the twentieth century, subsequently adapted by Diane von Furstenberg for her bestselling wrap dress.

The women's capsule was first presented as an entity in 1985 in New York by Donna Karan. 'Seven Easy Pieces' was her first collection under her own name after years spent learning the aesthetic of sportswear working for Anne Klein (see Sportswear, page 226). Karan's show began with eight models dressed only in bodysuits and tights, who then began to add individual garments to demonstrate their flexibility. Karan's vision was to give women style, practicality and variety from an interchangeable but limited number of garments. The clothes were able to be worn in different combinations in order to make up 'looks' of a much wider range than the sum of their components as individual wardrobe items.

Since Karan's innovation, the idea of the capsule wardrobe has become a standard approach to dressing. The number of garments it might contain varies – Susie Faux suggested that it contain a coat, a jacket, a knit, a dress or skirt, two pairs of trousers, two pairs of shoes and two bags – but the basic rules are well established. The clothes are usually in neutrals such as black, grey or beige that go with most other colours. They tend to be well made so they last – buying cheap clothes goes against the ethos of creating an enduring wardrobe – and come in plain designs and patterns that will not date rapidly. An interchangeable trouser suit and skirt suit, plus an extra shirt, will give a woman enough clothes almost to last a working week. The addition of a pair of jeans, a T-shirt and a sundress allows the wardrobe to be equally useful for the weekend.

Building and adding to a capsule wardrobe has become a standard of fashion magazines, columns and TV shows, whose producers understand the wide appeal of advice on how to dress well without spending a fortune. It is perhaps inevitable that a certain sameness is the result, but a glance at any high street will provide ample evidence of the lasting appeal of the capsule wardrobe. Few modern clothing retailers who aim at grown-up professional women – rather than teenagers – do not have a relatively unchanging line of typical capsule items alongside the more fashionable clothes that change every season.

'It started with the seven easy pieces and it was a time to reflect back to them. The turtleneck, the skirt, the pant, the jacket, the coat, the jean. All so simple, but all about the woman, and her body, and her silhouette, and her strength' – DONNA KARAN, 2009

Sportswear by Claire McCardell, 1953, photo by Frances McLaughlin-Gill

C
A
P
S
U
L
E

Model in Ceil Chapman coat, 1946

Duff Cooper and Lady Diana Manners, 'society wedding of the year', 1919

THE
BODY
CLOTHED

C
L
A
S
S

'I became increasingly anarchistic. I began to find people of my own class vicious, people in clean collars uninteresting. I even accepted smells, personal as well as official' – MARGARET ANDERSON, »My Thirty Years' War«, 1930

Harrow schoolboy at Eton vs. Harrow cricket match, Lords, London, 1937

There is a theory that fashion exists because members of the upper class attempt to distinguish themselves through their clothes. The mantra goes like this. Upper class innovations are copied by the middle classes, who want to emulate their social superiors, until the distinction disappears. Then the upper class innovates again, to reestablish the distinction. Meanwhile, from the early nineteenth century onwards, the lower classes have been busy emulating the middle classes. The theory had some truth in the past, but none now. Even Kate Middleton, Duchess of Cambridge, emulates her contemporaries by buying mass-produced and cheap high-street clothes.

Quite what is meant by 'class', of course, varies from society to society, and particularly between Europe and the United States. The American fashion follower, although she might indeed have the values of a European lady, was traditionally part of a more upwardly mobile society. While class in Europe was still intimately linked with breeding, in the United States it merely reflected having a large enough income to live a fashionable lifestyle. It was women from this background, whom Truman Capote dubbed the 'swans' – Mona Bismarck, Millicent Rogers, Pauline de Rothschild, Barbara 'Babe' Paley – who, despite being some of the richest individuals in the nation, became talismans of taste for middle-class America. As seen through the pages of fashion magazines, their wardrobes, homes and lifestyles became inspirations for all women.

Even though class systems everywhere have become less rigid, the desire to preserve some kind of hierarchy lives on. Now it is more often than not the middle classes who carefully guard the rules that identify class through clothing. It is this exaggerated insistence on dress rules that lies behind the complex regulations of what may or may not be worn in golf clubs, provincial nightclubs ('no jeans') or city pubs ('no boots') (see Ostentatious, page 214).

Not that it is a one-way street, or not always. It is fashionable for those from higher up the social scale to ape their inferiors. This is not a new phenomenon: Marie Antoinette dressed as a milkmaid; the Bucks of Regency England bribed coachmen to be allowed to drive their vehicles and wear their coats. During the Romantic period, physical work acquired an aura of being more authentic than industrial or intellectual pursuits; such a view was perpetuated later in the nineteenth century by thinkers such as Matthew Arnold and William Morris. This is a kind of misrule: an inversion of the social order that liberates the spirit. In the 1960s, again, the chirpy working-class 'lads' took over – the Beatles, David Bailey, Terence Donovan, Michael Caine – and the impulse for change in clothing came from the streets. Casualness was all. This happened again with punk in the late 1970s (see Punk, page 218). Being privileged was so uncool. So the young elite embraced the jeans and minidresses of the less privileged, rather than the corduroy and petticoats of their birthright.

Because clothes betoken power, the upper classes have often been wary of allowing others to ape their styles of dress. It is not fear of imitation. It would probably still be possible to tell a peasant from a noble, even if the peasant were dressed in ermine; but what if the peasant starts to feel too much like a noble? That is the real fear: that the appearance of power is itself empowering, and thus a threat. Sumptuary laws – named for the Latin word »sumptus«, meaning 'expense' – limited what ordinary people could wear. Used in many societies, their best-known applications came in the later Middle Ages and the Renaissance.

In Tudor England a contemporary hoped that 'there may be a difference of estates known by their apparel after the commendable custom of times past'. In other words, peasants should dress like peasants, kings like kings and everyone else according to his or her station. But sumptuary laws rarely aimed at the top or bottom of the social scale. They were most concerned with those in between, for it is the middle classes who frighten rulers with their social ambition.

High fashion remains fascinated by low life. It is often a given on a modern photo shoot that highly expensive, luxury clothes should be portrayed in surroundings that are dirty or derelict. The juxtaposition might be ironic, or even post-ironic, were it not that for many inhabitants of Planet Fashion it is clearly not that far from the truth. When Hans Holbein the Younger painted the French ambassadors showing off their luxurious possessions in 1533, he famously included a distorted skull in the foreground as a memento mori, or reminder of death, as much as an advertisement of his painterly skills. That juxtaposition – worldly wealth versus mortality – had a moral message. But today's contrasts between wealth and poverty are exercises in voyeurism that edify no one.

Babe Paley wearing marten fur by John Frederics, 1939, photograph by Horst P. Horst

Austin Reed magazine advertisement, 1929

For generations of young middle-class Britons, coming of age before the 1960s or later was marked by a trip to the local ladies' or gentlemen's outfitters to buy a 'grown-up' outfit. For a boy, this might be a sports jacket and a pair of corduroys, cavalry twills or other fitted trousers and a pair of leather shoes; for a girl, a skirt and perhaps a twinset of matching cardigan and sweater, or a two-piece suit and a sensible belted woollen coat. These might be termed classic garments: simply cut from high-quality materials in a limited range of colours to provide a highly adaptable, enduring wardrobe. The purveyors of such clothes were the familiar high street retail chains: Austin Reed, Aquascutum, Burberry and the like for men; Jaeger for women.

Founded in 1900 by the eponymous tailor who, significantly, had learned the art of retail from US manufacturers and sold high-quality ready-to-wear alongside bespoke tailoring, Austin Reed spread throughout the country. The chain opened concessions on the great ocean liners, where its patrons included the great and the good of show business, politics and finance. In 1925 Austin Reed introduced some of the first ready-to-wear male suits. (In the 1940s, coincidentally, the store made Winston Churchill the famous all-in-one Siren Suit he designed himself.)

Aquascutum was even older, having been founded in London's Regent Street in 1851 by John Emary, who took the store's name from the world's first waterproof wool, which he patented in 1853 (aquascutum is Latin for 'water shield'). The label was granted a royal warrant by Edward VII, and shared its royal favour with another Establishment retailer, Burberry, founded in 1856. In 1900 Aquascutum introduced women's wear, and a similar expansion was followed by Burberry and Jaeger. Jaeger had been opened in 1884 by Lewis Tomalin, who translated into English the works of the German health advocate Gustav Jaeger. In the late 1950s, Jean Muir joined as designer and cemented Jaeger's status on the high street.

Such retailers were part of the cultural landscape. They sold middle-class clothes, largely for the middle-aged. The basic shapes changed very little, although changes of detail and colour marked the passing of the seasons. These were clothes for both day and evening, equally acceptable for tea with the vicar, a drink at the local pub or a trip to the theatre or ballet. For women, hemlines and necklines were sensible, and decoration was understated, adding to the overall impression of elegance. This middle-class uniform was something to which lower social classes aspired, buying cheaper versions from retailers such as Burton and Moss Bros in Britain or from upmarket department stores in the United States.

What 'classic' clothes proclaim about their wearers is that they are aware of the rules of what is and is not acceptable. They dress 'presentably' because it is their social responsibility to set a good example to others in society. They are not particularly interested in following fashion for its own sake, because they see it as a generally shallow and vain affair.

For all the stability of classic fashion, it does change, albeit less quickly than other forms of dress. In particular, the rise of youth culture in the 1950s and 1960s signalled the declining influence of the middle-aged. Another major factor was the rise in the numbers of women who went out to work, and who needed suitable clothes. This saw the rise of a new generation of classic dressmakers, such as Margaret Howell, who began making men's shirts at home in 1972, opened a men's store four years later, and in the 1980s opened stores in major cities in Britain, New York and Tokyo. In up-market menswear, the top name was probably the German firm Hugo Boss, whose clothes added a touch of flash to classic style, but the lucrative possibilities also attracted names such as Giorgio Armani, whose Emporio Armani line was closely based on the traditional retailers.

The majority of people, particularly men, prefer clothes that do not pose questions. They want to dress unexceptionally so they can draw comfort from belonging to a group. For relatively affluent middle-aged men, the firms that provide such comfort are no longer limited to traditional English firms. In Italy, Ermenegildo Zegna, Brioni and Nino Cerruti make similar clothes, using classic materials such as tweed, worsted and flannel, and without smacking too obviously of 'fashion'. Gucci, Tom Ford, Valentino and Ralph Lauren regularly reference the elegant past of Hollywood and the huntin', shootin' and fishin' dress of the English and European upper classes. They can do so because menswear does not evolve as fashion in the way women's wear does but, rather, is about 'tweaking' solid sellers. Such a total wardrobe approach to classics does not exist in the fast-changing, even frenetic, world of womenswear in which the 'classics' are specific items, such as the little black dress.

'Her clothes were incomparable, with just that suggestion of the haphazard which raised them above the mere "chic" of the mere mannequin' – EVELYN WAUGH, »Vile Bodies«, 1930

C
L
A
S
S
I
C

THE
BODY
CLOTHED

Tania Mallett in Jaeger suit and hat, 1960s, photograph by John French

Burberry runway show, Milan, January 2012

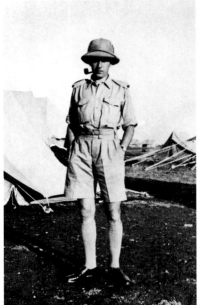

C
O
M
F
O
R
T

'With weather like ours, we've never had anything but the layered look, I can tell you' – Yorkshirewoman commenting on 1980s fashion

Woman in red duffle coat, »Le Petit Echo de la Mode«, front cover, October 1952

For most people, most of the time, clothes have to be comfortable: neither too restrictive nor too loose; neither too hot nor too cold. While high fashion is about statement, most clothing is designed to protect the body and help regulate its temperature. In this respect, clothing is far more flexible than hair, fur or other natural body coverings, and it is one reason why humans have been able to populate virtually all parts of the planet.

For centuries people in the Arctic Circle used layers of animal skins and furs to create outfits that were warm without being overpowering. Fur, it was clear, kept animals warm: therefore it would keep their hunters warm, too. It allows the body to breathe, avoiding trapped sweat that cools and reduces the body temperature. It was from the Inuit and other northern peoples that we learned how to layer modern performance clothing, typically creating a base layer that lifts moisture away from the skin, an insulation layer and a waterproof outer shell. This is the technology that underlies the clothes of modern outdoor labels such as The North Face, founded in San Francisco in 1968. Gore-tex, patented in 1980, is a fabric based on teflon that has the same waterproof but breathable qualities as the northern originals.

Worn widely in the Arctic Circle, the parka resembles the anorak, from the same region. Caribou and sealskin were oiled and used to make hooded, waterproof jackets; strictly speaking, parkas are longer and more heavily stuffed or lined than anoraks. The Barbour and associated waxed coats, meanwhile, came from Scotland, developed when hands on fishing boats began rubbing oil and wax onto their canvas sails to make them more efficient. (Scotland also produced knitwear styles using oiled wool from inhospitable islands such as Shetland.)

The duffel coat, meanwhile, can legitimately claim a crucial role in preserving democracy in Europe. Invented in 1890 by coatmaker John Partridge, the duffel – named for its textile, made in Duffel near Antwerp – was adopted by the British navy as part of its winter uniform. The outsized hood pulled over a navy cap, and the 'walrus teeth' toggles were usable even while wearing thick gloves. In World War II, the duffel helped to keep the sea lanes open – across the Atlantic and, even more so, in the Baltic, where convoys took supplies through arctic temperatures to keep the Soviet Union in the war.

As well as keeping the body warm, clothes can also keep it cool. Although any covering increases the temperature of the body, clothing is vital to protect the skin from the sun. The fine balance between protecting the skin and helping to cool the body continues in many parts of the world to be the prime motivation for how people dress. In the hottest parts of the Sahara traditional Bedouin wear the thawb or dishdasha, an all-covering robe that reaches virtually to the floor. The loose-fitting robes protect the body from the sun while trapping the cooling desert air as their ample material fills and floats away from the body. Most robes are white, so they reflect the sun's glare.

There are many ways to protect the head from the sun. The simplest is a covering of thin cloth, a style used by travellers in ancient Greece and continued in the knotted handkerchief worn on the heads of middle-aged men on British beaches in the middle years of last century. The sunhat must be light as a feather – of a material such as thin cotton, straw or pith, a type of light wood or cork – and large enough to shade the face and neck. The sombrero (from the Spanish for 'shade maker') may be associated with Mexicans lazing in the sun, but its origins were as workwear for cowboys and others who spent the day outdoors. Like the sombrero, the pith helmet of European colonials also cast a good shade and had a high crown that allowed heat to escape from the top of the head (see Head, page 54).

Khaki – from the Urdu for 'dust-coloured' – was adopted in the nineteenth century by the British in India and in 1900 khaki drill became the standard tropical uniform of the British army. In the early 1900s the look was appropriated by big-game hunters in Africa and the faux-military safari jacket became part of the standard uniform of the huntin', shootin' and fishin' brigade. It took a star of the ego of Ernest Hemingway – who once admitted that he'd prefer to be a great hunter than a great writer – to transfer the safari jacket to the mainstream, where it appeared as casual gear from the 1950s to the 1970s. In the British overseas territory of Bermuda, bankers are said to have adapted khaki drill during World War II to create tailored Bermuda shorts, which finish just above the knee and are traditionally worn with long socks that come to just below the knee. There are few places beyond the island where such clothing would be considered an appropriate outfit for a serious professional – or, indeed, anyone else.

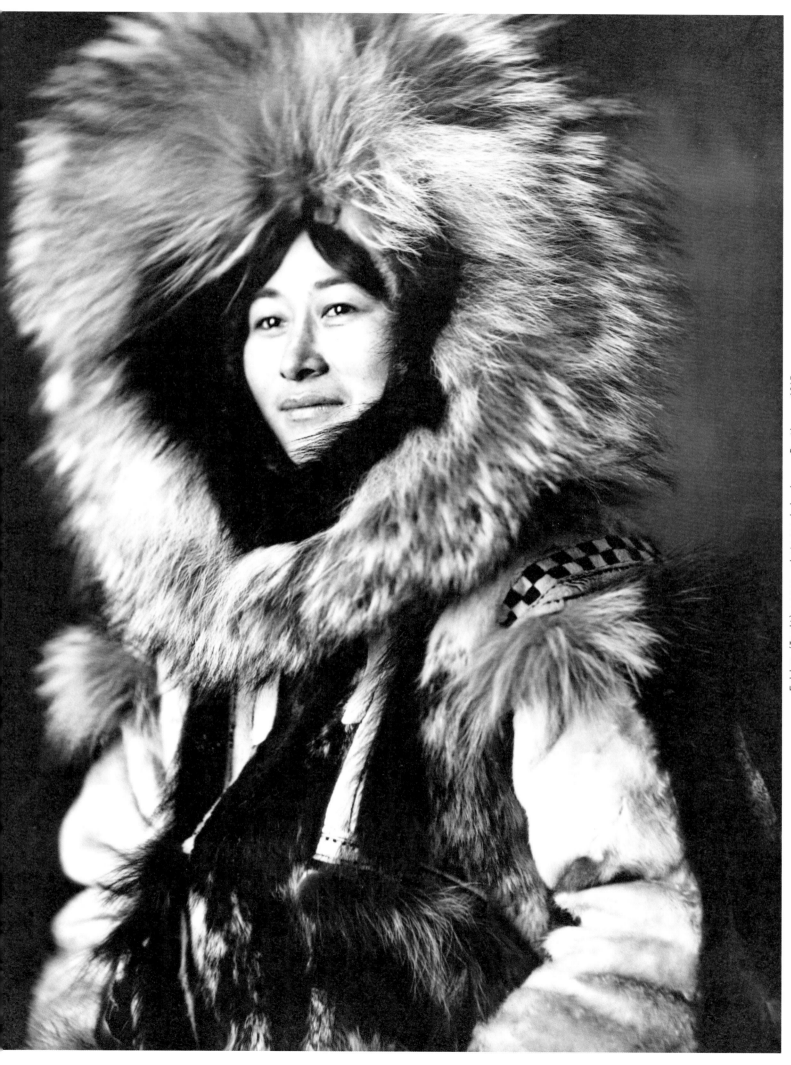

Eskimo (Inuit) woman, photograph by Loman Brothers, 1915

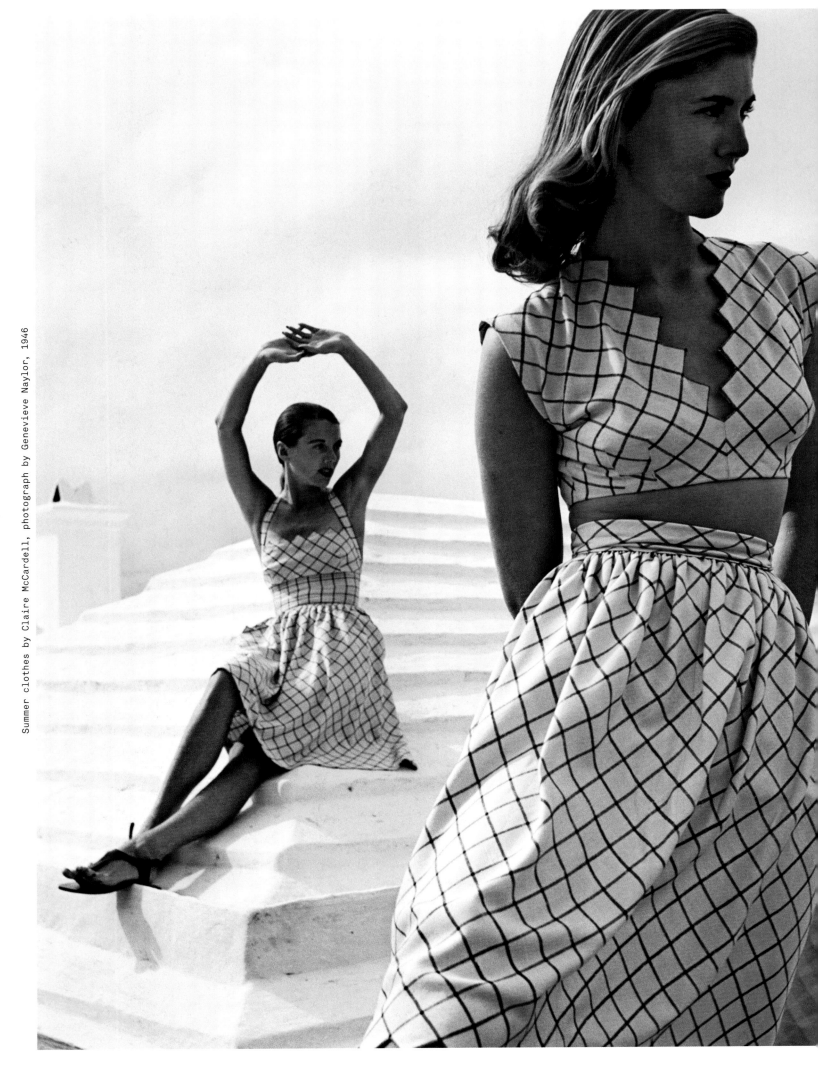

Summer clothes by Claire McCardell, photograph by Genevieve Naylor, 1946

As a rule, for most people at most times, clothes have to be easily wearable. Also as a rule, modern clothes are easy to put on and take off; easy to fasten and adjust; easy to repair and clean. They are easy to store, hanging in wardrobes or folded in drawers.

Over 6,000 years ago, the problem of holding clothes together was solved with needles of bone. Buttons appeared around 1000 BC but were decorative until the ancient Greeks pushed them through loops of thread to make fasteners. Buttonholes came later. After the Crusades of the thirteenth century, returning soldiers brought buttons to Europe, where the French elite seized on their potential for display. Ornate buttons became such status symbols that when Francis I of France met Henry VIII of England in 1520, his clothes reputedly had a total of some 13,600 buttons. Button-making was mechanized in the nineteenth century, and decorative buttons were used even on cheap clothes. Clothes that button down the back are a throwback to the days when everyone of quality had servants to help them get dressed, but certain garments simply look better with smooth fronts, and so the practice persists.

The next development from the button was originally conceived in 1851, but the zip – known at first as a continuous clothing fastener, clasp locker or separable fastener – did not reach its familiar form until 1917, when it was dubbed the zipper by the Goodyear company, which used it to fasten men's rubber boots. It was only in the 1930s that the fastener was applied to clothes: first for children's clothes, then as the preferred fastener for men's trouser flies, and ultimately to secure blouson jackets. By that time, the zip was itself being challenged. Velcro, the 'zipperless zipper', was the brainchild of a Swiss engineer, Georges de Mestral, who in 1941 was inspired when burrs of burdock stuck to his dog's fur. De Mestral developed a system of hooks and eyes that would lock together two pieces of fabric. The original was taken up by NASA for spacesuits and, ultimately, by manufacturers of children's clothes and then for sports shoes – although the zip has remained pre-eminent.

Since the point at which people began to have more than one set of garments, clothes have needed to be stored when they are not being worn. In the late medieval period they were kept in chests. Later, special rooms appeared for storing the formalwear of the wealthy: this garderobe evolved into the modern wardrobe. It was joined in the mid-seventeenth century by chests of drawers. As for hanging clothes, the breakthrough came in 1903, according to one account. Albert J. Parkhouse arrived at work at a wire company in Jackson, Mississippi, to find that there were no empty coat hooks, and twisted a length of wire into the now-classic coat hanger shape. More recent developments – such as suit bags, and vacuum bags for storing woollens – make it possible to store and transport clothing without even the need for smoothing them before wear.

The garment that requires no ironing is a holy grail. Modern fabrics often incorporate a proportion of synthethic material to help prevent wrinkles. Natural fabrics are coated with chemicals to help prevent creasing (and also to resist dirt and grime). In 1964 Levi's famously introduced Sta-Prest, trademarked jeans that retained the knife-like crease down the front of the leg, even after washing. This kind of clothing liberated young toughs from relying on their mothers to get their clothes ready, and so was popular among groups such as Mods and skinheads.

A similar ease was brought to women's everyday life in the 1940s and 1950s by Claire McCardell, who virtually single-handedly introduced the modern casual wardrobe (see Sportswear, page 226). Following the 1920s lead of Coco Chanel, McCardell used casual fabrics such as wool jersey and gingham and cut her clothes to fit easily. In 1942 she used denim to create the 'popover'. A wraparound dress that could be worn to do the housework and then to do the shopping, it swept the country because it was practical and comparatively cheap. It has never gone out of fashion and enjoyed a long renaissance in the form of Diane von Furstenberg's wrap dress.

The movement toward convenience dominated the late twentieth century, in terms of both care and ease of wear. Customers were reluctant to buy clothes that needed special care, especially after home washing machines became more common during the 1970s. And with the rise of a more casual approach to clothes, so easy-to-wear pull-ons and sweaters, jeans cut in an expanding range of styles to suit every physique and an emphasis on comfort rather than formality ensured that getting dressed has, almost literally, never been easier.

'My husband once asked [Cristóbal Balenciaga] to come to his rescue in doing up a Dior dress with thirty tiny buttons up the back, and Balenciaga kept muttering as he buttoned me up, "but Christian is mad, mad!"' – BETTINA BALLARD, »In my Fashion«, 1960

Pulling up a zip, 1964

C
O
N
V
E
N
I
E
N
C
E

THE
BODY
CLOTHED

Levi's Sta-Prest dacron pants advertisement, 1960

Cristóbal Balenciaga evening gown, drawing by Bernard Blossac, 1956

THE
BODY
CLOTHED

C
O
U
T
U
R
E

'A designer who is not also a couturier, who hasn't learned the most refined mysteries of physically creating his models, is like a sculptor who gives his drawings to another man, an artisan, to accomplish' – YVES SAINT LAURENT, »Ritz« magazine, 1984

The French word couture literally means 'sewing'; Haute Couture is therefore 'high sewing'. The term has come to signify the very highest standard in dressmaking and tailoring, but is often used too loosely to fully retain its original meaning. True couture is not just expensive ready-to-wear. It is about garments made exclusively to the measurements of individual customers. Up to the early Sixties, couture customers used to descend on Paris and stay for several weeks while they were measured and fitted. But as air travel increased mobility, women paradoxically became less inclined to make the trip to Paris. For everyday wear, couture houses introduced ready-to-wear and, later, demi-couture, by which a half-made garment was then made up to the exact measurements of the client. But by 1991, when Yves Saint Laurent closed his couture house, it seemed that couture was in its death throes. And although YSL later brought couture back, and the few houses that still have a couture clientele - Dior, Chanel, Valentino and Gaultier, preeminently - are benefiting from a resurgence of interest in couture, women no longer hang around waiting for their clothes to be made. Today the dress and a fitter fly to the customer – and the dress normally travels first class.

The Chambre Syndicale de la Couture Parisienne nominally controls whether an establishment is entitled to be called a couture house. The rules for entry, once strict, have been relaxed since the 1960s, when the advance of ready-to-wear began to menace the survival of Haute Couture. The rules include the following: clothes must be made to order with one or more fittings; the atelier must be located in Paris; at least fifteen full-time seamstresses and staff and twenty full-time technical staff must be employed; two seasonal collections per year must be presented; and the number of garments must be at least thirty-five, covering day- and eveningwear.

The birth of couture goes back to Charles Frederick Worth, the designer who made Paris a fashion centre in the second half of the nineteenth century. Worth changed the balance between the customer and the dressmaker: he scorned his clients for their lack of fashion culture, made them wait at his convenience and overcharged them hugely. Worth set the template for designers to follow, and most have done so enthusiastically. And yet Worth and his successors had the ability to see the fault with a dress in a single glance and to give the customer the best she could possibly buy. Worth's lead was followed by Paul Poiret, and by the start of World War I in 1914, the couturier was established as the arbiter of taste in dress.

Couture's heyday lasted until the rise of ready-to-wear after World War II. It was a rarefied and indulgent world, but the resulting clothes were remarkable works of art. Those who purveyed such clothing – Madame Vionnet, Coco Chanel, Elsa Schiaparelli, Jaques Fath, Christian Dior and Cristóbal Balenciaga in Paris; Norman Hartnell, Hardy Amies and Victor Stiebel in London; Charles James, Mainbocher and Norman Norrell in New York – were dedicated to perfection, whatever the cost in time and materials. Hence the vast expense of couture clothing: a Balenciaga dress in the 1950s could cost as much as a factory worker earned in a year.

Design, cut and taste are equally important in couture. Balenciaga was said to have spent his lifetime in a quest for the perfectly set-in sleeve. Paris developed a small army of highly skilled cutters, seamstresses and tailors to deliver technique of the highest standards for the most demanding clientele in the world.

Ready-to-wear was the eventual undoing of couture. The power and authority of Paris was increasingly challenged by cities such as Milan, New York and London, which placed a high premium on ready-to-wear and on convenience for the customer. As the age of fashion influence also fell, the market of super-rich women who were able to afford couture shrank. Today it is said to number about 3,000 women worldwide, of whom 300 are regular customers.

Couture still exists, with great houses such as Dior and Chanel. Today, however, couture survives largely as a means of promoting ready-to-wear lines, along with accessories and perfumes. Even a designer as renowned as Christian Lacroix failed to make a profit between founding his couture house in 1987 and going into administration in 2009. Today, the potential clientele for couture is likely to be among the wives of Russian and Chinese billionaires – and few of them are used to listening to the dictates of a designer. Many dresses are made for the individual customer – but without the underpinning of taste and technical perfection, they achieve something that is a long way short of traditional couture which, at its height, was a meeting of mutually attuned minds between clients and couturiers.

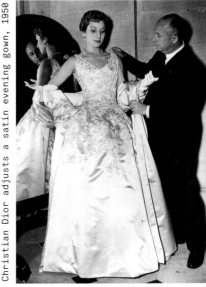

Christian Dior adjusts a satin evening gown, 1950

Evening gowns by Charles James, New York, 1948; photograph by Cecil Beaton

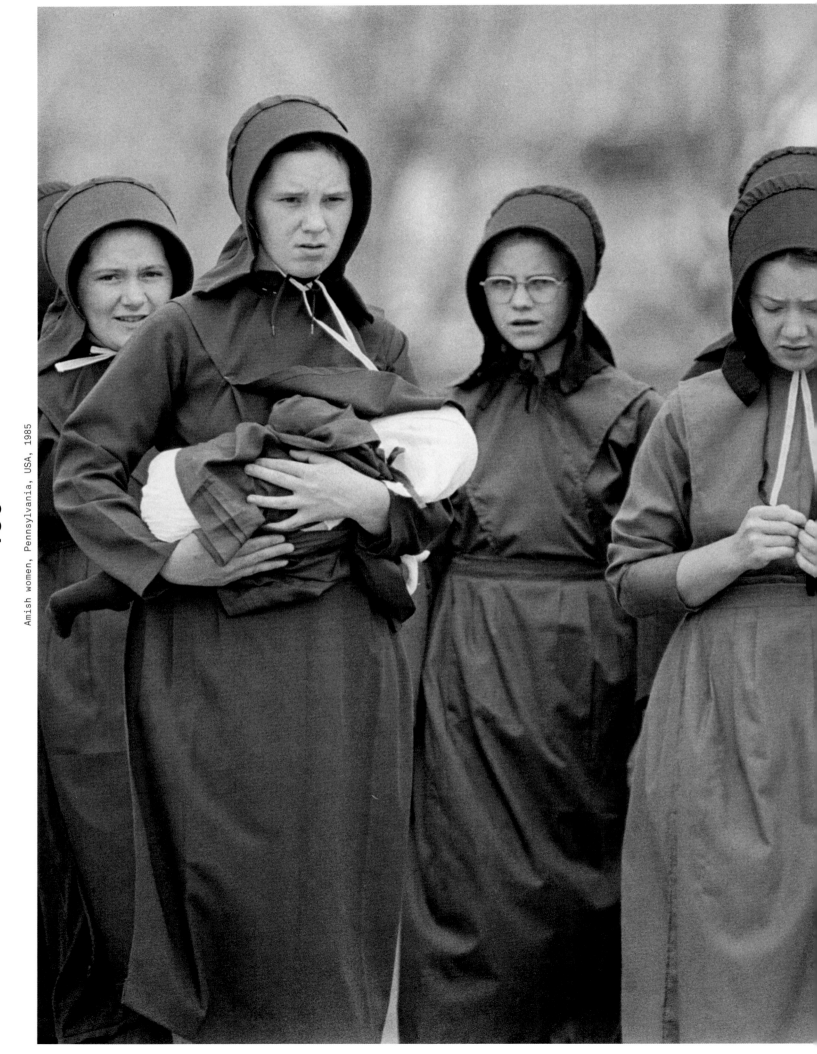

Amish women, Pennsylvania, USA, 1985

Ku Klux Klan ceremony, illustration, 1920

Cults are closed groups, bound by similar values and living by their own rules, typically based on music, or political or religious motivation. Today the word has acquired sinister overtones, thanks to the activities of religious and other oddballs, but cults traditionally have a positive effect for members – a feeling of not being alone against the world. Fashion is often key to this togetherness. Cult clothing is usually easily understandable: it instantly indicates a wearer's membership to other members and often also to nonmembers (think of the robes of the Ku Klux Klan, which provocatively signal membership while at the same time concealing identity).

The cult's rejection of the values of wider society is most evident in religious clothing, from the habits of monks and nuns to the anachronistic costumes still worn by Hasidic Jews and the Amish of Pennsylvania. This type of clothing declares its wearer dedicated to a simpler, more spiritual form of life. Cult clothing also rejects notions of class. In the eighteenth century, for example, the young aristocratic Bucks dressed like coachmen; some were said to have bribed real coachmen to let them drive the horses, in the same way that many professional men once grew up dreaming of becoming engine drivers.

Like the Bucks, influential fashion cults have been historically almost exclusively male. In the mid-eighteenth century, French courtiers at Versailles, the Petits-Maîtres, wore clothes that exaggerated current styles. Aped by the bourgeoisie, such dress became an anti-aristocrat and anti-monarchical political statement. The clothes and the pantomine gestures of their wearers were an expression of contempt for the ruling classes – and a precursor of the French Revolution that was to come in 1789. In Britain, too, fashion became political with the Macaronis: young members of the establishment who upset their elders by highlighting the feminine basis of contemporary dress. They wore fashionable lace, but too much; and satin and silk, but of the shiniest kinds. They rejected simple wigs and wore huge rococo piles of hair; on top of it, they rejected the cocked hat in favour of a ridiculously tiny version. They aped mincing female walks.

Following fashion is, in itself, a powerful cult. The women who buy two pairs of Manolos so that they can keep one pair for display, or women such as Mona Bismarck, who broke down and locked herself in her bedroom for days when her couturier, Balenciaga, retired, have an abundance of both money and time. They also require the sort of lives that allow them to cope with the inconvenience or ridicule associated with the extremes of fashion. No kind of normal life has room for garments like the panniered skirts of the eighteenth century that forced women to turn sideways to walk through doorways. As for ridicule, the topless or see-through fashions sometimes sent down runways in the 1970s by designers such as Yves Saint Laurent were only to be worn by those with nerves of steel in surroundings where they were sheltered from the vulgar attentions of hoi polloi.

Fashion cults have many sources. Some spring from the dress attitudes of influential individuals. The leader responsible for the understated form of dress that has become that of the archetypal English gentlemen, George Bryan "Beau" Brummell, was dedicated to good taste (see Dandy, page 182). For the dandies who followed him, extravagance was vulgar and sobriety was elegant. They predicated their appearance on the understatement of refinement. What the dandies proved was a lesson many modern young designers would do well to remember: making a statement is different from exhibitionism. Brummel himself exuded what his fellow dandy, Lord Byron, called "that certain exquisite propriety."

There may have been few Beau Brummells but there has been no shortage of royal fashion leaders. The red heels worn by Louis XIV at Versailles, which sparked a vogue among French courtiers, had a later counterpart in the ubiquitous craze among young British women for the "Lady Di" haircut in the early 1980s. The movers of cults have almost always come from the privileged classes. Even today fashion cults tend to start with former art-school students, as with the New Romantics in the 1990s, or middle-class professionals, like the Young Fogeys who followed their spiritual master, Tom Wolfe. And it continues. The Duchess of Cambridge started a fad for 'fascinators' which, although looking charming on her, were soon vulgarized by the sort of women who now attend once-elegant race meetings in order to drink champagne in large quantities (in 2012, stewards at Royal Ascot banned the headgear outright).

'A cult is a religion with no political power' – TOM WOLFE, »In Our Time«, 1980

C
U
L
T

»The Macaroni: A Real Character at the Late Masquerade« by Philip Dawe, 1773

THE
BODY
CLOTHED

D
A
N
D
Y

'Contrary to what many thoughtless people seem to believe, dandyism is not even an excessive delight in clothes and material elegance. For the perfect dandy, these things are no more than the symbol of the aristocratic superiority of his mind' – CHARLES BAUDELAIRE, 1863

Beau Brummell

Men, the popular view holds, are more likely to seek escape in the garden shed than in dress. Fashion has come to be seen as a predominantly female pursuit. Such was not always the case. Throughout most of history, male peacockery was the obligation of any wealthy and powerful male. Highly decorative clothing was a badge of rank. That situation changed in the eighteenth and nineteenth centuries as the rise of the middle class and the growth of industrialization produced a uniformity of male dress in which exceptions were viewed with suspicion. Moralists as far back as biblical times have condemned fashion as a form of vanity and usually tried to blame it on women, as a result of Eve and the apple. No wonder, then, that as men became so self-consciously the serious sex, a man's interest in display became more widely condemned than a woman's.

For fashionable men, dress remains primarily a means to demonstrate their solidarity with other men rather than to attract women. For three hundred years male costume has been largely the preserve of movements and groups. More than women, fashionable men like the reassurance of rules.

The modern worry about fashionable men is always that they might be a little … you know…. In the past, in contrast, the issue with men who obsessed over their appearance was that their vanity was closely associated with heterosexual display and predation. Henry VIII's peacockery no more called his sexuality into question than Louis XIV's scarlet high heels did his. But as the definition of a manly man changed in the nineteenth century to someone who was too serious for decoration, and as fashion slipped to being the hobby of the wealthy and indulgent, so paying too much attention to one's appearance became a sign of moral weakness. Conformity always kills creativity.

Male fashion has, for the past 180 years or so, been a muted and static affair. When men turned their backs on colour in the early part of the nineteenth century, and adopted shades of black, grey and brown, they rejected the merry-go-round of fashion change. There are exceptions, of course, but in the main the standard garments – trousers, shirts, jackets, overcoats – vary in detail rather than shape, colour or scale. Thus it is that men who care about how they dress pay greater attention to tiny details, an additional button here, a wider lapel there. This precision is the hallmark of the dandy – one who loves clothes but for whom the gaudy is usually a sign of vulgarity – and also tells where the wearer stands on many things he probably considers more important than his appearance.

The great leaders of male fashion were traditionally emperors and kings: from Julius Caesar (purple-fringed togas) to Charles V of Spain (black), Louis XIV of France (high heels and stockings) and Edward, Duke of Windsor (plus fours). In the first half of the twentieth century their place was taken by film stars and then by musicians and performers. Elvis Presley, the Beatles, the Jam: such performers made it acceptable for even utterly heterosexual men from the lower ranks of society to pay attention to their appearance. The new trend-setters, particularly in casual clothing, are sports personalities, from David Beckham to Usain Bolt.

The true dandy has always been a rarity. He sees dress as an expression of highly masculine qualities, such as precision, consideration and respect. There is no such thing as a female dandy. Dandies depend on a rational approach to clothing, relegating all other considerations to making a powerful statement without falling prey to the cardinal sin of ostentation. It was the leader of the dandies, Beau Brummell, who pointed out that a man does not dress to evince the interest of passersby, but for himself and the few who understand him.

Dedicated entirely to replacing the minutiae of dress with simplicity and purity, Brummell set the highest standard for the dandies at his height during the Regency, before he upset his 'fat friend' the Prince of Wales, later George IV, who came to resent Brummell's arrogance. The son of a minor nobleman, Brummell held all of British society in his sway because he captured the zeitgeist – the decline of the aristocracy and the rise of democratic politics. What Brummell did was to adopt the sporting costume of the English nobility – top hat and tails, linen cravat, breeches and riding boots – and wear it in the heart of London … and wear it with perfection. In doing so, he signalled that he was one of the leisure classes, who had the time to dedicate to a perfect appearance (but not, alas, the money … he fled to France to avoid debtor's prison in 1816, having lost the royal favour that had kept creditors at bay). One little-acknowledged result of his revolution in male dress was to ensure that from his time to now true aristocrats have felt happiest when dressed for country living.

Tom Ford, Autumn/Winter campaign, 2008–09

Fashion is rarely sure what to make of eccentricity, yet fashion has frequently been influenced by the eccentric: those who flout society's rules on how to dress. This is true not just about high-profile eccentrics such as Lady Gaga or even for the besuited Gilbert and George, for whom clothes are part of a performance. It is equally true for those who dye their hair green, wear gala make-up, dress in the clothes of the opposite sex, wear pyjamas to go shopping … The list goes on.

One powerful strain of unconventionality has been inspired by creativity, particularly among men, such as the painter's beret and smock reinvented by Augustus John in the early twentieth century. Other looks are self-consciously old fashioned, such as Oscar Wilde's knickerbocker suits, which made him look like something from an early Victorian nursery. Harold Acton and the aesthetes in Oxford in the 1920s wore exaggeratedly wide trousers, known as Oxford bags; in the middle of the century Noel Coward and Somerset Maugham drifted in silk dressing gowns and Cecil Beaton was one of the first men to wear make-up in public; while in the 1980s the 'young fogeys', led in the United States by Tom Wolfe and in Britain by A. N. Wilson, masqueraded in tweed suits, waistcoats and hats from some forty years earlier. This form of dressing is a conscious rejection of crude masculinity and its intimations of a lack of imagination and impulsiveness.

In the past, male vanity was mocked in the shape of the fop for both his foolishness and his effeminacy. The word is always derogatory. The fop came to attention as a stock character in Restoration drama (in 1701 Colley Cibber had a hit with »Love Makes a Man; Or, the Fop's Fortune«). Usually rich and foolish – and affected – the fop follows fashion for fashion's sake. He wears the latest style whether or not it suits him. A modern equivalent is rarely seen, but resurfaced in the 1970s among the long-haired stars of heavy metal in their tight leggings and spectacular perms. They were the embodiment of manliness for these most macho of men, whose flamboyance was that of the lion impressing females with its mane. They combined a pantomime quality with the air of menace that accompanies the man whose vanity allows no concern for others.

In designers, eccentricity has been evident from Paul Poiret and his advocacy of harem pants and the hobble skirt to modern enfants terrible such as Jean Paul Gaultier, Thierry Mugler or Vivienne Westwood. Inevitably, such creators do not come up with eccentric styles in a vacuum. They take existing strands in fashion and exaggerate them in the quest for novelty. For all the excitement of their fantasies and reinventions, it is sometimes difficult to see what there is at the bottom that people can actually wear. Their fantasies are often at their best when mixed with the designs of others by a stylist such as the »Italian Vogue« fashion editor, Anna Piaggi.

What Piaggi and other refined observers understand is that the key to dress is suitability. Wearing the wrong clothes in the wrong situation is eccentric even if in themselves they are not – wearing a diver's frogsuit to the opera, for example, or a ball gown to a football match. What sometimes appears mad is often simply unexpected. This kind of eccentric fashion has its roots in the surrealist movement of the 1920s and 1930s, which brought together ways of creating art with unlikely objects – a telephone, a lobster, a melting clock. In fashion, Elsa Schiaparelli played with her friend Dalí to achieve surreal effects and the eccentric Italian Marchesa Casati nearly killed herself with an electrically powered dress. The moment lives on, however. The fashion show staged in a shopping mall for the 1986 movie »True Stories« featured suits made from Astroturf or painted to look as if they were made of bricks. Moschino in the 1990s and Jeremy Scott in the 2000s used fabrics that resembled huge dollar bills in which to wrap the body. Today's equivalent is Lady Gaga, with outfits made from puppets of Kermit the Frog or from cuts of meat. Those who profess outrage are forgetting the significance of the surreal tradition (or that in 1983 the Undertones wrapped a model in meat for the cover of their album »All Wrapped Up«).

The only eccentricity that dress rarely excuses is ugliness. During the 1990s the Japanese avant garde designers offered a challenge to traditional ideas of beauty that bewildered many of those who saw it. Rei Kawakubo's 1997 'Body Meets Dress; Dress Meets Body' collection for Comme des Garçons incorporated large lumps and bumps within the clothes that distorted the shape of the body as if it were suffering a form of elephantisis, with huge bottoms, grossly distended stomachs or even humpbacks. Kawakubo's clothes questioned the nature of beauty in the West and the tyranny of line, drawing on models from Japanese architects who have also eschewed the conventional linear approach, such as Masaharu Takasaki's Crystal Light Building.

Oxford bags, c.1925

'That so few now dare to be eccentric, marks the chief danger of the time' – JOHN STUART MILL, »On Liberty«, 1859

E
C
C
E
N
T
R
I
C

THE
BODY
CLOTHED

Red satin cap by Elsa Schiaparelli, 1949

THE
BODY
CLOTHED

E
S
C
A
P
I
S
M

'In times of recession, I think fashion is escapism' – ALEXANDER MCQUEEN

We dress to display who we are – and sometimes to display who we would prefer to be. Dress is the costume for our fantasies. From an early age, children enjoy dressing up in an attempt to be noticed by others, especially adults; as we grow older, the impulse manifests itself in more subtle ways. To some extent all dress is performance clothing: it allows us to take the stage as someone other than we really are. Our clothes send signals not only to others but also to ourselves. We believe that new clothes will improve us – they will bring us into a heightened state, if not of grace, then perhaps in fashion.

The most effective form of escape is a literal disguise – a mask that conceals our own character. It is a cover for intrigue, for romantic liaisons or even for murder. (In 1792 the Swedish king Gustav II was assassinated by disguised noblemen at a masked ball.) The most glamorous forum for disguise is the masked ball, which became widely popular at the start of the eighteenth century, based on the renowned pre-Lent Carnival in Venice. Masks and decorative costumes or dark cloaks (called dominoes) enabled the participants to flirt incognito. Masks appeared in London, in 1710, first in theatres and then in pleasure gardens at Ranelagh and Vauxhall, where masqueraders wore such exotic costumes as those of the commedia dell'arte – Harlequin (Arlecchino), Columbine, Punchinello and Pantaloon – religious habits, or Turkish dress.

Masked balls today are normally third-rate affairs. That is not always the case, however. Parties with a theme give a license for self-expression that daily clothes do not. Thus they have been seen as the height of glamour in, for example, Truman Capote's renowned black-and-white masked ball of 1966 and again at Prince William's 21st birthday party in June 2003, which had an "Out of Africa" theme. But the capacity for embarrassment is ever present, even at the highest social levels: William's brother, Harry, had to apologize two years later for attending a similar party dressed as a Nazi, complete with swastika armband.

Few women's fashion make-believe has rivaled that of Marie Antoinette – and fewer still have perished for their fantasy. But at Versailles, the French queen and her ladies played at being milkmaids (with cows that were cleaned before entering the milkshed), for which the queen wore a simple chemise dress of white muslin, with a wide sash at the waist. It was a naive gesture, of course, and it unconsciously emphasized the gulf in French society between the haves and the have nots. The queen became increasingly regal as the political situation grew more chaotic until it erupted in 1789 in the Revolution that cost her her head. The public came to gawp at – and then to tear to shreds – the three rooms full of her clothes at Versailles. John Galliano's homage to Marie Antoinette in his 2000 Christian Dior show, "Masquerade and Bondage", was based on a 1780s' gown with décolletage, a rigidly corseted waist, flirty bows on the bodice and flounced skirts – but adorned with two subversive panels, one of which showed the Queen as a faux shepherdess and the other on her way to the guillotine.

The modern version of Marie Antoinette's rural dressing up was the idealized version of English cottage style produced in the 1970s by the designer Laura Ashley, a rarity in that she was based in mid-Wales, far from fashionable London. Ashley's frankly romantic view of the rural past – all ruffled swains' shirts, full skirts in floral prints and milkmaid pinafores – struck a chord: by 1981 she had 5,000 outlets worldwide, selling clothes, furniture, wallpaper and homeware. As many young people in recession-hit Britain turned to punk to express their frustrations, far more preferred to escape into the soft-focus meadows of Ashley's world, which encompassed not just clothes but a total lifestyle.

But escapism can also come from small gestures, as it did during the bleak years of World War II. Textiles were required for uniforms and so on, so British women were limited to 34 'utility' styles produced by the Incorporated Society of London Fashion Designers with no more than three buttons, no cuffs and no skirt-lengths longer than just below the knee. In Paris, couture houses closed down. Women turned to materials that weren't restricted, such as artificial flowers and feathers, and made their own headdresses and shoes; in Britain women decorated hats and gloves, made suits and coats from their husband's wardrobes and, anecdotally at least, coloured their legs and drew on seams to imitate nylon stockings. The war saw an early expression of the 'lipstick effect': in hard times, small indulgences replace larger ones. Women who are not able to buy clothes grow their hair – in World War II in emulation of Veronica Lake – or buy the 'in' lipstick or nail varnish, popularized by screen goddesses such as Rita Hayworth and Jane Russell, Hollywood being the one area not allowed to be restricted in anything that would help keep morale high.

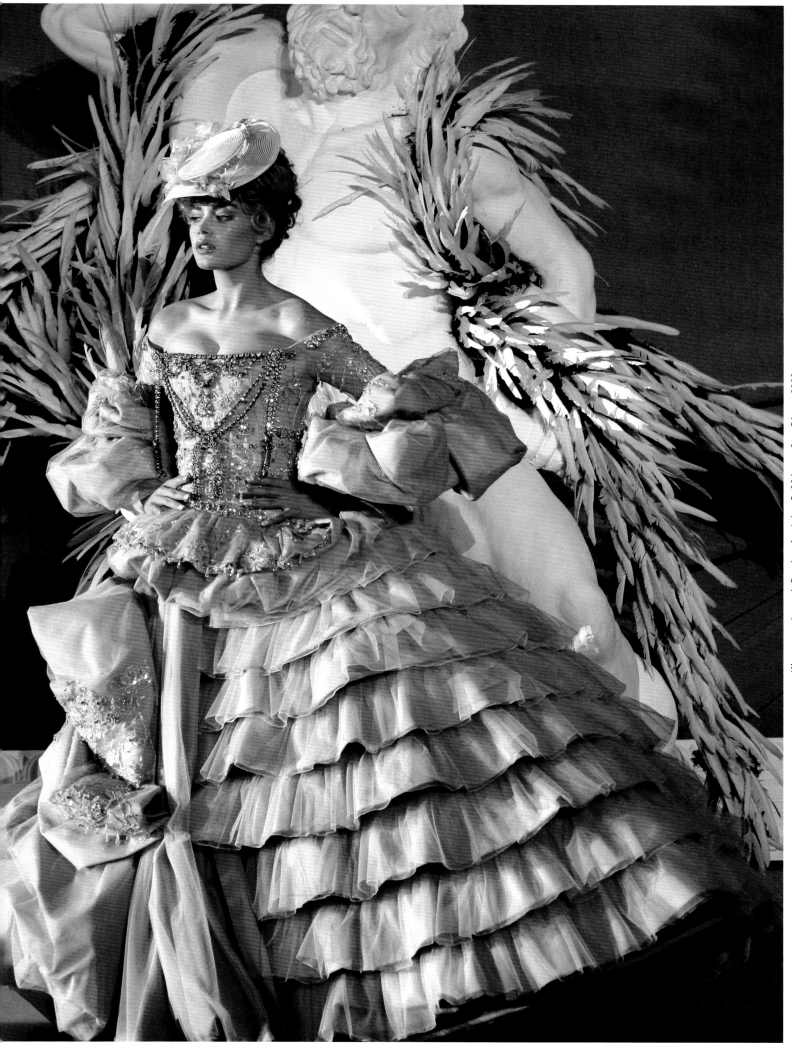

'Masquerade and Bondage', John Galliano for Dior, 2000

Gabriel Mann in »Revenge« (TV series), 2011

At the head of the class system is the Establishment; the small group that effectively runs the country. Until the last two centuries, the distinction between rulers and the ruled was always apparent through clothing. Put simply, the nobility wore the clothes of those who did no manual labour: luxurious and frequently impractical. That changed from the seventeenth century, thanks to the emergence of two new attitudes. The first was the Protestant emphasis on plainness of dress (as expressed by the contrast between the plain dress and short hair of the Puritan Roundheads and the flamboyant, long-tressed Cavaliers who, respectively, supported Parliament and the monarchy in the English Civil War of 1642–51). The second was the rise of the middle class and an expansion of the machinery of government. The decline of excessive finery and the emergence of a bureaucracy were eventually to put the emphasis on the business suit and the dark colours associated with doctors, clergy and lawyers.

This particular sobriety of dress made its appearance as the fun of the Regency descended into the Victorian age (when 'cleanliness is next to godliness' became the mantra). The plain business suit sprang from the financial classes. Usurers had always worn black, and towards the end of the nineteenth century City men and Wall Street swells went to work in black toppers, black cut-away coats and black and white striped trousers. Their clerks wore black from head to foot and, in an unusual counter-movement, the bosses' dress morphed into the all-black day suit which by the mid-1930s had banished the cut-away coat and top hat for good.

Nevertheless, despite the inherent conformity of the Establishment, it has always been the prerogative of society's leaders to indulge their individuality. The clothing allows for the quirkiness of bow ties worn with day shirts, coloured braces, brightly lined suits, loud socks … Such touches of self-expression are as much an indicator of social confidence as the monocle and the cigarette holder once were. This is not a dress approach for the middle classes, who tend to dress to reinforce their membership of a particular social group.

Even today we want our politicians to dress with dignity and propriety. The traditional dress for Parliament is sober: frock coats, wing collars and top hats. When Keir Hardie, the first Labour MP in Britain, took his place in the House of Commons in 1892 wearing a tweed suit and a soft hat, he was greeted by uproar. So it was throughout the century: socialists and, increasingly, liberals refused to adopt upper-class clothing. But their twisted ties and curling collars did not meet the expectations for the public image of those who ran society; even in 1981 Labour Party leader Michael Foot was castigated for wearing a perfectly respectable dark duffel coat to the Remembrance celebrations at the Cenotaph, because it was not as formal as an overcoat. It was no coincidence that the New Labour experiment of the late 1990s threw out all but regulation boss-class suits.

Even the ostensibly egalitarian United States has invented an Establishment, manifested in the WASP fashions of East Coast old money. The Ivy League has produced generations dressed to ape the British aristocracy, including blazers, striped ties and country tweeds. What the economist Thorstein Veblen dubbed in 1899 the 'leisure class' expressed the fact that they did not need to work by wearing patent leather shoes and top hats (for the men), and bonnets and French heels (for the women). They used cashmere and lace, which few others could afford. Today, retailers such as Ralph Lauren and LL Bean have taken advantage of the class confusion in US society to promote preppy fashion – Argyle sweaters, blazers, Oxford shirts, loafers – to everyone, regardless of class, wealth or ethnicity.

This preppy fashion originated not only in Ivy League colleges but also in the other great universities: Oxford, Cambridge and the Sorbonne in Paris. Oxford bags and the Oxford shirt were both named for the students who made them popular. At Princeton, Yale and other East Coast schools, the privileged elite pioneered not only raccoon fur coats but also the sportswear – the crew jerseys and shirts worn by rowers, the scarves of football players – that later so influenced Ralph Lauren and Tommy Hilfiger. The preppy look was based on a casual approach to dress, in turn based on college clothing and sportswear filtered through the influence of Hollywood and California. It became a kind of non-uniform uniform that, ostensibly classless, was in fact overlaid by fine gradations of materials – and cost. What a retailer such as Lauren knew – and acknowledged in the creation of his Rhinelander Mansion store in New York City in 1984, based on a traditional gentlemen's club in the Gilded Age – was that men craved not a feeling of democracy when buying clothes, but the thrill of membership of that privileged elite club of the past.

'The youth rebellion is a worldwide phenomenon that has not been seen before in history. I do not believe they will calm down and be ad execs at thirty as the Establishment would like us to believe' – WILLIAM S. BURROUGHS, 1968

E S T A B L I S H M E N T

THE BODY CLOTHED

Lord Morley, British politician (right), 1910

Mr and Mrs Harry New in raccoon skin coats, New Year reception, White House, 1928

Hippy, London, 1967

'I have always been inspired by the dream of America – weathered trucks and farmhouses; sailing off the coast of Maine; following dirt roads in an old wood-paneled station wagon; a convertible filled with college kids sporting crew cuts and sweatshirts and frayed sneakers' – RALPH LAUREN

THE
BODY
CLOTHED

E T H N I C

Yves Saint Laurent, Africa Collection, 1967

Like the exotic, the ethnic is most apparent to the outsider. To those who routinely wear them, 'ethnic' styles are to a greater or lesser extent normal. Ethnicity is a complicated concept, associated with both race and geography, but most strongly related to a shared cultural heritage: ethnic clothing identifies those who share a tradition. It is distinctive, and in that it is like the folk clothing traditions of European agricultural societies. A member of the Ashanti people is recognizable to those who understand African clothing wherever in the world he or she may be – in the same way as an Andean peasant or a Hmong from Vietnam is instantly identifiable. Ethnic influences have been absorbed by Western fashion, but often at the cost of the very qualities that make them distinctive. Eventually, of course, the 'ethnic' can spread so widely that it is no longer ethnic at all – like the denim overalls and jeans of the American folk tradition. Ralph Lauren has successfully mined the ethnic clothing of North America for a rich variety of inspiration. Around the world, meanwhile, true ethnic apparel is increasingly becoming relegated to fancy dress worn for tourists, as it is pushed out by T-shirts and jeans as a result of global homogenization – which can even result in indigenous people wearing a Westernized version of their own ethnic dress.

One of the earliest ethnic fashion crazes – and one of the longest lived – was the cashmere shawl, introduced to Europe from Kashmir in the late eighteenth century by soldiers who had served in the Indian Raj (see Shoulders, page 70). Women did not wear the shawls as ethnic costume but made them an integral part of their own Western wardrobe, as demonstrated by the women flaunting them in Ingres' portraits in the nineteenth century. This was early proof that garments produced by another culture could be considered equal to European garments, rather than being seen as the dress of savages. The British even adopted the patterns of Kashmir and used them as the basis for their own (continuing) industry – the manufacture of paisley from the early nineteenth century.

The late 1960s introduced a new wave of ethnic influence in clothes, heralded – as so much was – by Yves Saint Laurent, in his 1967 Africa collection. Laurent's adoption of traditional materials and colours proved too far in advance of the time, but it paved the way for later designers: Kenzo, sometimes described as fashion's most prominent traveller; the Missoni knitwear family; Christian Lacroix; and Jean Paul Gaultier, who later remodelled YSL's angular, pointed bras, based on the Cubists' interpretation of African statues – most famously for Madonna in 1990 (see Bust, page 76). In Gaultier's hands, a wild mix of ethnic influences – he is perfectly at home combining ancient Greece with Japan – becomes a tool with which to sweep away preconceived ideas of fashion and society, and destroy sexual and social prejudices by providing a constantly changing 'shock of the new'.

At the same time, the hippies were seizing back ethnic fashion from the selective hands of designers and, instead of buying in the great shopping centres of the West, went direct to the souks or the street markets to buy the clothes for themselves. They simply began to wear Moroccan djellabas or Indonesian batik or leather sandals or Latin American skirts, without adapting them at all (see Hippy, page 206). Such an approach was entirely in keeping with the times. It implied that ethnicity, along with nationalism and sexism and the other -isms rejected by the contemporary generation of young people, was not useful as a way to divide people one from another. And yet there remains something faintly absurd in assuming that a domino-checked scarf that has a cultural meaning and authenticity in Palestine is equally appropriate for the streets of north London; though those who sport them seem entirely unaware of any irony.

Wherever ethnic clothing originates, it is easy for those in the West to gain the impression that it is not subject to change. The sari of India, the pareo of the Pacific Islands, the cheongsam of China, the homesteader overalls of the United States – all seem to be static, beyond the vagaries of fashion. But ethnic and folk clothing do change, albeit in subtle and slow ways. Ethnic groups come into contact with others and borrow aspects of each other's clothing. The process is gradual – a parallel to the barely changing dress of peasants compared with the speeded-up fashion change of the ruling classes in Western history. But, viewed over time, changes become clear. Unlike modern high fashion, however, ethnic dress retains constant aspects, and it is those aspects – length of skirt, position of waist, type of collar – that make it identifiable, even when surface patterns and colour change quite radically.

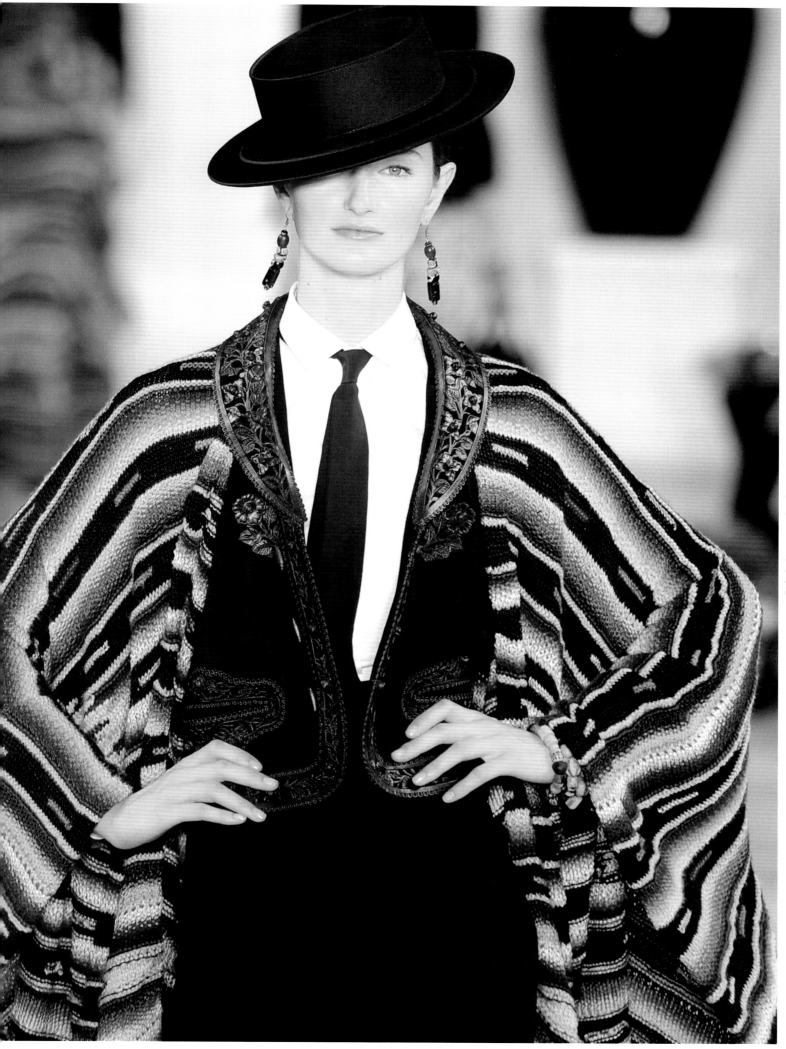

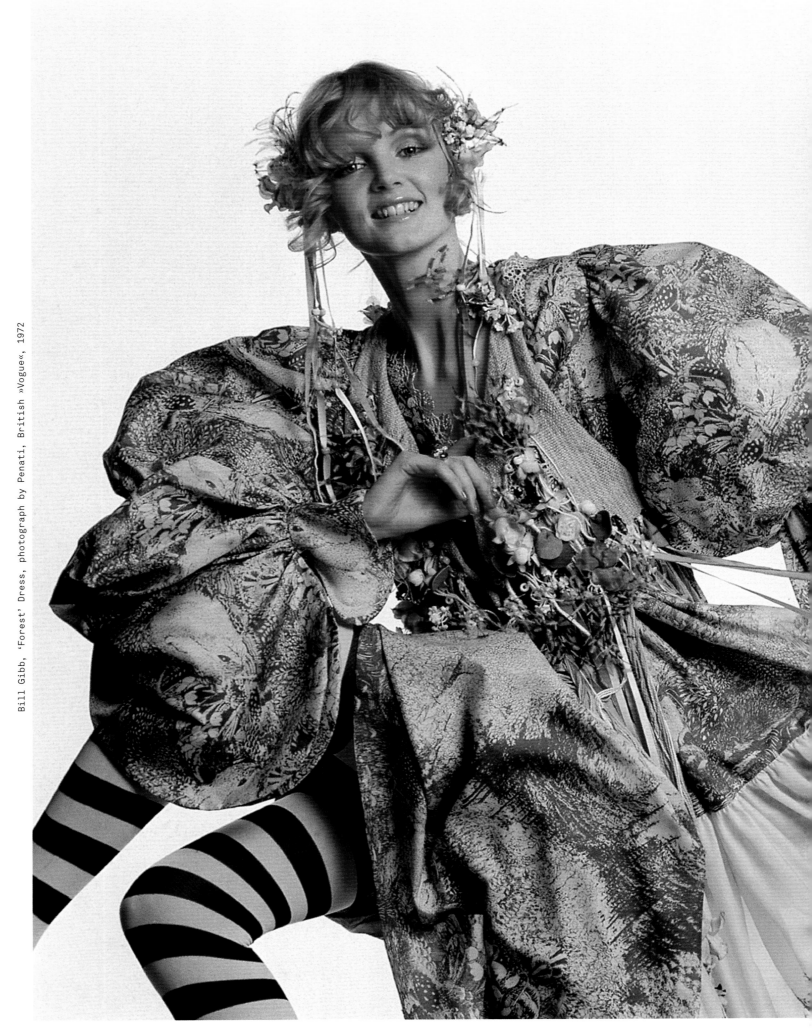

Bill Gibb, 'Forest' Dress, photograph by Penati, British »Vogue«, 1972

The exotic is something other: something exciting, striking or unusual (the word itself originally meant something that came from elsewhere). The lure of the exotic runs throughout fashion: the colours of the Orient, the fur of the big cat, the feathers of the bird of prey. The 'other' is strange, even mysterious, and thus desirable. This is what high-class clothing offers the wearer: the chance to leave behind the humdrum and to make a gesture towards the unusual, the fantastic and the glamorous. The history of exotic dress reflects geographical connections and cultural borrowings, from French society following the fashions of Italy introduced by Catherine de Medici in the 1530s to European teenagers adopting the beret of Che Guevara in the 1960s. It also reflects the appeal of the rare, the desire for the novel, and the rejection of the everyday and predictable.

Couturiers and top fashion designers have long been attracted to the exotic – but usually via a highly romanticized view of other cultures. Their vision is filtered through the rich fabrics of the wealthy, the privilege of the palace, the theatrical images of the great painters of Europe, the majestic novels of imperial Russia, the jewels and adornment of the court. Their re-creation of foreign cultures has as little to do with historical reality as the Hollywood epics of the 1950s, which in many ways their clothes emulate. They are selective about which parts of a tradition they borrow and how they clean them up in order to avoid falling into the trap of mere over-the-top fancy dress, and their references are more likely to be a costume worn by Elizabeth Taylor than a portrait of Elizabeth I.

The master of capturing a sense of the dress of the past was Yves Saint Laurent. His 1976 Autumn/Winter collection, based on Cossack Russia, was the richest, most exotic and most costly collection in his career – and is often judged the greatest collection of the twentieth century. Saint Laurent's babushka dresses and gypsy skirts, with Boyar vests and gold leather boots, were not authentic Russian, but neither were they fancy dress. They were the recasting of a past culture in such a way that they became entirely of his own time. By bringing to the folk tradition an intimate knowledge of Russian literature and history, Saint Laurent showed that it was possible to borrow from an alien culture to produce an artefact for our own without patronizing either.

A similar approach was evident in the elegiac and rhapsodic approach taken by the Belgian romanticist Dries van Noten in the 1990s to co-opting the clothes of Tibet – a region then, as now, as politically troubled as it is spiritually revered by many Buddhists. For Romeo Gigli, the beauty of the Renaissance was the catalyst for producing richly-coloured velvets, embroidery and patterns.

Because of their emphasis on texture and colour, and the use of unrefined skins and textiles, fabrics tend to encapsulate the various forms of the exotic more than individual garments do. Silk, transported over land along the Silk Road; cashmere, all the way from the valleys of northern India; batik, from Indonesia; calico, from southern India: all these have been in great demand for their rarity, just like animal furs from deepest Africa or farthest Siberia (see Materials and Texture, page 24).

Silk has long been among the most exotic of textiles, due to the remoteness of its Asian roots from the Western world, and the somewhat unusual manner of its production – the equivalent of making clothes out of spiders' webs. The Chinese jealously guarded its manufacture until the sixth century, when silkworms were smuggled into Europe. Chinese silk remains highly exotic; a hangover from earlier times, when it was worn only by the elite.

New materials have always been exotic: witness the demand for nylon when it was first invented, despite its unsuitability for many forms of clothing. The new materials in the 1960s were ostensibly even more humdrum – metals and plastics – but acquired an exotic sheen when incorporated into clothing bearing a currently fashionable label.

Dries van Noten, Ready-to-Wear, Autumn/Winter 2002–03, Paris

'For me, exoticism is the elsewhere, the other, the difference. It is generally associated with distant countries. But for me, it is everything that reroutes us from the ordinary … from our habits, our certainties and from everyday to plunge us into a world that is amazing, hospitable and warm' – DRIES VAN NOTEN

E X O T I C

THE BODY CLOTHED

Giorgio Armani, Haute Couture, Autumn/Winter 2011–12

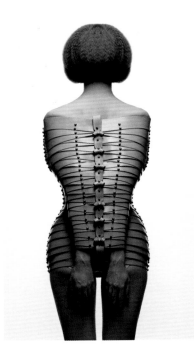

RE.TREAT #1, Úna Burke, c.2010, photograph by Diego Indraccolo, styling by Kay Korsh

THE
BODY
CLOTHED

E
X
T
R
E
M
E

'In difficult times, fashion is always outrageous' – ELSA SCHIAPARELLI

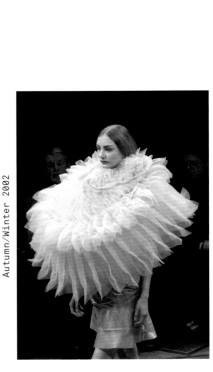

Cartwheel ruff, Junya Wanatabe, Autumn/Winter 2002

Dress becomes extreme when it becomes unfit for its purpose, perhaps because it has reached such exaggerated proportions that it becomes inconvenient; because it is inappropriate for the situation in which it will be worn. Extreme fashion has no point beyond its own display. It flaunts its own rejection of the rules. Shoes too tall or long to walk in; bustles that do not allow for sitting down; sleeves with cuffs so wide that they drag along the ground: extremes are nothing new. Throughout the history of clothing there has always been a minority (and usually an elite, as extreme dress is the prerogative of those with wealth and leisure) more concerned with making a striking appearance than with practicality.

The extreme offends on all levels. It rejects the attitudes of the majority and places itself above the crowd. In moral terms, it is over-expensive, wasteful frippery inspired by vanity (it is never cheap, unless one counts nudity as an extreme form of dress). In the eyes of the European Church in earlier centuries it also offended views of what form the body should take and how it could be judged. Panniers in skirts, for example, made it impossible to judge the suitability of a woman's hips for childbearing; stomach padding disguised who was or was not actually overweight, if not already (illicitly) pregnant.

Extreme fashion's regular home over the last three decades has been on the catwalk, where absurd visions and quasi-indecent exposure have become marketing props for desperate design houses. Shock sells – not the clothes themselves, but the watered-down versions of them and the accompanying accessories, make-up and fragrances. To that extent, it does not really matter that couture exists at the extremes of fashion, as long as buyers and designers do not lose sight of the distinction between clothes that are intended to be worn and clothes designed as a promotional tool.

By definition, extremes deviate from the norm. They may do so either by disregarding norms or by exaggerating them to an unfeasible degree. That is why certain garments have lent themselves more frequently to outlandish permutations. Given the idealized Western body shape of an inverted pyramid with broad shoulders and slender waist, with broad hips for women, together with long legs and small feet, it is no surprise that many of the garments that have been most distorted have been those that reinforce that appearance, such as the corset that draws in the waist, or the shoes that make the feet seem smaller.

Garments that begin with little point beyond show have a head start when it comes to extremism. The neck ruff that emerged in the Elizabethan court as a way of displaying the fine linen of the chemise grew larger and larger. It eventually reached proportions so wide – up to 45 cm across – that cartwheel ruffs required wiring to support the corrugations of lace. The ruff was flamboyant and rigid, and hugely inconvenient; thus it was a symbol of wealth and indolence (see Neck, page 68). The style eventually evolved to include a gap at the front for convenience when eating and drinking.

It was perhaps no coincidence that the French Revolution that did away with the Ancien Régime in 1789 followed a period when fashion had reached extremes of proportion. Underpinning and complex structural supports had made the skirt so full that women could barely sit down. Hats balanced on top of piled-up pompadours – named for the mistress of Louis XV – are said to have dictated that the doorway of London's St Paul's Cathedral be raised. These were the styles of the idle aristocracy, full of vanity and self-love.

In the 1840s and 1850s the corset – a staple of the Victorian woman's wardrobe – was increasingly tightly laced to keep the waist as slender as about 36 cm around (see Waist, page 96; Impractical, page 208). Contemporaries were horrified. Not only did they condemn tight lacing as an expression of vanity and immorality, doctors also lined up to protest that it displaced internal organs such as the liver, making the lungs less efficient and compressing the intestines. The fashion fell out of favour in the early 1900s; today it survives largely as an element of fetish wear, although it appears with great regularity on the catwalk.

It only takes a photograph of Ladies Day at Royal Ascot to remind one of the scope of the hat for extremes – often of vulgarity (see Ostentatious, page 214). The extreme itself is not inherently vulgar, however. In the hands of a milliner such as Stephen Jones, it is usually kept at bay by a sharp wit and historic referencing. Not so lesser fashion talents. They mistake sheer size for flare and unusualness as innovation. These hats are display objects and their only purpose is to make an impact, and it is a social rather than a fashion one.

Lady Gaga, Estada Naçional, Santiago, Chile, 2012

Park Avenue, Manhattan, USA, 1998

In dress, conformity is as powerful an instinct as individuality. The vast majority of people do not dye their hair orange, or wear black lipstick or gold platform shoes. They dress to not call attention to themselves; to be neither ahead of the times nor too far behind the times. They choose clothes that announce that the wearer has no wish to change his or her place in society and dresses in a way that will be recognized by others. Such conformity sends a message of fear of standing out from the crowd for being different.

Not following fashion was for much of history a result of lack of choice. Even in the early twentieth century, only the upper classes had any degree of choice. The majority of society dressed the same because they had the same income, the same lifestyle and, frequently, the same aspirations. Inhabitants of industrial cities in Western Europe or the United States shopped at the same stores, which sold garments made from the same fabrics by the same manufacturers, whether Brooks Brothers or Montague Burton. Within these parameters, however, emphasis was placed on small variations as clothing became more uniform: the colour of a tie or a breast-pocket handkerchief, the width of a lapel, the buckle of a belt, the shade of the socks. These were the first bat squeaks of designer fashion, a system of small signals and their recognition.

Even as the influence of fashion spread, the importance of conformity was underlined in the mid-twentieth century by the growth in sportswear, which itself was a response to the need for less formality (see Sportswear, page 226). Traditionally, sports clothing has employed only a few colours in related designs, originally as an easy sign of identification with a particular team and latterly as a sign of brand loyalty. Sweats, T-shirts and denims are now perhaps the most conformist garments throughout all social classes. This impulse came from the handful of designers known in France as stylistes, who revolutionized retail in the 1970s and 1980s by realizing that if you stripped individuality from clothes, even to dressing both sexes the same, you could sell your dream to more people, because you presented them with the simplest of choices. It was a movement promulgated as a shared, unisex style. Paradoxically, its greatest exponents were in fact couturiers, including Rudi Gernreich, Pierre Cardin and Emanuel Ungaro.

The style was short lived: clothes are about sexual attraction, and not even the most narcissistic person is attracted to a carbon-copy image of him or herself. But the strategy of offering generic clothing that consciously lacked a fashion edge was repeated in successive decades by global retailers, and in the twenty-first-century 'e-tailers': Gap and Next, Uniqlo and Muji, River Island and Zara. A few huge suppliers have cornered the market in producing only the slightest variations on common themes. There is little reason for anyone to miss out on looking the same when wardrobes are retailed to suit anyone from eight to eighty.

The approach of high street retailers simply acknowledges the limits of change. There are garment types that reached perfect expression early on, and have barely changed since, beyond minor variations: the T-shirt, the loincloth or dhoti, the beret. The shape of socks and stockings is limited largely by the shape of the foot (see Legs, page 134). Perhaps the most interesting variant is jeans. All jeans are limited variations on a limited theme, but they have nevertheless become a staple of status design – if only because, like fragrances, they make huge revenues for the labels, which everyone is proud to have emblazoned not just on their back pockets but currently curving across the posterior.

As with all dress, nonfashion has its own rules: they are the main apparatus for reinforcing the status quo. They are designed precisely to avoid making a fashion statement. 'Double denim' is considered a solecism by many, for example, as are smart shoes with blue jeans, trainers with a suit, horizontal stripes on the podgy or a plunging neckline in an office.

The idea of generic clothing is epitomized by the concept of dress-down Friday, introduced in the United States in the 1990s by firms seeking to encourage their workers to be a little less conventional. 'Fresh dress, fresh ideas' was the logic behind what was packaged as the new freedom of informality. By the mid-2000s about two-thirds of firms allowed their employees to dress more casually at least one day a month. But the abandonment of the work uniform only revealed the power of the leisure uniform – polo shirts and chinos or jeans became as standard as the business suits they replaced. Any divergence from the rules was heavily criticized: no shorts, fleeces or slogan T-shirts. 'Dressing down', like virtually all forms of dress, was still codified – and the rules were as rigid as those governing the dress codes of the Court of St James's in eighteenth-century London.

'To be one's self, and unafraid whether right or wrong, is more admirable than the easy cowardice of surrender to conformity' – IRVING WALLACE

G
E
N
E
R
I
C

Claire McCardell, summer dress, 1946, photograph by Genevieve Naylor

Brooks Brothers advertisement, 2007

G
L
A
M
O
U
R

'Elegance is not the prerogative of those who have just escaped from adolescence, but of those who have already taken possession of their future' – COCO CHANEL

In dress, as in other fields, glamour is more easily recognized than it is defined. It is that quality that makes something – an individual, a place, a lifestyle – seem somehow more attractive and alluring than normal; not only removed from the ordinary, but somehow amplified, intensified, more perfect. We recognize it in the ball gowns of the great age of couture, in images of Hollywood stars in the 1930s and 1940s, in the louche decadence of the casino at Monte Carlo. In clothing, glamour combines elements of perfection of cut, luxury of materials, elegance of appearance and the romance of a life of effortless privilege. No amount of expensive materials and dressmaking skills can achieve glamour in the hands of those who aim only for ostentation, however. This reflects the so-called 'Gucci fallacy', named for the aggressive marketing of the luxury Italian fashion labels in the 1980s: that simply buying endless luxury (and glamour) can bring happiness.

In Europe, glamour was long associated with royalty, but in the nineteenth century in the United States, the glamorous came to challenge and then replace the primacy of the regal. The tone was set in the Gilded Age, by the New York society described by Mrs Astor as 'the 500'. The balls and dinners held by the industrial and banking magnates who made up this elite were cynosures of glamour far removed from the everyday. In the early twentieth century the international rich charted by F. Scott Fitzgerald became the standard-bearers of glamour, bathing at St Tropez or skiing at St Moritz. There was little more glamorous than motoring along the Corniche in an open-top car, one's hair held in place with a silk Hermès scarf and one's face protected by huge sunglasses.

Everything changed with the rise of Hollywood. For early stars like Clara Bow, glamour was a permanent state. The studios believed the star system only worked if actresses were never seen as ordinary mortals, so they put huge efforts into turning them into goddesses, and that is how they remained. On screen, this meant that, even though films were shot in black and white, colour co-ordination of clothes was treated as seriously as it would be in a couture atelier. Nothing was faked. If diamonds were required, they were real. So were mink, ocelot and tiger skins. The result was that actresses were adored for being different. This was even more the case during the Depression.

The worlds of European glamour and Hollywood glamour came together in the wedding in 1956 of the screen goddess Grace Kelly to Prince Rainier of the royal house of Grimaldi, ruler of Monaco. Appropriately enough the bride wore a gown designed by Helen Rose, a costume designer at the MGM Studio. Here was an American, daughter of athletes from Philadelphia, marrying into a royal family. The actress even got a title: Her Serene Highness The Princess of Monaco. Some 30 million people watched on TV as old and new glamour were officially united.

Just as royals and movie stars have more glamour than bankers or politicians, so night has more glamour than day; flaws are hidden. In the same way, eveningwear has more glamour than other forms of dress. The evening gown is an invention of the late nineteenth century. Dressing differently for evening only began with the Edwardians, when women wished to reassert their femininity after dark and proclaim their husband's (and their own) wealth. The evening dress rose to ascendancy during the 1950s, off the back of Christian Dior's New Look of 1947, which reintroduced an extreme femininity not seen since the fin de siecle, but not a prissy, little-girl femininity, rather an imposing fairy queen grandeur of huge skirts, sweeping swags and deep decolleté.

Nowadays, for most women, evening gowns are what people wear to the Oscars and are almost always figure hugging. Still, every young girl goes through a stage where she longs to wear her first ball gown – even if only once at the high-school prom. The gowns and corsages are throwbacks to the grander days of pump rooms and dance cards. Many designers whose clothes rarely rise above the mediocre make a good living by meeting the demand for occasional clothes, using silks, velvets and taffetas to produce conservative designs. It is sometimes claimed that Middle Eastern and Oriental weddings keep couture alive by the number of grand ball gowns that are ordered for brides, families and guests.

In contrast, for men glamour means James Bond and, above all, Sean Connery's Bond. No other hero matches the sex appeal, the daring, the athleticism, the wit – or the effortless glamour that makes Bond so irresistible. He is the embodiment of the masculine hero: polite but tough, romantic yet ruthless. On Connery – a former model – a two-piece suit fitted immaculately, emphasizing his broad shoulders and slender waist: he was a modern reincarnation of Beau Brummell, that other incarnation of controlled masculine peacockery.

Millicent Rogers in an evening gown, 1947

Goth street fashion, 1995

The Gothic is pure pantomime. That is one reason why gothic clothing – dubbed haute goth by Cintra Weston – has turned up on so many couture runways, including those of Alexander McQueen, John Galliano and Anne Demeulemeester. Another is that the Gothic can have a spectral, ghostly quality that connects fashion with the past, as explored by John Galliano in his shows for Dior after 1997, which evoked the Paris of a century earlier. Gareth Pugh meanwhile explores the very adaptability of the Gothic, stressing here the connection with bondage and there the obscuring anonymity of necklines so high they almost cover the face.

Dark, dramatic, and self-consciously anachronistic, with flounced shirts, velvets and lace, fishnets, tight corsets, and lightened skin, this fashion owes as much to the bondage scene as to the horror novels that gave the gothic its name. It has nothing to do with history's real Goths, who dominated early medieval Europe after the fall of the Roman Empire. Style gothic was an invention of the Romantics – specifically of Horace Walpole – and carries the unmistakable whiff of Rimbaud and the French decadents, as well as Goethe, Frankenstein and Dracula. Its rise coincided with the Victorian cult of mourning and all things connected with death, as still reflected in its predominant palette (the black is occasionally relieved with blood red or papal purple), its nineteenth-century profusion of ruffles and jewellery such as crucifixes, which lends Goth something of the seriousness of the religious, and its seriousness. Humour has little place in a world this serious, which perhaps partly explains its appeal to a generation of designers who were reacting against the perceived shallowness of the 1980s, a decade characterized by extravagant and frothy pastels.

Lords of the Undead. Pirates. Highwaymen. For male Goths, clothes are dressing-up costumes. What better for a young person who is still unsure of himself than to adopt the guise of a larger-than-life figure from a romantic past? (Dracula is, after all, an aristocrat and always impeccable in his manners and appearance.) Female Goth style takes us closer to S&M. The tight velvet bodices of Transylvanian wenches or Morticia Adams share the same lineage as corsets and bustiers: they are clothes of constraint that invite the pleasure of being undone. The same is true of pencil skirts that make anything other than small steps impractical. Leather and plastics are the materials of bondage; and black is the only appropriate colour, with its associations with elegance but also with death and satanic practices (see Colour and Pattern, page 36).

The rise of Goth in the early 1980s coincided with the fetishization of black by the Japanese whose designers "invaded" Paris in 1982 with a visual declaration that fashion depended not on colour, but on shape, cut and intellectual probity. Black caught the imagination of the fashion industry at all levels and became all-embracing. Giorgio Armani wore black more often than not, as did Gianni Versace. Dolce & Gabbana made it a trademark. Karl Lagerfeld was so enamoured of the colour that in 1977 he had hosted a party at which guests were required to wear 'totally tragic black dress'. In Goth style, black clothes were complemented by a lightened face with contrasting dark eyeliner and lipstick that echoed the practices of ancient Egyptians and Japanese geisha. The more immediate roots of the Morticia face are pure Hollywood, however. It was created by the black and white movies of the 1920s and 1930s, when black lipstick was used by actresses to highlight their mouths and to make it easier for the audience to read their lips.

Inherent theatricality links Goth clothing inextricably with performance, and particularly with the bands of the 1990s, who projected a kind of inverted glamour, proclaiming alienation, misery and earnestness with top hats, swirling capes and black lipstick. And just as the music of Alien Sex Fiend or Bauhaus grew out of punk and New Wave, so Goth fashion also followed earlier trailblazers. Goth's rejection of fashion norms was nothing new; neither was its emphasis on gesture. But Goth celebrated not aggression, like the punks, nor glamour, like the New Romantics. Goth set out to celebrate brooding and preoccupation – but did so with such flamboyance that, to outsiders at least, it bordered on parody.

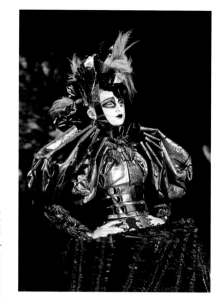

John Galliano for Dior, Haute Couture, Autumn/Winter 2006-07

'I tried to tell her / About Marx and Engels, God and Angels / I don't really know what for / But she looked good in ribbons' – SISTERS OF MERCY, 'Ribbons', 1990

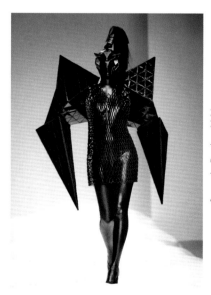

Gareth Pugh, 2006

GOTH

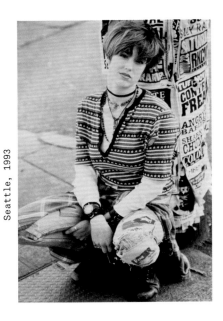

Seattle, 1993

G
R
U
N
G
E

'Wanting to be someone else is a waste of the person you are' – KURT COBAIN, 1990s

Anna Sui, Autumn/Winter 1998-99

'Come as you are,' sang Nirvana in 1992, and the words of singer Kurt Cobain set the tone for grunge, the pale and sickly offspring of punk, which first saw the light of day as a musical rather than sartorial phenomenon (see Punk, page 218). One of the outstanding examples of the legerdemain with which fashion seizes on movements that already exist in dress, grunge was a fancy package created to sell clothes at inflated prices and generate huge profits. Few Americans could understand the thinking behind it, which was, like much modern music and dress, subversion.

Grunge was based loosely on the alternative rock scene that began in Seattle, on the northwest coast of the United States. It was slacker style, an insult to those who cared about their appearance, and it was fuelled by beer, drugs and a general indifference. Above all, grunge was self-mocking: it was a club for the drop-outs, the no-hopers; the kids who were so uncool that they couldn't be in any real club. That changed when Nirvana became superstars and their album »Nevermind« (1991) sold eight million copies. At that point grunge became a phenomenon – and fashion sat up and took notice, because it could smell money.

The British in particular were bemused when grunge became fashionable in the early 1990s. More even than the rest of the world, they were shocked that traditional student dress – scruffy, well worn and the result of poverty – had been turned into a fancy catwalk statement. Ripped jeans, battered Converse, thin jumpers, flannel shirts and dreary T-shirts: this was fashion that reflected the time in which it appeared. An anarchic mood dominated culture, from Young British Artists Damien Hirst and Tracey Emin to the violence of movies such as Quentin Tarantino's »Reservoir Dogs« (1992) and books like Brett Easton Ellis's »American Psycho« (1991), or the music of Nirvana, Pearl Jam and even U2.

The person who saw the potential of grunge's move to the catwalk was the newly appointed editor-in-chief of »American Vogue«, Anna Wintour. In 1993, Wintour championed Marc Jacobs's now infamous collection for the casual sportswear brand, Perry Ellis, based loosely on the grungy clothes of bands like Nirvana and Soundgarden. Where Ellis led, others followed. For a fashion industry still reeling from the end of the ostentatious yuppie scene of the 1980s, grunge seemed to offer a foolproof way to plug into the youth zeitgeist and claw back lost sales.

But it turned out that what suited Kurt Cobain and his wife Courtney Love did not go down well in the fashion stores. Not for the first time, fashion learned that what might be big in cities such as Seattle may not have the same appeal in the real centres of fashion, such as New York and London. It was not just that it seemed counterintuitive to pay lots of money to dress as if in hand-me-downs. Even the most enthusiastic promoters of grunge as fashion had to pair signature Converse plimsolls and Dr Martens boots with 'urban' retailers such as J. Crew and Banana Republic to soften the sting. At the top of the line, Calvin Klein offered his own grunge line (modelled by Moss) while the Irish knitwear designer Lainey Keogh came up with a 'grunge' sweater in pure cashmere for anyone who could afford $1,400. But the real grunge fashion was the work of Marc Jacobs, head of design at Perry Ellis, who had died in 1986. Jacobs lost a job as a result of grunge, but gained a notoriety that made him a world figure.

Grunge might have triumphed. In its youthfulness, its rejection of authority, its casual spontaneity, it ticked the same boxes as punk and New Romantic before it (see Punk, page 218; New Romantic, page 212). But those movements had both been statements. One had sought to offer escape from the mundane world through aggression, the other through fantasy. Grunge offered no such escape. It merely acknowledged that being a suburban kid wasn't always fun and could be mind-numbingly boring and that, when it came down to it, the clothes you wore didn't change a thing. No fashionista was going to part with good money for long to buy in to that kind of message. But while grunge clothes had a short life in the spotlight, its elements have never been totally off the fashion scene since.

Grunge music, of course, went on, although the darkness at its core was laid bare by Kurt Cobain's suicide in 1994, after years of troubled heroin dependency. In terms of dress, grunge lives on for the same reasons that it existed before its rise to prominence. It is cheap and lasting; it neither comes into nor goes out of fashion; it is warm enough to wear outdoors. It is the timeless clothing of teenagers and the young who have neither the time nor the inclination to put a huge effort into what they look like when they go out to hang with their mates, but desperately need their approval. Like most other youth-inspired 'fashion' in the late twentieth century, grunge wasn't about fashion as much as cool.

Hunters with hounds, France, c.2000

Henley, UK, 1997, photo by Martin Parr

Everyone has a soft spot for tradition. In the modern world, people seem to find reassurance in physical links with the past – that is one reason why clothing continues to feature elements that are deliberately anachronistic. This tendency is found not just in ceremonial or establishment clothing; it is also everyday wear, which features sartorial anachronisms such as coats of arms and other crests on blazer pockets, the stripes of the regimental tie, or the fleur-de-lis woven into glamorous silk headscarves. These throwbacks keep reappearing not just because the vast majority of people have a strongly conservative attitude to dress, but also because most also like consciously dressing up to recall an earlier, more formal age, and imagining themselves as part of that time.

Many of these trappings originally emerged from the world of the medieval knight. Chivalry in dress was important and – occasionally – deadly earnest. It revolved around a set of emblems, such as colours or badges, that served to identify the wearer both on the battlefield and also in other social exchanges between nobles who might be unfamiliar with one another's appearance. Long after the chivalric ideal had disappeared, chivalry gave rise to a whole system of symbols that was intimately connected with family, inheritance and entitlement.

Principle among those symbols was the coat of arms, used for easy recognition on the battlefield. That ease was aided by limiting the range of colours, or 'tinctures', to seven. There are two light tinctures, called 'metals', and five dark tinctures, called 'colours'. The metals are gold or yellow (named 'or') and silver or white, known as 'argent'. The colours, and their heraldic names, are blue (azure), red (gules), purple (purpure), black (sable) and green (vert). Not only is the palette limited, there are also strict rules about how the colours are used together: a metal may not be laid on top of another metal, nor a colour on top of another colour. Non-standard colours are known as 'stains'. (More or less the same colours still dominate the traditional club tie, which today signifies membership of an exclusive body: a club, team, school or other group.)

The first recorded coat of arms belonged to Geoffrey V, Count of Anjou, in 1129, presented when he was knighted by Henry I of England and given a blue shield emblazoned with golden lions. The coat of arms became a treasured hereditary possession which was not just a status symbol – the College of Arms was incorporated in 1484 to govern the use of arms and to trace noble genealogy – but also as an indicator of a way of life: wealthy, privileged, established or traditional.

The trappings of heraldry have been co-opted by a generation of modern fashion designers, pre-eminently Ralph Lauren and Hermès, whose aesthetic harks back to the grandeur of life in the great country houses of England and the châteaux and castelli of the continent. Cod heraldry has become a marketer's shorthand for aspiration, reflecting a world in which the right logo proclaims your class – or that you have at least bought into one of its symbols.

One of the most enduring forms of heritage dressing is that of servants, whose standard uniforms evolved to reflect a strict hierarchy of rank. Before the rise of professional armies, servants working for great families dressed the same as soldiers, being pressed into armed duty when necessary. Much later, servants' coats often retained a vestigial slash pocket to allow access to a (by then, non-existent) sword. In another throwback, their collars also sometimes had a rosette at the back to echo the traditional queue, or pigtail.

Most servants wore livery, in the shape of a uniform or heraldic devices sewn on to clothing or hung on neck chains (the ancestors of today's mayoral chains). The use of livery began in the fourteenth century and passed its heyday in the sixteenth. Today it lives on in London's ancient livery companies. These 108 historic trade associations earned their name because their members were entitled to wear particular uniforms, as they still do today on special occasions. Senior servants such as stewards, valets and butlers usually went without livery but wore a highly formal version of their employers' clothes; in the eighteenth century American visitors complained that it was not always apparent who was the servant and who the employer. Senior male servants dressed in the style of their employers – but often in an out-of-date and highly formal version of it. Butlers wore knee breeches, white silk stockings and frilled shirts in the 1830s, just as gentlemen would have worn half a century earlier. A butler's afternoon dress often resembled what his master might wear in the evening. With the decline of household staff after the 1930s and 1940s, the traditional clothing survives in the uniforms of waiters, concierges in grand traditional hotels and court employees.

'A civilization is a heritage of beliefs, customs, and knowledge slowly accumulated in the course of centuries, elements difficult at times to justify by logic, but justifying themselves as paths when they lead somewhere, since they open up for man his inner distance' – ANTOINE DE SAINT-EXUPÉRY, 1942

Maid in domestic service, UK, 1937

H

I

P

P

Y

'Hippies weren't really offering any alternatives other than colorful short-term ones, and some of these were looking more and more like pure degeneracy. Degeneracy can be fun but it's hard to keep up as a serious lifetime occupation' – ROBERT PERSIG, c.1972

Yves Saint Laurent, gypsy bride dress, 1969

If you can remember the Sixties, the saying goes, you weren't there. No matter. Simply look at the clothes. Consider the much-maligned hippies – the 'hipsters' that grew out of the beatnik movement in San Francisco and other US cities in the early 1960s. The hippies may have been naively idealistic, but their influence has proved longer-lasting than most other youth movements. Their fashion was not particularly rigid – the hippies rejected the beatnik precedent of wearing only black – but it had a peculiar coherence that was also social comment. The hippies rejected standardization; they prized the handmade over the industrial; they championed the philosophies of the East; they chose to dress more like gypsies or tribesmen than like businessmen or teachers. Like other fashion cults, theirs was eventually taken over by the very commercial establishment it despised – and yet it continued to thrive.

The hippies were magpies; they stole ideas from wherever they found them - from the military uniforms in which Peter Blake dressed the Beatles for the »Sgt Pepper's Lonely Hearts Club Band« LP sleeve to the Afghan coats that carried the whiff of the Central Asian urine used to soak the pelts, the flimsy cottons that came from India or the hardwearing overalls of the Amish farmer. What brought everything together was the gesture: the wearing of clothing that proclaimed the individual's rejection of big corporation slickness and embrace of the authentic, even at the cost of championing the merely poorly made and second-rate.

Hippy naïvety is undeniable. The rejection of capitalism was only possible because of the wealth of western societies. The chance to take days out for drugs and sex at Woodstock or to take months out to follow the Hippy Trail was not open to the peasants of South and East Asia whom the hippies saw as the best hope for the world's future. But the naivety was charming rather than threatening. The hippies were too peaceful, too lazy, too frequently stoned, to fight many battles. Instead, they dressed to recall a simpler age – like western homesteaders in plaids and denim, or Hardyesque milkmaids in flowing smocks, or the Pilgrims with their large collars and long, loose dresses – or in ethnic clothes borrowed from idealized societies. There have been similar attempts to use clothing to create or imitate a perceived golden age. After the French Revolution, for example, the Empire style was a deliberate eschewing of the status clothing of the ancien regime in favour of the styles of republican Greece.

There is a perception that the hippies invented psychedelic colours in fashion, and that the colours echoed the hallucinatory effects of the drug LSD. True, the hippies' ragbag approach produced a kaleidoscope of colour, but bright colour did not always indicate a hippie sensibility. New dyes and cheap cottons were encouraging boldness in designers like Ken Scott and Kenzo, who were as interested in sales and profit in the 1960s as their equivalents are today. Meanwhile, many hippies were ecologically aware enough to turn their backs on artificial chemical dyes: neutral colours such as cream, khaki and beige far outnumbered hot pinks and loud purples.

The sixties saw length become the defining characteristic of skirts and dresses (see Legs, page 124). Both maxi skirts and miniskirts – and their close relatives, hot pants - became symbols of feminine freedom, in the same way as choosing not to wear a bra. In the designs of Mary Quant (short) and Laura Ashley (long), they emphasized not only choice but also a comfort with one's own sexuality. Both garments drew attention to the legs, by disguising or revealing them respectively, and both were therefore suitable garments for the decade when the invention of the Pill gave women sexual freedom. The same liberation applied also to the hair, which could be worn very long or very short by men and women alike and became a fetish celebrated by the cult musical, »Hair«, which opened to immediate outrage and success in 1967.

For all their rejection of commercialism, the hippies had an impact on retailing that is still with us. Inevitably the fashion establishment produced its own hippie variations: Yves Saint Laurent used the finest fabrics to create gypsy skirts that cost as much as a Romany caravan; Ossie Clark and Zandra Rhodes were somewhat more believable salon hippies. But the real change came in the United States. Benetton, the Gap, Esprit and LL Bean all jumped on the rejection of "fashion" to begin lines of clothing whose virtue was that they had virtually no fashion content. The development symbolically represented a rejection of the profit-driven Seventh Avenue rag-trade for the more laidback approach of the West Coast. A subsidiary development was the emergence of boutiques – like Paraphernalia in New York City – and the flourishing of thrift shops. From now on, old clothes had a value: vintage clothing would become big business.

Hyde Park 'Love-In', London, 1967

»Le Matin« by Numa Bassaget, c.1835

Some fashion remains stubbornly far removed from comfort and ease. Shoes that can't be walked in, buttons that can only be done up by someone else, delicate fabrics that have to be washed by hand, and dress codes that subject the individual to intense heat and discomfort have been part of civilized life for centuries. But this inconvenience does not exist for its own sake: it indicates either fashionability or, more often, status and power. It exists to demonstrate its own inconvenience, as it were: it says 'My clothes are unsuitable for everyday life because my life is not everyday'.

The men who governed the Raj in India habitually wore the full ceremonial regalia of the British Empire, addressing subjects who wore far more sensible cotton; when Queen Elizabeth II was crowned in 1953, the paraphernalia was so heavy that she had to practise wearing the crown first in order to cope. The powerful have always had to put up with personal inconvenience when in the public eye, and part of their burden is wearing clothes that are often stiffer, heavier and hotter than those of normal life. Putting up with discomfort demonstrates their ability to subjugate their personal desires to their duties – or a realization that the ultimate advantages strongly outweigh the initial inconvenience.

And so it is with the fashionable, as well as the powerful. Jeans so tight that it's easier to put them on while lying down are simply a part of modern dressing. The compulsion to wear clothes – even shoes – that are too small is not purely a feminine one: many men are equally addicted to the skinniest of skinny jeans. But size is a gender signifier, and for that reason as well as the value society places on thinness, women have a tendency to wear clothes that make the body appear smaller. The fact that this can result in hampered movement and outright pain seems to have had no impact at all. The garment that epitomized this was the corset, being restrictive to the point of deforming the rib cage. For the sake of their silhouette, for centuries women tied themselves into garments that, if pulled too tightly, left them almost unable to breathe, let alone exert themselves.

All bondage clothes are inconvenient, worn by their devotees precisely because they are difficult to put on or take off without help. These are garments that constrain the body, taking away the wearer's control over his or her own comfort. In rubber or leather, masks, straitjackets, corsets and bondage trousers are the dress of submission and domination. Perhaps it was Diana Rigg's black catsuit in »The Avengers«, designed by John Bates and manufactured by John Sutcliffe, that started this modern vogue in the 1960s; perhaps Vivienne Westwood's mischievous promotion of bondage wear in the 1970s. Helmut Newton's prosthetics and the experiments of Claude Montana, Thierry Mugler and Jean Paul Gaultier – including Mugler's 'neck corset' – made this an exciting cult that is still found in some of the small-circulation style magazines today.

On the catwalk, bondage gear remains a frequent presence. Usually, it has been watered down to mean simply the use of latex and leather festooned with belts and buckles, but there are occasional flashes of the discomfort associated with the original incarnation. The London couple Fleet Ilya – a combination of a Central Saint Martins-trained graphic designer and a Russian saddle-maker – produces a collection in studded leather frankly entitled 'Restraint'.

An object becomes a fetish when it is the subject of obsession. Shoes are among the most fetishized of all fashion items, and what people decide to wear often has little connection with practicality. The most famous fall in modern fashion history came in 1993, when Naomi Campbell fell off Vivienne Westwood's Super Elevated Ghillie platforms, making far more of an impact than a mere tumble from the 9-inch heels and 4-inch platforms would suggest. The combination of supermodel, eccentric visionary and unwearable clothes sparked a media frenzy. But Westwood's outlandish footwear was far from the only such example in costume history. Indeed, unwearable footwear appears regularly: from the long-toed poulaine of the fifteenth century (see Feet, page 142) and the towering chopines of the sixteenth century to recent 'limousine shoes', suitable only for those who have chauffer-driven cars to take them everywhere.

Japan has its own history of unwearable shoes. The tall platforms beloved of young Japanese are based on geta, sandals worn by geisha in order to keep their kimonos out of the mud. These geta were made from a solid block of wood with two more blocks beneath. They are inflexible and unshaped – and, like many of the other clothes and traditions associated with the geisha, walking in them takes such exhaustive practice to accomplish that they can rightly be seen as a form of female bondage.

'A mutilation undergone for the purpose of lowering the subject's utility and rendering her permanently and obviously unfit for work' –
THORSTEIN VEBLEN on the corset, 1899

51-cm-high platform shoes, Tokyo, 1973

IMPRACTICAL

Thierry Mugler, Men's Ready-to-Wear, Autumn/Winter 2011-12, Paris

Jimi Hendrix, photograph by
Gered Mankowitz, 1967

M
I
L
I
T
A
R
Y

'I always did like a man in uniform, and that one fits you grand. Why don't you come up sometime and see me?' – MAE WEST, 1933

Military garb is a staple of modern dress even outside the armed services, such is the glamour of the fighting man. It evolved to fulfil a range of requirements, some of which can be termed matters of life or death. The most basic are to distinguish fighting men from non-combatants, and one side from the other. Within an army, small differences in uniform distinguish different units and define a hierarchy in which an additional stripe on the shoulder decides who can issue orders – and who must take them. A secondary purpose of military dress has been to make the warrior as intimidating as possible to the enemy, often achieved in the past with bright colours and exaggerated headwear, like the towering busby that originated with Hungarian hussars, the bearskin hat of the British Brigade of Guards or the black capercaillie feathers in the hats of the Italian bersagliere.

Uniforms first appeared with the regimental system, which originated in France in the mid-seventeenth century. Military commanders learned that the best way to convince men to face danger was to build loyalty among a small group, so that soldiers fought for their companions rather than for a country or a cause. Although uniforms were broadly standardized, coloured facings, styles of braiding or variations in collar and cuffs made each regiment distinct. An example is the importance (bordering on reverence) placed on the 'red' beret – in fact maroon – of the British parachute regiment. This was literally fashion to die for, designed to engender loyalty, if necessary to the death.

The soldier that little boys used to want to be – adored by Jane Austen's wayward heroines; the leading character in Tchaikovsky's »Nutcracker Suite«; Sergeant Troy in »Far From the Madding Crowd« – was not the war-stained warrior: he was the guardsman, dressed up in bright jackets, glinting buttons and bear-skin hats. In virtually no other field of dress can males legitimately pay such minute attention to their appearance as in military wear. Indeed, this is one of the purposes of military finery: it reinforces the idea that armed service is glamorous. This is the military ideal that is frequently echoed on the catwalk in frogging and braiding, or in epaulettes, gold buttons and decorated cuffs.

Early uniforms were designed to cope with smoky battlefields dominated by gunpowder weapons – deep blues and madders were dominant; the scarlet of the British redcoat was an exception. Because uniforms all had the same constraints, such as being cheap to produce, and all performed the same role, they tended to be very similar. This inevitably led to confusion. At the start of the nineteenth century Britain's Prince Regent, later George IV, interested himself in all things military – except the fighting – and designed his own uniforms. But the outfits he designed meant the British units who wore them were dressed identically to Napoleon's French troops, whom they were fighting in Spain.

The introduction of smokeless ammunition in the late nineteenth century made brightly dressed soldiers highly vulnerable. Some British regiments in India had already worn khaki for at least half a century, dyeing their white uniforms a dusty brown. Equally drab shades of blue, green and grey dominated the battlefields of the Western Front … and not just in order to make soldiers less obvious targets. With millions of men under arms, it was cheaper to produce uniforms in such colours and to standard sizes (introduced in the American Civil War of 1861–65).

Although many armies went into World War I in 1914 in remnants of earlier military finery, they soon adapted. At the start of the conflict, »The Manchester Guardian« noted that 'The flamboyant uniform of the line regiments makes a fair mark as far as the modern rifle is effective. On the other hand, the Germans have adopted a grey-green colour that is almost invisible … What I have written to the French applies with more force to the Belgian troops. These soldiers are as conspicuous as claret stains on a new tablecloth.' By 1916 the practicalities of factory production meant that such anomalies had all but disappeared.

Military uniform probably has stricter rules than any other type of dress. In this respect, it is the cousin of 'must-have' fashion cults. Some of the rules clearly have roots in practicality: the constant shining of shoes – the spit and polish – was essential in preserving this most important item of uniform. But other rules have a more psychological function: they ensure that a soldier's appearance reflects precision and self-control. Eventually the dress rules were no longer practical for field service, so while dress uniform remained standard in the officers' mess or for ceremonial parades, soldiers went off to fight in a less showy, and more easily maintained, field uniform that increasingly used a form of camouflage – a development seized on by designers from the Finnish Marimekko in the 1960s to Marc Jacobs in the 2000s (see Camouflage, page 166).

Prince Eitel Friedrich of Prussia, 1911

King's Birthday Parade, Bangkok, Thailand, 2007

Stephen Linnard, Blitz Club, 1980

In cults, as in much else, many of the most beautiful flowers have their roots deepest in the manure. Rarely was this as true as for the New Romantics who emerged in Maggie Thatcher's London, when young Britons were unemployed, poor and bored. Young people with few prospects, which in London in 1978 included virtually all art and fashion students, used clubbing as an escape and dressed to fulfill their fantasies, drawing on the precedents of David Bowie, Elton John and – dare one mention? – Gary Glitter. Like punk, the movement was spread by music, but for the New Romantics, appearance was far more important than the music they listened to.

The unlikely apostles of the movement were nightclub hosts Leigh Bowery and Steve Strange. Bowery's club Taboo – so named because nothing was actually taboo – positively encouraged outrage, albeit of a kitsch, playbox kind. Cross-dressing, high-camp make-up, skin-tight lurex, fake fur, gaudy colours, lamé, sequins, plastics and nylons: these were essentially disaffected sixth formers seeking the most effective ways to throw bad taste into the face of their parents' generation. It was subversive and subterranean. It was also one of the twentieth century's great creative liberators, with an impact as powerful and long-lasting as that of Diaghilev's Ballets Russes (1909).

The exaggeration of New Romantic fashion evolved from stage costume, particularly the glam rock movement of the 1970s and contemporary musicians like Spandau Ballet, Cyndi Lauper and Blondie. Fans adapted what they could from thrift shops or suppliers such as London's Lawrence Corner. As on stage, the only thing that shaped the clothes was impact: historical authenticity – and virtually all the clothes were borrowed willynilly from earlier periods of fashion – troubled no-one.

New Romantics turned back to making their own clothes, partly because they wanted their appearance to proclaim their individuality, but also because they had no choice: they had no money. Necessity was the mother of invention: recycled clothes, recovered pieces of fabric, market-stall knock-offs, stolen goods. These were the materials on which John Galliano, Stephen Jones and Alexander McQueen cut their teeth, where they learned that there were no rules and no taste – that virtually nothing was taboo. It was a lesson not wasted on more established designers such as Body Map, Richmond-Cornejo and Katharine Hamnett. New Romanticism may well have disappeared under the weight of its own excessive theatricality – were it not for the fact that some of its lords of misrule grew up to become some of the most influential figures in international fashion.

If punks were democrats, New Romantics were the elite. This was arcane fashion that took the obsession with appearance to a level rarely seen since Versailles. The leaders came from a narrow clientele: almost entirely British art-school students – Saint Martin's led the way – who were often sexually androgynous, young, and virtually all from the metropolis, rather than the Home Counties. This has been a characteristic of all periods of intense fashion revolution: that the cognoscenti must break the ground before a look's influence can filter down to the High Street. Dressing up has always been a primarily upper-class occupation, and the New Romantics appropriated the snobbish appeal of charades. The emotion remained the same: escapism, fantasy and the chance, by changing one's clothes, to change one's life experience: to overcome boredom and insignificance. And, like all dressing up, they created new personas of simple but heightened power. As Vivienne Westwood – moving on from punk just at the perceptive moment – commented in 1981: 'All of my sources, the pirates and the Indians, are like comic book characters that appeal to the emotions.'

Steve Strange, c.1978–84

'I knew style and content went hand in hand' – BOY GEORGE

N
E
W

R
O
M
A
N
T
I
C

THE
BODY
CLOTHED

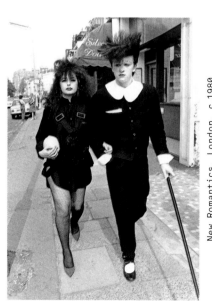

New Romantics, London, c.1980

THE
BODY
CLOTHED

O
S
T
E
N
T
A
T
I
O
U
S

'Never fear being vulgar, only boring' – DIANA VREELAND

Clothes as much as manners maketh the man. And the minority in the know make sure that, as with understanding the niceties of passing the port, the majority remain uninitiated. Good taste is a way to exclude those who do not understand the arcane rules that would admit them as insiders. These rules are quixotic and rarely written down, such as whether or not such-and-such a restaurant requires a male diner to wear a tie. The tie is, the restaurant argues, essential to maintain standards: not to wear a tie to dine is a social solecism that other diners may find offensive. This is rubbish, of course; in truth the tie has become a shibboleth. It is a password that only insiders know. In fact, even in upmarket restaurants the need for trade has done much to soften such rules, along with the rich and desirable customers no longer prepared to be dictated to about what they may wear in their leisure time.

Like notions of modesty and beauty, taste is created by the collective attitudes of a society, and thus varies over time or from place to place. In general, it is highly conservative: exceeding the accepted standards of a society is in itself tasteless. But whereas the courtiers of the sixteenth and seventeenth centuries piled jewellery on top of opulent fabrics to give a tasteful impression, a modern excess of display – bling – by a gangsta rapper is considered vulgar. The display and its purpose remain largely the same, but conspicuous shows of wealth have come to be seen as tasteless in a world in which so many people have little or nothing. This is why Manhattan heiresses ask for their Hermès purchases to be packed in plain white bags rather than the more famous – and more conspicuous – orange variety (it also deters possible muggers), and company executives consider a good, traditional tailor more vital to their status than a gaudy watch. After all, a bespoke suit cannot be copied so easily or cheaply. And that is also why the new nobility – pop stars and sportsmen – may lavish money on the most expensive of objects, and yet still fail the test of good taste.

There is an argument that fashion itself is an inherently tasteless pursuit. It feeds vanity and prodigality; it harnesses the resources of the poorest parts of the world for a relatively few wealthy people in the richest (and rewards Third World workers with pittances in the process). It reduces the worth of an individual to something as frivolous as appearance. It inflates style over substance. It flaunts the discrepancy between its own fairy tale and the real world around it: one thinks of the infamous Benetton advertisements of the 1990s which featured a man dying of AIDS and the hand of a starving African child. In the 2000s, »Italian Vogue« made both the Iraq War and an oil spill backdrops for Stephen Meisel photo shoots. Perhaps this self-referential knowingness expresses fashion's unease with its own absurdity, or perhaps it reflects a genuine belief that fashion actually does inhabit another world – Planet Fashion – remote and unaccountable.

Bright, acidic tones that dominate a room like a glitterball, jarring clashes of bold shades that scream 'look at me', plush velveteen or glimmering lamé – these are the antithesis of Beau Brummell's dictum that clothes should not make observers gawp. The designers who best realized that the world had changed were the Italians of the 1970s and 1980s, who challenged Paris's unassailable reputation for elegance in a riot of colour, shine and conspicuous consumption. Chief among them was Gianni Versace, whose patterned silk shirts chimed perfectly with the flash 'loadsamoney' spirit of the Thatcherite 1980s. For Versace, an expensive shirt was only worth the money if it proclaimed its own expense – and, in its vulgarity, its wearer's determination to give the finger to conventional taste and shape a new attitude based on wealth alone. The same principle underlies clothes in which the most important element is the designer's name made manifest, either as an easily identifiable logo or even as a label, with the name writ large. These are clothes that shout that their wearer is a fully-paid-up member of the fashion tribe … and shouting has never been anything but vulgar.

»Chancellor Seguier and his servants«, Charles Le Brun, 1661, oil on canvas

When Edward Elgar wrote the 'Pomp and Circumstance' marches in the early twentieth century, 'pomp' – a ceremonial or magnificent display – was a vital part of national life. If nothing else, it inspired civilians and soldiers alike to cope with 'circumstance', the brutal reality of warfare. At its heart, pomp was both pageantry and a display of might. It brought together formal ceremony, music and symbols such as flags, insignia, crowns and robes.

The grandest display was reserved for rulers: Chinese imperial rulers wore robes with dragons embroidered on the back to signify that the dynasty was descended from the dragon, which represented strength and good luck. Inca rulers wore gold to reflect their belief that they were descended from the sun god, Inti. Among the Zulu, rulers wore clothes made from leopard skins and carried ceremonial swords and shields as symbols of the protection they offered their people.

The creation of a monarch in a coronation is traditionally semi-magical, reflecting the belief that monarchy is a gift bestowed by a god or gods, and that anointing a ruler makes him or (sometimes) her somehow semi-divine. Today, most coronations are all about the crown. In its original form, it took the shape of a wreath of laurel or other leaves. This open 'hat', now often made of precious metal and adorned with jewels, has been a symbol of royalty since Roman emperors wore a diadem adorned with radiating sunrays, easily recognizable today from the Statue of Liberty (see Head, page 56).

Since the Norman invasion of 1066 British coronations have taken place in Westminster Abbey, with the exception of two (both monarchs, incidentally, paid the price: Edward V was one of the princes murdered in the Tower of London, and Edward VIII abdicated). The ceremony brings together the senior bishops and the great officers of state, all wearing their ceremonial robes and coronets. The new monarch wears various robes over a crimson surcoat; as part of the ceremony, he or she is invested with a white linen undergarment, or shroud tunic; a long coat of gold silk, or supertunica; and the robe royal, which is worn during the actual crowning. The regalia – the Crown jewels (the crowns, orbs, sceptres, spurs, armills (bracelets) and swords that symbolize royal power) – have been handed down for centuries. The coronation robes, however, are usually newly made for each monarch. The last dress for a British coronation was designed by Sir Norman Hartnell for Elizabeth II in 1953, and contained richly embroidered symbols for the countries and continents the new queen was to rule, such as maple leaves for Canada and mimosa for Australia.

Beyond coronations, the high point of spectacle for the British monarchy was the Delhi Durbar of 1911, the pinnacle of the pomp of the Raj. The Indian princes gathered to pay homage to George V and Queen Mary, after their twenty-two-day sea journey. The maharajas' canvas city of medieval magnificence spread over twenty-five square miles. The British official party wore full dress uniform despite the heat; the queen wore her coronation gown and jewels including the Koh-i-Noor, the world's largest diamond. The king-emperor wore a new crown – the Crown jewels are not allowed to leave Britain – with 6,100 diamonds that contributed to a weight of nearly a kilogram. The Imperial Crown of India was so heavy that George V complained … and no monarch has ever worn it since.

After rulers came warriors: in Europe, the monarchs that emerged from the late Middle Ages were often simply the strongest among the class of knights. When William of Normandy conquered England in 1066, his knights became barons in the new kingdom. These warriors each maintained a household, ready to fight when called upon. Livery indicated which household an individual belonged to, with variations to indicate on which level of the household he existed.

This kind of projection of power can be termed 'panoply': an array of individuals in co-ordinated clothing and trappings. The term derives from clothing. It appeared in the late sixteenth century and referred to the complete suit of armour of a mounted knight. By extension it has come to mean not only ceremonial dress in general, but a magnificent array. Panoply – like the empires and monarchies that supported it – eventually had its day. At the courts of the maharajas of India in the eighteenth and nineteenth centuries, households were paraded in splendour. The maharajas themselves dressed extravagantly; when there was no room left on their bodies for jewellery, they encrusted their swords with precious stones. Such opulence would later provide an unflattering contrast with the simplicity espoused by Mahatma Gandhi, who in the early 1920s promoted the production of khadi to express Indian nationalism; he wore the cloth as a plain white dhoti (see Materials and Texture, page 24).

P O M P

»The Maharaja Dulep Singh«, Franz Xaver Winterhalter, 1850

Elizabeth II in coronation robes, 1953, photograph by Cecil Beaton

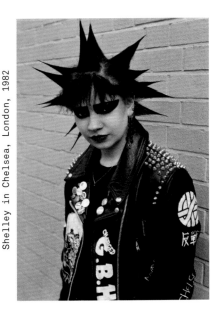

P U N K

'We wanted to step off our island and add the colour of the Third World. We got gold cigarette paper and stuck it around our teeth. We really did look like pirates and dressed to look the part' – VIVIENNE WESTWOOD

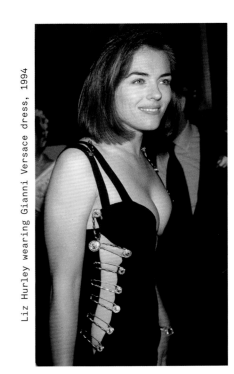

Liz Hurley wearing Gianni Versace dress, 1994

In the early 1970s in Britain and the United States a new generation of bands began to play what they called 'punk rock', drawing on a word used to describe a hustler or a loser. This was music of alienation, in which spirit was more important than technical ability. And that spirit was anger: anger at the Establishment, anger at recession, anger at unemployment, at wasteland cities, at their elders. The clothes that dressed punk were a way for the young to show contempt for a social system that seemed to exclude them.

Punk was DIY. It sought out what society would have rejected – jeans and tights so ripped that they should be thrown away, heavy chains and studs, garish fur or fake fur, bastardized military clothing, tattoos, black leather jackets and tight skirts – and put them together. It was not as revolutionary as it seemed: it belonged to the traditions of the hippies, of makeshift and mend and, indeed, the middle-class dressing-up box or jumble sale. What was new was its overt aggression.

Punk clothing had a wide range of sources. The ripped clothing echoed the slashes of the Landsknechte of the late fifteenth and early sixteenth centuries, mercenaries who tore their clothes in order to show that they stood outside the norms of society. The leather recalled bikers and rockers (see Materials and Texture, page 24). The jeans were James Dean. The short skirts and fishnet tights were borrowed from the bordello, by way of the boutiques of the Sixties. The iconoclastic T-shirts owed much to Andy Warhol and the poster culture of stores such as Athena (see Torso, page 74). The safety pins, studs and chains were a parody of the earrings, watch chains and medals of the establishment. And the care that young punks took over their apparently artless appearance – the hair spiked just so, the clothes carefully layered – echoed the hours their elders spent under dryers at the hairdressers or in ironing shirts. Anti-fashion can be as domineering a master as fashion itself.

With bands being spat at, banned or arrested, punk received media coverage out of all proportion to its real significance. It was one of the first style movements to spread through news photography rather than advertising or fashion coverage. Everywhere, young people saw punks in the media and put some safety pins through their clothes or Vaseline and talcum powder in their hair in order to share the new excitement. In that way, it was an authentic popular movement, even if it had its art-college leaders in New York and London.

The tragedy of punk was that eventually the punks sold themselves to the very establishment they were rejecting. While the Sex Pistols notoriously signed to and were then fired from a mainstream record company – with a huge payoff – their svengali Malcolm McLaren was also working with his partner Vivienne Westwood to commercialize punk fashion. From their boutique Sex at World's End on the King's Road, the pair sold clothes designed to shock, including the infamous T-shirt of the Queen with a safety-pin through her nose. But as the economy continued to slump, few punks could afford to buy the clothes. Instead, they were reduced to begging from the tourists who paid to photograph their outrageous mohican hairstyles. They had become totems who eventually would be tamed by boredom, having been bought by the very society they despised.

Vivienne Westwood was too talented a designer to stay within punk's highly limited vocabulary. There were other avenues for her to upset the bourgeois apple cart. Other designers placed punk on the catwalk in a blatant hijacking of the movement's original principles. Zandra Rhodes used safety pins to hold her clothes together as, famously, did Versace in the dress that did more for Liz Hurley's career than her acting ever could. Azzedine Alaïa used black leather for gauntlets studded with black rivets, although it was Yves Saint Laurent who first made the biker's jacket into a high fashion garment, a move that got him sacked from his job as chief designer at Dior in 1960. For a while punk perhaps gave fashion a sense that its own rules had become redundant, but that feeling of liberation soon passed. The movement that began in anger and then became desperate eventually ended in defeat.

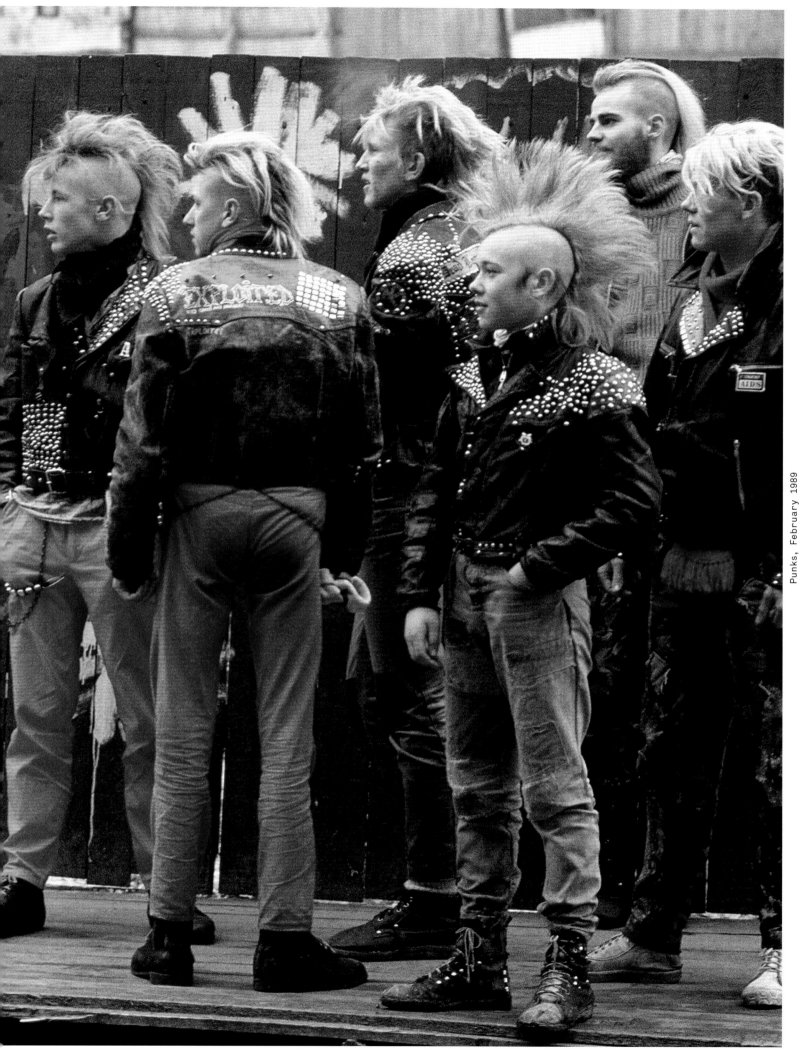

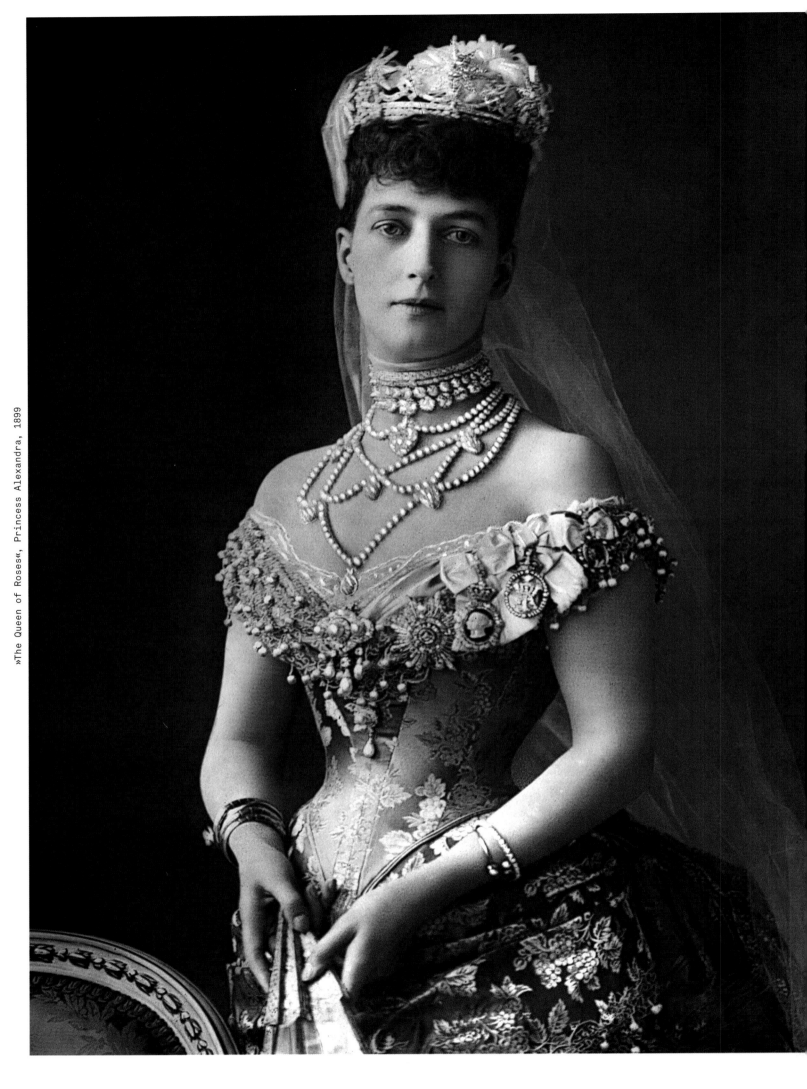

»The Queen of Roses«, Princess Alexandra, 1899

Royalty sits at the top of the class pile – and sometimes at the top of the fashion pile. Whatever the actual personalities of monarchs, the institution itself must be rarified and other-worldly. The royal family dresses accordingly. For state occasions, they wear finery that outshines all other; the rest of the time, their outfits clothe their role as social leaders. Since earliest times, rulers have been entitled to the finest of all clothes: gossamer linen in ancient Egypt; the imperial purple in ancient Rome; the most spectacular feathers of the quetzal in Aztec Mexico; the finest lionskin in tribal Africa; the whitest ermine in European courts: these extreme luxuries have long been the prerogative of the ruling class.

Monarchs have frequently been trendsetters, from the pharaohs of ancient Egypt – whose long-toed sandals showed their rank – to the Duchess of Cambridge. Royals who changed clothing styles include Charles II of England, who introduced what eventually became the waistcoat; Queen Elizabeth I, who popularized accentuated waistlines; and Princess Alexandra, whose choker, worn to disguise a blemish on her neck, became a fixture of society dress. Others, like Louis XIV, France's 'Sun King', created a fashionable milieu in which dress and manners were the very qualities on which individuals were judged.

Few modern royals have been so fluent in the language of clothes as Diana, Princess of Wales. She learned it after her engagement, bringing in British »Vogue« fashion editor Anna Harvey to help guide her choice of British designers. Harvey was too late to prevent Diana's first purchase: a black taffeta ball gown by the Emanuels that nearly exposed her bosoms as she got out of a car. The nineteen-year-old saw black as sophisticated: the royal family's tradition was that it was a colour for mourning. So when, thirteen years later, Diana went out on the very evening her husband was appearing on TV to confess his infidelities, her outfit made a statement. The off-the-shoulder black dress by Christina Stambolian sent out a clear message. Next day, Diana had knocked her husband off the front pages. »The Telegraph Magazine« called her choice "possibly the most strategic dress ever worn by a woman in modern times."

Diana's mother in law, Queen Elizabeth II, so far as we can tell, sees clothes merely as part of a uniform for her job. Off duty, she is happiest in country tweeds, Barbours, headscarves and wellington boots. But even this conservative dresser – her sister, Princess Margaret, was a far more dedicated fashion follower – has inadvertently set trends, such as the green felt beret she wore on her 16th birthday (she was an honorary colonel of the Grenadier Guards) or in 1953, when the so-called Magpie Dress by Norman Hartnell, a slim black evening dress with a white panel at the front became a best-selling pattern for women who wanted to sew it at home, as well as selling in its thousands in Oxford Street.

The queen is not unusual in separating regal style from fashion. Her own mother, Queen Elizabeth, set out to restore the reputation of the monarchy after the Abdication Crisis of 1936 and her husband's ascent to the throne as George VI. Her clothes were those of the fairy tale princess: crinolines, lace, taffeta and lots of diamonds (see Romantic, page 222). The look was frothy and colourful … and frankly ludicrous. But once her style was established, it did not change. Nothing could be in greater contrast to the woman who sparked the Abdication, Wallis Simpson, whose dress was fashionable, elegant and simple. In the 1930s, Simpson, by then Duchess of Windsor, was asked what the Queen could do to promote British fashion abroad; she is said to have replied, 'Stay at home'.

The most magnificent public displays of regality, beyond the grand ceremonies of state, are weddings. Europe's royal weddings – Charles and Diana in 1981, Frederik and Mary in Denmark in 2004, Albert and Charlene in Monaco in 2011, William and Kate in London the same year – are international media events. Queen Victoria started the modern tradition in 1840 when marrying Prince Albert, by introducing the convention that the bride should wear white. A century later, Elizabeth II was married in 1947 in a Norman Hartnell gown for which in the postwar climate she paid with ration coupons. The culmination of the tradition was the wedding of Charles and Diana. The revelations about the failure of that marriage temporarily put paid to the royal venture into the world of fairy-tale romance, but Kate Middleton's dress for her marriage to Prince William retained a degree of romance, though far more understated. Sarah Burton at Alexander McQueen set out to combine an essentially Victorian corset with modern materials and delicate embroidery by the Royal School of Needlework in Hampton Court. The dress drew a reported 600,000 visitors when it was put on display in Buckingham Palace.

Dress is a trifling matter … but it gives one also the outward sign from which people in general can and often do judge the inward state of mind and feeling of a person … On that account it is of some importance, particularly in persons of high rank' – QUEEN VICTORIA to the Prince of Wales, 1858

»Louis XVIII«, François Gérard, 1775, oil on canvas

R
E
G
A
L

THE
BODY
CLOTHED

Queen Elizabeth the Queen Mother, photograph by Cecil Beaton, 1950s

R O M A N T I C

'Deceiving others. This is what the world calls a romance' – OSCAR WILDE

The romantic is always perfect. The princess marries the prince – in the end, at least – the ogres are banished, the white ball gowns are pristine more than merely clean, the glass slippers fit exactly, the prince is virile and handsome, his bride modest and virginal and, of course, the good always live happily ever after. The fairytale is a strong one when we are young – and often it never quite goes away. When we look at high fashion clothes in magazines, we see them at their most perfect, a state only attainable in advertising and in fairytales; when we buy them, we are striving to achieve that perfection for ourselves. We believe, albeit unconsciously, that the clothes will also help us to realize the dream behind all fairy tales. That is what we are buying into: the idea that perfection is possible, that the ugly duckling can become the swan. We can marry the prince or the princess. All we need are the magical garments to clothe the part – and they are always the extremely expensive ones that clog the advertising section of all 'glossy' magazines.

No more romantic form of dressing has ever existed than Haute Couture, which flowered for perhaps a hundred years before it entered the long decline that continues today (see Couture, page 178). For a handful of women around the world, an even smaller handful of couturiers applied genius, painstaking attention and the most expensive of materials to create dresses that were as near perfection as it is possible to achieve. The truly great – Christian Dior, Cristóbal Balenciaga, Charles James, Yves Saint Laurent – understood that even the wealthy have fantasies and that their task was to clothe the princess inside every woman in such a way that she feels the most perfect and privileged creature not just in the room, but on Earth, and is perceived as such by her male companion who pays for the clothes. It is a truism that no woman ever buys couture out of her own pocket.

Beyond Haute Couture, our idea of what constitutes romantic fashion barely changes: it includes pastels, flowers, floaty fabrics such as chiffon, delicate lace, ruffles, many of which derive from the early nineteenth-century neo-Gothic fashion that lasted until the 1840s. The silhouette of the archetypal romantic dress – small waist and bosom, bare collarbone and neck and billowing skirts, the kind of garment worn by Princess Barbie – arrived in the same period. The most famous example, of course, was the wedding dress worn by Lady Diana Spencer when she married Prince Charles in 1981: the Emanuels concocted a confection of ivory taffeta and antique lace. Like the princess herself, the designers were young and naïve, making them seem ideal for dressing the fantasy, but in fact, the 25-foot train soon crumpled where it had to be bundled around her legs, the veil had to be cut off with scissors at the entrance to Westminster Abbey, and the whole outfit was not judged a success – rather like the romance it clothed.

Romance requires a conscious rejection of reality. Take the 'queen of Romance', Barbara Cartland, who wore only pink chiffon and pearls and wrote hundreds of sexless romances (723, at the final tally) that sold in their millions despite – or because of – their lack of realism. Think of the New Romantics who emerged from London's squats and seedy clubs in the mid-1980s – simultaneously with Cartland's greatest success – flamboyant in their frills and bows (see New Romantic, page 212). At the height of a recession in Britain, these pirates and highwaymen set out to recapture the Hollywood glamour of Errol Flynn and Barbara Stanwyck in thirties' costume drama and wore the antithesis of work clothing to proclaim their refusal to accept a role in daily life.

The New Romantics, like other romantics, sought influences in the past, aptly described by L. P. Hartley as a foreign country, where they do things differently. Mr. Darcy and Heathcliffe, the balls of the Romanovs, Mrs Astor's 400, the Morocco of »Casablanca« (1942), Richard Burton and Elizabeth Taylor, the London Season, the postwar balls in Versailles, Monte Carlo and Venice for a dwindling high society and international café elite – it seems that the age of romance is always behind us. Every age considers itself just a little late: real life has finally overwhelmed the romance. So we seek romance in the past, and particularly in the past of immense privilege, and steadfastly ignore the reality: for every Cinderella, how many countless Cinders were there on whose door the prince didn't knock or whose feet the slipper wouldn't fit? We recreate a version of the past and how it dressed that has no relation to reality: remember the TV »Pride and Prejudice« in which Mr Darcy climbs from a pond in a dripping shirt, a social solecism at a time when shirts were worn as underwear that would have had him dropped by Longbourn society for ever and Elizabeth Bennett fainting with disgust.

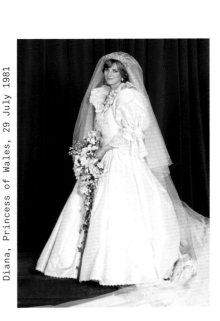

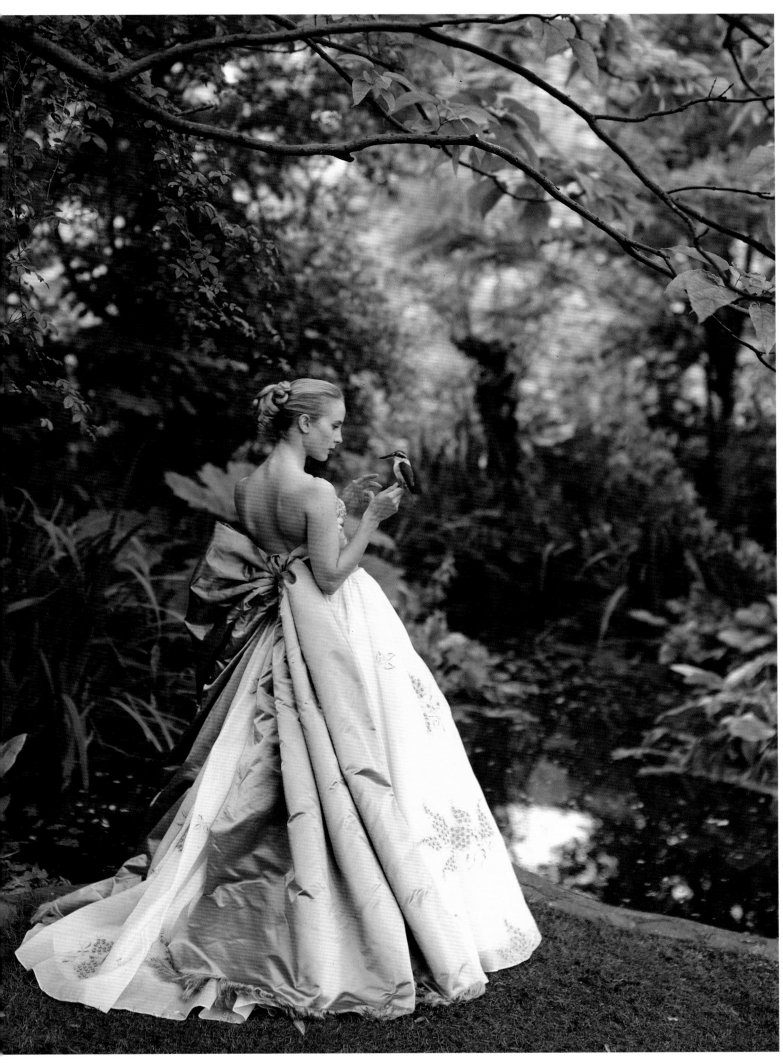

Haute Couture shoot for Modess, photograph by Cecil Beaton, c.1950s

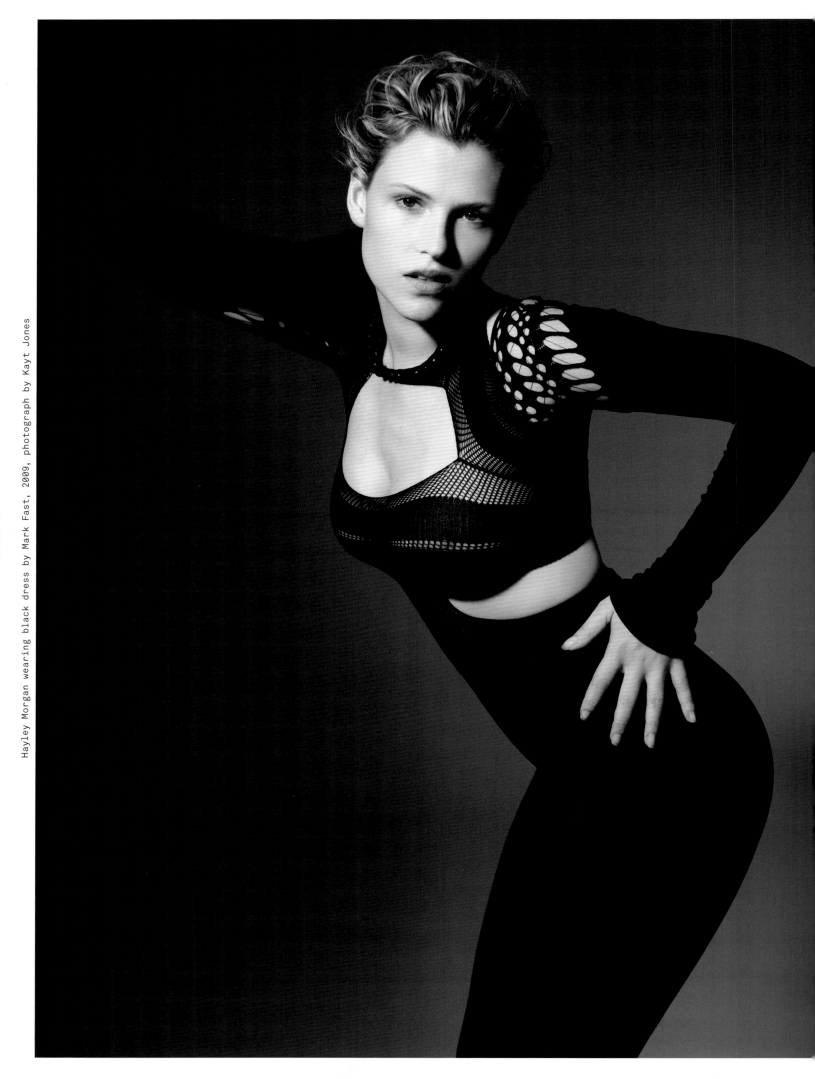

Hayley Morgan wearing black dress by Mark Fast, 2009, photograph by Kayt Jones

Sex is as old as the species – of course – but the word 'sexy' only dates from 1905. That underlines that sexiness, certainly in terms of fashion, is not natural. People are not sexy all the time. Sexiness is a form of standing, walking, speaking or wearing clothes that sparks arousal in the onlooker. The early religions banned nudity; but when they realized the power of clothes to sexually arouse, they started banning different forms of clothes. Many would feel that, while the naked body can frequently be attractive, to be truly sexy it needs clothes.

The covered or artfully displayed skin offers what nudity does not: the thrill of anticipation and revelation. A glimpse of stocking, a flash of décolletage, the waistband of underpants peeking above the top of jeans: these are what get fantasies and pulses racing (but normally only on the right body, which is the one about which the onlooker fantasizes).

To the Victorians, the forbidden place beneath a woman's crinoline was full of seductive promise. The Victorians even had a word for the rustling sound made by the layers of petticoats: frou-frou. The promise implicit in the sound was part of the thrill of the hidden legs. In the 1920s, the thrill came from the Flappers' short skirts, just on or above the knee. In the 1960s sexiness was linked to very much shorter skirts that virtually fully exposed the legs. The youthful quality of smooth, bare legs gave the miniskirt a certain girlish innocence, however, far removed from the see-through blouses, camisole tops and lingerie of the 1970s (underwear is usually highly erotic when worn as outerwear) or the body-hugging lycra of the 1980s and 1990s.

Certain materials have always been considered sexy. Most of them are associated with luxury, exclusiveness and power. They include fur, loved for its beauty but also the untamed associations it carried; leather, with its covert associations with violence and its role as a second skin; rubber, beloved of the fetish market or its touch and smell; lace, for its ability to conceal and reveal at the same time; and satin and silk, for their smooth coolness and their tinge of exoticism.

Satin and silk are closely linked with lingerie, which appeared on the high street in a highly sexualized form in the early 1970s in the shape of Anne Summers in the UK and Victoria's Secret in the United States in 1977. The stores were initially regarded with a certain amount of moral disaste and Victoria's Secret's policy of trying to sell sexy underwear to men for their wives or girlfriends was so unsuccessful that the company came close to bankruptcy before it changed its strategy in 1983 to aim its clothes at women themselves. It deliberately set out to echo the feeling of nineteenth-century England, in an effort to give it a touch of upmarket class. In 1994, the British retailer Agent Provocateur was founded to exploit the mainstream acceptance of women expressing their own sexuality. It was more brash and confident, with blatant echoes of bondage gear – as one would expect of Vivienne Westwood's son, Joseph Corré, who co-founded the label in 1994 with Serena Rees.

In the early 1980s, fashion designers began to bring the world of fetish and bondage onto the catwalk. They included Claude Montana, whose leather collections presented women as figures of power, as did those of Thierry Mugler, who combined leather with more futuristic trappings. Again, Azzadine Alaia, famed for his figure-accentuating cut, used leather and materials such as PVC, as well as injecting sex appeal into the usually more sedate jersey. More than almost any other designer, Alaia understood the erotic fascination of fastenings. Buttons, buckles, laces, zips: all promise the reward of being undone. In his hands, the zip curled around the body, making it an element in the new vocabulary of fashion. There was even a new word to go with it: body-conscious, which refers to clothing that hugs the wearer so tightly that it makes him or her – and the observer – aware of the body inside. A new generation of young designers such as Mark Fast deliberately design clothes to show off the sexy feminine figure.

Too much body consciousness is sometimes condemned as clothing that leaves nothing to the imagination. Certainly, it reveals the outline of the breasts, bottom and pudenda more clearly than any clothing before the late twentieth century. But the whole point is that it does leave something to the imagination. It leaves the actual sight and feel of the body within to the imagination, and thus creates far more of a sexual frisson than the nudity to which it is apparently so closely allied.

'Women's sexy underwear is a minor but significant growth industry of late-twentieth-century Britain in the twilight of capitalism' – ANGELA CARTER, »Nothing Sacred«, 1977

David Beckham, advertisement for Police sunglasses, 2001

POLICE
sunglasses

S
E
X
Y

THE
BODY
CLOTHED

Agent Provocateur collection, Berlin Fashion Week, 2008

S
P
O
R
T
S
W
E
A
R

THE
BODY
CLOTHED

'I've always designed things I needed myself. It just turns out that other people need them, too' – CLAIRE MCCARDELL, »Time« magazine, May 1955

Special clothes worn for sporting activities appeared in the late nineteenth century, and were associated with the 'sports' of the elite, such as riding, sailing, cycling and tennis. It was telling that the first purveyor of such garments, John Redfern, was a tailor based in Cowes on the Isle of Wight, a yachting centre made chic in the late 1800s by Edward VII, then Prince of Wales. In the 1870s, Redfern began tailoring clothes for women following the guns and also sailing or playing tennis. Comfortable and relaxed compared to the prevailing fashions, the garments gradually became acceptable for everyday activities. Sportswear has had little direct connection with activewear ever since (see Activewear, page 150). Instead, the term has come to denote informal clothes that in modern parlance might be termed smart-casual.

Realizing where his market lay, Redfern opened branches in New York and Rhode Island. He was only the first. At a time when fashion influence was disseminated from Europe – which is to say, from Paris – sportswear thrived in less class-constricted US society. American women wanted a wardrobe that was practical and flexible: easy-to-match shirts, blouses, skirts, shorts and slacks; cuts that were flattering yet relaxed; fastenings that were quick to use; and fabrics that were comfortable yet easy to care for.

The United States was – and remains – the powerhouse of sportswear. The key figures were initially women designers such as Claire McCardell, Tina Leser, Clare Potter and Bonnie Cashin. Ignoring the sneers from Paris that New York was all technique and no creativity, they evolved clothes that were quintessentially American in their sensibility: plain to the point of monasticism and as functional as workwear. Even more important, they were modern in a way that few clothes created in Paris or London were. And they were young. During World War II, Paris was cut off from the United States and that gave American designers their chance to reconsider the dress needs of modern women and produce garments that women wanted to wear to suit their own lifestyles, not those of Europe.

McCardell believed that women needed only a few silk T-shirts, a few cashmere sweaters and some woollen trousers, helping to popularize the capsule wardrobe long before the phrase existed (see Capsule, page 168). She invented the flat ballet pump in 1944 to overcome wartime restrictions on material: it has never been out of fashion since. Tina Leser, who worked in Hawaii before moving to New York, used brocades from China, silk from Japan and satins from Mexico to produce glamorous sportswear with an eclectic collection of ethnic influences. Meanwhile Cashin pioneered the layered look, with functional clothes such as sleeveless leather jerkins, reversible silk shirts, hooded dresses in jersey, and canvas coats trimmed with leather and suede, as well as buckles that were the precursors of many modern 'outdoor' ready-to-wear fastenings, taken from camping and climbing gear.

Male sportswear, like women's, is functional and unfussy. The emphasis remains on easy wearability and comfort. Linen trousers and denim jeans, silk shirts and cashmere sweaters are universal, thanks to the perceived glamour of the United States and the strength of its retail industry. The great breakthrough in American sportswear came in the 1930s, when Americans began to develop their own resorts in Florida and California; due to cheap flights, they also discovered South America, the Carribean and especially Bermuda. In sunshine paradises, it seemed ridiculous to wear dark city clothes. Pink, blue, yellow appeared in seersucker, linen and light cottons. Madras checks and Hawaiian shirts were standard holiday dress, as were Bermuda shorts, short-sleeved shirts with soft collars and sandals. In Europe, such liberty was rare. It took the rest of the world over twenty-five years to catch up.

But catch up it did because, above all, sportswear is a retail phenomenon. US designers understand that, in order to succeed for the customer, it has to succeed for them, too. It needs to be relatively easy to make in large numbers – and it needs to be easily saleable. The coming of sportswear in the 1940s coincided with a golden age of US department stores, whose buyers found that the clothes virtually walked off the shelves and, as we all know, it is the ethos of American stores that has led the great retail surge of the last forty years in Europe and the rest of the world.

By the end of the twentieth century, the elements of sportswear had become virtually synonymous with ready-to-wear as a whole. This reflected the democratization of fashion and the rise of lifestyles that called for less formality outside, and sometimes even inside, the workplace. We are all Americans now.

Bonnie Cashin, reversible Shantung shirt, 1952, photograph by Henry Clarke

Gieves and Hawkes single-breasted suit, Autumn/Winter 2012

Far more men than women wear custom-made clothes. Women rarely have garments made specifically for them, seeing it as the height of luxurious indulgence. But among senior members male of the professions bespoke tailoring remains something of a badge of honour. The basis of the relationship between a man and his tailor is precise measurement. Originally, measurements were taken with a strip of parchment marked by a snip of the scissors; the invention of the tape measure in the early nineteenth century made the process more systematic. Bespoke has the advantage of dressing to disguise and enhance the body in ways impossible with mass-produced clothes, and sharp young players find their own men who make clothes just as well as Savile Row tailors at a fraction of the cost.

The male business suit can be seen as the ultimate sign of dress probity. Whether it comes from a Savile Row tailor, a designer label or a chain store, the suit is a reassuring sign that its wearer belongs to the dress-coded club of his peers. It is dark in the tradition of the clergyman, doctor or lawyer, who habitually wore black as a sign of their renunciation of frivolity. Choosing to forget that Al Capone and the Kray Brothers wore suits, many believe that a suit is proof that its wearer can be trusted. Even for those who do not wear it for work, the suit remains de rigueur for social occasions such as weddings, funerals and interviews.

The best suits have always been bespoke: measured, cut, sewn and fitted by skilled tailors who can judge the width of the shoulder or the placement of a button to produce a garment that will flatter the individual customer. Tailoring is generally considered to have reached its apogee in Europe by the late nineteenth century. At a time when male dress was being stripped of virtually all individuality, cut and tailoring became the main marks of distinction. The British led the way, particularly on Savile Row in London, which remains at least the titular heart of the bespoke establishment. In the United States, however, Americans came up with a more egalitarian approach to the suit with well cut, reasonably well fitting ready-to-wear suits. They were modelled on processes used to manufacture military uniforms in large numbers. Fresh from military service after World War I, demobbed doughboys wanted a civilian equivalent to their uniform: the well made citizens' suit had arrived.

The modern suit has two or three pieces and is conservative in cut, though it was not always so. The two-piece suit – minus the waistcoat of the three-piece suit – was an invention of the 1920s, in the aftermath of World War I, when young men who wanted less formal and constricting dress than their fathers began to influence male fashion – for the first time since Beau Brummell a century earlier. Their suits were loosely cut and increasingly worn with soft shirt collars to allow for freer body movement.

The idea that a suit should be black, grey or dark blue is relatively recent. Men have not always been the duller sex in dress. The male rejection of bold colour and decoration, known as the Great Masculine Renunciation, began in the early nineteenth century. As late as the mid-nineteenth century, well-dressed men wore primrose waistcoats or tartan and striped trousers with their dark coats (see Colour and Pattern, page 36). But the Industrial Revolution, which made cities filthy, and the French Revolution, which made overt signs of social superiority dangerous, had begun an unstoppable change. The overthrow of the peacock aristocrats brought to prominence dull-clad men who knew that social power now came from involvement in the affairs of life, not the affairs of fashion.

For extroverts, there remained opportunities for projection, precisely because a suit's formality amplifies the effect of any variation. Benjamin Disraeli, prime minister of Britain in the 1860s and 1870s, was a famous dandy who wore primrose waistcoats and lilac gloves in the House of Commons. A direct line through the Knuts, mashers and stage-door Johnnies of the 1890s links him with the Beatles, in their 1960s collarless suits based on a design by Pierre Cardin and the absurdly large suit worn by David Byrne in the Talking Heads movie »Stop Making Sense« in 1984, inspired by Noh theatre styles.

At the start of the 1980s, as the suited yuppies rose to prominence, designers such as Paul Smith reintroduced fashion to business suits, with linings and pinstripes in bright colours. The development proved popular, but the flamboyance of the modern male is still cautious. Apart from linings of jackets, only boxer shorts and socks are allowed full decorative rein. Dark suits are still the norm in business.

'The only man who behaved sensibly was my Tailor; he took my measurement anew every time he saw me, while all the rest went on with their old measurements and expected them to fit me' – GEORGE BERNARD SHAW, »Man and Superman«, 1903

Jaeger suit, 1952

Fitting for demob suit, c.1945

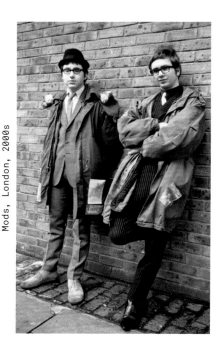

THE
BODY
CLOTHED

U
R
B
A
N

The roots of fashion have more often been urban than rural. Ralph Lauren may peddle the homesteader dream, and Laura Ashley may have built a business empire on a rose-tinted view of the simple life of the countryside (see Escapism, page 186), but it is in cities that fashion sells, if only because it is in cities that most people live, at least in the West. Fashion is also urbane and glamorous; there is little glamorous about the county-town livestock market, the peasants' annual carnival or the back-of-beyond rodeo.

Since the 1970s and 1980s city youth has portrayed itself as combatants in a daily war of survival – perhaps with good reason. New York City reached a nadir in the 1970s, when parts of lower Manhattan became virtual no-go areas after dark because of gangs, drug dealers and prostitutes. Los Angeles, Detroit, London, Paris: cities around the world experienced a similar flight to the suburbs as the middle classes abandoned the inner city to the lawless, the poor and unemployed, the newly arrived immigrants and the indigent homeless. Urban renewal has changed much, though: some of the poorest areas three decades ago are now prime real estate – a knock-on effect of the 1980s vogue among young professionals for living in bohemian lofts and industrial spaces. But a struggle of sorts still goes on, and the combatants need to dress accordingly. Cycle couriers, street cleaners, students and others have all adopted a kind of charity-shop chic, a practical mix-and-match (or mismatch) of camouflage, bits and pieces of borrowed military uniforms, workwear and sportswear. Even the ultra-smart Mods wore their suits with military parkas. It is perhaps no accident that one of Alexander McQueen's most powerful collections of womenswear, shown under the railway bridges of south London in 1997, complete with burned out and burning cars, was called 'It's a Jungle Out There'.

Women love a man in uniform, the saying goes. But not as much as men love a man in uniform – especially themselves. Militaristic clothing has an irresistible appeal for urban men who have little connection with the armed forces. To put on military uniform is to adopt the clothing of the alpha male, particularly in a battleground like the modern city. Like any proscribed form of clothing, uniform has a particular appeal to those outside the system, who flaunt it as a sign of their rejection of that system. The disaffected have, especially since the middle of the twentieth century, co-opted militaristic clothing in ways that would have been unthinkable earlier, when the wearing of uniform by non-military individuals would have been severely censured by social convention. The green light was given by Fidel Castro: when he took over Cuba in 1959 and made army fatigues his standard clothing, any radical worth his or her salt turned to combat wear in sympathy. And in the post-Vietnam world of the 1980s, movies such as Rambo again inspired young males to adopt the symbols of overt masculinity: chains and studs, Nazi insignia, shaven heads and, all too often, bovine expressions.

The urban warrior's clothing echoes even older roots. The Landsknechte (a band of mercenaries) was created by the Holy Roman emperor Maximilian I in the late 1400s. After Maximilian's death, the Landsknechte became more lawless, and their ragged, ripped and layered clothing became associated with the terror being visited upon the villages of the empire. Their modern equivalent, the urban hipster wearing artificially ripped and frayed designer jeans, is, thankfully, almost entirely form and virtually no substance.

In terms of urban clothing, the glamour of the military is echoed by the glamour of the criminal. The Michigan-based company Carhartt had made hard-wearing clothes for America's urban labourers for a century before, in 1989 the company's 'chain gang' blue jackets became a craze when they were worn by gangsta rappers NWA (Niggaz Wit Attitudes). A couple of years later »The New York Times« commented that heavy, fleece-lined Carhartt coats had become de rigueur for drug dealers. They were perfect for standing out on street corners in all weathers.

That association with the urban underworld gave Carhartt a certain cachet and it soon became one of those labels – like Diesel and Stüssy – that manages to turn over huge amounts of money while keeping its distance from the fashion mainstream. Such brands stick to their roots – Western wear, industrial and work clothing, sports gear – because they know that these wellsprings of fashion reflect the moods and aspirations of the urban young. 'Diesel: Jeans and Workwear' reads Diesel's label, enfranchising the urban warriors who wear them with their link to the aggression-tinged self-reliance of the generations of manual workers who built our modern cities.

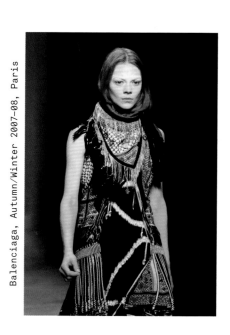

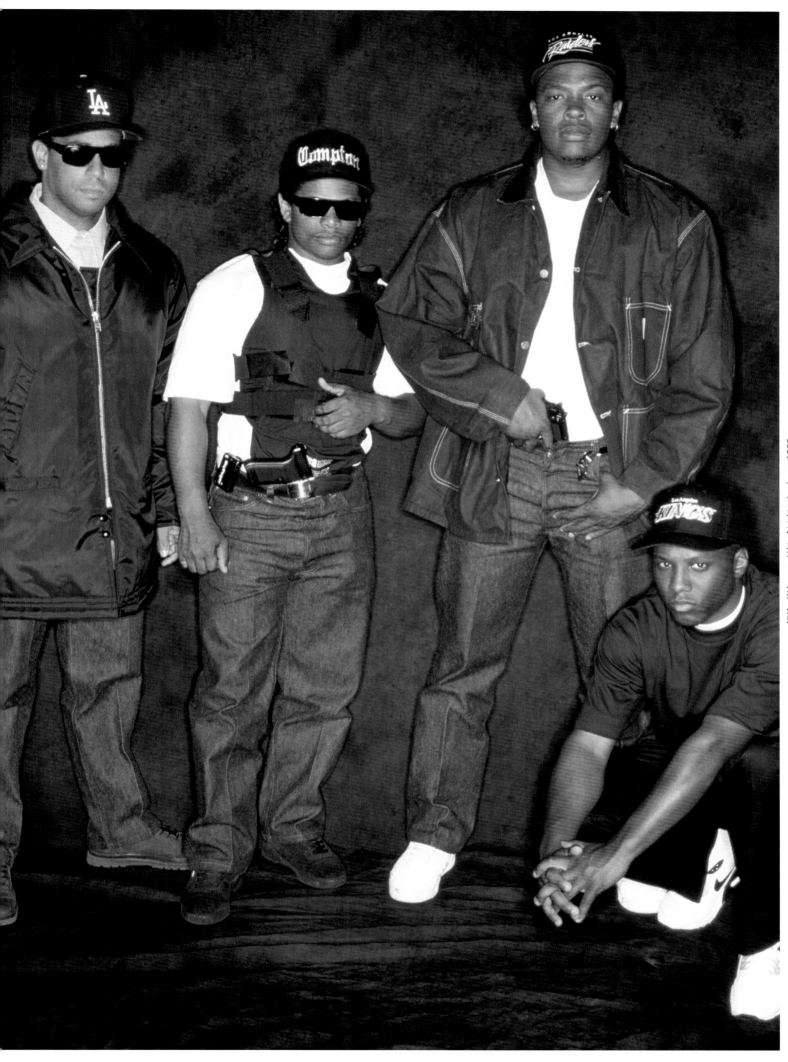

Paris fashion, summer 1964

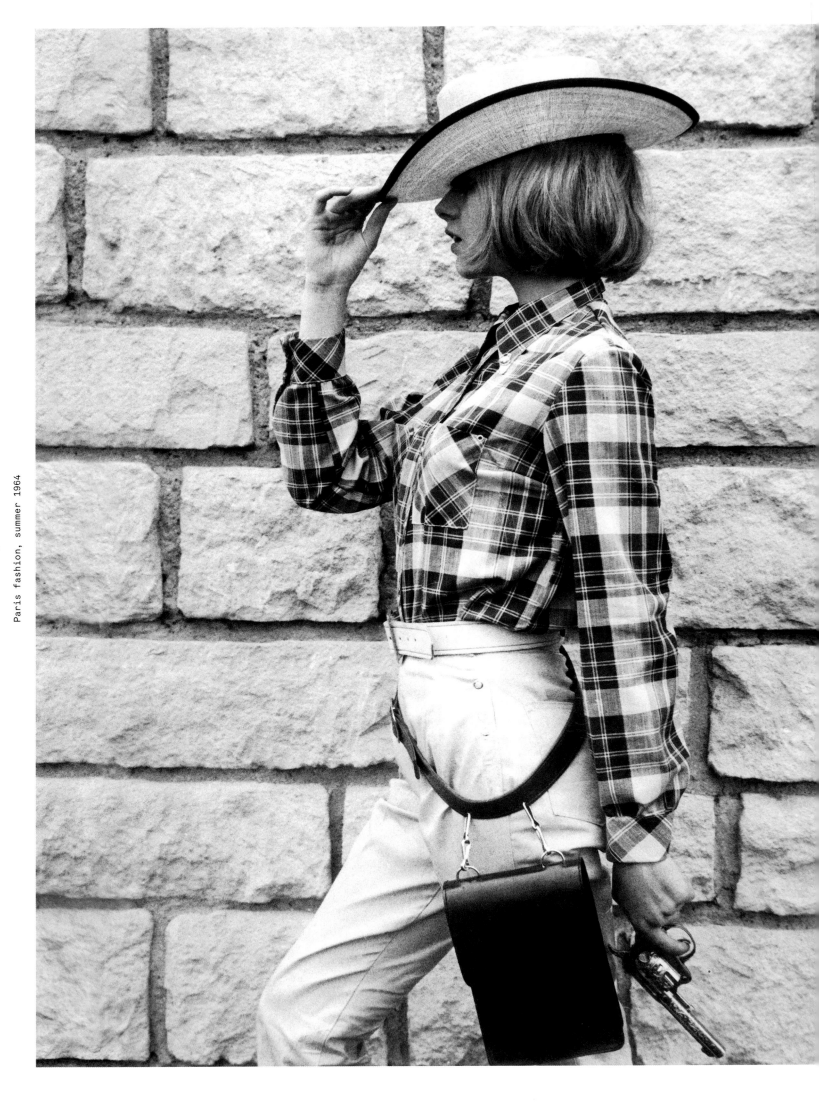

Like the past, freedom is an endless source of romance. Nowhere was it possible to enjoy escaping the restrictions of life more easily than in the Wild West. That is why since the 1850s the cowboy has been a mythical character in America. The clothing of the cowboys and their southern equivalents (gauchos and vaqueros, from Argentina and Mexico, respectively) still persists, and not only on the 'dude ranches' that emerged in the 1950s to give urban-dwellers the thrill of re-creating the spirit of the West (albeit with superior catering). At formal events in the American Southwest, men dress in their best Stetsons, western shirts, fancy belts and boots, while their wives wear western shirts, full skirts and high-heeled cowboy boots, complemented in an entirely unironic way by Native American jewellery of turquoise and silver. The cowboy's jeans, denim jacket and boots are also the clothing of those who yearn to throw off society's constraints: James Dean's image in »Giant« gave birth to a style that persisted long after his death and still has a romantic resonance.

Although sanitized by Hollywood, the real cowboys were dirt poor and illiterate; many were Hispanics and African Americans. But their association with freedom and their self-reliance make them a type that refuses to disappear. The first mythologizing came early, when Buffalo Bill Cody created his Wild West Show in 1883, touring the world in his extravagantly fringed buckskins and hyping a similar romanticized version of the West to that familiar from the novels of Zane Grey and Owen Whistler or the paintings of Frederic S. Remington.

Four items of clothing, themselves practical and egalitarian, came to sum up the qualities of the west. The Stetson, created in 1865 by John B. Stetson, came to personify the western hero. By 1906, the Stetson factory was producing four million hats a year; today the hats remain part of business wear in the Big Country of the Southwest and Texas. So too the cowboy boot, originally a working protective boot but later extravagantly decorated and adopted by rhinestone cowboys everywhere (see Feet, page 138). Boot makers such as Lucchese of San Antonio or Tony Lama of El Paso create handmade fantasies for those rich enough to afford them. Such footwear has less to do with the working cowboy than with Hollywood's 'singing cowboys', such as Roy Rogers and Gene Autry, who peddled an ever-more show-business version of the West in the B-movies of the 1930s and 1940s. The cowboy shirt – with poppers instead of buttons for ease of use – also moved far from its roots in the 1930s, by which time western wear had become a lucrative sector of the US clothing industry. Shirts were brightly coloured satin with intricate patterns picked out in rhinestones or embroidery. By the 1970s, brocade, Lurex and gold lamé had completely overwhelmed the noble traditions of working clothing.

A similar bowdlerization threatened the fourth staple of western dress: but for all their appropriation by the world of high fashion, denim jeans remain a staple of practical dress around the world. Introduced by Levi Strauss, they were originally worn by gold-rush prospectors before being adopted by cowboys in the 1890s. By the 1940s they were the standard wear of farmers, miners, truck drivers and factory workers. It was only when college students began wearing them as a sign of non-conformity that they began the process of moving up the fashion scale, as Seventh Avenue took the standard design – unchanged for 100 years – and cut them with more finesse to make jeans acceptable as leisurewear.

One reason for the longevity of western wear in the United States is that men in particular seem to be happier in clothing that in some way retains a connection with an original practical purpose. Jeans, cowboy boots, lumberjack shirts, cargo pants: they all proclaim that clothing is more than simply show. They suggest that dressing is part of a process we go through when getting ready to get down to business. Above all, it is useful … and perhaps it indicates that its wearer is, too.

The contemporary designer who best understands the appeal of the West is Ralph Lauren. The clothes of homesteaders – quilted patchwork skirts, knitwear in the style of samplers, even Amish bonnets and pinafore dresses – all echo a folk tradition that developed during the settlement of North America alongside the costume that the colonials had originally inherited from Europe (see Ethnic, page 190) . While rich women in New York still sent to Paris for the latest styles, in the West a uniquely American form of dress had gradually developed. While many designers had drawn on the traditions of western wear and workwear, Lauren went a step further. He more or less reinvented American visual history as the basis of a whole vision of the people that shaped the continent and the clothes that helped them build it.

'Wild Bill [Hicock] was a strange character. Add to this figure a costume blending the immaculate neatness of the dandy with the extravagant taste and style of a frontiersman and you have Wild Bill, the most famous scout on the plains' – GEORGE ARMSTRONG CUSTER, c.1860s

W
E
S
T
E
R
N

THE
BODY
CLOTHED

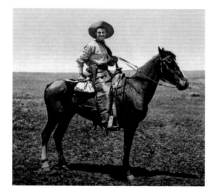

A cowboy, 1880s, hand-coloured photograph

James Dean in »Giant«, 1956

W
O
R
K
W
E
A
R

'Women are in bondage; their clothes are a great hindrance to their engaging in any business which will make them pecuniarily independent' – LUCY STONE, 1854

Clothes worn for work put practicality above all other considerations. Medieval working clothes, for instance, drew distinctions between the various functionaries of a noble household. Conventions developed to distinguish the butcher, the baker and the candlestick maker. Some work clothes were based on protection, like the blue-and-white-striped aprons of food vendors (horizontal stripes for the butcher, vertical for the fishmonger) or their coats or overalls. Others were a form of self-promotion, like the scarlet jackets of London's shoeshine boys, the 'City Reds', which got them noticed in the nineteenth and early twentieth century.

Workwear has straightforward requirements. It must be inexpensive, as it is replaced often; it needs to be hard-wearing and easily cleaned, because it is traditionally worn at least five days a week; and it needs to be fit for purpose. Overalls need loops for screwdrivers or hammers; waitresses' aprons need to hold an order pad; nurses' shirts need pockets for watches and thermometers. Extraneous belts and straps might get caught in machinery. Any shoes other than the most sensible might inhibit movement, or fail to protect the wearer from falling heavy weights. In 'clean' environments, clothing acts in reverse, protecting sensitive machinery from dust, sweat or dirt from workers' skin or clothes.

Dress is also a signal of someone's qualifications to do a particular job. Dressing as something one is not has always been seen as deeply suspicious, however, because our clothes are so closely linked with our position in society. Some clothes can only be worn by those who have earned the right to do so. The scholar's gown signifies academic success, in the same way as the barrister's silk gown and wig signify having been called to the bar (becoming King's or Queen's Counsel is referred to as 'taking silk'). Indicating qualifications was formerly one of the most important functions of clothing for professional people: it prevented the possibility of deception at a time when it was almost impossible otherwise to check any credentials. Someone who dressed as a priest could be relied upon to be a priest; likewise a lawyer. This form of work clothes – which range from the postman's uniform to the doctor's white coat – are visual signals that these are individuals we can trust, with a letter … or with our lives.

The distinction between blue-collar and white-collar workers is a reminder of the ancient differences between the clothes of those who were permanently dirty and the privileged who never were. Clothes that highlight competence in a particular role are encapsulated in the white collar and business suit, the chosen uniform of professionals worldwide (see Neck, page 68). The white collar and cuffs signify cleanliness: someone who takes care of him- or herself will be well placed to take care of business. In fact, the lower level of clerk, always susceptible to ink stains, often wore over-cuffs to protect his shirt cuffs, as rolling up the sleeves was – like removing the jacket – totally inconceivable at all levels of business even as late as the 1930s.

The blue collar, to some extent, had the opposite purpose: it hides or disguises dirt. Work clothes associated with manual or industrial work are traditionally dark-coloured and are made from coarser but more durable fabrics. The romance of the blue-collar worker is a staple of fiction and of Hollywood: the worker from the wrong side of the tracks captures the heart of the posh heroine; the downtrodden factory hand learns that his children regard him as a hero. In terms of clothing, it was probably first Elvis Presley and later Bruce Springsteen who established the worker's uniform of blue jeans, plaid shirt and working boots as an iconic male fashion statement.

Some jobs are inherently dirty, so a major purpose of workwear is to keep the body and normal clothes clean. The first overalls were protective over-trousers, to which a front was later added to create the bib-and-brace style of dungarees usually seen on homesteaders in Hollywood westerns. In the modern sense of boiler suits, overalls appeared in the late nineteenth century, when the growth of new industries required workers to wear protective clothes. They were soon adopted by those, including female arms workers in both world wars, whose work brought them into contact with dirty or potentially hazardous materials. In the 1970s and 1980s blue overalls were appropriated by a particular type of feminist. What better way to show that the wearer had disassociated herself from the stereotypical female role? The clothes appropriated the uniform not just of men, but of the most masculine of men.

Railroad workers, Clinton, Iowa, 1943

236

c.40,000 BC
Humans begin to wear animal skins

c.30,000 BC
The first dyes are invented: they include red, blue, lilac and yellow

c.25,000 BC
The first footwear consists of strips of hide wrapped around the feet
[+]
The twisting together of plant fibres makes longer, stronger single fibres such as ropes and cords
[+]
Prehistoric people use ochre as make-up

c.22,000 BC
A statuette carved in what is now Austria, the Venus of Willendorf, emphasizes the female genitals and thighs as a fertility fetish; the Venus has a head of tight, stylized curls

c.10,000 BC
The first linen loincloths are worn in West Asia
[+]
Prehistoric women tie bands and belts around their bellies and arms in order to accentuate them

c.8000 BC
Cave paintings show hunters wearing 'bags' of fur on their feet, possibly to disguise their footprints and smell
[+]
Rock art in what is now the Sahara – at the time, wetter and more fertile than today – features figures that may be tattooed

c.6500 BC
Felt, pressed together from animal wool, is the first fabric

c.5000 BC
Flax is introduced and cultivated, initially in southeastern Europe and southwestern Asia; it is the first plant textile fibre. Wool remains more commonly used, probably due to its superior ability to absorb dyes
[+]
Cotton is grown in the Indus Valley

c.4000 BC
Egyptians make hair combs from fish bones
[+]
According to the biblical account, Adam and Eve begin wearing clothes after being expelled from the Garden of Eden
[+]
Silk is first produced in China; in legend, it is not invented until 2600 BC by a Chinese princess
[+]
Cosmetics such as kohl and henna are in widespread use in ancient Egypt; kohl is used as eye make-up and henna to paint nails
[+]
Egyptian women remove their pubic hair with depilatory creams

c.3300 BC
Europeans use bearskin and woven plant fibres to make shoes
[+]
The world's oldest known mummy, found frozen in a glacier in the Tyrol Mountains and named Ötzi, has fifty-seven tattoos and pierced ears to accommodate earrings; his coat is made of goat fur

3100 BC
The pharaoh's double crown, the Pschent, becomes the symbol of united Egypt, following the coming together of the Upper and Lower Kingdoms of the Nile

c.3000 BC
Egyptian women highlight the varicose veins on their legs
[+]
Late Stone Age Europeans make clothing from sheep wool
[+]

Noah wears the Hollywood biblical
dress of ankle-length tunic
[+]
First evidence of Celts and
Gauls wearing chainmail
[+]

Egyptian men wear knee- to
ankle-length skirts
[+]
In the Indus Valley people
use vegetable dyes to colour
their cotton clothes

c.2900 BC
Sumerians in Mesopotamia wear
wraparound skirts and shawls made
with twisted tufts of wool or flax

c.2800 BC
The Egyptians use tattooing,
and pass the practice on to Greece,
Persia, Arabia and Crete
[+]
Wedding rings are worn in Egypt

c.2500 BC
Egyptians are wearing
cotton garments

2400 BC
Rich jewellery is worn in
Mesopotamia; a major hoard,
including beads and pendants,
is discovered in the royal tombs
of Ur, close to the shoreline
of the Gulf, in 1927

2270 BC
In Akkad, Mesopotamia,
men wear squared beards

c.2350 BC
Sargon the Great, ruler of Akkad,
is depicted wearing sandals

2250 BC
Mesopotamian men and women wear
shawls above tiered skirts

c.2100 BC
Babylonians wear loin skirts
with elaborate decorations

2000 BC
Egyptians use citrus
juice to make shampoo

1800 BC
Rulers of Babylon wear
ornate crowns
[+]
Babylonian men powder
their hair with gold dust

1750 BC
For the first time, most women
begin to cover their breasts
[+]
Minoan men and women use linen
for undergarments, and colourful
wool for outer garments

1700 BC
The Minoans on the Aegean
island of Crete adopt long,
complex hairstyles

c.1600 BC
Stylish Minoan women display
their naked breasts, as
depicted in the well-known
faience figurine known as the
'Snake Goddess' from the Palace
at Knossos, who wears a breast-
baring, tightly fitting bodice
and a flounced, layered skirt

1500 BC
Greek women wear bandolettes,
an early form of brassiere,
outside their clothes
[+]

Chinese and Japanese women
use rice powder to paint
their faces white; they paint their
teeth gold or black and dye
their hair with henna

c.1485 BC
Egyptians paint images of
their enemies on the soles of their
shoes, so they tread on them
when they walk

c.1370 BC
Egtved Girl, whose well-preserved
remains were discovered in an
oak coffin in Jutland, Denmark,
in 1921, wears a woven wool upper-
body garment, wool belt and wool
skirt. A bronze box found in
the coffin contains an awl,
bronze pins and a hair net

c.1350 BC
Egyptian women adopt sheath
skirts, which remain in fashion
for 1,000 years

1330 BC
The famed bust of Queen Nefertiti,
the wife of King Akhenaten,
is carved; it shows Egyptian
ideals of beauty – arched brows,
high cheekbones, a slim neck
and an aquiline nose

c.1250 BC
Egyptian pharaohs wear
pointed peaked sandals as
a sign of their rank

c.1200 BC
The veil is introduced for women
in Assyria and spreads through
the Mediterranean region

900 BC
Jezebel, a Phoenician princess,
becomes renowned for dressing
in finery and painting her face
ready for her death

720 BC
Athletes at the Olympic Games
in Greece compete naked

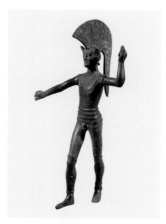

700 BC
Etruscan warriors wear large bronze
helmets with tall crests
[+]
First appearance in myth of fabled
beauty Helen of Troy, whose
abduction sparks the Trojan War

600 BC
Babylon is the principle
market for perfume

c.500 BC
Nomadic Scythians introduce
trousers to Europe; historians
associate the origin of trousers
with the domestication of
horses in around 4,000 BC
[+]
Hair styling is introduced
in western Africa
[+]
Both male and female Romans
wear tunics or chitons, held in
place by brooches or pins and
a cord or belt round the waist
[+]
Persian men and women wear
tailored clothes, and the men
curl their hair and beards
with hot tongs
[+]
Greek historian Herodotus
describes a Babylonian walking
stick with a decorative handle

c.400 BC
Roman soldiers wear the first
recorded scarves, in order
to keep their necks warm
[+]

A mosaic from Sicily, often now
referred to as the 'Bikini Girls',
shows women wearing bandeau breast
coverings and underwear
[+]
Greece has a sophisticated
shoemaking industry with
a strict hierarchy and many
social conventions
[+]
The Egyptians use the batik
technique to dye cloth

c.320 BC
Alexander the Great wears
Tyrian purple, made from
a rare Phoenician shellfish

c.300 BC
The development of the Greek
toga is complete; it gradually
changes from a gender neutral
garment to a masculine one

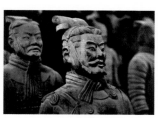

212 BC
In China, the Terracotta Army
is buried wearing neckties

c.100 BC
Julius Caesar reports that
the Celts shave their bodies,
like the Romans
[+]
Greeks wear sandals – »calcei« –
with broad straps, laced high
over the ankles

69 BC
Birth of Cleopatra, famed Egyptian
beauty; French philosopher Blaise
Pascal later remarks: 'Cleopatra's
nose, had it been shorter,
the whole face of the world
would have been changed'

35 BC
Roman prostitutes are forced
to dye their hair blonde

AD 1
Make-up is widely used in Rome;
Plautus comments, 'A woman without
paint is like food without salt'

c.AD 1
Christian moralists condemn wearing
gloves as a sign of effeteness
[+]
Julius Caesar wears red high
heels as a sign of nobility

60
Queen Boudicca wears a Celtic
chieftain's torque around her neck
when she leads the Iceni into
battle against the Romans

c.100
Saxon warriors dye their hair blue,
green or orange for battle
[+]
Celtic warriors go into battle
naked but daubed in blue paint

113
Roman orators wear neckerchiefs
to protect their vocal cords

200
Roman sculptors carve
statues and busts with detachable
marble wigs that are changed
to remain up to date

201
The first known liturgy of Christian
baptism specifies that those being
baptized must be naked

c.250
Japanese men tattoo
their whole bodies

303
The first barbershop opens in Rome

c.400
Hair nets and scarves become common
[+]
Reliquaries and good luck
charms are first used
[+]
Catholic Church authorities cover
Christ's genitals on crucifixes
[+]

239

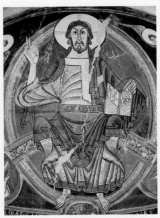

The Byzantines wear tunics with ornate decorated panels called tablions and long sleeves to cover arms

c.550
Monks smuggle silkworms and mulberry leaves (supposedly hidden inside bamboo canes) from East Asia to Constantinople in Byzantium and thence to Europe, breaking the Chinese monopoly on silk production

576
The fall of the Roman Empire sees cosmetics disappear from Europe

c.600
The Persians adopt the Greek soft felt Phrygian cap, later worn as a symbol of liberty by French revolutionaries

634
The hijab, or women's head covering, is adopted in Islamic countries for modesty

c.700
Under Carolingian rule, the Catholic Church abandons naked baptism
[+]
Europeans wear brightly coloured hose with embroidered and scalloped tops

787
Pope Hadrian bans tattoos, based on Leviticus 19:28 'Ye shall not make any cuttings in your flesh for the dead, nor print any marks upon you; I am the Lord'

c.800
Gloves are universal in Europe and the Middle East

c.900
For the first time, mantles worn over tunics are fastened at the front, rather than at the shoulder
[+]
Barbarian men and women both wear their sleeves extra long, but men's are tight and bunched up over their forearms, while women's hang loose
[+]

The clergy begin wearing mittens or hand coverings made of felt during Mass
[+]
Women wear very baggy tunics and ponchos

c.1000
Men's sleeves grow shorter but women's become looser still
[+]

The Bayeaux Tapestry depicts the Norman invasion of England in 1066, and illustrates early forms of armour, notably chainmail shirts (hauberks) and helmets with nose guards
[+]

Women wear the wimple, a short white veil and neckcloth, to cover their necks and bosoms
[+]
Large brimmed hats are worn over hoods for travelling on foot or horseback
[+]
The Phrygian cap is standard wear for men

c.1100
Women who perform any kind of work wear ankle length tunics, loosely fitted and unbelted, with wide sleeves and often a small scarf covering the head
[+]
The hood becomes a separate garment
[+]
The spinning wheel is invented in Asia
[+]
Velvet is introduced to Europe from Asia along the Silk Road
[+]
Crusaders bring fustian
– corduroy – home from Egypt
[+]
Fur becomes a mark of luxury

1129
The first recorded coat of arms belongs to Geoffrey V, Count of Anjou

1152
Eleanor of Aquitaine wears extra long trains on her dresses as a sign of her wealth

1175
Henry II of England commissions gloves with separate fingers

c.1180
The coif – a tight linen bonnet – becomes fashionable for men; it lasts until the 15th century

c.1200
Buttons appear, but are used like jewellery, for decoration rather than fastening
[+]
Both men and women are wearing surcoats over their other garments
[+]
The bifurcated leggings worn by European peasants fall out of use
[+]
Castles in Europe are built with special rooms where women can shave their legs, a practice imported from the Crusades
[+]

Opus anglicanum, 'English work',
which is often produced using
opulent gold and silver threads,
is considered the most desirable
embroidery in Europe
[+]
In England, prostitutes are
forced to wear a striped hood to
indicate their profession

c.1205
The word 'breeches'
is introduced to English,
usually to refer to underwear

1275
The 'Great Custom' taxes
the wool trade in England

c.1300
Cosmetics reappear as face
make-up in northern Europe; they
are most often used by prostitutes
[+]

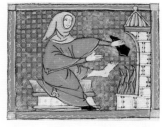

The excessively long-toed
'poulaine' or 'crakow' shoe appears
in Europe, probably introduced
from the Holy Land by Crusaders;
the pointed ends are flat
or curl upward
[+]
Women's hairstyles become
more elaborate and are often
coiled around the ears or piled
on their heads to make their
necks seem longer
[+]
A costume of short doublet and
tights replaces coats of chainmail
in the city-states of Italy
[+]
Fur linings on coats and outer
garments increase in popularity
[+]
The wealth of Renaissance Florence
is dependent upon the wool trade

1343
Such is the popularity of
bells as decoration, an edict
is passed by the Town Council
of Nuremberg declaring that
'no man or woman might wear bells
or silver tinsel of any kind
on chain or belt'

1348
Edward III of England founds
the Knights of the Garter

c.1350
Hose are made with primitive
soles, removing the need for
separate shoes
[+]
Gloves become a high fashion
garment in England; they are
sometimes cut to reveal the
wearer's valuable rings

1350
Jeanne de Bourbon, Queen of
France, has 50 buttons on
the stomacher that constrains
her stomach and chest

1355
Prostitutes in England are
forbidden to wear fur

c.1360
The liripipe, a long dangling
hood, is popular for men

c.1370
The codpiece evolves when separate
legs of hose are sewn together

c.1380
Hoods are often worn as turbans

1386
Shoes have become so long
that knights at the Battle
of Sembach have to cut the toes
from their shoes to fight

c.1390
The flowing houppeland replaces
the tighter cotehardie as a
standard upper garment; women's
houppelands sometimes leave
the breasts exposed
[+]
In »The Canterbury Tales«,
Geoffrey Chaucer criticizes
tight hose in 'The Parson's Tale'
as vain and unvirtuous

c.1400
Trains have become so long and heavy
they have to be carried by pages
[+]
Stockings are woven garments
in two parts, upper and lower
[+]
Women wear soft cauls that
often cover their hair
[+]
The high-crowned, broad-brimmed
beaver hat becomes highly
prestigious headgear
[+]
Italian women pluck their hairlines
to raise their brows; they use
saffron or onion skins to bleach
their hair in the sun
[+]
European aristocracy abandon
the long tunic in favour of a
short urban coat, but peasants
continue to wear the long tunic
throughout the Middle Ages
[+]
Lyon in France becomes the
leading silk centre in Europe

1400
Richard II of England is
buried in velvet clothing

1405
French renaissance writer and poet
Christine de Pizan writes »The Book
of Three Virtues«, in which she
delivers a scathing critique of the
fashions of her contemporaries,
criticizing their excessive and
eccentric nature, and encourages
a more tasteful middle ground

1423
The ruler of Kashmir,
Zayn-ul-Abidin, introduces
weavers from Turkestan to found
the cashmere wool industry

1430
The Broderers Company is
set up to protect London's
embroiderers from competition

1434
Jan van Eyck paints »The Arnolfini
Wedding«, featuring the ideal
female shape of the time: an S-shape
with chest in and belly out

1440
The word 'fop' appears in English
to describe a foolish person;
by 1672 it describes anyone overly
attentive to their appearance

c.1450
Agnes Sorel, mistress of Charles VII of France, drops her neckline to her waist to reveal her breasts
[+]
European women adopt the tall conical hennin headdress popular in France

c.1460
Pointed toes are replaced by broad duck's-bill shoes slashed to reveal coloured hose (the shoes eventually grow up to 1 foot across)

1470
Queen Juana of Portugal is the first to wear the stiffened hoop skirt, or farthingale, in which whalebone or steel holds the skirt away from the body to produce a bell-shaped silhouette; in some accounts, it hides an unwanted pregnancy

1479
Slippers are invented and named for the ease with which they are put on and off

c.1480
Pattens appear, with raised wooden soles; they are probably the origin of clogs

c.1500
Women cover their hair with hoods with barbes, pleated linen bibs that also hide their chins
[+]
European men wear caps, or bonnets, based on the Turkish fez

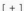
[+]
The codpiece becomes a symbol of male power and status more than a sexual statement
[+]
White is the colour of mourning in England, France and Spain
[+]
Edicts passed in Italian city-states forbid women from wearing low necklines
[+]

The Holy Roman Emperor Maximilian I creates the Landsknechte as a mercenary force
[+]
The galliard becomes a scandalous dance craze because it potentially exposes the legs of female dancers
[+]
High heels and pumps make their first appearance, in Elizabethan England
[+]
Male doublets often have double sleeves to increase opportunities for display
[+]
Women use a form of cushion to pad and exaggerate their hips

c.1520
Machiavelli describes the ideal women's hair as 'loose and blond, sometimes the colour of gold, at other times honey, shiny as the rays of the sun'

1520
Henry VIII of England and Francis I of France attempt to outdo one another in opulent clothing at the 'Field of the Cloth of Gold'
[+]
Sleeveless fur-trimmed gowns become popular as outer garments

1525
Michelangelo designs the bases (skirt-like garments worn by knights) that are still worn by the Swiss Guard

1528
Baldassare Castiglione identifies black as an ideal colour for courtiers

1533
Catherine de Medici starts wearing high heels to match the height of her new husband, Henri II of France. For the wedding day itself, she acquires a parasol, which goes on to become a key fashion accessory through to the 1800s

1539
An Italian beauty manual by Alessandro Piccolomini is published as »A dialogue of the faire perfectioning of ladies«

c.1550
Upper stocks, the top part of men's hose, develop into breeches
[+]

Chopines, originally introduced from Turkey to Europe via Venice, become fashionable footwear; some are so tall the wearer has to be supported in order to walk
[+]
Men wear court bonnets, with high crowns and stylish rolled brims

1551
The Commedia dell'Arte, a form of Italian drama, introduces the modern trouser to Europe

c.1555
The flat cap for men is introduced from Italy

1558
The ruff develops from fastenings
at the necks of shirts
[+]
The Puritan religious
movement equates modesty
in dress with godliness

1559
For her marriage to
Francis II of France, Mary
Queen of Scots wears white,
previously reserved
as a mourning colour

c.1560
Austrian law forbids girls
from wearing corsets during
their education
[+]

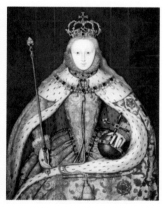

In England, Elizabeth I sets
a fashion for using white face
powder, made of white lead
held in place with egg white

1561
Elizabeth I of England is given
her first pair of silk stockings

1562
Sumptuary laws limit the width
of the ruff to 4 inches either
side of the neck

1565
After the invention of pockets,
Charles IX of France outlaws purses
because they can disguise weapons

1572
Jeanne d'Albret, Queen of Navarre,
is said to be poisoned by a pair of
perfumed gloves, given as a gift

c.1580
Philip II's preference for black
starts a fashion in Spain that
spreads through Europe
[+]

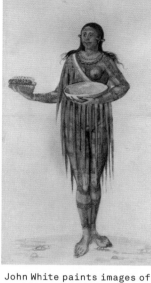

John White paints images of
tattooed Native Americans

c.1585
Ruffs reach their largest extent

1589
William Lee invents the
stocking frame, mechanizing
the production of hosiery

c.1590
Women in Elizabethan England,
including the queen, expose the
tops of their breasts to display
their availability for marriage
[+]
The modern kilt evolves from the
greater kilt, which includes a
shawl wrapped around the upper body
[+]
The term 'panoply' first appears
in English, referring to a knight's
full range of armour

1599
Philip III of Spain gives
his bride, Margaret of Austria,
200 pairs of gloves as
a wedding present

c.1600
Europe's fur trade encourages
exploration of North America
[+]
Watches hanging from necks
become the fashionable style
[+]

Charles I, whose legs are
weakened by rickets and need
support, popularizes wearing
boots in England
[+]
Hat bands become popular
as expensive trim

c.1610
The sash is adopted in Denmark

c.1620
Women's necklines begin to fall
[+]
Puritans in America wear
tight-fitting bodices that
disguise their breasts

1621
In »The Anatomy of Melancholy«,
Robert Burton calls clothes
'the greatest provocation to lust'

1623
Sumptuary laws in France outlaw
the ruff completely

1630
Men's breeches become
longer and are no longer stuffed
[+]
The baldric emerges as a
combined sash and sword belt

1635
The first ladies' hair
salon opens in Paris

c.1640
Men's doublets are worn
without any stuffing, creating
a natural waistline fastened
with many buttons

1645
Dorgon, a Manchu emperor,
forces all male Chinese
to wear their hair in pigtails,
shaved at the top

c.1650
A Croatian style of military
scarf becomes fashionable
at Versailles as 'le cravat'
[+]
The copotain (sugar loaf)
is the dominant style of hat
[+]
Women's bodices begin to spread
at the waist into a peplum
[+]

Petticoat breeches are highly
fashionable for Frenchmen
[+]
The regimental system of
organizing an army into smaller
units emerges in France
[+]
In the Netherlands, the ruff is
replaced by other types of collar
[+]
Sleeves grow shorter to
expose the forearm

1653
Off-the-shoulder
dresses become popular

1656
Women at the French court use
beauty spots made from taffeta to
highlight their facial features

c.1660
Cardinal Mazarin's attempt to ban
the use of gold and silver thread
in France as an economy measure is
defeated by popular reaction
[+]

Louis XIV of France sets a fashion
for wearing stockings and high
heels, hastening the fall from
favour of boots, as well as
instituting the dominant forms of
decoration: lace and embroidery
[+]
European women are said to bind
their feet with their own hair
to try to make them smaller

1666
King Charles II of England
introduces the waistcoat to proper
dress, based on garments worn by
Persian ambassadors to his court

c.1675
Women's and men's shoes grow more
distinct; women's shoes are
exquisitely embroidered with lace
flounces and slipper heels up to
6 inches high; men's shoes
remain more utilitarian
[+]
Petticoat breeches die out

c.1680
The justacorps appears; this longer
male coat covers the bottom

1685
The most glamorous head covering
for women is the fontange,
a construction involving curled
hair piled over a wire framework,
dressed with folded ribbons.
The style is sometimes worn
with a starched linen frill
[+]
Huguenot (Protestant)
silk weavers flee religious
persecution in France; many
settle in England, importing
their craft with them

c.1690
The tricorne or cocked
hat appears for men
[+]
The popularity of the tailored coat
and breeches for men throws the
fashion emphasis on the shapely
leg, accentuated by hose and shoe

1692
The steinkirk style of necktie
becomes popular after the
battle of the same name

c.1700
As wigs dominate, hats become
incidental to fashion; men have
their heads shaved in order wear
wigs, so wear soft nightcaps to
cover their heads warm at home
(although not in bed)
[+]
What is now known as the French
manicure style of nail-dressing
becomes popular in France
[+]
Women begin to bunch up their
overskirts to reveal the layers
of petticoats beneath; hooped
skirts become popular
[+]
Young aristocratic Bucks,
also known as Bloods, enjoy
dressing as coachmen and racing
coaches against each other
[+]
Men's breeches become fitted
and finish close to the knee
[+]
Fashionable women's shoes are
high heels, with rich brocades,
painted leather and transferable
metallic buckles, often of silver
and occasionally ornamented
with precious stones
[+]

The masked ball becomes a
popular form of entertainment
[+]
Indigo inspires European
expansion in South Carolina
[+]
The huge hairstyles popular in
France, led by Marie Antoinette,
become homes for vermin; in 1780
the doorway of St Paul's Cathedral
in London has to be raised 4
feet to accommodate the fashion
[+]
In Japan, geisha bring the vogue for
white faces to a peak of popularity

1703
Martin Martin in »A Description
of the Western Isles of Scotland«
observes that tartans can now be
used to distinguish residents
of different islands

1715
In France, the death of Louis XIV
introduces the Regency style
of simple long, draped gowns

c.1730
The tall hat is worn for hunting

1730
In Scotland, Highlanders wear
kilts with long hose and jackets
[+]

Women's hips are widened to
exaggerated widths with steel-
framed panniers, some are so wide
women are forced turn sideways
to walk through doorways

1736
American statesman Benjamin
Franklin is an early wearer of
braces (suspenders), which develop
at the French court of Louis XVI

1742
»The Graham Children«, a painting
by William Hogarth, illustrates
the similarities of children's
and adult's clothes

c.1750
Sleeves are highly extravagant;
they finish at the elbow to reveal
the lace of the chemise beneath
[+]
The Petits-Maitres of the French
court at Versailles wear highly
exaggerated clothing
[+]
Richard Arkwright mechanizes
cotton spinning
[+]
Elizabeth Montagu founds the
Blue Stockings Society, for male
and female intellectuals

1757
A new tax on fabric in France leads
to narrower breeches with no pockets

c.1760
George Washington is the
possessor of many pairs of
false teeth, including some made
from wood and hippopotamus teeth
[+]

The polonaise skirt requires
three small panniers to
give it shape: one on each hip
and one at the back
[+]
Invention of the spinning jenny and
the spinning frame revolutionizes
textile production
[+]
Women abandon stomachers
and instead wear bodices
that display their breasts

1764
Madame de Pompadour is said
to apply rouge on her deathbed
[+]
A French law includes uniform among
the measures needed to give a
peasant 'the air of a soldier'

1769
British explorer James Cook
encounters tattooed people
in Polynesia

1770
In Britain, the Matrimonial Act
makes it an offence for women to
use cosmetics to lure a man into
marriage; this is condemned
as a form of witchcraft

c.1770
In London the Macaronis take
to extremes fashions they have
encountered in Italy while
on the Grand Tour
[+]
The tricorne hat begins to go out
of fashion; the bicorne and the tall
riding hat become popular
[+]

The large, lace-trimmed
dormeuse mob cap is all the rage
for women's indoor wear
[+]
The Chevalier d'Eon lives in
London wearing women's clothes
and is a popular sensation

c.1780
After growing more closely cut for
a century, men's coats become so
slim they can no longer be done
up, creating a new fashion
[+]
Marie Antoinette, Queen of France,
has a vast wardrobe of muted pastels
[+]
Breeches are worn so tight that
they have to be made from leather in
order to stand up to the strain

c.1785
Beau Brummell, an iconic
fashion figure in Regency London,
uses his neck cloth as an expression
of his identity; he becomes
the emblematic personification
of Dandyism

1785
Englishman Edmund Cartwright
invents the first steam-powered
loom, the precursor of the
modern sewing machine

1789
In the French Revolution, breeches are seen as aristocratic and are abandoned by the Sans Culottes
[+]
The French Revolution sees the aristocracy toppled

c.1790
The cashmere shawl arrives in Europe from Kashmir, India
[+]
Jeans arrive in the United States, having been previously exported throughout Europe from Genoa for many years
[+]
Oiled flax is developed in Arbroath, Scotland, as a waterproof fabric
[+]

Women wear large 'Gainsborough hats'

1792
After the French Revolution, women wear leather rather than embroidered shoes, and heels almost disappear

1793
Eli Whitney invents the cotton gin and revolutionizes cotton production in the South of the United States

1795
In France, the Directoire (or Directory) style includes tops of sheer muslin for women that reveal the breasts beneath; for men, Revolutionaries favour trousers rather than aristocratic breeches

1797
Goya paints the »Naked Maja«, one of the first clear depictions of female pubic hair in a large Western painting

1798
First attempts at waterproofing clothing with a layer of rubber
[+]
New Englander Betsey Metcalf invents the straw hat at the age of 12 in Rhode Island

c.1800
Black shoes become standard for men
[+]
Bell bottoms appear in the US Navy, to allow sailors unencumbered movement
[+]
The Directoire style introduces the hobble skirt
[+]
The laced-up shoe becomes popular for men: its basic style barely changes until the 1970s
[+]
The riding boot, low heeled and practical, becomes fashionable for a time
[+]
Trousers are ankle length
[+]

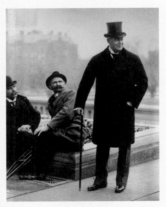

The tall hat evolves into the top hat, which dominates the century
[+]
Touching another man's cravat is said to be grounds for a duel
[+]
Ancient Greek and Roman styles are the vogue
[+]
French emperor Napoleon condemns the corset, but with little effect
[+]
Belfast is the major linen producer in the world

[+]
The Duke of Wellington has the Hessian boot adapted to make it comfortable enough to wear all day
[+]
Sailors in the Royal Navy commonly have tattoos

1801
The Jacquard loom is invented in Lyon, France, by Joseph Marie Charles, known as Jacquard; it allows the mechanical weaving of textiles with complex patterns

c.1810
The Napoleonic Wars herald a golden age of uniform, associated with the rise of nationalism and the middle classes; uniforms appear even for postmen and teachers
[+]
Britain's Prince Regent, George IV, designs military uniforms for British troops, one of his favourite pastimes

1810
In the Regency style women wear low-heeled slippers in romantic pastels

1811
The first two-piece swimming costume for men is seen in Britain

1815
Napoleon reintroduces breeches to France, though looser trousers come into fashion after soldiers fighting at Waterloo find their trousers too tight
[+]
Waistcoats become more colourful and heavily decorated

1818
The manual »Necklothitania« illustrates 14 ways to tie a cravat
[+]
The patent leather process is invented

1820
Bonnets and caps grow larger, with bavolets to cover the back of the neck
[+]
In London a Frenchman, Eugene Rimmel, invents the first nontoxic mascara, consisting of a mixture of petroleum jelly and coal
[+]

Women take lead or drink vinegar mixed with chalk to blanch their complexions; they also use arsenic as a cream and drop belladonna in their eyes to dilate the pupils

c.1820
In the Great Masculine Renunciation, men abandon their colourful wardrobes for sombre blacks, greys and browns
[+]

The European Romantic movement inspires a fashion for short puffed sleeves, which they believe echo Renaissance originals
[+]
Men's frockcoats enhance the chest and biceps

1823
The Scot Charles Macintosh patents rubberized cloth, selling his first raincoat a year later

1828
Acrobat Nelson Howard is the first circus performer recorded to have worn tights for his act

c.1830
George Catlin's portraits of North American Indians depict them wearing highly decorated clothes, adorned with feathers, fur and beads
[+]

Fops wear their hair in a bunch of curls at each temple, with sideburns; women have whimsical sausage curls
[+]
For the first time, trousers button down the front rather than at the side; Mormon leader Brigham Young condemns them as 'fornication pants'
[+]
»Godey's Lady's Book«, a monthly woman's journal, is published in the United States; it features lavish hand-coloured fashion illustrations
[+]
The Scots establish their own cashmere industry
[+]

Leg-of-mutton sleeves for women reach their most extreme proportions

1834
The company of Louis Vuitton is founded to make luggage
[+]
The Ecuadorian-made Panama hat appears
[+]
Czar Nicholas I reforms the Russian bureaucracy using military ranks

1837
Hermès opens in Paris as a saddle and harness maker

c.1840
Men's collars acquire down-turned wings
[+]
The deerstalker and glengarry are popular country hats in Britain
[+]
Shirts are highly coloured and elaborately decorated
[+]
Naked swimming in public is acceptable in Britain
[+]

Giuseppe Garibaldi, later the liberator of Italy, adopts a distinctive red shirt, which his soldiers wear as well

1840
Queen Victoria is married in a white dress, setting a fashion for weddings

1846
The first tattoo shop opens in New York City
[+]
Catherine Murray, Countess of Dunmore, promotes and modernizes Harris Tweed in Britain

1848
Harry Burnett Lumsden and William Stephen Raikes Hodson select khaki as the fabric for British soldiers stationed in India, judging it ideal for the monsoon climate

c.1850
Women wear gloves at all times in public, frequently even when eating
[+]
The corset is increasingly tightly laced to keep women's waists about 14 inches around
[+]
French colonial rulers ban wearing veils in Muslim Algeria
[+]
Warfare becomes increasingly industrialized

[+]
The Empress Eugenie, wife of Napoleon III, inspires a fashion for the Eugenie paletot, a women's greatcoat with bell sleeves and a single button closure at the neck
[+]
The first trouser turn-ups appear
[+]
Shoes are usually hidden beneath large dresses, so there are only three practical styles: boot, clog and dress slipper
[+]

The dandy is at his peak
[+]
Lock & Co. make the first bowler hat
[+]
The London Missionary Society forbids public nudity among native peoples in Polynesia
[+]
The cravat is replaced by the bow tie
[+]

The pagoda sleeve comes into fashion

1850
»Chambers Edinburgh Review« criticizes the vogue for over-tight breeches
[+]
Prince Albert wears the top hat in public, making it acceptable in society

1851
Isaac Merrit Singer invents the sewing machine, creating a new industry: the mass production of clothing
[+]

Amelia Bloomer promotes the bifurcated undergarments now known by her name; forty years later, they are reinvented for cycling

1852
Newly invented vulcanized rubber is applied to the Wellington boot by Hiram Hutchinson in France, replacing the clog as fieldworker's footwear

1853
The balaclava is invented during the Crimean War; its name comes from the Ukrainian town of Balaklava on the Black Sea

1856
Mauve is the first aniline dye

1857
After the Indian Mutiny, khaki becomes more widespread for British soldiers

c.1860
The acrobat Jules Léotard introduces the maillot, now known as the leotard
[+]
European photographers take nude pictures of Africans in the guise of ethnic 'studies'
[+]

Hoop skirts and crinolines are back in fashion, the latter made popular by Empress Eugenie's familiarity with the British Court

1860
Cravats develop longer tips, similar to modern ties
[+]
Ladies' hats largely go out of style; women wear bonnets

1861
Civil War breaks out in the United States over slavery, disrupting the Southern cotton industry
[+]
During the American Civil War uniform sizing becomes standardized

1862
Visiting the Holy Land, Edward, Prince of Wales, has his arm tattooed

1863
Invention of the Bradley, Voorhees & Day 'union suit' underwear (BVDs)

1864
The first mass-produced neckties are sold in the United States and Germany

1865
Men's side whiskers are named after the American Civil War general Ambrose Burnside
[+]
Shoes are made for the first time with different shapes for right and left

1866
Gustave Courbet paints »L'origine du Monde«, a close-up image of female genitalia

1867
The B. Altman store introduces the first 'making up' department

1868
The first sneakers are made from
rubber soles and canvas uppers

1870
Straw boaters, previously
only acceptable on holidays
or when watching summer sports,
become popular city wear
[+]
Western explorers trying
to reach the North Pole wear
layers of canvas clothes
[+]
Women wear feather boas
to protect the neck and add
allure to their profile
[+]
Tailoring reaches its
apogee in Europe
[+]
The jockstrap is introduced
for male cyclists
[+]

Members of the Aesthetic
Movement such as Oscar Wilde
wear knickerbockers
[+]
There is an explosion
of women's hat styles, many
with veils and feathers or
decorations of fruit
[+]
A smaller style of top hat – the
chimney pot – becomes popular
[+]
Photography encourages the
use of make-up by women having
their portraits taken
[+]
The first beauty parlours
open in the United States
[+]
British clergyman and diarist
Francis Kilvert reports having to
buy his first swimming costume

1872
The Marcel wave is invented
by François Marcel

1873
Barnum's American Museum in New
York City introduces the attraction
'Prince' Constantine, a Greek
performer with 388 tattoos

c.1880
Paris is the centre of nude
and erotic photography
[+]
British actress and singer, Lillie
Langtry, popularizes opera gloves,
partly because she does not like
her arms and prefers them to be
covered at least to the elbow
[+]
French workers in Nîmes wear twill
work clothes, that will become
known as denim, literally 'de Nîmes'
[+]
The homburg and fedora
become popular headwear
[+]

Bustles reach their
largest dimensions
[+]
The British Army abandons its
coloured uniforms, but the colours
survive on regimental ties
[+]
The British force indigenous
children to wear Western clothes to
school throughout the Empire
[+]
The jersey and kilted skirt are
popularized by Lillie Langtry

1884
The invention of the power
loom increases the number of
available cotton variations

1885
In the United States,
the first worker safety laws are
passed: they protect hatters
from dangerous chemicals

1886
The first Avon lady begins
to sell cosmetics

c.1890
The iconic British policeman's
helmet is introduced
[+]

Levi Strauss and Jacob Davis invent
blue jeans after selling denim
overalls since the Gold Rush

1890
In the United States, the Society
for the Protection of Birds
protests the use of feathers
in boas and on hats
[+]
Kicking Bear introduces the
ghost shirt to his people,
the Lakota Sioux, believing that
the garment has spiritual powers
to protect them from bullets
[+]
John Partridge invents the
duffle coat, to be made popular
by the British Royal Navy

1891
Shirtwaists – dresses whose tops
are modeled on men's shirts –
become the most popular garment
in the United States for middle
class, secretarial women
[+]
The first electric tattooing machine
is invented in the United States

1892
The first Labour MP, Keir Hardie,
takes his seat in the House
of Commons wearing a tweed suit
and soft hat rather than the
traditional tailcoat normally
associated with power

1893
Whitcomb Judson invents the 'clasp-locker', later renamed the 'zipper'

1894
Artificial silk (viscose) is the first artificial fabric; it is made from wood pulp soaked in caustic soda and extensively treated

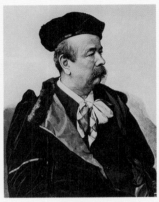

1895
Charles Frederick Worth dies having coined the term 'haute couture'; he was the first fashion designer rather than dressmaker

1896
The first study of camouflage in nature is published by the American artist, Abbott H. Thayer

1898
Papers report that US servicemen wear pyjamas for sleeping during the Spanish War

c.1900
French designer Paul Poiret introduces the corsetless chemise
[+]

The hips and the mono-bosom are the key elements of the idealized Edwardian S-shape
[+]

Blouses – softer versions of men's shirts – become fashionable for women
[+]
Men's shoe colours expand from black to include brown and grey
[+]
The S-bend health corset is introduced
[+]
Wealthy women wear silk stockings, with handmade shoes with pointed toes and 2- or 3-inch heels
[+]
German students wear 'mensur' dueling scars as badges of courage
[+]
Women's hats are small, and perched on the top of the head
[+]
The introduction of smokeless ammunition leaves brightly dressed soldiers exposed on the battlefield; uniforms begin to become far more drab in colour
[+]
Rich tourists appropriate khaki for wearing on safari trips to Africa

1900
Herminie Cadolle exhibits a bra and corset set at Paris Great Exposition

1901
After having worn black for forty years to mourn her husband, Queen Victoria directs that white and purple should be used for the trappings at her own funeral

1903
Paul Poiret revolutionizes womens' fashion with the kimono coat and corsetless dresses; he introduces draping and popularizes the turban, muff, hobble and tango skirts and harem pants for women

1904
The jeweller Cartier makes a wrist watch for Brazilian aviator Alberto Santos-Dumont, which bears the pilot's name

1905
Foundation of the English Gymnosophist Society, which promotes naturism
[+]
German hairdresser Charles Nessler invents the permanent wave (perm)

1906
Madame C. J. Walker markets hair products specifically for black Americans
[+]
Gucci is established in Milan, as a saddlery house

1907
The first chemical hair colour formula is sold as Aureole; it later becomes known as L'Oreal
[+]
Australian swimmer and actress Annette Kellerman wears a one-piece bathing suit
[+]
Josephine Baker, American dancer, singer and actress is famous for her sleek style and Marcel wave
[+]
The word 'brassiere' appears, derived from a French word for a military breastplate, later used to refer to a type of women's corset
[+]
Screen-printing, already an ancient technology, is patented
[+]
The first seersucker suit is made, in New Orleans
[+]
Baden Powell forms the Boy Scout Movement and specifies that their uniform includes shorts, helping to popularize them in Europe, although short trousers (lederhosen) were already worn in Austria and Germany

1908
Selfridges store opens in London; it sells cosmetics, previously sold surreptitiously by chemists

1909
The House of Chanel opens
as a millinery shop in Paris
[+]
Elizabeth Arden founds
her cosmetics company,
inspired by French make-up
[+]

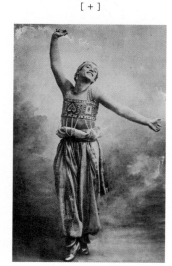

The Russian Ballet Russes'
visit to London inspires
a demand for eye make-up, and
their unrestrained Leon Bakst
costumes – featuring harem pants
and striking, bright colours –
trigger designers of the day to
start abandoning corsetry and
a wave of romantic Orientalism
[+]
Conde Montrose Nast acquires
»Vogue« magazine, established by
Arthur Turnure in 1892, and begins
its expansion, acquiring »Vanity
Fair« (then »Dress and Vanity Fair«)
four years later

c.1910
Narrow feet become a sign of
gentility; some women are
said to have their little
toes surgically removed
[+]
British society attends
Black Ascot following the
death of Edward VII

1910
Rayon is a new artificial
fibre based on viscose
[+]
The Delhi Durbar represents
a peak of imperial display
as the Indian princes use opulent
clothing and ceremonies to
demonstrate their wealth
to the visiting King George V
and Queen Mary
[+]
The tunic suit, or zhongshan,
as later worn by Mao Zedong,
becomes acceptable wear in China
[+]

Caresse Crosby patents the bra
in the United States

1911
The male impersonator Vesta Tilley
performs at the Royal Variety Show

1912
Elizabeth Arden invents the
'makeover' in her salons
[+]

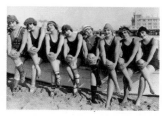

Mack Sennett forms his
'Bathing Beauties', who appear
in movies in bathing suits
which reveal their legs
[+]
American T. L. Williams creates a
petroleum and coal mascara for his
sister Maybel; its production is
the basis of the company Maybelline
[+]
Mario Prada establishes his
eponymous luggage company

1913
The variety of women's
hats rivals that of 1870
[+]
The US Navy issues crew with
short-sleeved, white cotton
undershirts, or T-shirts
[+]
One the eve of World War I,
drab colours have become
standard in military uniform
[+]
The V-neck, though pilloried by
doctors and clergymen as indecent
and a danger to health, becomes
popular in European dress designs

1914
The trench coat, as made by
Burberry, becomes standard wear
for British officers in World War I
[+]

The French Camouflage Corps
adopt camouflage schemes designed
and painted by Lucien-Victor
Guirand de Scévola, André
Mare and others
[+]
Invention of the
hand-held hair dryer

1915
Lipstick becomes popular after
Maurice Levy invents the metal
lipstick container
[+]
The top hat is replaced by the
bowler for all but formal occasions
[+]
The first flying jacket is created for
German air ace Baron von Richthofen
[+]
The blazer becomes popular for men
[+]
Detailing on uniforms disappears
due to the mass factory production
of uniforms
[+]
The first sneakers are developed
with rubber soles and named
because they make no noise

1916
Louise Brooks' bob sets the
style for the flappers;
it is echoed by Clara Bow

1917
The US government decides to
give returning soldiers $60
to buy a 'demob' suit; the British
will do something similar
[+]
A children's clothing trade
publication says, 'the generally
accepted rule is pink for the boys,
and blue for the girls'

1918
A drive to collect US women's
corsets is said to have produced
28,000 tons of steel to be recycled
for the war effort
[+]
In a Franz Kafka short story,
the protagonist is killed
by a 12-hour tattoo
[+]
Suzanne Lenglen plays tennis in
pleated skirts by Jean Patou that
reach only to the knee

1919
Chanel adopts the military
cardigan, introduced during the
Crimean War of the 1850s, to create
an inexpensive jersey twinset

c.1920
Flappers wear tight cloche hats
based on military helmets,
while their dresses reveal their
calves and even their knees.
The cloche makes it almost
impossible to have long hair
[+]
The cocktail dress appears as a
variant on the at-home tea dress
[+]
Uniformed cheerleaders
are introduced to team sports
in the United States
[+]
The fledgling Nazi and fascist
parties in Germany and Italy
adopt brown and black shirts,
respectively, as their uniform
[+]
The two-piece suit is increasingly
popular as an alternative to the
more formal three-piece suit of
jacket, trousers and waistcoat
[+]
A Gillette advertising campaign
convinces women that unshaved
legs are in bad taste
[+]
Women's shoes become lighter
and finer, with pointed toes
and bar or T-straps to keep
them on while dancing
[+]

Men wear a range of trousers,
including knickerbockers, plus-
fours and hugely wide Oxford bags,
which first appear at the university
for which they are named and
are largely confined to a clique
of undergraduates, led by
Harold Acton and called
the Oxford Aesthetes
[+]
Women begin to shave their
armpits after a Gillette
advertising campaign, designed
to sell razors for female use
[+]
Flappers reject the hourglass
shape and use tape to achieve an
androgynous, flat-chested look
[+]
Theodore Baer invents
the teddy or camiknicker
[+]
Tanned skin becomes more
fashionable as a consequence of
the new popularity of sun-bathing
[+]
Mussolini's Blackshirts
come to power in Italy

1920
The first designer ties appear,
with Cubist and Art Deco designs

1921
The inclusion of new ingredients
make the eyebrow pencil popular
[+]
Gandhi adopts the spinning wheel
and homespun cloth as symbols of
Indian nationalism, wearing his
emblematic homespun khadi
[+]
Beige-coloured stockings become
available for the first time
[+]

Charles Atlas begins to promote
'dynamic tension' as a form
of bodybuilding for men
[+]
Edward, Prince of Wales,
causes a fashion craze when he
wears plus-four knickerbockers
in the United States
[+]
Acetate fibre is produced
in the United States

1924
Boxer shorts are introduced
in the USA by Jacob Golomb
[+]
Kemal Atatürk bans the traditional
fez as part of his plans to
Westernize Turkey

1925
Skirts reach their shortest of
the early century: knee length
[+]
In Utah, a law is brought in to fine
or imprison women who wear 'skirts
higher than three inches above the
ankle' in public
[+]
Louis Weinberg applies the visual
language of camouflage to civilian
fashion for the first time

1926
The Perfecto is designed; it
becomes the iconic leather jacket

1927
The American League for
Physical Culture is founded

1928
Jeanne Lanvin creates a short,
bobbed 'Pierrette' hairstyle
[+]
John Carl Flugel coins the term
the 'Great Masculine Renunciation'
to describe men's rejection of
bold colours and decoration
in the early 19th century

1929
Shirley Temple's tight ringlets
set a fashion among adult women

c.1930
The popularity of outdoor
activities brings sandals back
into fashion (they are originally
beachwear, then worn for parties
and eveningwear)
[+]
Lightweight shoes develop for men,
of which the loafer is the prime
example; only labourers now tend
to wear boots

[+]
Fishnet stockings first appear
[+]

Two-toned brogues, known
as co-respondent shoes and
popularized by Fred Astaire,
become fashionable for men
[+]
Butterfly sleeves are
popular on dresses
[+]
Fashion historian James Laver
articulates the (now discredited)
theory of shifting erogenous zones
[+]
Khaki clothing is adopted as
leisurewear in the United States
[+]
Bra fashions change with each
season; previously their use
was limited to practicality
[+]
Madame Vionnet cuts the
cowl neck and halter
[+]

Elsa Schiaparelli uses surrealist
images and unusual materials such
as cellophane in her designs
[+]
Jean Harlow's appearance in
the movie »Platinum Blonde«
starts a nationwide craze
[+]
Marcel Rochas claims to invent
the word 'slacks' and introduces
the women's trouser suit
[+]
Betty Broadbent features as
The Tattooed Woman in
Barnum & Bailey's Circus
[+]

Marlene Dietrich wears a man's
dress suit in the movie »Morocco«
[+]
Hollywood popularizes leather for
women as clothing for 'tough babes'

1930
Tanning lotions become popular
[+]
Bunny Austin becomes the first male
tennis player to wear shorts
[+]
Women's clothing in the Great
Depression is a simple print dress,
midcalf for day, long for evening

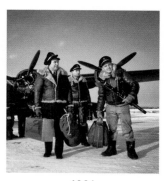

1931
The A2 becomes the
iconic flying jacket

1932
Evening gowns begin to emphasize
the back after Travis Barton
dresses Tallulah Bankhead in
a backless dress for her role
in the movie »Thunder Below«
[+]
Berets, pillboxes and tricornes
are popular hats for women
[+]

The trilby is an almost
universal headwear for men

1935
Jockey briefs are first sold by
Coopers Inc. in Chicago, Illinois
[+]
The Windsor knot appears and is
named after the Duke of Windsor
[+]
Bare male chests become
legal in the United States

1936
The United States Congress
legislates on safety
standards for cosmetics
[+]
Norman Hartnell creates a white
mourning wardrobe for the Queen
Mother, May of Teck

1938
In her essay 'Three Guineas',
Virginia Woolf identifies ways
in which contemporary fashion
provides men with a rigid
social symbolism in the form
of signs of their social
and professional role
[+]
Horst photographs a
Mainbocher corset for »Vogue«
[+]
During the Nazi occupation
of Paris, high turbans are a
symbol of defiance for French women

1939
Betty Grable stars in »Million
Dollar Legs«; Paramount Pictures
publicizes that she has insured
her legs for the same amount
[+]

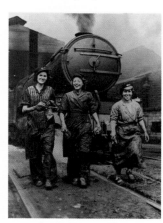

Fabric shortages in World
War II – and the need to do
manual labour – see more women
wearing trousers, leading
to women factory workers
wearing denim overalls
[+]
When Hitler bans cosmetics,
German women refuse to work
in war industries
[+]
Slouches, hoods, snoods and turbans
are popular forms of headwear
throughout the war
[+]
Carmen Miranda helps to
popularize platform shoes
[+]
The colour pink becomes almost
exclusively associated with
baby girls, blue with baby boys
[+]

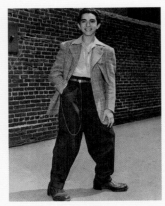

The baggy 'sack' pants and wide padded shoulders of the zoot suit, worn by black and Hispanic Americans, influence the cut of more mainstream suits

c.1940
Women use coordinating separates to help overcome the appearance of clothing shortages
[+]
Restrictions on fabric lead to short, straight skirts and, in England, utility clothing designed within tight restrictions by London's top couturiers
[+]
Cork or wood-soled wedgies for women are limited to heels up to only 1 inch
[+]
Leather is reserved for military use; it is widely replaced by reptile skin and mesh
[+]
Men wear Oxfords, brogues or moccasins; students wear spectator and saddle shoes, which are associated with sport
[+]
At work, women wear their hair in neat rolls, often with a headscarf; rollers and styling lotion are common
[+]
Neckties become wider
[+]
Red lipstick is popular as a gesture against wartime privations
[+]
The first nylon stockings go on display and sell out in days; later in the war, when stocking sales are very restricted, women paint trompe l'oeil nylon seams on their already dyed brown legs
[+]
Jane Russell in »The Outlaw« wears a bra that pushes her breasts up and forwards, reputedly designed by Howard Hughes, who is also said to have come up with the 'How Would You Like to Tussle with Russell?' poster strapline
[+]

Women wear long, skin-tight gloves, often made from kid leather, with evening dresses. Glove stretchers are used to allow the hand to fit inside

1940
Acrylic fibre is invented by the Dupont Corporation; it is originally called Orion and made from the polymer, polyacrylonitrile

1941
Claire McCardell, creator of the 'American Look', invents the popover, a wraparound denim dress
[+]
Race riots break out in Los Angeles provoked by the zoot suits worn by young Hispanic Americans

1942
The first fashion week in New York is held when travel to Paris is made impossible by the war
[+]
Wool Field Jacket M1944 – a short-cut combat jacket favoured by General Dwight D. Eisenhower – is so popular among United States soldiers that it becomes a standard item of men's sportswear

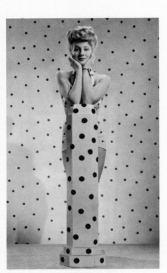

1943
The model Chili Williams poses on the April cover of »Life« magazine wearing camouflage
[+]
American fashion and art publicist, Eleanor Lambert, establishes 'Fashion Press Week', which evolves into what is now New York Fashion Week

1944
Despite restrictions, sales of make-up rise 53 per cent in the war

1946
Christian Dior opens his fashion house, which revives corsetry and revolutionizes women's wear with extravagantly proportioned full skirts, unseen during war shortages. A year later, his first collection is christened by Carmel Snow, editor in chief of »Harper's Bazaar«, the 'New Look'
[+]

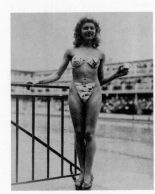

French engineer Louis Reard invents the bikini, named after the atoll where the first atom bomb was detonated

1947
Jean Cassegrain founds Longchamp to craft pipe and smoking-related leather goods

1948
With the Chinese Revolution the zhongshan suit – renamed the Mao suit – becomes the accepted uniform for the Chinese communist party
[+]
American designer Norman Norell introduces the chemise as a high-fashion garment
[+]
Sonja de Lennart invents Capri pants
[+]

Converse introduce black and white tennis shoes for men

c.1950
The stiletto, a shoe with the slimmest possible heel, emerges – with many designers claiming its invention
[+]
Coloured cotton underwear for men appears
[+]

Pencil skirts are worn with girdles
to accentuate the hourglass figure;
the skirts reach an apotheosis
as office dress
[+]

British Teddy Boys wear brothel
creepers with thick soles,
day-glo socks and drainpipe
trousers with 4 inch turn-ups
[+]
Teenage American girls known as
bobbysoxers wear loafers, saddle
shoes, flats and ballet slippers;
they wear them with dresses or
calf-length skirts, rather than
trousers or shorts
[+]
Longer hairstyles for men catch on,
particularly the so-called 'duck's
ass' combed-back look
[+]
For the first time in the
twentieth century, males
frequently bare their arms
[+]
Breasts become the most prominent
erogenous zone, popularized by
stars such as Gina Lollobrigida
and Anita Ekberg in Italian movies
[+]
Gloves fall out of
fashion for everyday wear
[+]
The corset is largely
replaced by the panty girdle
[+]

British middle-aged men
wear a knotted handkerchief
on their heads on their beach
holidays, to replace the trilby
and cloth cap
[+]
Elizabeth Arden and Helena
Rubenstein lead a boom
in high-luxury make-up
[+]
Cristóbal Balenciaga's coolie hat
is universally copied in straw
[+]
Hair conditioners are invented
from fabric softeners
[+]

The fashion for the male
hat has almost entirely
disappeared after the war
[+]
Hair and make-up are more
indulged after the war to achieve
the 'domestic goddess' look
[+]
Neckties become thinner
[+]
The urchin haircut begins to
reduce the need for women's hats
as a way of controlling the hair
[+]

Elvis Presley sets the
fashion for male hairdos
[+]
Hazel Bishop, chemist, creates
kiss-proof long-lasting lipstick
[+]
Yves Saint Laurent at Dior creates
the middy, a dropped waist-line

1950
The first man's suit is
made from polyester

1952
Marlon Brando wears a leather
jacket throughout »The Wild One«

1953
Queen Elizabeth II sets fashion
with the so-called Magpie Dress,
which is copied and on sale in
Oxford Street within a week
[+]
Chanel reopens her fashion
house, closed since the
outbreak of World War II
[+]

TV show »Davy Crockett« inspires
a craze for coonskin hats
[+]
In »The Night of the Hunter«,
psychopathic priest Robert Mitchum
has tattoos on his knuckles

1954
»Playboy Magazine« introduces the
nude centrefold; the first is
Marilyn Monroe in a photo taken in
1951, while she was still unknown
[+]
Jeans become a sign of
youthful rebelliousness, mainly
through the films of James Dean

1955
Christian Dior introduces
the A-line dress
[+]
Cristóbal Balenciaga designs
the tunic or sack dress, which will
later develop into the
chemise dress of 1957
[+]
Clairol introduces first
home-colouring kit with the slogan
'Does she or doesn't she?'
[+]
Queen Elizabeth II ends the
practice of debutantes being
presented to the monarch

1956
Inspired by their close
collaboration, Hubert de Givenchy
creates the scent L'Interdit,
dedicated to Audrey Hepburn
who is the first actress to be
the face of a brand or perfume

1957
Brigitte Bardot wears a bikini
in the film »And God Created Women«
[+]
British Nylon Spinners
introduce Bri-Nylon
[+]
Spandex, a polyurethane-polyurea
copolymer, is invented at DuPont
by C. L. Sandquist and Joseph
Shivers, and patented by the
Spanjian brothers, who give
it its American name

1958
Tourists introduce Hawaiian
shirts to North America

1959
The Beatniks in Paris adopt
a minimalist uniform of
black clothing; black jeans,
turtlenecks, Breton T-shirts
and sunglasses
[+]
Farah Diba chooses Yves Saint
Laurent to design her dress for
her wedding to the Shah of Iran
[+]
Paco Rabanne and André Courrèges
use chainmail in their designs
[+]
Following the Cuban Revolution,
its leader, Fidel Castro, adopts
army fatigues as everyday wear

c.1960
Paco Rabanne, André Courrèges
and Pierre Cardin experiment
with 'space age' fabrics,
plastics and metallics
[+]
Jackie Kennedy popularizes
the pillbox hat
[+]
New dyes render acid colours
popular in youth clothing
[+]
The focus of female sexuality
shifts away from breasts to legs
and thighs with the falling age
of the fashion figure, and the
prevalence of such gamine models
as Twiggy and Jean Shrimpton
[+]
»Vogue« editor and trendsetter
Diana Vreeland uses red
throughout her apartment

[+]
The age of fashion influence
falls from the forties
to the twenties
[+]
The hippy movement begins
a new boom in tattoos
[+]
Going without a bra becomes
a political gesture; bras are
burned in protests against social
injustice
[+]
Coloured tights become popular
[+]
Hippies wear moccasins and sandals
[+]
Men's popular shoe styles include
ankle boots with square Cuban
heels, called Chelsea or Beatle
boots; men's shoes are coloured for
the first time in over 100 years
[+]
Short shorts manifest themselves
as hotpants in London
[+]
The beehive hairstyle is
developed by Margaret Vinci
Heldt of Chicago, Illinois,
who had been asked by the editors
of »Modern Beauty Salon« magazine
to design a new hairstyle that
would reflect the coming decade
[+]
The modern mechanized
silkscreen process is invented
by Michael Vasilantone
[+]
Men's fashion becomes more
colourful, experimental and
decorative, and cravats and
frills re-enter young men's
wardrobes. »Esquire« magazine,
link this to the fashions found
on Carnaby Street, London,
calls it the 'peacock revolution'

1960
Australian Peter Travis
invents the Speedo
[+]
Laura Ashley designs clothes
based on an idealized nineteenth-
century English cottage style:
cotton, velvet, lace and long skirts

1961
Louise Poirier invents the
modern Wonderbra, launching the
Model 1300 plunge push-up bra
[+]
After a hepatitis B scare, tattoo
parlours are banned in New York
City; the ban lasts until 1997
[+]
Emergence of the Mod
movement in Britain
[+]

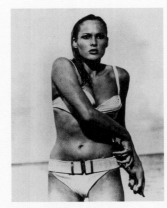

Ursula Andress wears a bikini in
»Dr No«; the picture of her emerging
with a knife tucked in a belt makes
her a pin-up around the world

1962
The rise of the Beatles
popularizes collar-length hair
[+]
Cecil Beaton creates black and white
Ascot in the movie »My Fair Lady«

1963
Mary Quant conceives the miniskirt

1964
Rudi Gernreich creates the monokini
[+]
Rudi Gernreich designs
the topless swimsuit
[+]
Paco Rabanne uses plastic
disks to make dresses
[+]
André Courrèges shows a minidress
in his Mod look collection

1965
Yves Saint Laurent produces
the Aran cocoon wedding dress
[+]
Hair is simpler as more women work
and natural looks gain popularity
[+]
The hippy movement emerges in
San Francisco and other American
cities with its own distinctive
fashion, best described
as 'colourful gypsy'
[+]

Truman Capote holds his renowned
black-and-white masked ball

1966
Jimi Hendrix performs wearing
a hussar jacket
[+]

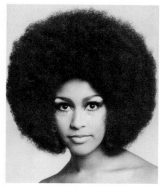

Afro becomes popular hairstyle
[+]
Michael Fish designs the kipper tie
in Piccadilly; Elvis Presley will
later introduce it to America
[+]
Yves Saint Laurent launches
his famous 'smoking jacket' –
an androgynous tuxedo for women –
in Paris, followed a year later
by his knickerbocker suits,
and a year later by culottes
[+]
Biba sells soft, pull-on
'anti-fashion' hats

c.1967
Jim Fitzpatrick's iconic poster
of Che Guevara, wearing a beret
with star insignia, appears and
becomes a standard image in
student 'digs' across the globe

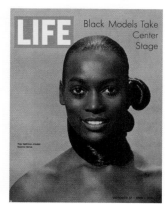

1967
Naomi Sims becomes the first
black woman to appear on the
cover of »Life« magazine
[+]
Yves Saint Laurent produces a
collection based on African clothing
[+]
The musical »Hair« opens on
Broadway; it makes long hair
a symbol of youth rebellion

1968
Yves Saint Laurent features
a high level of nudity and
topless models in his shows
[+]
Missoni's elaborate knitted
clothes take inspiration from
op art and African imagery
[+]
Yves Saint Laurent creates a
golden breastplate molded by
the sculptor Claude Lalanne
[+]

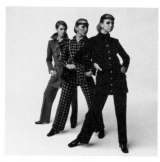

Pant suits are popular women's
wear, ranging from Yves Saint
Laurent sexy elegance to terylene
shopping-mall horrors

1969
TV show »Charlie's Angels« sets
a vogue for 'big hair'; feathered
cuts are popular for men

1970
Feminists turn on cosmetics as a
sign of male oppression of women
[+]

Glam rock popularizes
men's platform soles,
often to absurd proportions
[+]
Hat decorations reflect the
growing ethnic movement
[+]
Issey Miyake, Kenzo and Sonia
Rykiel experiment with bold
colours and challenge Western
traditions of tailoring
[+]
Soccer shorts rise to expose thighs
[+]
The midi becomes a
popular skirt length

[+]
Rich patterns compensate
for static fashion silhouette
[+]
The coloured handkerchief code
is in use among homosexuals in
the United States, first identified
by a journalist for New York City
newspaper, »The Village Voice«

1971
The crimping iron is
invented by Geri Cusenza
of Sebastien Professional
[+]
The US Olympic swimmer
Mark Spitz causes scandal
by wearing Speedos

1972
Gang members in Los Angeles
begin to wear colours to show
their different allegiances
[+]
The knit Polo shirt, designed
by Ralph Lauren, appears
in the United States
[+]
Rudi Gernreich invents the G-string

c.1973
Designer jeans for
women appear from Jean Paul
Gaultier and Vivienne Westwood;
Brooke Shields advertises
Calvin Klein jeans
[+]
Barbara Hulanicki opens an
art deco emporium, Biba, in
Kensington, London; her early
designs express nostalgia
for 1930s styling,
and feature 'flares'

1974
Streaking – naked running – enjoys
brief popularity in the United
States, followed by Britain
[+]
Beverly Johnson becomes American
»Vogue«'s first black cover model
[+]
Zandra Rhodes, nicknamed the
'princess of punk', designs
a 'winged' white satin outfit
for Freddie Mercury
[+]
African American
braids become popular

[+]
Yves Saint Laurent bases a
celebrated winter collection
on Cossack Russia

1975

Punk emerges as a youth subculture
in Britain and New York, identified
primarily by mohawks, spiked and
coloured hair and heavy-duty boots
[+]
Giorgio Armani and Sergio Galeotti
launch their first collection,
showcasing soft clothes with a
natural fit and a neutral palette.
Armani's jacket becomes a US
status symbol; in 1982 he appears
on the cover of »Time« magazine

1976

Miuccia Prada takes over
the family luggage company

c.1976

Celebrities begin to market
their own make-up brands

1978

Ralph Lauren designs influential
clothes for Diane Keaton in the
Woody Allen movie »Annie Hall«
[+]
The Body Shop is founded to
sell ethical cosmetics

c.1980

Rei Kawakubo works with
'eight shades of black'
[+]
Business women wear sling-back
court shoes with pointed toes
[+]

Paul Smith reintroduces
colour to business suits
[+]
The shell-suit – a nylon tracksuit,
often in garish colours – becomes
popular leisurewear among the
British working classes
[+]

A craze for wearing replica soccer
shirts takes off; fans also
appropriate classic British labels
such as Aquascutum and Burberry
[+]
Thierry Mugler experiments
with vinyl clothing
[+]
Wide, padded shoulders in
womenswear make a comeback,
and come to define an era of
'power dressing'
[+]
Supermodels lead protests
against wearing fur
[+]
The so-called 'young fogeys' dress
in tweed suits, waistcoats and hats
[+]
Gianni Versace's flamboyant
silk shirts of swirling colours
for men chime well with the
era of extravagance
[+]
Bob Marley appears on stage
in football gear and tracksuits
[+]
Fashionable men in London wear
shorts with business jackets
[+]
Women – and some men – wear leg
warmers and stirrup pants,
particularly for exercise
[+]
Men's shoes are usually
conservative models, such as
loafers, brogues and Oxfords
[+]
Sneaker wars break out as Adidas
and Nike spearhead advertising
campaigns that make training shoes
desirable and collectible
[+]
»The Official Preppy Handbook«
cites Lacoste, founded in 1933,
as essential preppy wear

1980

British women want to copy the
haircut of Lady Diana Spencer,
fiancé of Prince Charles, which will
become an international trend
[+]
Yves Saint Laurent creates a
show-stopping black wedding dress

1981

Princess Diana wears a wedding
dress of extravagant proportions
when she marries Prince Charles
[+]
Azzedine Alaïa produces overtly
sexual, body-hugging clothes
[+]
Labour Party leader Michael Foot
is widely condemned for wearing a
duffle coat to a Remembrance Sunday
ceremony at the Cenotaph

[+]
Skinny leather ties become popular
[+]
Japanese designers shock the
Paris fashion scene with their
emphasis on cut and shape and
their wide use of black
[+]
Karl Lagerfeld takes over as
creative director at Chanel, after
an extensive freelance career

1983

Vivienne Westwood revives
the concept of the crinoline
as the mini-crini
[+]
Paco Rabanne introduces the
first wrinkle cream for men

1984

The first London Fashion Week is held
[+]
John Galliano presents his French-
Revolution themed graduate show
'Les Incroyables' at Central St
Martin's in London

1985

The film »Dangerous Liaisons«
inspires a rise in corset sales
in Britain and the United States
[+]

Levi's 'laundrette' advertising
campaign, promoting the now-
classic 501's, sparks phenomenal
sales and gives the flailing
brand a new lease of life

1987

The first microfibres are
introduced; they can be 100 times
thinner than human hair
[+]
Christian Lacroix shows his first
independent couture collection,
featuring short puff skirts and
bubble dresses in warm
Mediterranean colours

1988

Shaved hair becomes
more popular for men

1989

Mens' toiletries and hair products
become more widely available

c.1990
Black takes over fashion
[+]
Khaki becomes associated with
a kind of casual luxury, being
used by Diesel and Maharishi
along with camouflage for
everyday clothing
[+]

Dries van Noten takes the
clothes of Tibet as the inspiration
for his designs
[+]
Dress-down Fridays are introduced
by US corporations to promote
an illusion of informality
in office life
[+]
Among the other manifestations of
logo mania is a spreading craze
for Burberry check among young men
[+]
The term 'deconstruction' or
La Mode Destroy is used to describe
a new trend for incorporating
frayed hems and recycled materials
into clothes designs
[+]
Miuccia Prada experiments with
abstract prints based on colours
and designs from the 1950s
[+]
The Austrian designer Helmut
Lang's sharp, chic designs define
nineties minimalism
[+]
Jean Paul Gaultier designs
conical bras for Madonna's live
performances, copying those
originally created by Yves Saint
Laurent in his sixties'
African collection
[+]
Naomi Wolf's influential book
»The Beauty Myth« questions the
assumptions and demands of social
ideas of beauty

1990
The Grunge movement emerges in
music, with an associated fashion
based on ragged and unkempt clothes;
used as the basis of a high-profile
grunge collection for Perry Ellis
by Marc Jacobs, it results in the
designer losing his job

1991
Thierry Mugler designs a
Harley Davidson bustier

1992
Jack Nicholson wears a purple
Tommy Nutter suit in the movie
»Batman Returns«
[+]
Combat pants appear on
the London club scene
[+]
Alexander McQueen's low-slung
'bumster' trousers make their first
appearance at London Fashion Week
[+]

Naomi Campbell falls off Vivienne
Westwood's 5-inch Super
Elevated Gillie platform shoes

1993
The 'Rachel cut' worn by
Jennifer Anniston in »Friends«
becomes widely popular

1994
US designer Laura Whitcomb bases
dresses on UPS uniforms
[+]

Princess Diana wears a black dress
by Cristina Stamboulian on the
evening her husband confesses his
infidelity on national TV
[+]

Marc Jacobs designs Louis Vuitton's
first ready-to-wear collection
[+]
Prada's military-influence
collection is dubbed utility chic;
Miuccia Prada calls uniforms
'the most reassuring and
elegant dictatorship'
[+]
British actress Liz Hurley wears
a low-cut black Versace dress, held
together with oversized gold safety
pins, to the premiere of Hugh Grant's
film »Four Weddings and a Funeral«.
It catapults Hurley to stardom
comes to be known as 'That Dress'
[+]
Eva Herzegovina appears
in a Wonderbra billboard with
the slogan 'Hello Boys'
[+]
First Victoria's Secret
Fashion Show takes place, soon
to be known less for lingerie
design than for its 'angels'

1995
Kate Moss's campaign for Calvin
Klein produces the terms
'waif-look' and 'heroin chic'

1997
Donatella Versace presents her
first collection as design director
of Versace after the murder of her
brother, Gianni a year before; the
collection brings combat pants to
haute couture in beige moiré satin
[+]
John Galliano presents his first
collection for Dior; it features
playful clothes, electric colours
and eclectic influences

1998
'Coco' Chanel is the only fashion
designer to appear on »Time«
magazine's list of the 100 most
influential people of the century
[+]
Vivienne Westwood begins to
revive the corset as outerwear

1999
Hollister & Co., a division
of Abercrombie & Fitch, Co.
founded in 1892, eschews any
black in its collection or on
its sales representatives

2001
Financial challenges in the
luxury fashion sector lead to
collaborations between
big designers and high street
retailers, such as Matthew
Williamson for H&M and
Jill Sanders for Uniqlo

c.2000
Botox becomes a major player
in anti-ageing cosmetics

2001
David Beckham shirts sell out when
the footballer moves to Real Madrid
[+]
Alexander McQueen stages
a catwalk show for his Spring/
Summer collection entitled VOSS -
the stage is dominated by an
enormous glass box unlit from the
inside, later revealed to be filled
with moths and, at the centre,
a naked model on a chaise longue
with her face obscured by a gas
mask; the glass walls then
fall away and smash on the ground

2002
Japanese women wear spray-on
stockings to overcome the
workplace requirement that
their legs are covered

2003
Prince William's 21st birthday has
an 'Out of Africa' fancy-dress theme
[+]
In Ukrainian presidential
elections, orange is worn
to show allegiance with the
defeated Victor Yushchenko
[+]

Boho-chic, drawing on influences
from both the sixties and
nineteenth-century Pre-
Raphaelites, is at its height
as exemplified by Sienna Miller
and Kate Moss in the UK and
Nicole Richie, Mary-Kate and
Ashley Olsen in the United States

2004
Prince Harry attends a fancy
dress party wearing a Nazi uniform
[+]
A pubic hair runway show is
held in Los Angeles

2005
Frida Giannini reintroduces
puffed sleeves at Gucci

2006
John Galliano makes up his Spring/
Summer models with white faces

2007
Batik is designated Masterpiece
of Humanity by UNESCO
[+]
In Iran, opponents of
President Ahmadinejad wear green
[+]

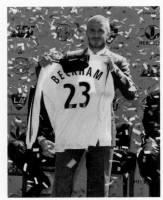

After David Beckham signs for
LA Galaxy, more than 200,000
replica shirts are sold

2009
Marios Schwab bases a
collection on the colours
of beetles and other insects
[+]
64-year-old Cher wears a sheer body
stocking to the MTV music awards
[+]
First Lady Michelle Obama
transforms Jason Wu from a fashion
insider and virtually unknown
designer into a household name by
wearing a Wu ball gown at President
Obama's inaugural ball. She chooses
to wear another of his gowns at
the 2013 inaugural ball

2010
Victoria Beckham is selected
as 'Designer of the Year' for her
eponymous brand at the British
Fashion Awards
[+]
John Galliano designs a Dior
runway collection based
on a 1940s sailor theme; it will
be his last collection before
dismissal for anti-Semitism

2011
At the wedding of Prince
William and Kate Middleton,
the bride's dress is designed by
Sarah Burton, creative director
of Alexander McQueen

2012
Feminine peplum silhouette
regains popularity
[+]
Lady Gaga opens milliner
Philip Treacy's show at
London Fashion Week
[+]
High street retailer H&M
pairs up with iconic high-end
design house Versace
[+]

Wedge trainers emerge on the
catwalk and quickly find their way
into high street collections
[+]
Stella McCartney designs the
Team GB kit for the London 2012
Olympic Games, and is crowned
'Designer of the Year' at the
British Fashion Awards
[+]
Raf Simons replaces John
Galliano as creative director
at Christian Dior
[+]
Brad Pitt is the first man to
front an advertising campaign for
Chanel No. 5; the first $7-million ad
receives mixed reviews

Ashelford, Jane. »A Visual History of Costume: 16th Century«. London: Batsford, 1993.

Baudot, François. »A Century of Fashion«. London: Thames and Hudson, 1999.

Bonami, Francesco (ed). »Uniform: Order and Disorder«. Milan: Edizioni Charta, 2000.

Boucher, François. »A History of Costume in the West«. London: Thames and Hudson, 1987 (rev edn).

Brubach, Holly. »A Dedicated Follower of Fashion«. London: Phaidon Press, 1999.

Charles-Roux, Edmonde. »Chanel«. London: The Harvill Press, 1989.

Coleridge, Nicholas. »The Fashion Conspiracy«. London: HarperCollins, 1988.

Corson, Richard. »Fashions in Make-up from Ancient to Modern Times«. London: Peter Owen, 2003 (rev edn).

Cumming, Valerie. »A Visual History of Costume: 17th Century«. London: Batsford, 1984.

Cunnington, Drs. C. Willett and Phillis. »The History of Underclothes«. London: Michael Joseph, 1951.

Cunnington, Phillis, and Alan Mansfield. »English Costume for Sports and Outdoor Recreation from the 16th to the 19th Centuries«. London: A&C Black, 1969.

Daria, Irene. »The Fashion Cycle«. New York: HarperCollins, 1990.

Davis, Fred. »Fashion, Culture and Identity«. Chicago: University of Chicago Press, 1992.

De La Haye, Amy, and Elizabeth Wilson. »Defining Dress: Dress as Object, Meaning and Identity«. Manchester: Manchester University Press, 1999.

De Marly, Diana. »The History of Haute Couture 1850–1950«. London: Batsford, 1980.

Deryck, Luc, and Sandra van de Veire. »Belgian Fashion Design«. Amsterdam: Ludion Editions NV, 1999.

Dupire, Beatrice, and Hady Sy. »Yves Saint Laurent: 40 Years of Creation«. New York: Distributed Art Publishers, 1998.

Eco, Umberto. »On Beauty«. London: Secker & Warburg, 2004.

Evans, Caroline. »Fashion at the Edge«. New Haven, CT: Yale University Press, 2003.

Evans, Caroline, and Minna Thornton. »Women and Fashion: A New Look«. London: Quartet Books, 1989.

Fairchild, John. »Chic Savages«. New York: Simon and Schuster, 1989.

»The Fashion Book«. London: Phaidon Press, 2013 (rev edn).

Finlayson, Iain. »Denim: An American Legend«. Norwich: Fireside, 1990.

Foster, Vanda. »A Visual History of Costume: 19th Century«. London: Batsford, 1984.

Gan, Stephen. »Visionaire's Fashion 2000: Designers at the Turn of the Millennium«. New York: Universe Publishing, 1997.

Harvey, John. »Men in Black«. London: Reaktion Books, 1995.

Jones, Mablen. »Getting It On: The Clothing of Rock 'n' Roll«. New York: Abbeville Press, 1987.

Koda, Harold. »Extreme Beauty: The Body Transformed«. New York: The Metropolitan Museum of Art, 2001.

Kybalova, Ludmilla, Olga Herbenova and Milena Lamarova. »The Pictorial Encyclopedia of Fashion«. London: Paul Hamlyn, 1968.

Laver, James. »A Concise History of Costume«. London: Thames and Hudson, 1969.

McCardell, Claire. »What Shall I Wear? The What, Where, When and How Much of Fashion«. New York: Simon and Schuster, 1956.

McDowell, Colin. »Fashion Today«. London: Phaidon Press, 2002.

McDowell, Colin. »The Literary Companion to Fashion«. London: Sinclair Stevenson, 1995.

McDowell, Colin. »Dressed to Kill: Sex, Power and Clothes«. London: Hutchinson, 1992.

McDowell, Colin. »Forties' Fashion and the New Look«. London: Bloomsbury, 1994.

McDowell, Colin. »The Man of Fashion«. London: Thames and Hudson, 1997.

Malossi, Giannino (ed.). »Material Man: Masculinity, Sexuality, Style«. New York: H. N. Abrams, 2000.

Mansel, Philip. »Dressed to Rule: Royal and Court Costume from Louis XIV to Elizabeth II«. New Haven, CT: Yale University Press, 2005.

Morris, Desmond. »The Naked Man: A Study of the Male Body«. London: Vintage, 2009.

Morris, Desmond. »The Naked Woman: A Study of the Female Body«. London: Vintage, 2005.

Oakes, Alma, and Margot Hamilton Hill. »Rural Costume«. London: Batsford, 1970.

»Pattern«. London: Phaidon Press, 2013.

Quilleriet, Anne-Laure. »The Leather Book«. New York: Assouline, 2004.

Remaury, Bruno. »Dictionnaire de la Mode au XXe Siecle«. Paris: Éditions du Regard, 1996.

Ribeiro, Aileen. »A Visual History of Costume: 18th Century«. London: Batsford, 1983.

Rudofsky, Bernard. »The Unfashionable Human Body«. London: HarperCollins, 1972.

Schnurnberger, Lynn. »Let There Be Clothes: 40,000 Years of Fashion«. New York: Workman Publishing, 1991.

Wilcox, R. Turner. »Five Centuries of American Costume«. London: A&C Black, 1963.

S
E
L
E
C
T

B
I
B
L
I
O
G
R
A
P
H
Y

I
N
D
E
X

Page numbers in *italics* refer to illustrations.
Tip-in pages are indexed by the number of
the facing illustration page.

270

AUTHOR'S ACKNOWLEDGEMENTS
In writing a book such as this,
I have turned to many sources,
including conversations with many
colleagues whose knowledge of
specifics within their disciplines
has been generously shared with me.
There are too many such sources for
me to list so it is better that I say
thank you to them all and add that
I hope I have not misrepresented
their scholarship. Particular
thanks, however, must go to Amanda
Renshaw at Phaidon Press for
understanding a complicated book
and sticking with it even when
it took longer than either of us
had imagined, and to my editors,
Victoria Clarke and Timothy Cooke.
Victoria has shown a remarkable
and rare level of dedication to the
project, while Timothy, who had
the original idea for the book, did
much of the research. Anita Croy
also contributed useful research,
as did Pauline Bache in the early
stages of the project. At Phaidon,
I am also grateful to our picture
researchers, Emmanuelle Peri and
Jenny Faithful, and our production
controller, Laurence Poos.